PM
23 SEP
1988
LOS ANGELES CA 900

LOS ANGELES
CALIF

.45

19 JUN
1992

From
M. Bellamy
1362 East Holt Blvd,
Ontario, Calif.
91761

£ 1

Mr. Howard Mewse
19 Maria Theresa Close
New Malden
Surrey KT3 J6F
ENGLAND

TE 916
069

CHARLTON HESTON

on Hepburn

- 1993

se -

I'm fine

In answer to your question, there are always disappointments in one's life and ones work. I had hoped to dance in my picture as I was a professional dancer but only danced in two pictures. The deeper disappointment that hurt most was when Max Arnow who call'd me for the part of Belle Watling in "Gone with the Wind" and I was too ill to take it at that time. Old Hollywood, as I knew it as a young girl is gone - All the narrow streets and small bungalows are replaced with Hi Rise but progress can't stop.

Wishing you health & happiness

appear
Film Festiva
well and I enjo
ve to all of you

I used to be in Pictures

AN UNTOLD STORY OF HOLLYWOOD

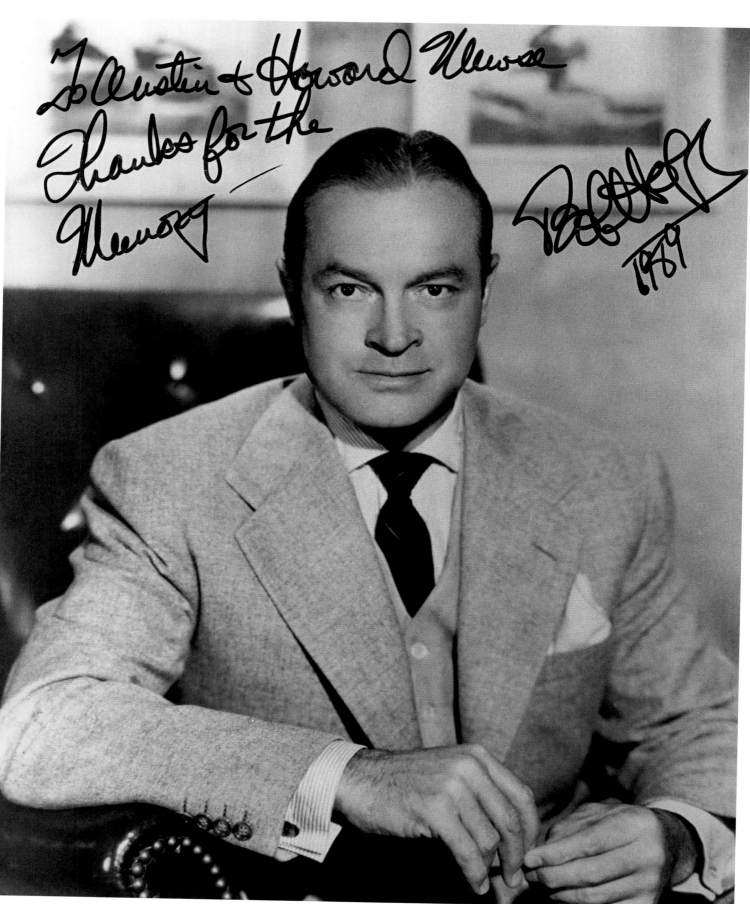

American Treasure: Bob Hope.

I used to be in Pictures

AN UNTOLD STORY OF HOLLYWOOD

AUSTIN MUTTI-MEWSE AND HOWARD MUTTI-MEWSE

FOREWORD BY DOMINICK FAIRBANKS

ACC EDITIONS

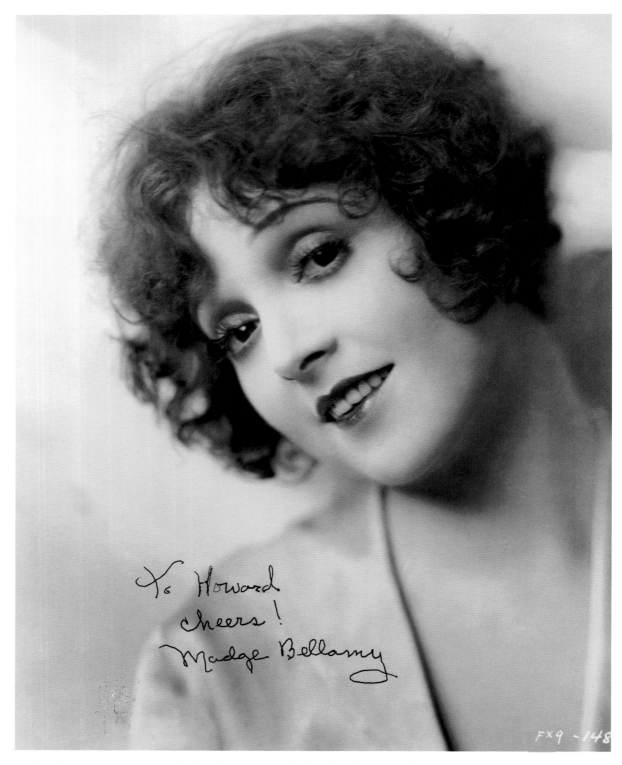

To Howard cheers! Madge Bellamy

FX9 - 148

Madge Bellamy, was one of the brightest stars during the silent era. She was, however, often considered unconventional and impulsive. By her own admission, Madge felt that beauty came before talent, *"and then I woke up,"* she said in 1989. *"I fell out with the director Frank Borzage on the film Lazybones because he wanted to get my manicured finger-nails dirty. Borzage was absolutely furious with me. That's when I learnt acting is a serious business!"* Bellamy was typecast early on playing bobbed-haired floozies and Jazz Babies in such films as *Sandy* (1926), *Ankles Preferred* (1927) and *Silk Legs* (1927). She did occasionally shake off her stereotyping, winning plaudits for her roles in *Lorna Doone* (1922), *The Iron Horse* (1924), *Mother Knows Best* (1928) and *White Zombie* (1932) opposite Bela Lugosi. During the 1940s, she made the headlines again, for the wrong reasons, when she shot three bullets at her former lover, millionaire A. Stanford Murphy, after he jilted her to marry another woman. Hers was a happy ending though: during the 1970s she sold her Ontario home for more money than she'd earned during her entire film career. *"I described my fall from popularity with the four 'F's: fame, fortune and false friends, it went in that order."*

In memory of Violet Mutti, our grandmother, who taught us how to write a letter.

To Joanna, Nathan and Ferhat for their love and support.

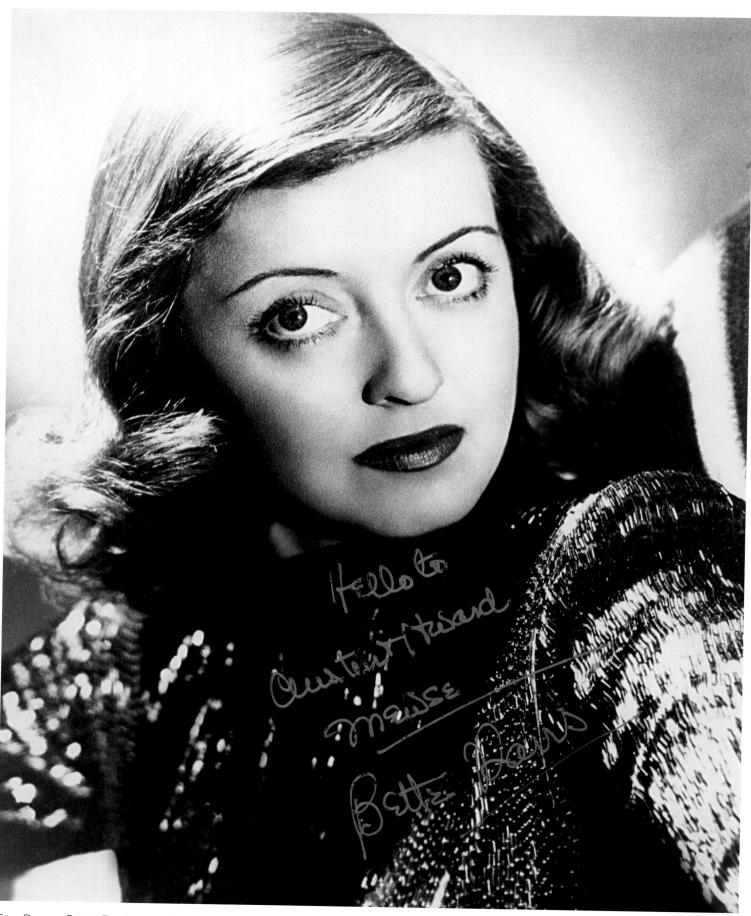

Star Power: Bette Davis was given the title 'First Lady of the Silver Screen' for good reason: she enjoyed a film career spanning six decades, starred in more than 100 films and won two Academy Awards. *"I survived because I was tougher than anybody else,"* she once said.

Contents

FOREWORD - BY DOMINICK FAIRBANKS 8

INTRODUCTION 10

PALM SPRINGS - THE (MOVIE) STARS AND (ZEBRA) STRIPES 14

HOLLYWOOD AT HOME 34

I USED TO BE IN PICTURES 68

HOLLYWOOD ON SET 86

I'M STILL BIG - IT'S THE ROOMS THAT GOT SMALL 172

HOLLYWOOD ON THE TOWN 196

VAMPIRA - A HOLLYWOOD HORROR STORY 230

HOLLYWOOD AFTER DARK 240

COCKS AND COCKTAILS 284

FILMOGRAPHY 298

INDEXES 299

ACKNOWLEDGEMENTS 303

PICTURE CREDITS 304

Foreword

It was and is such a huge honour and a privilege to have been asked by Howard and Austin to write the foreword for this incredible book.

I met both of them first in their capacity as public relation marketers for menswear fashion brands. I was introduced to Austin initially at the House of Hardy Amies, 14 Savile Row. This is a street I know well, since my grandfather Douglas Fairbanks Jr., a man of great taste and impeccable style, frequently shopped here. He was prominently positioned over the years on various 'Best Dressed Lists' and was a fan of The Row. It was a happy reminder for me walking to meet Austin on that first day and passing Gieves and Hawkes, Kent & Curwen, and Kilgour – all stores favoured by my grandfather. Fashion style and film have, afterall, always gone hand in hand.

Our meeting was one of chance, but it soon became clear to me that this was a meeting of minds. I was overwhelmed initially by Austin's energy and enthusiasm and then by Howard's too; not just for their day jobs – both have followed the same career paths, Howard working for Dockers as part of Levi Strauss & Co. – but moreover by their passion for film of a bygone age.

Their story slowly began to unfold. I learned how, as two young boys, they knew and corresponded with my grandfather. How they met him at a bookstore in Kingston-Upon-Thames, England in 1988, still dressed in their school uniforms. I was moved by their description of him; their praise and thanks to him for choosing to reply to their fan letters and that he should have taken such a keen interest. My grandfather saw in them then their fascination for early film and film stars. As their friendship grew, and in true Fairbanks character, he connected them both to a few of his former contemporaries, actors who were almost forgotten and living in obscurity; Fay Wray, Vilma Bánky and William Bakewell amongst them.

It was this thoughtful gesture that gave further momentum to their incredible journey of rediscovery. My grandfather would be so very happy today in the knowledge that Austin and Howard are telling their story – celebrating the lives of Hollywood stars, through stories and photographs they have collected, many of which have never been published before.

Douglas Fairbanks Jr. would be so very happy to see Austin and Howard's dream come true, to be able to pick up and read a book that celebrates a bygone but forever glamourous era.

I Used to be in Pictures is written in such a way, that as a reader, one almost feels as if one is there with the brothers in and around Hollywood, spending time amongst the pioneers, film makers and innovators.

I feel as if I am there with them eating lunch with Rose Hobart and her fellow movie makers at the Motion Picture Country House and Hospital, or dining with Ginger Rogers in Palm Springs.

How I wish, upon reading, that I could have joined Austin that afternoon spent with Mildred Shay at her apartment in Belgravia; her life story recorded with such wit and charm in the chapter 'Cocks & Cocktails'.

I Used to be in Pictures is a book one can read or pick up and leaf through any time. Open any page and one can't but help be transformed back to a vanished era: the silent screen, the Talkies, the magnificent studio system and the rise of television. Many of the photographs throughout the book I've certainly never seen before and are remarkable, made even more so when one reads the accompanying captions, each one cleverly detailing a life lived in a few lines.

This book is a true delight and a great tribute to all those interviewed; though 'interviewed' may not be quite the right word here, since these are just wonderful casual chats and fantastic stories. This book is a credit to the twins for their obvious care, passion and remembrance not just for the supernovas, but the less-known players. *I Used to be in Pictures* is born out of earned knowledge and pure hard work over many, many years.

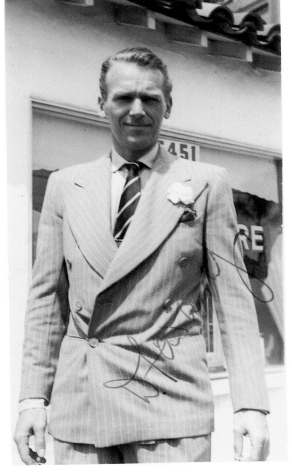

As I see it, the tables have turned as we the readers become fans not just of the stars from yesteryear, but of the brothers themselves, as I am a fan now. *I Used to be in Pictures* is also the story of two ordinary guys from Weybridge in Surrey, doing extraordinary things.

Dominick Fairbanks
London, September 2013

Douglas Fairbanks, Jr. (image courtesy of The Estate of Douglas Fairbanks Jr.)

Introduction

Lillian Gish said it was our 'Englishness' and Ginger Rogers 'our youth', whilst Beverly Roberts, Elizabeth Taylor and Douglas Fairbanks Jr. believed that our being twins had a lot to do with our growing mass of film star correspondents. "*With you both, one gets two for the price of one,*" noted Elizabeth Taylor during a party in Bel-Air. Maybe it was a combination of things? Certainly, the rate of replies to our 'fan' letters suggested that we were touching a nerve. Howard always said our success was down to our grandmother, Violet Mutti, who felt all three aspects, provided a rather unique calling card.

As children, Saturdays during the winter months in Surrey usually went like this: Dad would drop us off at Violet's house in Motspur Park and then, seated at the kitchen banquette over a percolated coffee, she'd ask Howard to take a look at the *Radio Times* to see what films were being shown that day as part of the BBC Two Movie Matinee.

She'd time the morning accordingly. She'd wash up the cups and I'd dry them. She'd put on her hat, gloves – always gloves – fur coat, Hermès silk scarf and, with black patent handbag in hand, strut to the local parade of shops with Howard and I four paces behind her and to the Co-op, where she'd buy slices of ham, and then next door to Coombes the Bakers for crusty bread rolls. On the short walk home again we'd pay a pre-scheduled visit of 30 minutes to Aunty Beattie Skilton's house or Mrs. Lucas', where she'd have another coffee and we would have a Kia-Ora orange squash and two Garibaldi biscuits each. Home again; still in her coat, and handbag in the crook of her arm, Violet would open the doors to the black and white Grundig television set that loomed like a giant teak wardrobe in the corner of the living room, switch it on and give the top a bang with her fist, informing us that it needed to be 'warmed up' in plenty of time.

We repeated this pattern for years, Howard and I together on the settee and Violet in the armchair; her permed grey hair resting on an antimacassar. Our special treat – the ham roll, crisps, gherkins and Barley water – were eaten from trays on our laps as we'd wait, the three of us, for the titles to appear on the small TV screen and watch old movies together.

Some of those films we watched have stayed with us for over three decades: the magnificent Dennie Moore as 'Olga' the gossipy manicurist in *The Women* (1939), Clare Boothe Luce's acidic commentary on pampered Manhattan society, and the equally witty *All About Eve* (1950); Clark Gable as the hero in *San Francisco* (1937); Peggy Cummins as the pistol wielding femme fatale in *Gun Crazy* (1949); the WWII melodrama *Between Two Worlds* (1944); and the majestic Gloria Swanson as the deranged silent siren 'Norma Desmond' in *Sunset Boulevard* (1950), the plot of which – a star forgotten by the world that had once made her famous – would soon mirror our own experiences with some of our former silent screen pen-pals.

Violet preferred musicals: *The King & I* (1950) and *South Pacific* (1956). She'd have a tray of tea and giant home-baked rock cakes at the ready for the interval. (She was an excellent cook and would later teach us.)

Afterwards we'd chat about the films we'd watched. Violet, with her background in music publishing, enjoyed the accompaniments to the silent films, whilst Howard and I – with a future in fashion – had made mental notes of impressive screen styles as personified by David Niven, Clark Gable and Lyle Talbot.

Things changed as we grew up: we got part-time jobs, we forged friendships, I applied to universities in Norwich and Falmouth and found fleeting girlfriends. Violet's old friends and the Co-op had died or disappeared; with her eyesight all but gone, the horror of being labelled 'disabled' saddened her. She no longer lead the way, and we and the family cared for her as much as we could. In a fit of frustration at losing her

Myrna Loy, her lady-like but wry manner made her an instant star in Hollywood during the 1930s. Her career would go on to span decades.

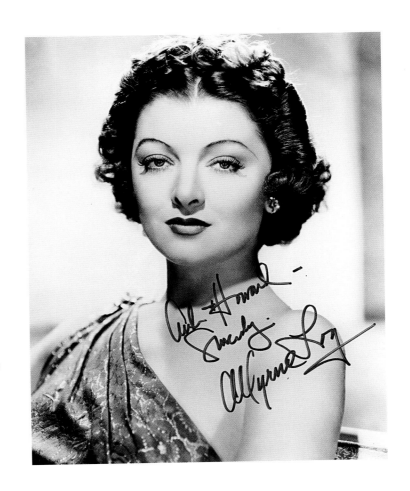

sight she asked her septuagenarian neighbours to unplug and banish the Grundig for evermore to the under-stairs cupboard, spelling the end of our halcyon days in filmland.

What hadn't diminished though was her unwavering demand for tradition and etiquette. Howard and I always joked with our Mum and sister Rowena, that Violet expected one to pen a thank you note within a heart-beat of opening a gift. She loved writing letters but unable to do so now, she'd dictate her letters for Howard and I to write. Violet demanded her correspondence to be impeccably written and so we'd read out every line on its completion, often being scolded for poor grammar. It was painstaking and tiring but it paved the way for our 30-year journey of corresponding with the stars.

What started as a terribly enthusiastic fan letter to Lillian Gish after seeing her on the BBC in *The Wind* (1928) turned into a hobby, a fascination, an obsession with film and film stars from a bygone era. We had located her address in the *Who's Who* of 1984. Initially it was the big stars who attracted us. We were overwhelmed when Marlene Dietrich replied, recycling our envelope and packing it out with old Christian Dior stocking packets so not to bend the glossy 10x8 of her in her heyday. We were in raptures when the postman knocked at the front door of the family home in New Malden with a photo, inscribed in gold pen, from Bette Davis. The second post that day brought with it two photos from James Stewart as well as letters from Myrna Loy and Lana Turner.

There was a snowball effect as one star recommended we contact another. Douglas Fairbanks Jr. suggested his cousin Lucille; and Lillian Gish, her friends Colleen Moore, Blanche Sweet and Aileen Pringle. Rowena moaned constantly at our mountain of mail delivered weekly by the postman we now knew as Bob, complaining that *she* never received a letter, but then as Mum reminded her, she never *wrote* one either.

Only one screen legend eluded us: Greta Garbo. Rex Harrison, who lived in the same apartment building as Garbo, suggested to Howard and I that our flattery was futile, "Gentleman she has no interest," he once told us. "Miss Garbo has made a second career out of trying to avoid anything relating to her first as a film actress, and like the former she's succeeding rather brilliantly at it."

As our interest grew, we played detective. We asked ourselves what happened to those lower down the cast list, the supporting players who – although they had shone less brightly in the firmament cast as gangster's molls, maids, soldiers and chauffeurs – were monumental in their praise at being re-discovered by teenagers. There was Jean Rogers, who as 'Dale Arden' was Flash Gordon's favourite squeeze; Keye Luke – 'Charlie Chan's No.1 son'; Carroll Borland, whose career started and finished with playing the ghoulish 'Luna' opposite Bela Lugosi in *Mark of the Vampire* (1935); Charlie Chaplin's second wife Lita Grey; the 'Munchkins' from *The Wizard of Oz* (1939); and the last of the 'Our Gang' kids.

When I think back now to those first letters and our friendships, our sojourns across California, I realise that these reached far wider than Howard and I, encompassing our family and contemporaries, our school chums and, later, flatmates during the years we

studied at Epsom Art School. All came to know the names of those we wrote to or telephoned.

Someone once asked Mum about our fascination for film, she was always nonchalant: "It's something they do." She and Dad were equally relaxed when Marlene Dietrich called and one New Year's Eve when Robert Mitchum rang. Dad was more of a film fan. "Tell Tony Curtis I wore my hair the same way he wore his." Dad told me. I relayed this to Tony some time later, "Oh tell your Dad that I still wear it the same way, but I can now leave it on my dressing table when I take a shower!" Tony Curtis was always comical during our conversations.

By the mid-90s we'd moved out of home and into a house-share with college mates. They were enthralled at first, possibly finding it a bit odd and certainly like nothing they knew. Yet as our friendships with Barry and Victoria grew, they as well as Corinne each came to see it all as a matter of course. There'd be calls from Tony Curtis, Marion Shilling, Joan Marion and Ann Miller. Judith Allen, in particular, was always thrilled to hear the voice of our Kelso-born flatmate Barry and less so when Victoria answered; Judith much preferring the chance to flirt with a man.

Howard's partner Ferhat and my wife Joanna would come to know the last of our film star friends, they would write to the four of us now excited about new chapters in our lives. Joanna and I were delighted when Elizabeth Taylor, Beverly Roberts and Luise Rainer sent notes congratulating us on our wedding. And we were overwhelmed when they wrote again *en masse* on the birth of our son Nathan. He marvels now when I tell him stories of Daddy and Uncle Howard writing to people who stare at us from the TV or iPad. Although he is more interested in Disney's *Up* and *Cars*, it strikes a chord when I sit and watch him laughing at Harold Lloyd and Laurel & Hardy, or cajole him from behind the sofa cushions scared of 'The Wicked Witch of the West' in *The Wizard of Oz* (1939).

The full-stop to many of our friendships came by way of the obituaries I penned for the *Daily Telegraph* newspaper, debuting with Billie Dove in 1997. My then editor Andrew McKee, marvelling at just who had survived into the 21st century, eagerly accepted even the most obscure of names from Tiny Doll and her pint-sized brother Harry, to forgotten Mack Sennett, discoveries such as Yvonne Howell, the Vitagraph girls like Pauline Curley, and the spouses of Ed Wood and Roscoe Fatty Arbuckle.

Almost 30 years ago, Warner Bros. stalwart Beverly Roberts wrote to us saying that she had told us her stories so we may re-count her Tinsel Town tales when she was no more, thereby keeping her memory alive. Although out of the spotlight for decades, Beverly still missed it. When she died in 2009, her gravestone simply read: 'BEVERLY ROBERTS: STILL SHINING'.

Mildred Shay was another, although in many ways quite different, as she was the only star with whom Joanna and I, and then later Howard, ended up living. We would come to witness on a daily basis her anguish at being a forgotten film star, although her make-up with platinum coiffeur and constant stories of her shimmering past – however inappropriate the setting in which she recounted them – told onlookers that she must once have been 'someone'. And then there was Judith Allen, who every time we met, cried because of the demise of her Hollywood dream, run out of town by Cecil B. DeMille and beaten up by both wrestler husband Gus 'the Goat' Sonnenberg and her boxer beau Jack Doyle... Dorothy Revier, Margie Stewart, Bob Hope, Rose Hobart each had their stories too.

As Howard and I share these untold Hollywood stories, I think of Beverly and Mildred and all those others who used to be in pictures. I feel content that we've made it, that we have delivered as we'd always promised and have shared their likeness by way of the photos they sent us, and that Howard and I have told their stories.

Austin Mutti-Mewse, 2013

Have a good
life !!

(above) Beverly signs off on a Post-It note, 2006.

(top right) Beverly Roberts in her heyday.

(right) Beverly with Howard (left) and Austin on the veranda of her home in Laguna Niguel, California, 2000.

Palm Springs

THE (MOVIE) STARS AND (ZEBRA) STRIPES

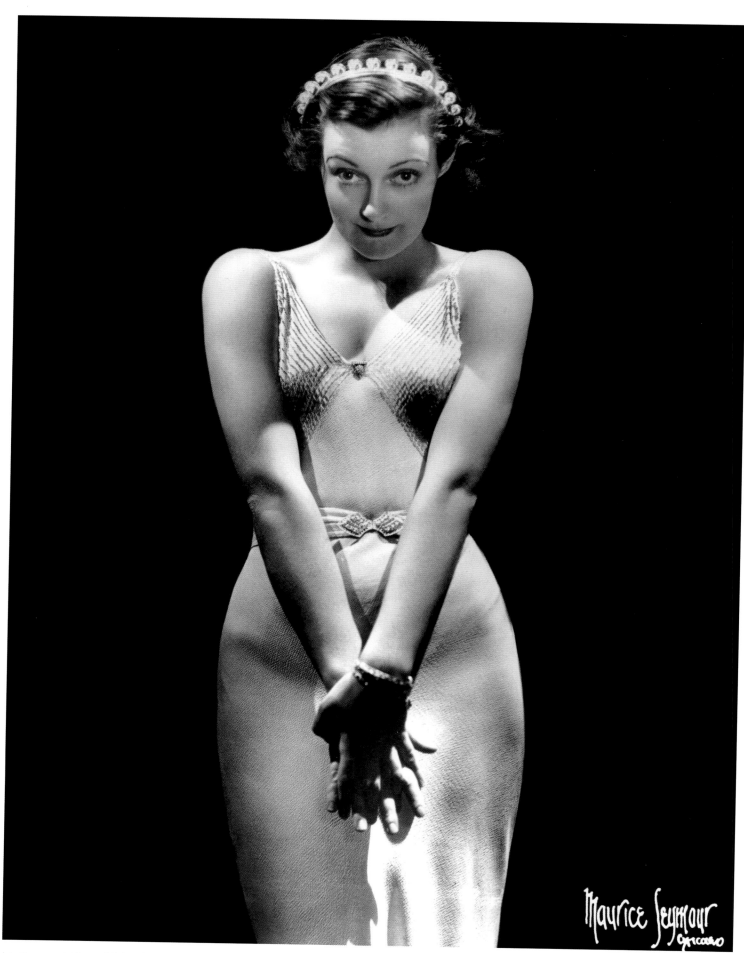

Hollywood Hopeful: Joy Hodges, Universal Studios portrait, 1937.

It's midday as I drive towards the main gates of the Thunderbird Country Club, Howard beside me and Joy Hodges in the back. She's been showing us the sights of Palm Springs for the past 40 minutes mostly where the stars live or have lived – from Liberace to Lana Turner – the houses all similar low-rise white and magnificent. Well, as much as one could see of them hidden away behind giant gates.

Joy has nominated me as the designated driver; the car, her white '70s Mercedes. It's a smooth drive and I'm not complaining. As we come to a stop, a stout man in his sixties dressed in uniform flags me down. Joy, who's been re-applying her make-up, knows the man as Walter.

"Hellooo Walt!" she shouts through her window that she's wound down now. Walter looks at me but then walks to the open window. "Hi M'am," he says. "Oh Walt, dear, I've told you to call me Joy." "Okay, Miss Joy," he says tipping his cap. "Miss Ginger Rogers said you were coming today." "Yes, we are having lunch. These boys are from London and are fans and it's their first time in Palm Springs."

Walter looks us over. "Well that's nice fellas. You like it?" "Yes," says Howard. "Gosh, it's hot." "Oh it is, fellas. It is. You should come here in August – scorching!" Walter says, wiping beads of sweat from his top lip with a hanky. "Well it rains in London all the time doesn't it? I was there for your Queen's Coronation. What a fine woman she is and my wife Gail, well she loved your Lady Di. Tell me do you still have the smogs? Oh and hey, does London still have the pound quid?"

Howard laughs. "The London smogs of yesteryear have gone – what we have now is the result of the pollution in London," says Howard and, smiling now, "Oh and a quid is a pound. It's the same thing. It's British slang."

"It is? The same thing! Oh boy and I've been telling everyone for years that's what the currency is called. Oh darn it!" Walter's head rocks back as he laughs loud and hearty. "Oh boy, oh boy. Hey, you here for a while fellas?"

Joy butts in, looking at her watch. "They are Walt. They are staying at my second house in Cathedral City. I can't have teenagers as house guests. I've never done it. I couldn't – imagine!"

"Well fellas, if it's okay with Miss Joy, I may introduce my grandson Brett to you gentleman. He'd love to meet you. He collects anything that relates to your Queen Mother – he adores her, has done since he was about

six. Brett has scrapbooks full of memorabilia. Do you know her? Have you met her?" "No, we haven't Walter, sorry," says Howard. "Oh, you haven't? Shame. He's 14, so a bit younger than you."

Walter changed track as he made a note of the car registration number on a pad and clicking his fingers looked up again at Joy. "Oh hey, Miss Joy, I saw you on the Nostalgia channel last night in an old movie – and looking swell."

"Well, you don't say," says Joy beaming widely "Yes M'am, you had a little bit in the Ginger Rogers and Fred Astaire film *Follow the Fleet*. I told Miss Ginger a moment ago that I'd seen her on the TV last night and how wonderfully she danced."

I watch Joy in the rear-view mirror. Her initial excitement has faded. "That's always on TV and so *dated* and hammy. Oh, I thought you'd seen one of my bigger pictures, Walter. I was on the other night in *Service de Luxe*, a much bigger part. Walter Winchell said I interpreted the lead to perfection, which led to a huge increase in my fan following! You should go and rent a copy." "Oh, I'll keep a look-out Miss Joy" "Yes, you do that Walter," says Joy, rolling up her window. "You do that."

Joy now repeats her list of triumphs, already familiar to us having known Joy since 1987. "Do you know, boys," says Joy crossly wagging her finger in our direction, "I made 20 pictures, I was the toast of Broadway with the song 'Have You Met Miss Jones?' written especially for me by Lorenz Hart for the musical *I'd Rather Be Right*. I did 290 shows. 290... imagine! It was a smash hit. Oh, and so was the revival of *No, No, Nanette*; I replaced Ruby Keeler! And wait for this, I sang my heart out to 45,000 American GIs, who built a stage *especially for me* at the Nuremberg Stadium during WWII! ... and yet all I hear about is my 'bit' in that darn movie!" She pulls out her compact checking her make-up. From under her breath we hear her mutter, "Oh brother!"

We drive just 20 yards before a valet flags us down. We get out of the car and I hand him the keys. Howard is off with Joy – who is swinging her square perspex handbag in one hand, her other in his – towards the entrance to the Club House situated in the heart of the Thunderbird. Built in 1952, Thunderbird is an impressive assortment of rather magnificent white air-conditioned concrete condos. This is where, as Joy tells us, most of old Hollywood now lives or comes to dine: Ginger Rogers, Billie Dove, Marceline Day, Alice Faye and her husband Phil Harris. Nestled close-by are the homes of President Gerald and Betty Ford, and

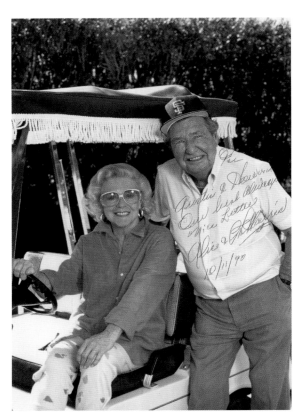

(left) Happy Couple: Phil Harris and Alice Faye met and married when she turned to radio after the decline of her film career. He was a big band leader most famous as the voice of 'Baloo' in Disney's *Jungle Book* (1967). The couple became two of the Thunderbird Country Club's most celebrated residents.

(below) Joy Hodges signed a two-year contract with Universal Studios. She played 'Gale Rogers' in the comedy *Personal Secretary* (1939), took the female lead in *They Asked for It* (1939) and appeared in *Service De-Luxe* (1939). *"I had a glorious part in that picture and co-starred with a young Vincent Price in his first film."* Here with Charles Ruggles (left) and Mischa Auer in *Service De-Luxe* (1939).

the former US ambassador to London, Walter Annenberg and his wife Leonore. "They are all my darling friends," says Joy proudly as she looks about the entrance room. "I'm dining here with 'Lee' next week."

Soft low chairs upholstered in pale pastel floral fabrics are dotted around, with giant cactus giving the feel of the outside inside. Partly tiled, partly carpeted, the decor isn't overly luxurious but simple and modern, mirroring the building itself. People are milling about us, some with golf clubs, others with tennis racquets. A tall man in a navy blazer welcomes Joy.

"Good afternoon Miss Hodges," he says, recognising her. "Oh, hi Trey!" "Miss Ginger Rogers is expecting you," he says almost bowing. "You are not at the table you requested Miss Hodges," apologises Trey. "Miss Rogers said she's selected a more suitable table." Joy smiled as she played with her right ear. "Hmm, okay Trey."

Trey looked us up and down. "Good afternoon gentlemen." "These boys are from London," says Joy waving in our direction. "Cute," says Trey checking us out and letting us pass.

Ginger Rogers is already seated at the table in a wheelchair. As we approach, I realise that Ginger has chosen a table in the centre of the room and is holding court. A regal wave acknowledges Jack Lemmon who is sitting close by, another wave satisfies Susan Fleming-Marx who is with Loretta Young, I watch as both blow Ginger a kiss. She gives Joy a wave as we edge closer. Joy gives Ginger a salute. Ginger Rogers is quite weighty now in old age and surrounded by an enormous shoulder-length canary-yellow mane off-set by a colourful casual jacket and white flares, from under which twinkle gold T-bar sandals; her neck is hidden behind a pale pink scarf. A stroke has left the former dancer paralyzed down one side. Joy told us when still in the car that Ginger's religious beliefs had meant a doctor was not an option.

"Ginger is like me and a Christian Scientist. But honestly, I wished the poor darling would seek out some therapy," says Joy of her friend. "She eats too much Häagen Dazs and is spilling out of that darn wheelchair."

"Darling," says Joy, bending down and embracing her friend. "Joy, darling," says Ginger, seemingly overwhelmed at seeing her, in comparison, youthful-looking friend. "Oh Joy, how wonderful to see you!" Joy stands as they admire each other. Ginger dabs her eyes and sits more upright, playing with her napkin. "Joy darling, I had to select a table," she says and, pointing to the rear of the

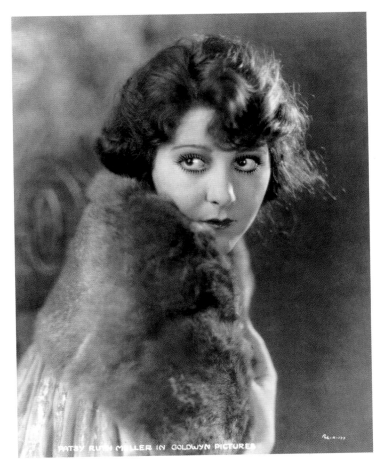

(top) Patsy Ruth Miller, star of light romantic comedies, later divided her time between her homes in Connecticut and Palm Desert.

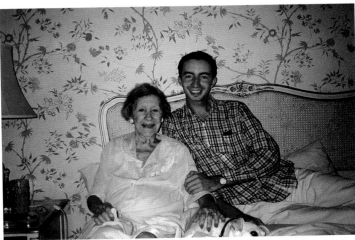

(bottom) When the world became too much, Patsy took to her bed deeming it as, *"a new and unfulfilled adventure"*. Here with Austin, Palm Desert, 1994.

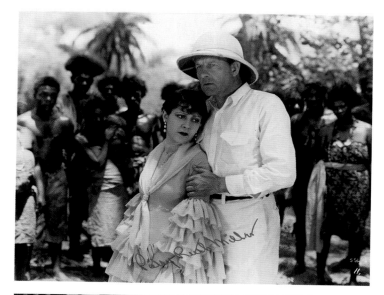

(top) Patsy Ruth Miller and Lee Shumway (seen here) become entangled in a romantic jungle melodrama, risking their lives for love in *South Sea Love* (1927).

(bottom) At home; Joy Hodges spent the last 10 years of her life in Palm Springs surrounded by her friends Charles 'Buddy' Rogers, Frank Sinatra, Bob Hope, Ginger Rogers, Zsa Zsa Gabor and Jane Wyman.

restaurant, "Darling, you had us out in the boondocks! Well really darling! I don't sit in Siberia!"

Joy says nothing. I wonder if she's registered what her friend has said. I turn and look at her. She looks back and barely smiles as she takes her place at the table.

Howard and I seemed to tower over Ginger Rogers and yet we're dwarfed by her magnificence: she is wearing heavy black false eyelashes off-set by giant gold-rimmed spectacles and lashings of candy-pink lipstick. I can feel that I am in the presence of a Hollywood legend. She oozes glamour only really ever seen in the old movies and from the old movie stars.

"Lovely to meet you Miss Rogers," says Howard kneeling beside her. I was still standing. "Oh thank you, thank you," she says beaming and holding out her right hand. I kneel down too now so she can clasp my hand as well as Howard's. Her voice, once powerful in her movies, is now almost a whisper. Close up I notice that on each temple she has Elastoplasts – partially covered with heavy tangerine-coloured foundation – to disguise dark blemishes; the appearance is finished off with pink pan-stick. "I think it's just darling that you should have taken an interest in me and at such a young age," she says in almost a hush. And then, louder, "I mean I have fans, hundreds of fans but how touching it is to have such young fans and twins – a matched pair, Bless you. Bless you both."

"We are really very different," says Howard. "That's nice for you, dear" she says looking for a waiter. "I need refreshment – my voice is awful. I'm sure I have laryngitis." She coughs three times for effect. "How wonderful that in your letters you tell me that you are fans of the thirties," she says. "It was such a pretty time for me, if not the world, but I was on the crest of something big and was singing 'We're in the Money' in the film *Gold Diggers*. My world, the world I shared with my beloved mother, was a magical one," she says humming the tune, her head rocking in syncopation.

"Not for everyone, Ginger," says Joy with a sort of chuckle, "There was something called a Depression on!" "Yes, of course," says Ginger, still now, "But the gentlemen are asking about *me* and for me the 1930s was a haze of happiness." Joy says nothing.

"And you were on television last night, Miss Rogers," says Howard. I look at Joy; Howard doesn't dare, realising his mistake "Is there anyone who didn't see *Follow the Fleet* last night?" asks Joy sternly and, looking at Ginger, and calmer now, "Ah boys, this darling woman and I met on the set of that film. Ginger had been dancing with Fred Astaire since *Flying Down to Rio* – it was one of my early roles. I was as cute as hell."

Seemingly ignoring her friend, Ginger beams, "Well I happened to catch it. I liked it. I'm a very different sort of actress, gentlemen" she says, watching Howard and I as we rise to our feet to be seated by a waiter. "I'm just not like some people who say they can't watch themselves. I watch my performances and look at how I reacted to my

co-stars. I'm modern as I critique myself," she tells us and then holds up her hand adding, "Oh but boys, I watch other movies too. I don't just watch myself, honestly." She chuckles slightly, "If people demand to watch my movies, though, I'll sit through them; I watch and I'll remember."

We've just got settled with menus when Ginger decides to move us. "Austin, you and Howard swap places," she instructs, just as the waiter is filling our glasses with water. This positions me opposite Ginger and Joy, and Howard either side of her. I can't see any reason for this change except to make sure that we know she is in charge. Ginger Rogers is considered and pleasant and as she speaks, absolutely without malice. In the same way, she orders for us all without looking at the menu, everything seems rehearsed: every line, each gesture. Everyone we ask her about is either 'darling' or 'wonderful'. When Howard asks her about her legendary partnership with Fred Astaire, Ginger Rogers has an answer off-pat: "Katharine Hepburn said I did everything that Fred did but backwards and in high heels." She says, "I didn't coin that, someone else made the observation. It was a good one."

Howard asks if they were friends. "Oh well, oh my dear, Fred and I were our own people. We had different agendas. I made it on my own and I succeeded. I won the Academy Award for Best Actress for *Kitty Foyle*."

"Would you say the same about Mr. Astaire?" I ask. "He was an extraordinary dancer; I took straight parts - like *Kitty Foyle*, like *The Major and the Minor*…he danced and was a marvel."

I sense that Miss Rogers is rather irritated. So I tone down on the questions and instead ask Joy about a story I've heard about her friendship with Ronald Reagan.

"We grew up together in Des Moines, Iowa. He was on radio and wanted to get into Pictures and when he visited me in Hollywood begged that I try and set-up a screen test." She was animated. Ginger was looking about the restaurant. "Do you remember, Ginger, how I told Ronnie to take off his glasses? And once he did, he became a huge success." "Sure darling, you've told me that before," says Ginger.

Joy takes no notice. Throughout her three marriages, Joy Hodges has remained close to Reagan, from his days as Hollywood actor to Governor of California through to his years at the White House.

"I was at a party at the White House and I found myself sat next to President Gorbachev at dinner. Do you know boys,

I turned to that man and said, 'Gorby, take down that wall' – and he did!" All smiles, she waits for our congratulations.

"You asked me about Fred Astaire," interrupts Ginger. "Well he was such a perfectionist. I remember on set one day after rehearsing for hours and hours someone asked why I'd changed into pink shoes. I hadn't realised I'd been working so hard that my feet had bled into my white slippers."

"What a story – my goodness, Miss Rogers." She nodded accepting my acknowledgement of her hard work. "Yes, yes. I learnt the hard way. I take credit for the good times and the bad… I see everything as a stepping stone and I've done everything, everything but Shakespeare."

Joy looks across at Ginger Rogers and says, "Yes, true darling, true. Listen, I've heard that about Fred Astaire a few times," and animated again continues, "Well then on a flight to London some years later, a young boy turned to me, 'Oh, Miss Hodges,' he said 'you changed the world. If you hadn't gotten Reagan into pictures, he may not have become the President, you wouldn't have met Gorbachev and Communism would still have a firm grip across Europe'." Joy Hodges smiles and slams the table as satisfied now as she was then by what the young man had said. Turning to Howard and I, she exclaims, "I told him, as I'm telling you, 'You're darn right kid!'"

Joy is in full-throttle, drawing the attention of neighbouring diners. "Oh sure, sure Joy. You take the credit for all that dear," says Ginger and looking at us, "It's a hell of a story, isn't it. She got us our President. You've heard it for sure before but, yes; Joy has the credit for that one." "Well, I'm telling you again dear, for the benefit of the boys." Joy retorts.

"Amazing story!" says Howard feeling the tension. "Something a lot of people wouldn't know," I add. "And fancy, the President of the USSR listened to you. That's what is so amazing Joy." She looks at me grinning and with a sort of snarl says. "Yeah, isn't it."

Taking it back to Ginger, Howard asks her what it was like working with Katharine Hepburn on *Stage Door*. Ginger sighs and doesn't look up, "Ah, we were never going to be best of friends." "I remember watching you dance on a TV Special; *Night of 100 Stars* a few years ago with Christopher Walken. I didn't know he could dance! He was really good." I say.

"Oh sure, I remember that. That was a lot of fun. It was a benefit for the Motion Picture Fund – for the Actors'

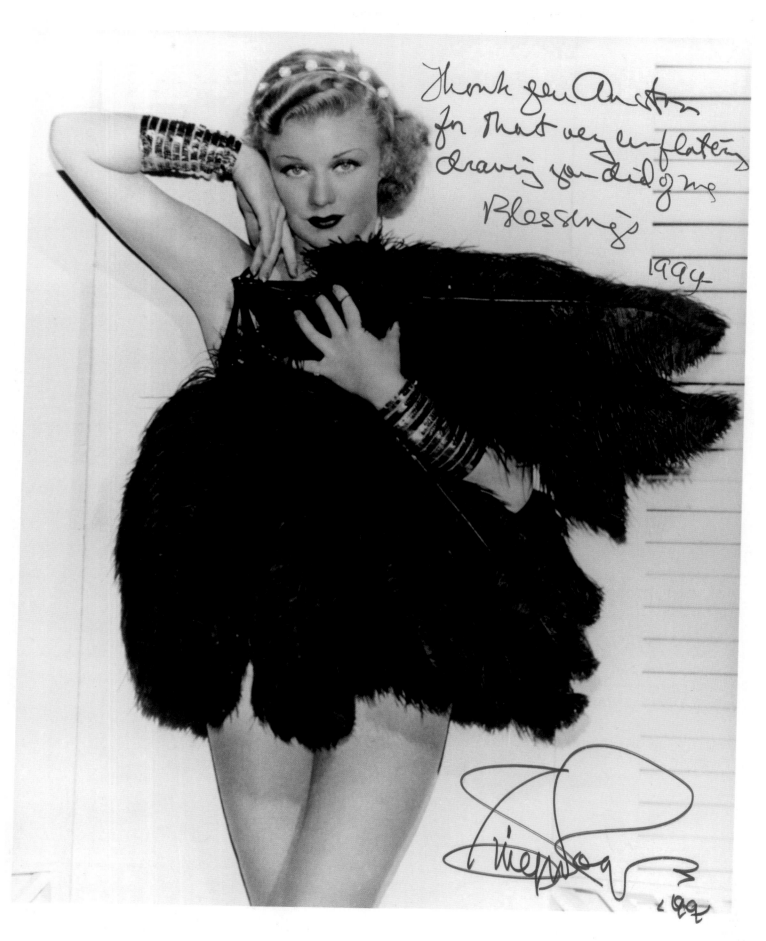

Thank you Austin
for that very unflattering
drawing you did of me
Blessings
1994

A risqué Ginger Rogers hides her modesty behind a fan of ostrich feathers, 1933.

home." She looks down to her feet and then at me. "I was coaxed into it, into dancing. I hadn't done that for the longest time. You are right though, Christopher can really dance. I'm glad you enjoyed watching me on that show."

I watch Ginger Rogers, quiet now, stabling lemon quarters and ice-cubes with a Thunderbird-branded straw, bejewelled fingers playing with a lettuce leaf lunch. I can't get enough of her. As we eat and we talk, she appears to me to be more magnificent than any of the fellow diners — everyone a recognizable face, although either lifted, filled or faded from another time. Each is coiffured to perfection and perma-tanned, which colour coordinates rather nicely with the preferred refreshment in Palm Springs: iced-tea.

It is apparent that when allowed to flow freely without being asked anything specific, Ginger will talk and talk. She tells us how she follows the sun summering in Oregon at her house named the 'Rogers Rogue River Ranch' and then, after she sold that in 1990, at a smaller home, and spent winters at Thunderbird. Her career, as she tells it, was sugar-sweet and candy-covered, which by the way she talks, obviously awards her much pleasure still. "I receive so much fan mail," she says, "I've been blessed."

I am in awe of her. But though I don't feel *uncomfortable* in Ginger Rogers's presence, I am certainly not at ease. I guess I want her to be more friendly; not that she isn't being exactly... I suppose what I had hoped for was for Howard and I to feel free to be ourselves and laugh and joke like we did with other stars we knew, but Ginger doesn't allow that. She is, well, guarded and acutely aware of the magnitude of her star status. Just at this point two handsome middle-aged men hover by the table, one plucks up the courage to ask for an autograph. Joy leans over to me and whispers, "That darling woman has forgone everything, including a marriage that worked, and children for a career — to be a star!"

"She always wanted to be a star then, Joy?" I ask. "Yes, her darling mother wanted it for her too — badly. She managed her until the end. She always lived with her — she died in 1977. Nobody else was allowed in." Joy turns away from me and joins Ginger as she politely chats to the men. Joy chimes in too, both flirting a little and waving away any such idea that the men are disrupting lunch.

I watch both Joy and Ginger — coquettish at times, more forthright at others — and feel sure that had Howard and I been men rather than boys, Ginger may have been

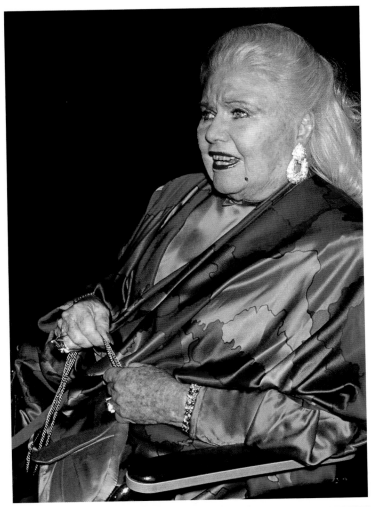

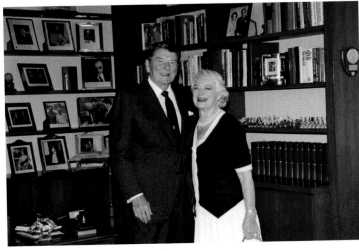

(top) Ginger was a firm fixture in Hollywood well into her 80s, a true example of film star royalty.

(bottom) Joy made her greatest impact by advising Ronald Reagan to ditch his spectacles. *"I also got Ronnie his first pair of contact lenses. He was the first leading man in Hollywood to wear them and would take them out on a regular basis to show all his friends."* Here with Reagan in the office of his Bel-Air home, 1991.

more relaxed. She knows men, she doesn't know boys and, in her defence, she is on foreign ground. Her admirers go to leave.

"Thank you, oh thank you. Bless you," says Ginger Rogers as the two men kiss her hand and leave. "Oh well, they are just darlings, aren't they?" says Ginger, looking at the three of us in turn. "Well they are. You hear the tall one say he's met me at Sinatra's?" beams Joy. "He did? Well, I didn't realise he recognised you at all. Oh well darling, you and Frank Sinatra go back such a long way," says Ginger, looking at her watch and waving in Trey's direction.

Joy looks at us. "I tell you boys, my husband, my second husband Paul Dudley, was big in radio and managed Frank and produced his early TV shows, so we had Frank and his wife over to the house all the time."

"What's he like?" asks Howard "Frank or Paul?" "Oh Frank!" says Howard. "He's happy when he's singing," answers Joy. "Otherwise less so, but he sings all the time, so he's just fine. Tell you what, I'll ring him. Would you like to visit with him? Of course you would. I'll fix it up." "That would be wonderful!" says Howard.

Ginger smiles at us both as she pushes away what is left of her lunch and takes one last slurp of iced-tea. "Sorry. It was rude of me not to introduce you to those two men. I didn't think – they were so gushing. Oh fans!" "Not at all; it's fine, Miss Rogers," reassures Howard. "Yes, it is, isn't it" agrees Ginger. "And it's not like those gentlemen were movie folk. You'd had nothing in common."

Trey appears, ready to escort Ginger back to her condo. As we bid fond farewells to her, I feel like a fan, like all the other people at Thunderbird who are watching her. Without question she has worked very hard to create 'Ginger Rogers – movie star' and despite the ravages of illness in old age she holds that immaculate star quality still. There is no denying she had worked bloody hard to get where she was, to have her name up in lights. Her association with Fred Astaire fixing her forever in modern day popular culture, even if she'd like to be remembered more in my mind for her roles off the dance floor. The introduction is something we'd never forget. I can see why movie stars of her status were once looked upon by movie-goers as being akin to The Gods. Ginger Rogers was almighty.

The next evening Joy telephones to remind us that we are to join her at Bob Hope's fantastic John Lautner-

designed house or rather outside on his terrace, large enough Joy told us to cater for 300 for dinner under the enormous covered terrace. Tonight Bob and Dolores Hope will be hosting a soiree for 150.

This is where Howard and I meet Bob Hope for the first time. Howard has decided on a yellow checked Mulberry suit for the occasion. He isn't fazed when we arrive and everyone else seems to be in pastels, and neither is Bob, who waves in our direction. Howard is shocked that Bob Hope should take an interest in him, but it's Howard's suit, not his personality that has captured Bob's interest.

"I can't see who is who," he says in Howard's direction. "Everybody looks the same. Whatcha name kid?" "Howard, Mr. Hope."

"Well, stick with me Harold, everything else is a blur." Bob Hope's eyes red and dropping with his increasing old age was happy to have Howard – or, as he continues to call him, 'Harold' – beside him. "I don't feel old," he jokes with Howard, who is standing rather awkwardly, not knowing whether to correct Bob Hope *again*, "I don't feel a thing until noon, when it's time for my nap!"

Hope is holding court and more relaxed now and Howard laps up his one-liners. There are one or two about him being proud to have been born in England: "I bleed orange marmalade..." and quite a few poking fun at his age: "I'm so old they've cancelled my blood type." And when Zsa Zsa Gabor arrives, Bob Hope turns to Howard and jokes, "She got married as a one-off and was so successful at it, turned it into a series!" (Howard can't help laughing again when he recounts this one to Joy and I later.)

I get a kick out of watching my brother beside him. There is perspiration forming at Howard's temples but this doesn't deter him from wearing his jacket, which by the time I step in has become the topic of conversation. I watch Howard, so cool and calm now, creating his own gaggle amongst the glamourous guests. Eventually we step into an outer-circle, still watching and astonished that he – or possibly the suit – should have made such an impact.

We leave the party at 10. Joy asks that we stop by Denny's eatery where, over coffee and pancakes, she dissects the party minute by minute. I drive Joy home and am parked inside our garage by midnight. Noticing our camera left behind on the coffee table, Howard

blames me for forgetting to pick it up. But as he calms down and we chat, feet up over a beer, we realise that trying to take a few pictures would have seemed unfitting and too futile.

<div align="center">***</div>

Joy is on the phone by 7.30am. "Hey boys, you up?" "Hi Joy, it's Austin and yes, I've been for a swim" "Oh, happy you are using the pool. I swim in the nude – do it. Nobody will see you."

I block out the thought of Joy skinny dipping but as soon as I'm off the phone can't resist giving it a go myself. From the pool, through the wide expanse of glass between the pool area and living room, I can see Howard on the phone. I watched him put the receiver down and head outside to me.

"Hey listen Austin, Joy's spoken with Patsy Ruth Miller. She says Patsy wants to see us." "Great, but not now, I'm staying out right here until it gets too hot." "Well Austin, we're on for 3pm," says Howard as he goes back inside, sliding the doors behind him. I stay poolside under the shade of a parasol until the desert heat makes me retreat inside for the cool of the air conditioning.

We head to Joy's condo at 2.30. She's ready to go as soon as we arrive. We leave the house through an integral door and into the garage. She lets me take the lead. I choose her silver-blue fifties Mercedes soft-top. She gets in and sits beside me – Howard looks irritated as I flip the driver's seat forward and he squashes into the back.

To gain entry to Patsy's home on Sierra Madre Drive within the Monterrey Country Club, we have to show the gate-keeper two pieces of I.D. Once through the electric gates I park Joy's car on the road.

Patsy's home is positively low-key compared to Thunderbird. From the road it resembles Dorothy Gale's house after it has crash-landed in Oz, a lemon tree sprouting from its very foundations.

A plaque next to the front door reads: 'Mrs. Patricia Deans' – Patsy's married name. During her former incarnation as movie star, she had received over thirty marriage proposals, earning her the sobriquet 'the most engaged girl in Hollywood'. It had left Patsy Ruth Miller all but exhausted and so she had decided, with the advances of age firmly taking a grip, that 'bed' was to be a new adventure.

We are greeted by a middle-aged man who opens the door just enough for the three of us to slide through. He shows us into the house, mostly empty of furniture and what is here wouldn't have looked out of place on a film set. Huge over-sized art pieces loom over sofas covered with white dust sheets, dark spots of walls betray where mirrors once hung. Joy, Howard and I are shown into the floral master bedroom. Here, propped up on pink pillows atop a gargantuan bed, wearing a short nightdress and sporting a 1920s shingled hair-do still dark brown in colour, is Patsy Ruth Miller. She is puffing on a Winston cigarette.

"Hello, hello," she says, her speech staccato. "Don't look too closely, I'm a wreck. It's a pleasure to meet you. I have your letters here. I love your stamps – your Queen is so beautiful." Howard hands Patsy a gift of Fortnum & Mason chocolates. She takes them from him, "Oh my waistline!"

Joy looks over. "Oh nice, Howard. Are they soft or hard centres?" Patsy looks at Joy. "They're mine!" Joy just smiles and then rolls her eyes at me. "Let's have drinks." Patsy picks up the receiver of a white telephone beside her bed, the sort you only see in the old movies, and orders two scotch and Americans for Howard and I, and ice tea for Joy and her. "You don't drink Joy, right?" "Well my religion doesn't allow it but…" "No, didn't think so."

Joy looks slightly annoyed. A few minutes later the man who showed us in earlier brings the drinks in to Patsy's room on a silver tray. Patsy asks Howard to hand them round.

"I love, love, love London," she exclaims. "I love to dine at the Savoy, fish and chips at J. Sheekey." After a while, Joy urges Howard and I to tell Patsy of other actresses we've been in contact with during our years of letter writing. Patsy pulls another Winston from the packet beside her bed and waits for me to light her up before looking at a small folder of photographs we've brought with us. She stops at a page with a photo of Douglas Fairbanks Jr. "He calls me every week," and again on recognising Lina Basquette, "She calls me sometimes."

"They are going to see a movie actress called Pauline Curley who is older than you and a cute as hell!" says Joy gleefully. Stubbing out her Winston and waiting for me to light another, Patsy gives Joy a glare "I really don't want to hear about older fitter people. Last year I would swim, go shopping on Date Palm Drive… I was swell now I'm a mess." In unison we reassure her that she looks fine, humouring her a little.

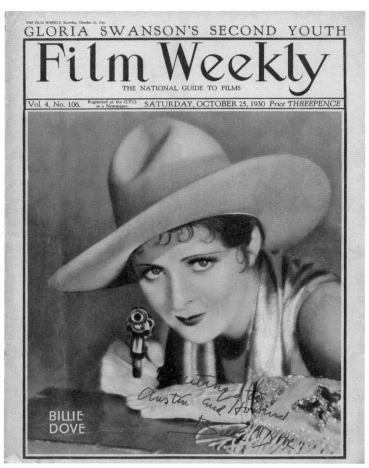

Golden Boy: Charles 'Buddy' Rogers, is best remembered on-screen for his lead role in *Wings* (1927) – the film went on to win the Academy Award for Best Picture. Off-screen, he succeeded Douglas Fairbanks Sr. as the husband of Mary Pickford. The pair met whilst working on the film *My Best Girl* (1927). He'd admired her since boyhood. Following Mary's death in 1979, he relocated to the Palm Springs area and became a real-estate dealer. In 1986, he won the Jean Hersholt Humanitarian Academy Award for his philanthropic activities. He died in 1999.

From the back of chorus in *The Ziegfeld Follies* to 'The Most Beautiful Woman in Pictures', Billie Dove's career was eclipsed by scandal. In 1930, Howard Hughes, then in the process of his own divorce, reportedly paid Dove's husband, director Irving Willat, $300,000 to divorce her so they could be together. Whilst they never married, their union lasted three years. *"He became so jealous and would even follow me to the powder room!"*

Back from the despair of her situation she looks about the bedroom: me on the bed and Joy and Howard sitting in Queen Anne chairs that perfectly match the floral surroundings; daylight is blocked out by blinds and heavy curtains.

Next to her bed is a copy of her autobiography. Published in the late eighties, the book sits atop a jumble of medicines, cigarette packets and correspondence. Patsy spots a lipstick, takes off the lid and applies it blindly over and above her lip-line. Happy again, she asks who else we've written to. Howard rolls off names that include Buddy Rogers, Dorothy Revier and Vilma Bánky.

"Vilma and her husband Rod la Rocque were in Berlin," Patsy tells us. "It was just before the war. The SS men were around us all the time. I had a new camera that one would point in one direction but it would shoot in the other. The SS were aware of the make. Hitler walked right infront of me and the SS men grabbed the camera before I could shoot and I didn't argue. Hitler was everywhere giving lectures. A woman who recognized us and whispered that the German people were not in favour of Hitler but were frightened and brow-beaten into supporting him. It was Goebbels who recognized us. He said he was a fan. Two of Rod La Rocque's cameramen were Jewish and boy did they look it – we had no trouble."

Patsy shivers at the memory and rings for our drinks to be refreshed. She soon begins yawning, which gives Joy the excuse for us to leave. I'm positive we'll see Patsy again. Joy asks that we drop her off and suggests we go back to our condo and drive back for her at seven. "I'll book a table at the Red Bird restaurant," says Joy and adds defiantly "And I'm having me a spritzer tonight!"

The following day I telephone Patsy Ruth Miller to thank her for a memorable afternoon. She begs for Howard and I to come back and suggests we leave Cathedral City that very moment. "Oh please do. I'm lonely," she pleas.

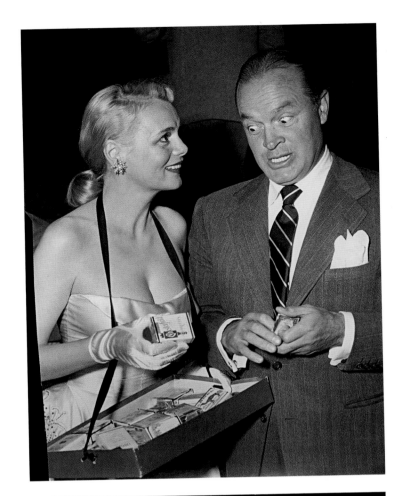

(top right) Smokin'! Bob Hope hot-footed it to the desert in the late 1970s, his wife Dolores commissioned architect John Lautner to build them a futuristic-style home. Neighbour Joy Hodges suggested it resembled a UFO. *One thing is for sure, Bob looks down on us all!* Here with Marie Wilson, 1950s.

(right) Cover Girl: Ginger Rogers, 1940s.

We are at Patsy's house within the hour. At the front door we are shown the way once again by her housekeeper. The kitchen door is open ajar: a TV is playing a soap opera and something is hissing on the cooker hob. He shows us to Patsy's room. She is poised on her pillow, wearing the same nightie over which she's wearing a frothy gown with white mink fur collar and cuffs. On the dressing table in the window are a pile of photographs she's signed.

"Please take what you want," she says pointing to the pile, "I know you'll appreciate them." She waits for me to light her up as before. Scotch and America on ice are waiting for us on a silver tray atop a walnut chest. This time there was one for Patsy too. Howard passes it to her, "Cheers!" she says. She lifts her autobiography from a side table "I've just decided to send this to Ronald and Nancy Reagan," she says. "They've asked me over to dinner but I can't, I'm a mess." She has inscribed: 'to President and Nancy Reagan, with my best wishes, P.R.M'.

"I haven't been to Beverly Hills in a year. My house is still in Beverly Hills, still standing at 808 North Crescent drive just off Sunset…" she drifts off. Howard suggests we take her to re-visit it and at first she seems all excited and even asks that we help her out of bed. With one of us either side of her she wobbles towards a bank of fitted wardrobes that we are told house clothes dating back decades. She pulls out a day dress and a cape but then asks to be returned to the bed, giving up on the idea of venturing out. "The Reagans can come here" she says. Howard and I smile, hiding our sadness that she is all too quickly defeated.

I changed the subject, "So you knew Rudolph Valentino?" "Oh I knew him very well," she says, brighter now. "The first movie I made was *Camille* and he was my leading man. I got to know him very well." She sighs, "Yep, I knew him very well… how long has he been gone?" "Nearly 70 years," says Howard. "He was amazing in *The Eagle* and *Son of the Sheik* and…"

Patsy interrupts: "He wasn't a bit like the way they [the studio] portrayed him. He was not a real Latin lover, that wasn't the case but, of course, he was a very attractive man. He was Italian and that stands for something. He was very dark and very gallant but he wasn't all that tall. They made him out to be a womanizer. He posed a lot. That's all they talked about – like he was a talking mannequin. He wasn't, he was a fabulous horseback rider – he loved doing that."

Patsy asks Howard to return to the bank of wardrobes. She orders him to slide open the furthest door. Clothes bulge out. She asks Howard to pull out two or three dresses, dresses from the 1920s, dresses she wore when with Valentino.

"This is amazing!" Howard exclaims as he pulls out a short dress, white with deep red stitching and a plunging neck-line. She looks at the dress. She turns up her nose. "He was prudish in a way – again, very Italian in my mind. See that?" she says pointing to the white gown. "He didn't approve of the styles women were wearing in those days." She points at another dress; Howard pulls from the wardrobe a canary yellow gown with orange zigzag. "He thought that horrible – we wore these with socks rolled below the knee."

With some knowledge of fashion, I comment that the look is back in vogue. "I know Twiggy did it in the '60s, with a twist though. Rudy would have thought Twiggy just awful, just terrible. I like her, she copied my hairdo," says Patsy tapping the under-side of her bob. "Oh and he didn't approve of my smoking," she said as she stubbed out her cigarette. "I started smoking and Rudy didn't like that at all. He said women shouldn't smoke." Howard suggests that Patsy was merely following a trend, following fashion. Patsy waves her hand "Well, Rudy didn't like it!"

When I ask her about Valentino's wife Natacha Rambova, Patsy pulls a long face and rolls her eyes. "Oh her, yuk! I never understood how she got him, I really didn't. She'd walk into the room and I'd say under my breath, 'Well just look, there goes Pavlova'. There was nothing exotic or sultry to her. She was a phony, she was Winifred Kimball Shaughnessy Hudnut from Salt Lake City."

If there is nothing but hatred for Rambova, then Patsy's opinion of Rambova's friend Paul Ivano is pure poison. Howard and I haven't heard of him, but Patsy is very vocal. "He was a nasty piece of work," she snarls. "I thought he was a drug addict. He certainly liked Rudy's fame and wealth. Patsy also revealed how she detested Valentino's first wife Jean Acker. "She was a lesbian and not a nice one. They were all adventurous in every way. Rudy never saw it."

Patsy asks Howard to put the dresses back in the closet. "We'll keep them there."

She asks me to pass over the photos she's left out for us. Howard questions Patsy about working with Lon Chaney on *The Hunchback of Notre Dame* and her eyes widen "We'll have more drinks first," and she rings for refreshments. The same man brings in the bottle this time

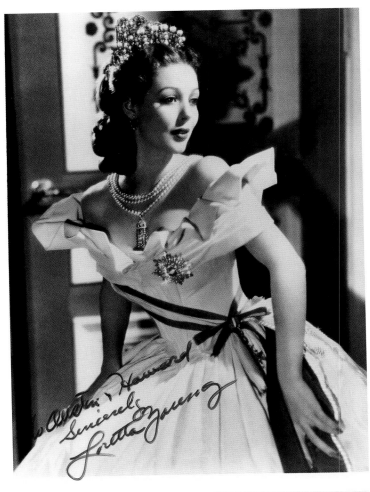

and a pink dish filled with ice-cubes with a litre bottle of Canadian Dry Ginger. "Help yourselves," he says miserably.

"*Hunchback* was a great picture and I had a good part in that. They show it on television. Oh it was on the other night. I just happened upon it by accident when I switched over to the Nostalgia Channel just as it was about to start and there I was on the screen... ah!" She put her hands in the air and smiles. "There was Lon Chaney and in BIG letters: 'Patsy Ruth Miller' and I talked at the screen and said, 'Yep, that's me. I'm still here'." There's a silence in the room. Patsy's eyes fill with tears but she composes herself and taps her cigarettes. "Don't let me smoke alone," she says, so I join her.

"If you want to watch it, come back and we'll have a movie night," she says as she taps the bed asking me to sit and share her ashtray. "I wouldn't watch myself alone. I just wouldn't sit around and do that." She picks up the chocolates from yesterday and offers them to us. "Jock put these in the fridge yesterday so they wouldn't melt." She pops two in her mouth, "Oh, heaven!"

Looking at the photos I ask if Patsy preferred making silent films. She takes a sip of her scotch. "I guess so but we were never silent, never. I used to act on stage between films with the Henry Duff Company and so, of course, we used our voices. So speaking to a 'talkie' camera recording voices was nothing new. It was the equipment and not the people that proved a failure. People don't realise that even in silent films we would often speak. I know it wasn't picked up, but when we opened and shut our mouths words came out!"

Patsy polishes off her drink and yawns widely. It is time to leave. "Have I crushed the illusion, telling you that I was never silent, not ever, not really?" "No, not really, Patsy" I say. "I know from listening to Esther Ralston once that when Talkies came in, audiences were shocked that the stars had voices just like the neighbour next door." "We were unreal," she says. "Oh, but they would die if they saw me now."

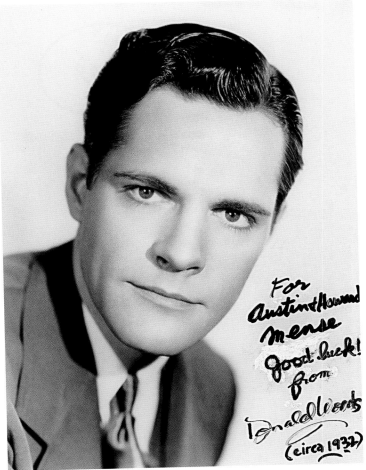

(top left) Loretta Young, moved to Palm Springs with her last husband, Hollywood costume designer Jean Louis in 1993. The couple had met decades earlier when he designed her wardrobe for *The Loretta Young Show*.

(left) Donald Woods, spent a career in B-movies before quitting to become a successful real estate broker in Palm Springs.

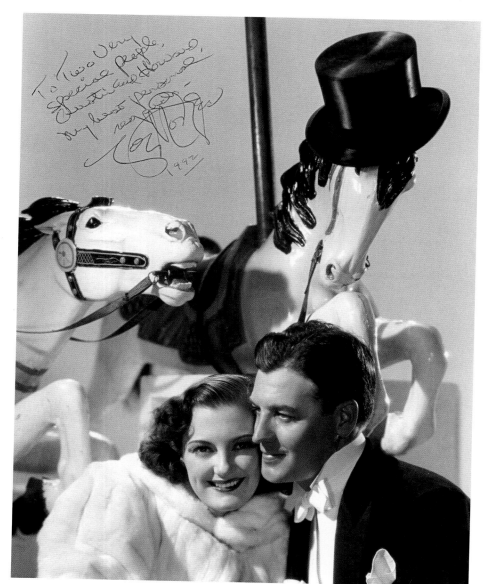

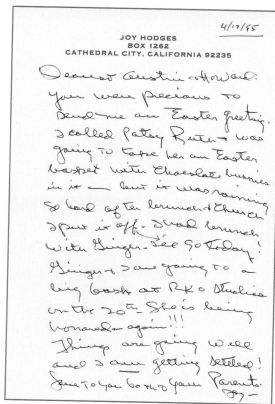

(above) Palm Springs life: a letter from Joy Hodges, April 1995.

(left) Joy Hodges with John King in *Merry-Go-Round of 1938* (1937).

Howard and I disagree. She is a woman in her late 80s and actually looked pretty good. We give her a kiss and promise to call on our return to England. "You're great. Loved today. Loved it!" Before we leave she signs the visitor's book we have with us for the trip. She writes: 'Thank you for bringing youth back into my life'.

She hauls herself out of bed and wobbles to the bedroom door, hanging on to its frame. "Goodbye and good luck," she says. As we leave her, Patsy shuts the door behind us. Howard is sure he hears her crying. I think not. I imagine she is happy to have had visitors and on a high gets back into bed and with a drink in one hand and a Winston in the other watches herself in *The Hunchback*.

A few years later, after Patsy has died, Joy tells us that Gloria, a maid that she and Patsy Ruth Miller shared, said

her mistress had kept every letter we'd sent her. "Oh my gawd, boys," says Joy. "You kept her going."

We meet up with Ginger Rogers one more time before leaving Palm Springs for LA. Howard and I and Joy meet her at the home of their church friends Trudy and PK, who have organised a film night; the film is one of Ginger's called *Lady in the Dark* with Ray Milland. She is thrilled when Howard tells her that the burgundy and gold gown she wore in the film is on display at the Museum of the Moving Image in London.

"I love it," she said. "Edith Head made it for me. Oh do take lots of photographs of it and send them to me." Howard promises. It is at this point that he also suggests

Charles Farrell, (left) the tall, dark, athletic and impossibly handsome leading man during the silent era, made his name co-starring opposite Janet Gaynor in *Seventh Heaven* (1927) – the first film to win an Academy Award in 1928. The film's accolades did well to establish him as one of the most powerful exponents of masculinity. The fanfare was short-lived, however, since his high-pitched raspy sort of voice didn't record well for Talkies. In 1941, he became the Mayor of Palm Springs, bringing vitality to the desert community by way of opening the Racquet Club with his friend, actor Ralph Bellamy. Charles sold his share in 1959, but remained a fixture on the Palm Springs social scene until his death in May 1990. His wife was the former silent screen star Virginia Valli. Here with Hollywood gossip columnist Louella Parsons and Jimmy McHugh at the Racquet Club, 1953.

I give Ginger a sketch I've been working on of her in her heyday.

"Go on, Austin," he says. "It's great." Howard had put it in the car earlier and I'd left it there hoping he'd forget all about it. Egged on by PK, I reluctantly go to the car to fetch it.

I'm annoyed that Howard has built it up somewhat, telling Joy and Ginger that my artwork resembles that of British artist Stanley Spencer. Embarrassed, I reluctantly show the pencil sketch to Ginger Rogers. "It's a work in progress and really not all that great" I say.

Ginger Rogers looks at it as everyone looks at Ginger. She is terribly polite as she inspects it but I feel she isn't all that impressed. Her smile appears awkward; strained. Months later, when we are both back in the UK, Ginger Rogers sends Howard and I signed photographs of her from the 1930s. She has written on mine: 'Dear Austin, Thank you for that very unflattering drawing you did of me'.

The roster of parties, openings and cook-outs continue right up until we leave Palm Springs, with Joy happy for Howard and I to be her plus one. "You're twins, so you count as one" she says, clearly just revelling in telling everyone of "her twins." She fixes an afternoon at Frank Sinatra's Palm Springs home twice; he cancels both times. We do get to meet Frank eventually at a Palm Springs party, where the host has hired two zebras from a guy in Hollywood. The man walks the zebras around the pool on leads scaring Zsa Zsa Gabor, her centenarian mother Jolie and Billie Dove.

Joy is gushing when she confronts Frank by the pool. He is wearing grey flannels – the crease razor sharp – and a shiny dark blue Ralph Lauren baseball-style jacket. His eyes are a vibrant blue; and he is puffing on a cigarette. Joy is clutching Howard and my hands and holds them aloft as she introduces us, as if congratulating champions. He laughs, "Do these boys minder you, Joy?" he asks. "Why's that?" retorts Joy.

"Oh, Mr. Sinatra, I suppose one could say she's our adoptive granny whilst we are in California," interrupts Howard nervously, "We are from England." Frank Sinatra looks at Howard and then at me. "Nice." He seems diminutive, round and quite disinterested. "Grandmother!" says Joy loudly and with a look of disgust. "Howard, I'm really not – you age me darling, you age me!" Howard stands quietly as Sinatra laughs.

Billie Dove, standing next to us, breaks the awkwardness with a rather meek scream. Frank looks over, "Shit,

someone's woken the bird!" He laughs to himself. As he passes Joy, Howard and I, he winks at me and then slaps my lower back, "Good luck fella."

"Oh my dear, it reminds me of San Simeon," says Billie in Frank Sinatra's direction. He laughs as he lights another cigarette and then picks up a tumbler filled with what looks like bourbon, murmuring, "Oh brother."

Billie pulls on Howard's arm. "Look! look!" she says nervously. She moves closer to Howard. The zebras seemed at ease centre stage in a garden full of stars. "William Randolph Hearst had a zoo in the backyard of his castle. Marlene Dietrich and I had to carry a gun just to walk around the garden. She kept pistols in the glove compartment of her sports car."

"I'm so pleased to be chatting with you," says Howard shouting in Billie's good ear. She is still staring straight ahead. Billie looks at Howard, "What's that... oh, you know me." Howard repeats himself, she smiles at the compliment, her eyes still as wide and expressive as they'd been during her days in silent films.

"Am I wearing lipstick?" she asks. "Yes!" I shout on the third attempt to be heard. I am still watching Frank Sinatra. He is on a sun lounger, his wife Barbara not far away watching him and watching me. I quickly look away and choose to concentrate now on Billie Dove "How did it feel being called, 'The Most Beautiful Woman in Pictures'?" I ask her. "Oh dear," she says, her hand shaking as she applies more red lipstick, "Well people kept on saying it over and over and labelling me, so I guess it was true."

Unsteady, she asks Howard to hold her arm whilst she fumbles in her white handbag. Eventually she finds a photo of herself as a young woman in The Black Pirate with Douglas Fairbanks Sr. and another of her pictured with Gilbert Roland and then what she'd been looking for, an envelope and opening it, pulls out a letter dated 1926, it was from the Los Angeles Post Office Department demanding that she pay for an increase of workers to handle her enormous influx of mail. She hands us all three.

"What wonderful photos," Howard says. "Aren't they. I was the first star to be filmed in colour," triumphant, she beams as she points at the shot of her with Fairbanks. "That's incredible and what a letter," I say handing her back the well-thumbed piece of paper.

"I suppose it validates who I am," she looks at the letter and the photo for a while longer, her head has a slight

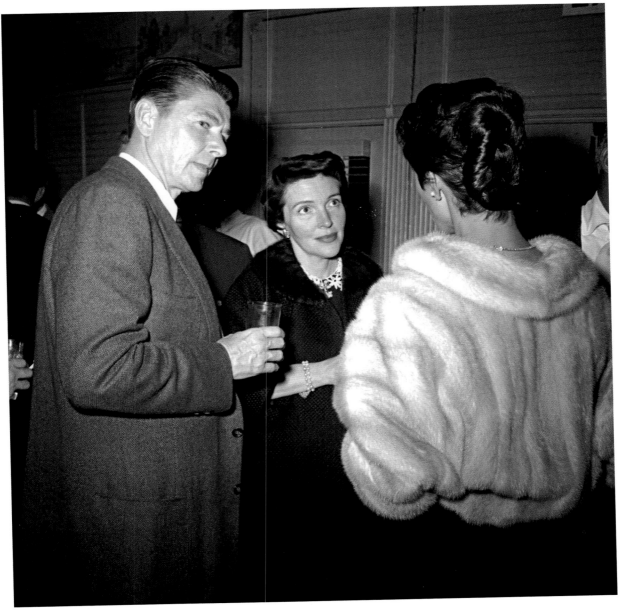

Ronald and Nancy Reagan, celebrated New Years Eve 18 times at the fabulous pink palace that was 'Sunnylands', home to Walter and Leonore Annenberg. The Palm Springs estate, which covered more than 400 acres, was where the old guard could happily rub shoulders with Hollywood's new wave. "Lee had the knack to mix things up," wrote Joy Hodges. "Weekend guests would come to stay from all over the world with Lee the centrepiece of everything."

wobble, and looks at us, "Yes, I was the Most Beautiful Woman in Pictures."

Billie Dove becomes a regular correspondent on our return to the UK. She eventually leaves her beloved Palm Springs for the Motion Picture Home and, although terribly frail and impossibly deaf, mentions the letter each time we call. Other Palm Springs personalities remain in touch too. Joy continues to write and telephone; with Joy, we finally visit with Frank Sinatra at

home for a BBQ the following year. And we hear from Patsy Ruth Miller by phone weekly. She is willing herself to live long enough to see O.J. Simpson 'nailed', as she puts it; she doesn't make it. Bob Hope sends photos; and Loretta Young, her new phone number.

Some two years before our sojourn across California, on learning of our letters to film stars of The Golden Age of film, The Independent newspaper had written: 'When Austin and Howard write to Hollywood, Hollywood Jumps'. And, for a while, it did until those we knew couldn't jump anymore.

Hollywood at Home

ADDRESSES ADDRESSES

Name MRS GREGORY WOOD	Name ALFRED HITCHCOCK
Street LOXLEY HALL	Street 609. ST. CLOUD RD
City WARWICK	City BEL AIR
Telephone WELSBOURNE . 10	Telephone
Name JOHN HYDE	Name MRS HERRICK (THELMA)
Street 3311. WONDERVIEW DR	Street CHATEAU MARMONT
City HOLLYWOOD KNOLLS	City HOLLYWOOD
Telephone	Telephone
Name DR ADRIAN HARTOG	Name 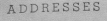 ARTHUR-GOULD-PORTER
Street 133. N. CARMELINA DR	Street 237. S. REEVES DR
City W L.A	City BEV. HILLS
Telephone	Telephone CASTLE HORNECK. PENZANCE. CORNWALL
Name DENIS HOEY	Name MAJ. HUTCHINSON
Street 167 N. CRESCENT DR	Street LA FONTAINE APTS
City BEV. HILLS	City FONTAINAV L.A
Telephone	Telephone

I J
K L
M N
O P Q R
S T U V
W X Y Z

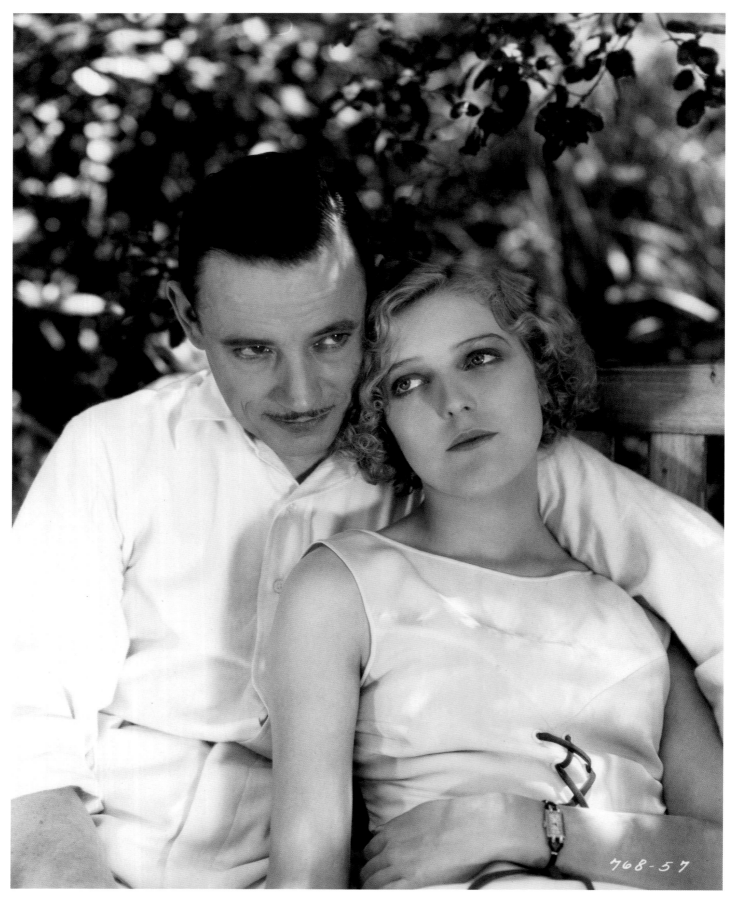

768-57

Miriam Seeger, followed her success on Broadway with a contract to Paramount, appearing in a succession of dramas. *"What shocked me most about Hollywood were the extremes actresses would go to in the pursuit of glamour. When Dietrich was placed under contract, for example, all the young starlets promptly shaved off their eyebrows in order to look like Marlene."* Here with Lawford Davidson in *The Love Doctor* (1929).

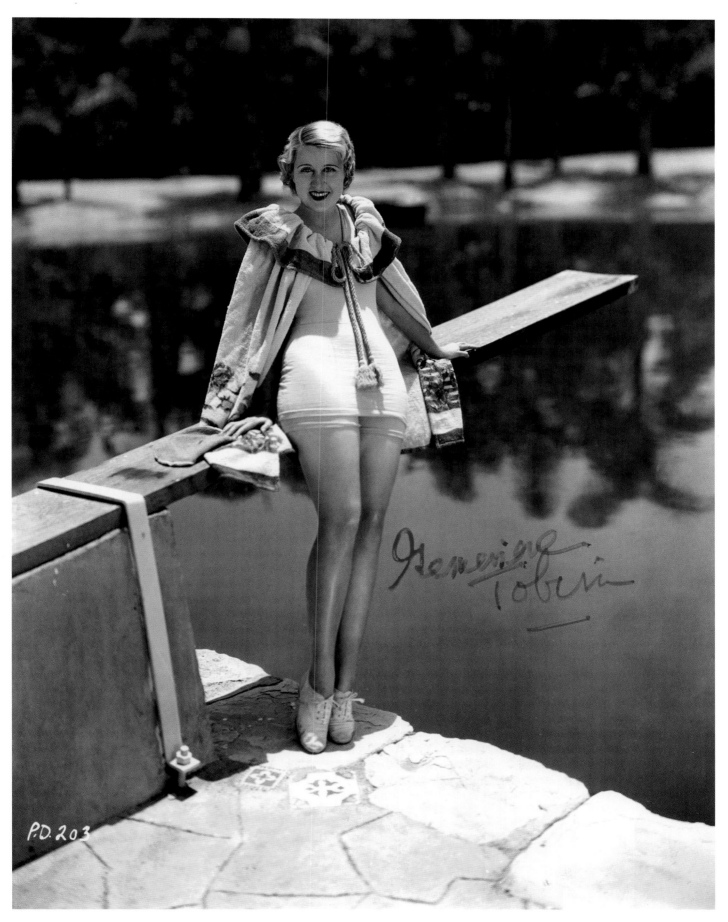

Genevieve Tobin, arrived in Hollywood following a successful career on Broadway with the arrival of talking pictures. She was rich, cultured and well-travelled; as a result her private life (she married film director William Keighley) received more column inches than reviews of her film appearances. She retired in 1941.

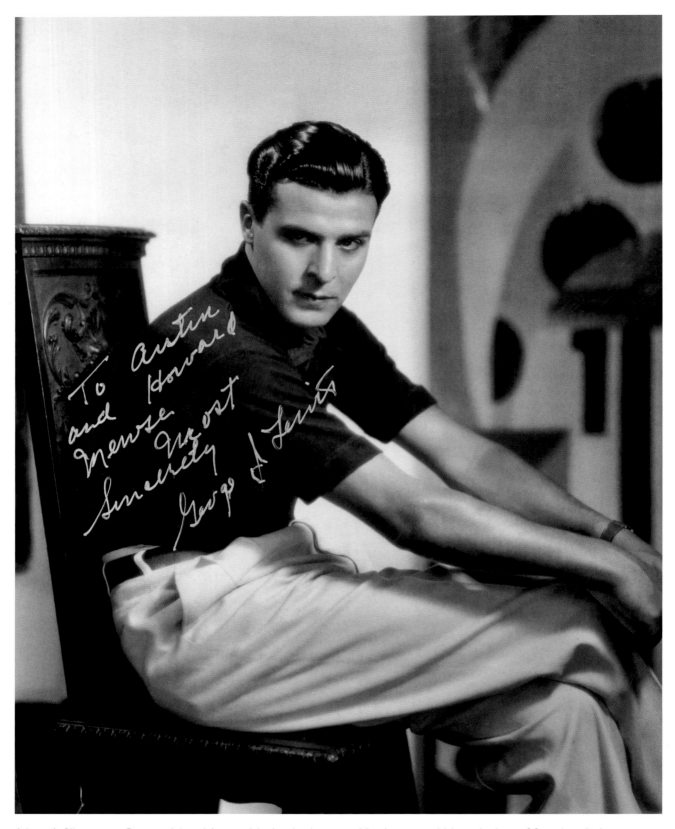

(above) Silent star George J. Lewis' smouldering Latino good looks earned him a legion of female admirers as well as the lead in Universal Studios' short subject series *The Collegians* co-starring Dorothy Gulliver, during the 1920s. Later he became a popular actor in low-budget crime serials and Westerns.

(page right) William Bakewell found fame as one of Hollywood's most handsome juvenile leads during the 1920s -30s. He was a founding member of The Screen Actors Guild of America, and during WWII served with the US Army, rising to the rank of Second Lieutenant. In retirement, he became a successful real estate agent.

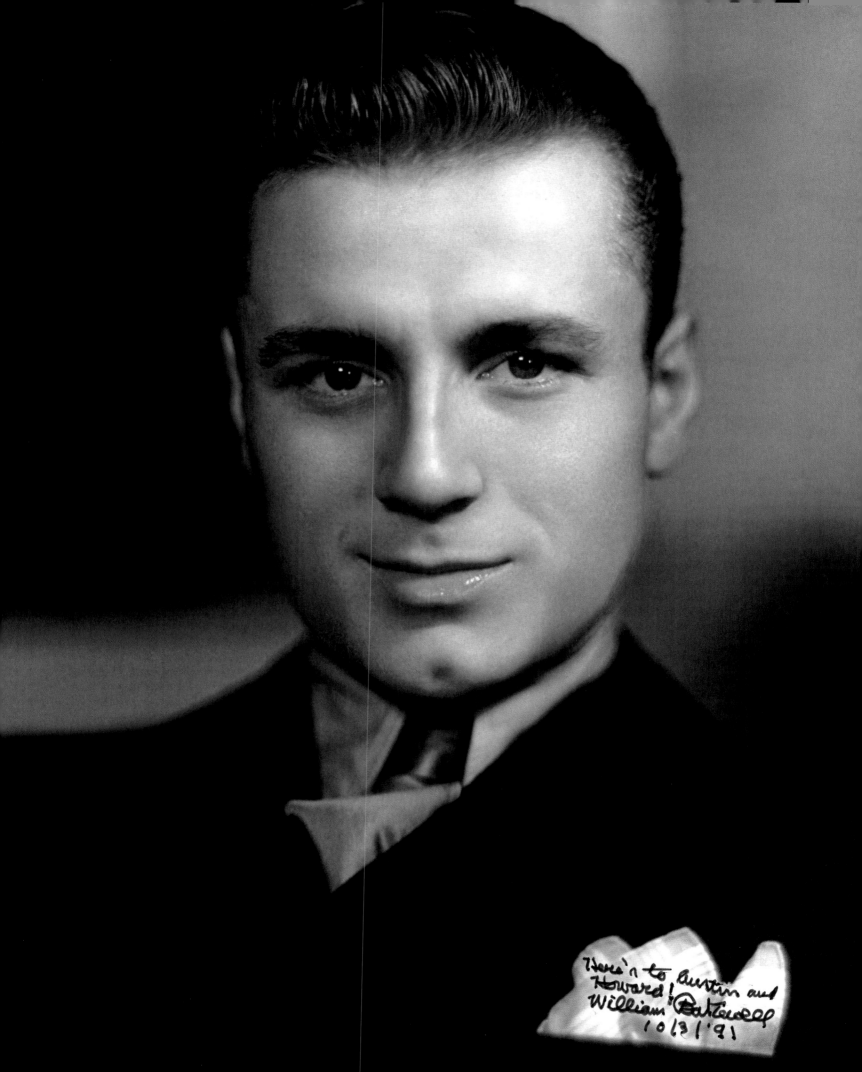

Here's to Austin and
Howard!
William Bakewell
10/31/91

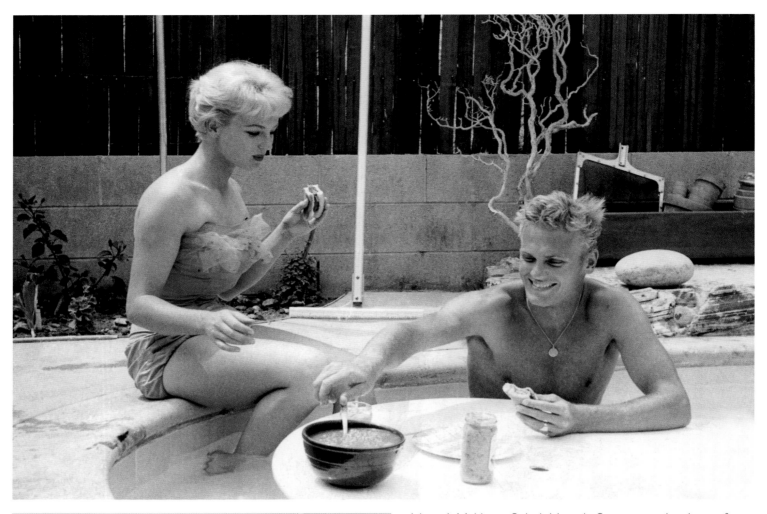

(above) Making a Splash: Venetia Stevenson, daughter of actress Anna Lee and film director Robert Stevenson, was a popular starlet during the late 1950s. She was named 'Most Popular Newcomer of 1957' alongside Jayne Mansfield, by gossip columnist Hedda Hopper, but it was not to last. She retired in 1962 following her marriage to singer Don Everly. Here with Tab Hunter, poolside in Hollywood, March 1959.

(left) Hiding his modesty, Van Williams is perhaps most famous for his role as the masked crusader *The Green Hornet* during the 1960s, opposite his side-kick 'Kato', played by Bruce Lee.

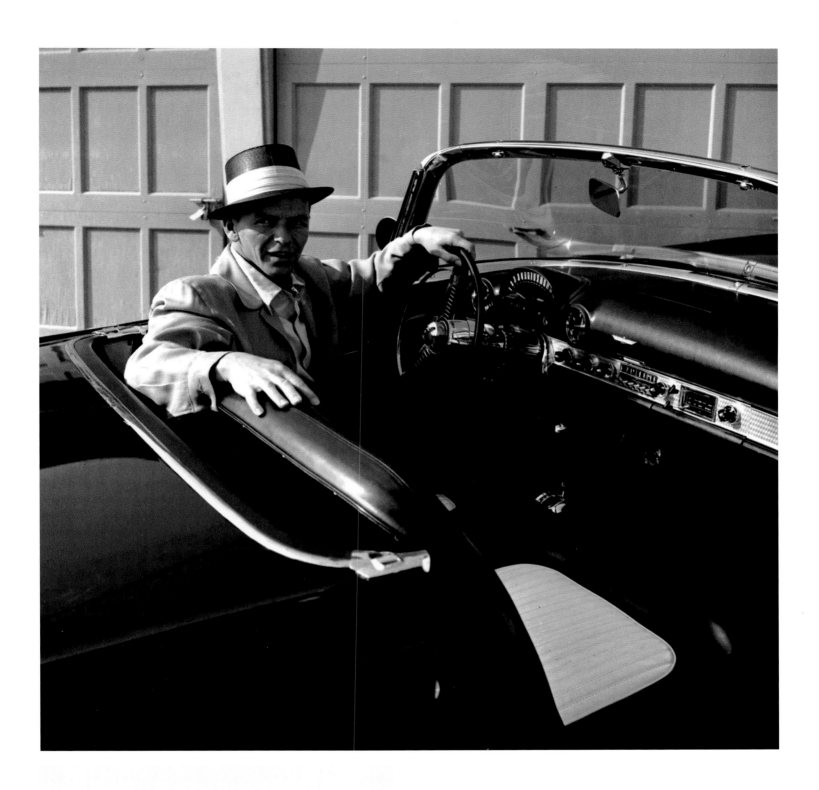

Ol' Blue Eyes: Frank Sinatra was an idol for the 'Bobby Socks' generation. However, despite his early popularity, his success began to wane. It wasn't until his astounding performance as 'Maggio' in *From Here to Eternity* (1953), that he saw a dramatic change in his fortunes. He was seldom out of the public eye for the rest of his life, both for his music and his private life, which included marriages to Ava Gardner and Mia Farrow.

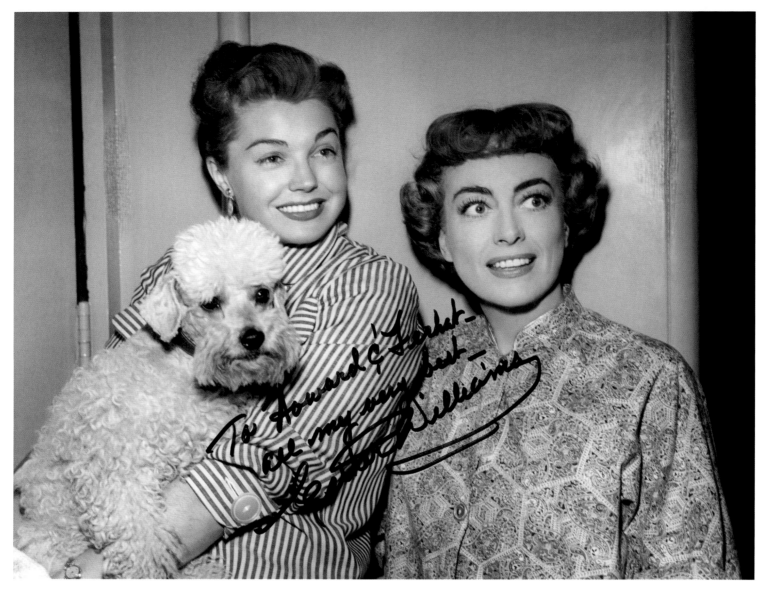

Making Waves: Esther Williams burst on to the big screen as Hollywood's 'Million Dollar Mermaid' during the late 1940s-early '50s, making a career and a fortune as Hollywood's premiere swimming star (she did with water what Sonja Henie did on ice!). During the 1980s, she launched the Esther Williams Swimming Pools and the Esther Williams Collection, which quickly became one of America's most recognised swimwear brands. Here with Joan Crawford (right) and her pet poodle Cliquot on the set of *Torch Song* (1953).

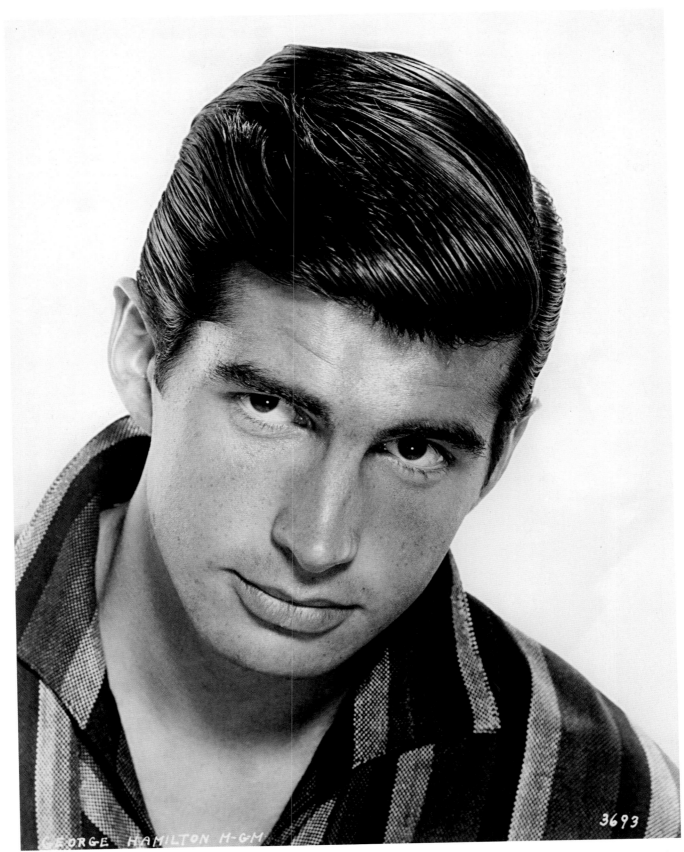

George Hamilton had the looks of the 1920s bygone era – dark pencil-thin moustache, raven black slicked-back hair – rather than that of his contemporaries, such as George Peppard or Robert Wagner. A contract player at MGM at the very end of the contract system, he was obviously photogenic. He was awarded a Golden Globe as 'Most Promising Newcomer of 1959', which led to his break-out role as the effeminate youngster in *Home From the Hill* (1959). His reputation as a playboy off-screen often cost him better roles, though he fared well in *Where the Boys Are* (1960) and *Light in the Piazza* (1962). George was typecast thereafter as the playboy or ageing lothario; something which suited him handsomely on such TV shows as *Dynasty*.

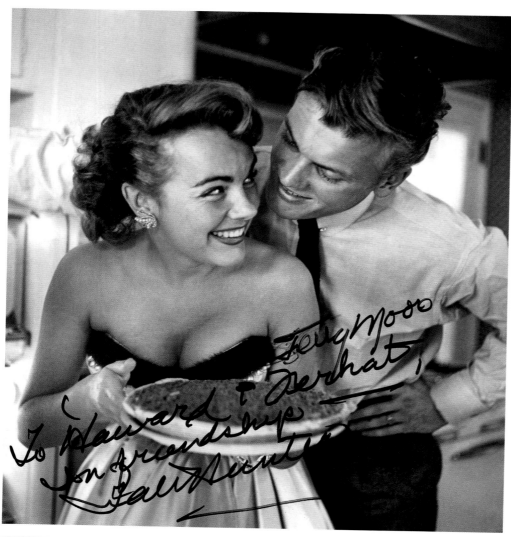

(above) Hollywood Cheesecake: Terry Moore featured in numerous films from the 1940s, making a name for herself for her roles in *Mighty Joe Young* (1949) and *Come Back, Little Sheba* (1952), which earned her an Oscar nomination. During the 1970s, she told the press that she was the widow of Howard Hughes; a claim she took 17 years to verify with Hughes' estate. Here with Tab Hunter.

(left) Joe Morrison was a minor actor during the 1960s, who found fame on television rather than on film. His career was short-lived, however, disappearing from view after guesting on the hit US TV series *Flipper* (1965-67).

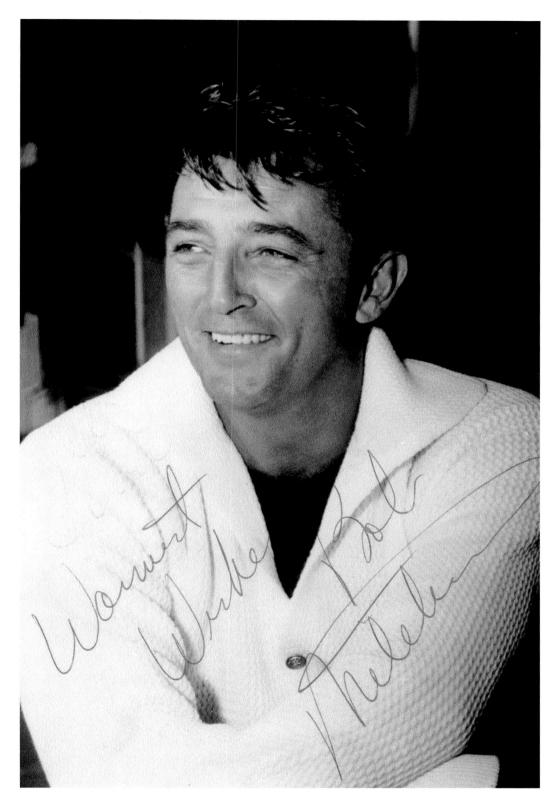

Robert Mitchum was a bad boy: *"Broads 'n' booze. It's all true, make some more stuff up if you want to,"* Robert said of his off-screen reputation. The son of a railroad worker, killed when Robert and his younger brother John (who also became an actor) were young boys, he got into a series of scrapes before his teenage years. He was extremely bright and incredibly handsome, arriving in Hollywood via the stage with his childhood sweetheart Dorothy. He appeared in mostly bit parts, before finding fame as a film-noir favourite during the late forties. He is best remembered for his role as 'Reverend Harry Powell' in *The Night of the Hunter* (1955), and the villaine 'Max Cady' in *Cape Fear* (1962). By his own admission he was lazy, which caused many producers to overlook his obvious talent. In 2012, he was named 23rd on the list of 'The Greatest Actors of All Time' by The American Film Institute.

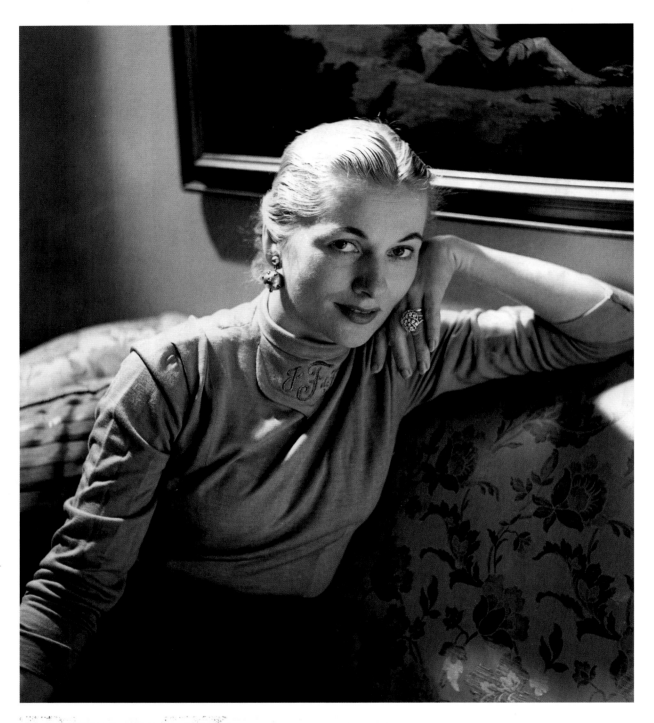

THANK YOU, DEAR FRIENDS, FOR
YOUR CHRISTMAS CARDS (AND)
KIND WORDS.
Pray THE COMING YEAR
BRING YOU CONTENTMENT AND
GOOD HEALTH. HUGS,
Joan.

(above) Joan Fontaine, made her stage debut in 1934 in San Francisco, before embarking on a screen career in 1937 at RKO. Her two films for Alfred Hitchcock, *Rebecca* (1940) and *Suspicion* (1941), brought her critical acclaim and an Oscar nomination for the latter. She appeared less on screen by the 1950s, retiring a decade later. Her sibling rivalry with Olivia de Havilland is legendary.

(left) Thank you note from Joan Fontaine, January 2011.

(right) Homemaker: Susan Kohner, the daughter of Hollywood super-agent Paul Kohner and Mexican actress Lupita Tovar, first emerged on screen as the Italian girlfriend of WWII hero Audie Murphy in the bio-pic, *To Hell and Back* (1955). A dark-haired exotic beauty, she quickly caught the attention of film producers, who put her to work in a series of films during the mid-late 1950s, including *The Last Wagon* (1956) co-starring Richard Widmark, and *Dino* (1957) with Sal Mineo. It was, however, her role in Douglas Sirk's 1959 remake of *Imitation of Life* that gained Susan most praise as well as an Academy Award nomination as Best Supporting Actress.

(below) MacDonald Carey started out in theatre, treading the boards at his university in Iowa, before conquering Broadway. His early work in Hollywood consisted mainly of bit-parts, before Alfred Hitchcock cast him in *Shadow of a Doubt* (1943). He later quit to concentrate on TV, but suffered with depression and alcoholism. Here with his wife and child.

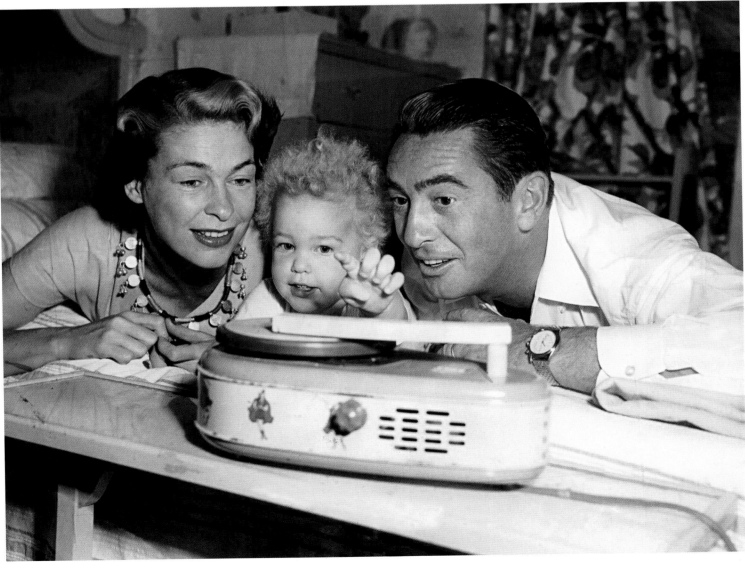

47

Della Lind was a Viennese musical star who came out to Hollywood via England, where she had already had some success on stage and in musical comedies under her real name of Grete Natzler. Unfortunately, Hollywood didn't quite know what to do with her and, after a handful of films, most notably *Swiss Miss* (1938) with Laurel and Hardy, she disappeared from the screen.

Rosina Lawrence made a name for herself in musicals during the 1930s, including *Mister Cinderella* (1936) and *Pick a Star* (1937), but is best remembered for her lead role as 'Mary Roberts' opposite Laurel and Hardy in *Way Out West* (1937).

Jo-Ann Sayers, spent her career during the 1930s as a leading lady in B-movies at MGM. Tall, beautiful and elegant, she was not unlike Olivia De Havilland in looks. She was one of the many starlets tested for the role of 'Scarlett O'Hara' in *Gone With The Wind* (1939) – producer David O. Selznick thought she looked too aristocratic. Instead she settled for starring roles as 'Susan' in *The Adventures of Huckleberry Finn* (1939), opposite Robert Montgomery in *Fast and Loose* (1939), and the horror mystery *The Man With Nine Lives* (1940) starring Boris Karloff. In 1940 she turned to Broadway, playing the title role in *My Sister Eileen* opposite Shirley Booth and won rave reviews.

Good luck! Douglas Fairbanks Jr. -99

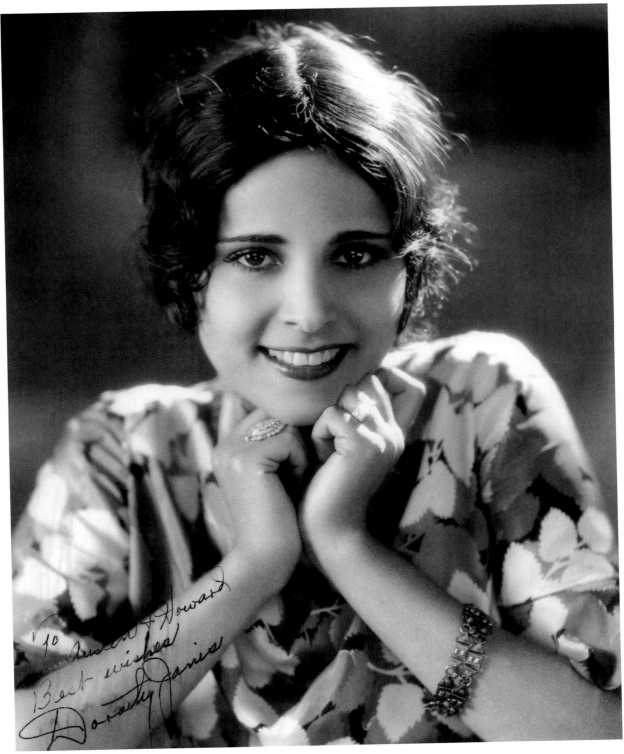

(above) Smoke screen: Dorothy Janis, arrived in Hollywood during the tale-end of the silent era and was instantly peddled by the Hollywood publicity machine. Her most famous role was opposite Ramon Novarro in *The Pagan* (1929); she retired aged only 20.

(page left) Prince Charming: If Douglas Fairbanks Sr. and Mary Pickford were the 'King and Queen of early Hollywood', then Douglas Fairbanks Jr. was its Prince. Accomplished actor, writer, producer and WWII hero, he was awarded an honorary knighthood by The Queen in 1949. Douglas was without doubt one of the most stylish men of the 20th-century, making the US Best Dressed List time and again. On screen, he literally stepped in where his father left off: owning the swashbuckler movie genre throughout the 1940s and early '50s. He married three times: including Joan Crawford and socialite Mary Lee Eppling.

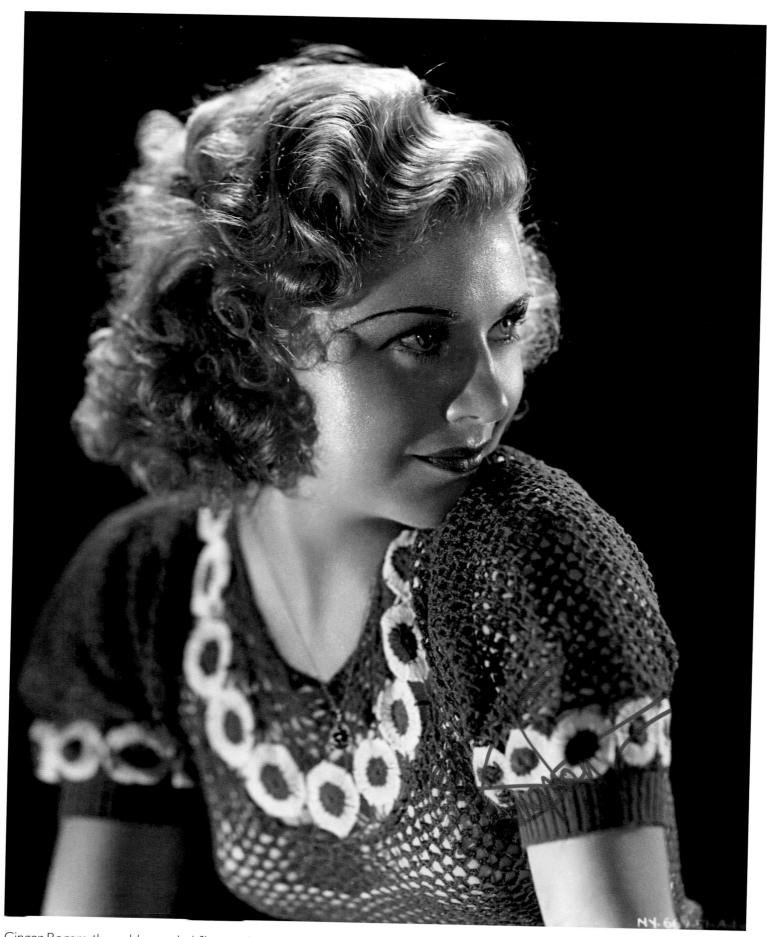

Ginger Rogers, the golden-curled film star best remembered as Fred Astaire's dance partner. However, she craved to be a serious actress and won the Oscar for Best Actress for her role in *Kitty Foyle* (1940).

Family Affair: Robert Young spent almost the entire 1930s at MGM doing nothing. He fared better in the 1940s, notably as the lead in the film-noir masterpiece *Crossfire* (1947). He later found fame on television in *Father Knows Best* (1954-60) and *Marcus Welby, M.D* (1969-76). Here at home with his wife Elizabeth and daughters Betty and Carole, Hollywood, 1930s.

Bruce Guerin got his biggest break in films in 1922, courtesy of his sister Marjorie, who had worked for director D.W. Griffith during the 1910s. Popular from the start, he was christened, 'Hollywood's Most Woebegone Urchin', as well as being one of the most well paid. He earned $80 per week, double that of Hollywood's most celebrated child star of the time, Jackie Coogan. He was often cast as the grubby toddler or orphaned child; his natural ability to act on cue won him a legion of admirers, notably film directors Raoul Walsh and Tod Browning. It all ended as fast as it had begun, and following director Josef Von Sternberg's infamous failure, *The Salvation Hunters* (1925), Bruce's star power began to wane. *"When you are born in Hollywood, whether you like it or not, you end up in show business,"* he said, *"It's tough on a kid to be told it's all over, aged six!"*

Twinkle Watts was nothing if not precocious. The apple of her father's eye – he ran Republic Studios commissary – this curly-haired moppet started out waiting tables before she was hired by studio mogul Herbert Yates. So sure of her popularity amongst movie goers, Yates insisted that Watts play herself in the majority of movies in which she starred. By the late 1940s the party was over, and Watts' moment in the limelight was up.

Scream Queen: Anne Gwynne began her career as a swimwear model, hitting the big time by way of minor parts. Later she starred opposite Deanna Durbin, teaming up together in three films. During WWII, she was one of Universal's top pin-ups for America G.I.s. During the same period she became one of the studio's 'Scream Queens' in a number of horror films: *The Black Cat* (1941) and *House of Frankenstein* (1944) among them. Here with her daughter Gwynne. Her grandson is the actor Chris Pine.

(above) Riding High: Tab Hunter was likened to James Dean and Paul Newman as a male pin-up during the 1950s. An actor and singer, he knocked Elvis Presley off the top-spot with *Red Sails in the Sunset* in 1957. His autobiography, *Tab Hunter: Confidential* was published to high acclaim in 2006.

(left) Kathleen Hughes, the sexy B-movie pin-up featured in a slew of Sci-fi films during the 1950s, most famously the 3-D cult classic *It Came from Outer Space* (1953).

(above) Lizabeth Scott quit the film industry in 1957 after co-starring with Elvis Presley in *Loving You*. She then retreated to her home on Hollywood Boulevard, where she still resides.

(left) Don Murray was a teen heartthrob in the same vein as Elvis Presley, Tab Hunter and Troy Donahue during the late 1950s, and made some considerable impact on screen. Undoubtedly his most prominent early role was as 'Beauregard 'Bo' Decker' in Joshua Logan's *Bus Stop* (1956). *"Working on* Bus Stop *was like working in a fish bowl – Marilyn Monroe was a star and everywhere one turned there'd be a journalist or photographer. I wondered at the time how she could live and survive that kind of attention."* His other work includes *A Hatful of Rain* (1957) with Eva Marie Saint, Otto Preminger's *Advise & Consent* (1962), and *Endless Love* (1981).

Patric Knowles was forever likened to Errol Flynn. Both were stars at Warner Bros. during the studio's Golden Age; they signed their screen contracts within a heartbeat of one another and later appeared on screen together in *Charge of the Light Brigade* (1936) and *The Adventures of Robin Hood* (1938). *"We even had the same decorated top lip,"* said Knowles in 1994, of the duo's wafer-thin moustaches. *"If there were differences it was that Errol was a rebel and I was not. I was never a goody-goody since I had my moments, but I wasn't a cad either."*

1179X1
MGM

Made in U.S.A.

Marsha Hunt, fresh-faced leading lady of the 1930s-40s, began her career at Paramount before moving to MGM, which promised to do more with her career than have her stand around looking pretty. One of her early stand-out roles was as 'Mary Bennett' in *Pride and Prejudice* (1940), following swiftly by *Blossoms in the Dust* (1941), *Kid Glove Killer* (1942) and *The Affairs of Martha* (1942). During the 1950s, she found herself embroiled in the McCarthy era witch hunts; Marsha became *persona non grata*. In 1994, she published *The Way We Wore*, a book dedicated to Hollywood fashion of the 1930s-40s. She has for decades been the Honourary Mayor of Sherman Oaks.

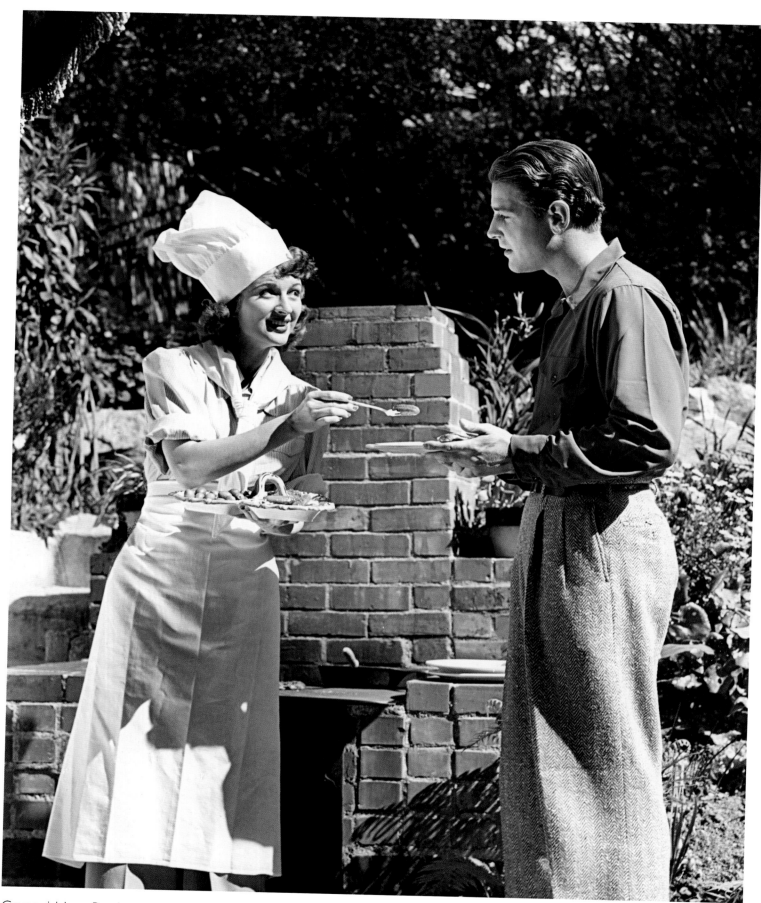

Cover girl: Joan Barclay, actress and photographer's model, appeared on the cover of various US women's monthlies and on screen during the 1930-40s. She started out in film as Geraine Greear, appearing in *The Gaucho* (1927) with Douglas Fairbanks Sr., who wanted her as his leading lady for his next film, though she was only aged 12. She went on to star in more than 60 films, mostly minor features, Westerns and serials, including *The Falcon* and *Charlie Chan*.

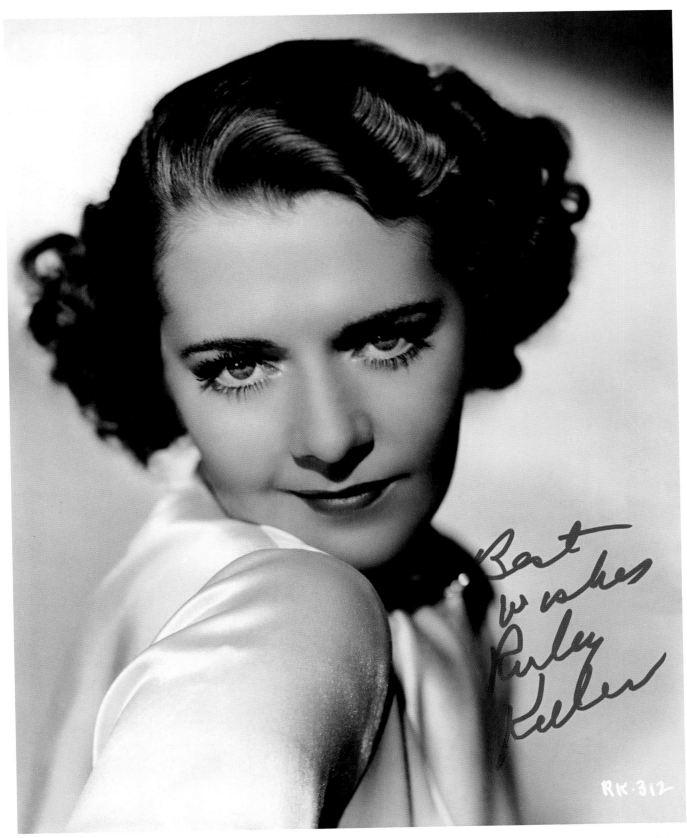

Best
wishes
Ruby
Keeler

RK·312

No other star during the Great Depression made Americans feel less depressed than Ruby Keeler, the quintessential thirties camp chorine who brought choreographer Busby Berkeley's kaleidoscopic musical masterpieces to life, including *42nd Street* (1932), *Gold Diggers of 1933*, *Flirtation Walk* (1934), and *Go Into Your Dance* (1935). Her own beginnings were not that dissimilar to the roles she played; an impoverished childhood spent in New York where her ice-trucker father and washerwoman mother had to scrape together what they could so Ruby could dance. She later caught the eye of Al Jolson (they married in secret in 1928), then gradually hit the big time. The Berkeley style eventually went out of fashion, which subsequently proved the end of her glittering career. Following her divorce from Jolson, Ruby retired, only to make a triumphant return to Broadway in 1971 as the lead in *No, No Nanette*.

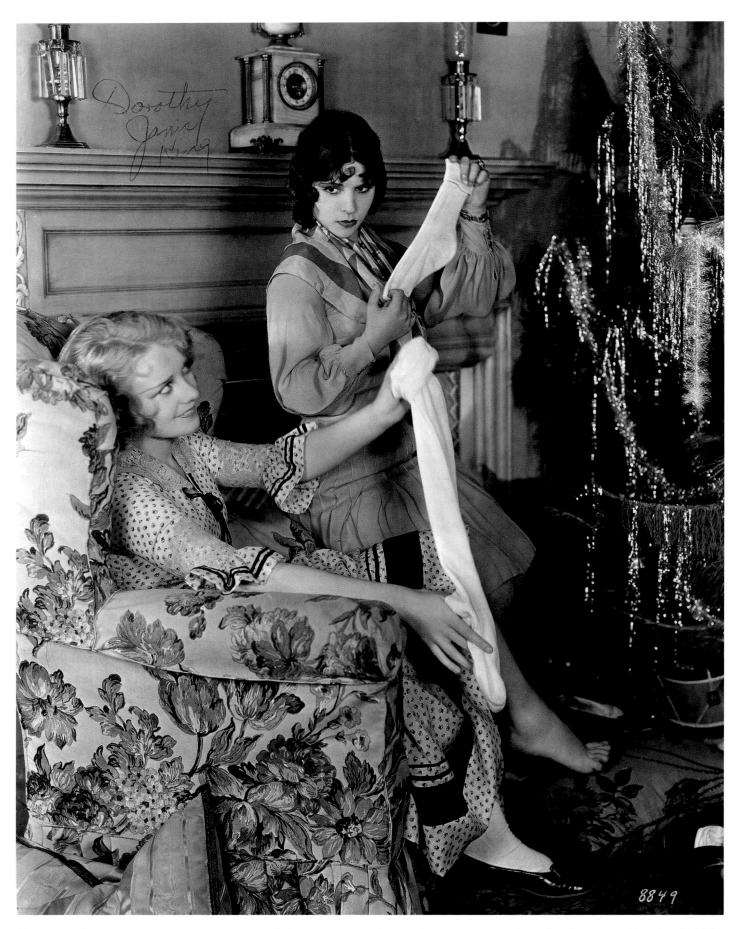

Christmas Crackers: Anita Page (left) took MGM into the sound era with her leading role in *The Broadway Melody of 1929*, whilst contemporary Dorothy Janis failed to succeed beyond Hollywood's publicity machine. *Film Fan* magazine wrote: *"Dorothy Janis is part Cherokee – but she is no papoose."*

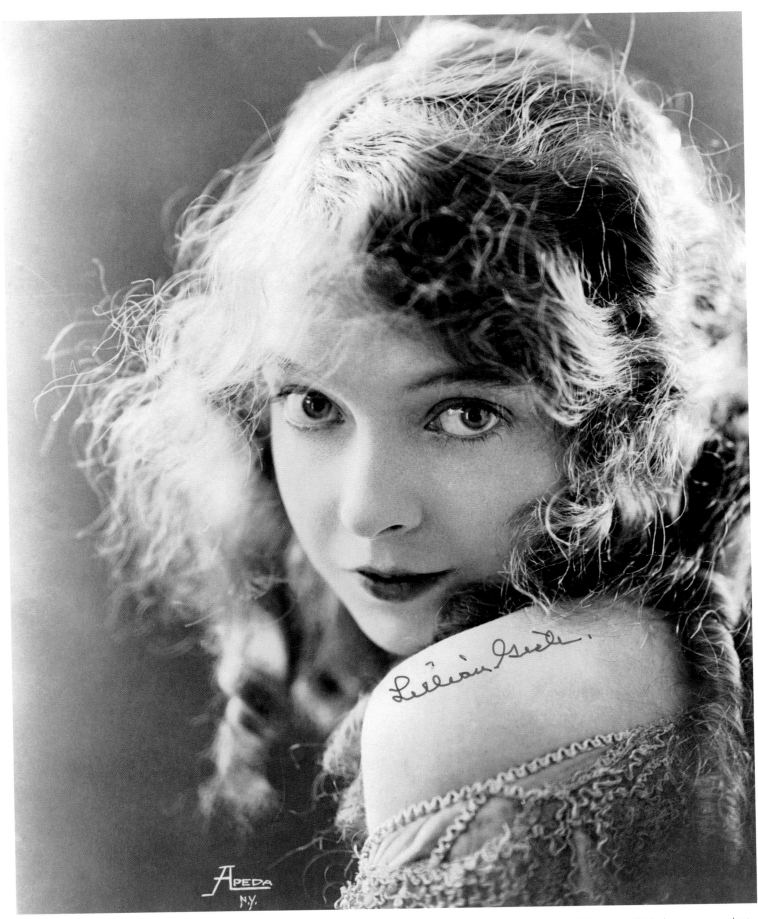

Off-Limits: No man managed to pull Lillian Gish away from her work, her mother or actress-sister Dorothy Gish. In a career that spanned 80 years and every known medium, from silent film to television, she lived her life alone, dedicating almost 65 years to the preservation of silent film and the memory of her first film director and mentor D.W. Griffith.

(left) Edith Fellows was an expressive actress in Hollywood during the 1930s-40s. A rival of Shirley Temple, Edith was the first child star signed to a long-term film contract.

(below) "Marilyn Knowlden is the personification of success," wrote *Hollywood Filmograph* in 1933. Born in 1926, the impossibly cute red curly-haired moppet made five films in her first six months in Hollywood, including *Women Love Once* (1931) with Eleanor Boardman (pictured here). Her other credits include *David Copperfield* (1935), as 'Little Cosette' in *Les Misérables* (1935), *Anthony Adverse* (1936) and *Marie Antoinette* (1938). Unlike the majority of contemporaries her own age, Knowlden recalled home life as heavenly. *"I was a survivor!"* In 2010 she wrote a book on her experiences, *Little Girl in Big Pictures,* giving a unique viewpoint of a happy girl in Hollywood. *"My parents were fabulous and kept me grounded even though I had the most surreal time of any child – being so young I didn't always understand what was going on, but I had so much fun."*

For
Austin
and Joanna
My very
Best wishes,
Virginia Patton
Moss –
Ruth Dakin Bailey

Virginia Patton, featured in a string of WWII moral boosters including *Thank Your Lucky Stars* (1943), *Janie* (1944) and the all-star *Hollywood Canteen* (1944), before securing her most famous role as George Bailey's sister-in-law 'Ruth Bailey' in the 1946 holiday classic *It's a Wonderful Life*. Patton had just turned 20 when the film was released, and quit Hollywood three years later upon her marriage to automobile executive Cruse W. Moss, moving to Ann Arbor, Michigan in 1949 to start a family. "*It's a Wonderful Life was one of those lifetime film roles,*" she said later.

P1085-152

Haven't I Seen You Somewhere Before? Regis Toomey, was one of Hollywood's most familiar faces, playing a series of gangsters, police men or the reliable friend to the male lead in more than 200 films across five decades, making his film debut in 1929. Regis died at The Motion Picture Country House and Hospital in October 1991, aged 93.

Name Changer: Billed as Jacqueline Wells when she first arrived in Hollywood, Julie Bishop enjoyed a brief career as a child star in silent films beginning with *Bluebeard's Eighth Wife* (1923), before leaving briefly to return to her studies. She returned as 'Diane Duval' working with the likes of Laurel and Hardy for Hal Roach Studios, before reverting back to 'Jacqueline Wells' for the remainder of the 1930s. In 1940, she made her final attempt at superstardom, this time as 'Julie Bishop' and for the rest of her film career enjoyed relative success at Columbia Studios, then Warner Bros. She appeared as Ronald Reagan's first love interest in *International Squadron* (1941), opposite Errol Flynn in *Northern Pursuit* (1943), and opposite John Wayne in *Sand of Iwo Jima* (1949). During the 1970s she earned her pilot's licence, sharing the cockpit with her husband, surgeon William Bergin.

I used to be in Pictures

We walk along a path and through a small gate and suddenly, there she is, sitting poolside on a white plastic sun-bed wearing a white and pink polka-dot short-sleeve day-dress – no make-up; bare arms with just wisps of white hair; her skin, alabaster. Randal 'Film Star' Malone, her rotund and perpetually jolly companion, is sat next to her dressed head-to-toe in black on a pool chair waving away the heat with one of those battery-powered hand-held fans. On spying the pair of us, he quickly grabs a Walmart carrier bag and pulls out a honey-coloured curly wig and in a flash forces it rather haphazardly on her head, giving the impression of youth and her former beauty. She lets out a short high-pitched yelp. Film Star smiles embarrassed and, quite flustered, jokes: "She's the loudest silent star around!" Now she's laughing too.

Howard and I are agog. There she is stripped back, but somehow still magnificent – helped by the wig, of course, which makes her look like Harpo Marx! Anita Page had once been one of the biggest stars in Hollywood. A former ingénue of the silent screen, she had all but single-handedly taken Metro-Goldwyn-Mayer into the sound era with *Broadway Melody of 1929*, the first 'talkie' to win an Academy Award. She was one of the silent screen's biggest box office draws and starred opposite Buster Keaton and Lon Chaney, among others. Everyone in Hollywood knew Anita Page; as one of MGM's greatest assets, she'd been adopted by the Head of Production, Irving Thalberg. In the past, she had recalled to us how Thalberg liked her to call him 'Daddy', and because she wouldn't have sex with him, he gave newcomer Jean Harlow the lead in *Red-Headed Woman* (1932). Jean had played the game. As the second biggest female draw at the studio next to Greta Garbo, for a split second Anita Page even outshone Joan Crawford. Such was her fame, that she received thousands of fan letters each month with dozens of marriage proposals, with Benito Mussolini as her most persistent suitor. Things quickly changed when Joan discovered that one's popularity at the studio depended on the amount of fan mail received. She simply bribed the MGM postmen and arranged to have Anita's intercepted and burnt, and so overtook her in the popularity stakes.

Every encounter over the years since we first met has been memorable. This one will be mind-blowing as this time we are going to capture Anita Page on film decades after her last movie. We are both somewhat apprehensive: our small film crew is more used to working on soap operas and adverts than filming a former star of the silent screen who was once captured on celluloid by the likes of Tod Browning, legendary director on *Dracula* and *Freaks*.

Film Star's enthusiasm eases any great concerns. One can never be fully prepared for Anita Page, so chaotic is the jumbled world in which she exists. Earlier this week we spent the day with former thirties actress Marion Shilling, whom we know well and have visited often. We mentioned to Marion that we were to pay Anita Page a visit. Marion nodded her head in remembrance of her old friend from long ago.

"I was a guest at Anita's 21st birthday party at The Hollywood Roosevelt. My date was Robert Young," she remembered wistfully. "I often see Anita and her gaggle of friends at film festivals in Hollywood." Marion shook her head, "Poor dear, she is still on stage. She just can't let go of the old days like the rest of us. The party is still playing in her head – the old world isn't over."

Howard and I are with the group now. Film Star is on his feet and, as we approach, smiles. Anita is still sat beside him, still smiling a toothless smile. I go over to her, Howard beside me.

"Oh brother, you are handsome!" she exclaims, as she gets a closer look, in her thick Brooklyn accent that sounds like Mae West, slow and somehow sexy with lots of oomph. "That's right. You can come here and see me sometime again once or twice more." She's laughing now and showing off the brown stumps where her Hollywood smile had once been. Film Star holds her hand as he reminds Anita who we are and of our letters and cards and previous encounters when Howard and I have visited Hollywood.

"You know these gentlemen, Miss Page. They are our friends; the twins from England," he says shouting in her ear. "Oh well whatcha know, a good looking couple of twinners, I mean sinners, I mean twins," she says, muddled. Anita nods at us both. She shows no obvious comprehension of who we are. Listening to Anita Page is like listening to a radio slipping between the frequencies. Then, in a flash, she asks me: "Are you Novarro?" turning to Film Star, she repeats, "He is Novarro! He looks exactly like Novarro!"

Film Star looks at me and says nothing, waiting for my reaction. "Oh boy, didn't I love you once or twice?" she continues eyeing me up and down slowly. Film Star smiles at Anita and turns to me. Now he is looking me up and down with his head to one side. "Well, Miss Page, he could well be."

Anita is still giving me a certain look and starts blowing kisses. Film Star stands behind her now waving his hands

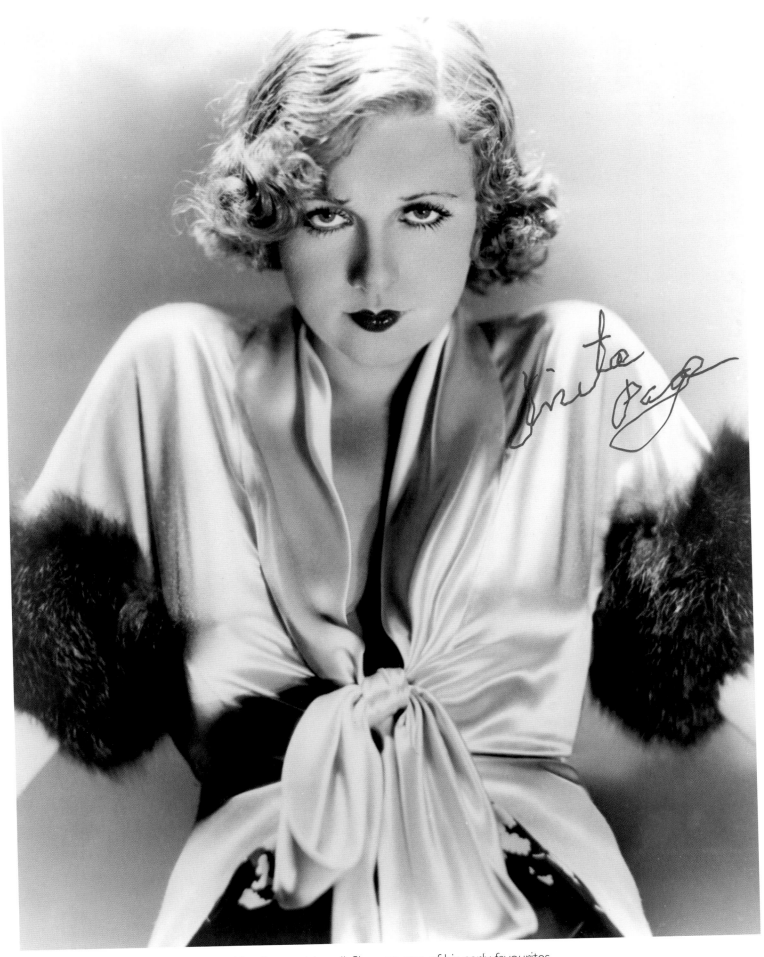

Sultry siren Anita Page, photographed by George Hurrell. She was one of his early favourites.

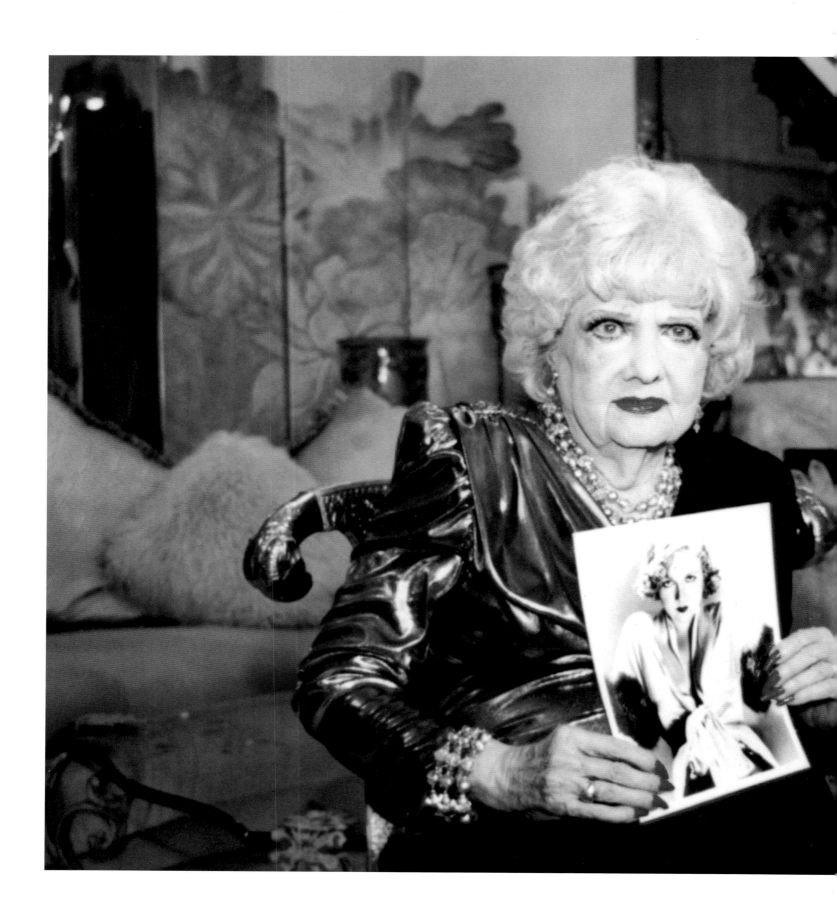

The eyes have it; *"Honey, I can vamp for you, see?"* Anita Page, Hollywood, 1999.

in a circular motion as if to say, 'just play along'. I do as the scene commands.

Ramon Novarro had been a beloved co-star of Anita's and a treasured friend, the 'new' Rudolph Valentino after Valentino's premature death in 1926, both in looks and popularity. Novarro was the lead in the original *Ben Hur* and became famous for a string of other film credits. In 1968, he came to a sticky end in his Hollywood apartment, murdered by brothers Paul and Tom Ferguson whom he'd hired for sex, believing the rumours that Novarro had a large amount of cash hidden in his Laurel Canyon home. Tortured for several hours, they left him for dead with a mere $20.

Anita lets out a slow moan. "Oh boy! When I heard what had happened to Ramon I was sick for nearly three days," making a dramatic emphasis on the words 'sick' and 'days'.

She holds her hand out for me. I move closer, kneeling on the concrete beside her chair. Howard is taking in the scene: the swimming pool, empty apart from fallen palm tree leaves, some fast food wrappings and Coke cans. I lean forward and kiss her tiny hand. It was something 'they' did in old films, yet it is something I've never had an inkling to do myself before now, yet it feels oddly apt. From the very moment Howard and I walked in on Anita Page and Film Star, it has been as if we were acting in a film ourselves, with me cast in the role of the long-dead Novarro.

The scene as it is more than resembles Billy Wilder's classic masterpiece *Sunset Boulevard*, only 50 years on. We're all playing the central characters: our 'Joe Gillis' to Anita's 'Norma Desmond'. Film Star is 'Max the butler'; and the other characters that come and go later through the day, her 'Waxworks'.

Anita lingers over my kiss. Her nails scratch my face like talons as she strokes my cheek. For the moment the only apparent suggestion of her once glamourous past, besides the wig that she pulled firmly into place a while ago, are her scarlet-painted nails.

"Oh my hands," she says pulling away now and looking at them intently. "Marion Davies said something about my hands when we were out at San Simeon." San Simeon, the William Randolph Hearst castle in Santa Barbara was a playground for the rich and famous during Hollywood's Golden Era. An invite for the weekend was a much sought after ticket.

"Did you know Marion well?" I ask. "Know her?!" she screams. "I was like a sister to her. I stayed at the castle for

Unrequited love: there were many who knew of his homosexuality, however, Ramon Novarro managed to keep his private life private during his career in silent films. Anita Page didn't believe the rumours and asked for his hand in marriage several times. *"I know he loved me once or twice,"* she said. *"I sort of dreamed he'd be the kinda guy to take me up the aisle."*

a year holding out for a call from Daddy." Thalberg had refused her demand for a salary increase, undaunted she turned her back on him and took seclusion at San Simeon waiting for the call that never came. That was in 1933.

Anita is still admiring her hands, holding them up to the sunlight. "Marion liked my hands, since they are small and so soft – just like a baby's."

Anita continues, "She was so dear to me and when I remember how she was in later years, her pretty jaw tied to her head with a scarf to keep it from falling off with that cancer that killed her." Anita lets out a sigh, "I cried for six days." Howard asks who else visited San Simeon. She shoots him a look and runs off the names like fire from a gun: William Powell. Marlene Dietrich. Joan Marsh. Gary Cooper. Clark Gable. Beatrice Lillie. Buster Keaton. Aileen Pringle. Eleanor Boardman. Norma Shearer... bam. bam. bam.

She pauses then for a moment. "Clark Gable loved me. Oh yes he did. He told me when he looked in Grace Kelly's eyes, they reminded him of mine; oh yes, he was a

doll and so handsome." Howard reminds Anita that they worked together on *The Easiest Way* (1931). "Sure honey, I was the 'easiest' and he was 'the way'."

Howard asks more questions about San Simeon. "It's dry up there, no booze whilst William Randolph Hearst is on watch! He wouldn't have it inside the place, so Marion asked arriving guests to smuggle it in. Later at dinner she'd keep excusing herself to go to the bathroom where often Billy (William) Haines had hidden it in the toilet cistern." Anita taps her finger on the arm of the plastic chair for emphasis. The anecdote starts a trail of remembrance…

"Do you know what, that Harlean went and tried to steal my date at the castle right from in front of my nose!" Harlean Carpenter later became Jean Harlow, MGM's most famous platinum blonde.

"She tried to spin some phony line that she was scared to walk in the grounds alone in case a tiger tried to chase and eat her. Hearst kept a zoo up there, though he assured us the animals were all locked up tight at night."

"Maybe she was genuinely scared?" Howard asks. "She was a bit I guess, but then so was I and I didn't want Harlean getting her hands on William Powell – he was my date. Harlean could be like that."

Film Star breaks in to remind Anita about another admirer, Mussolini. "Oh yeah him," she shrugs. "Wasn't he all palsy-walsy with Hitler? Yeah, I think I'm right." She is silent for a moment then remembers, "He liked my hands; that's right isn't it, baby?" she looks to Film Star, "Didn't he want to marry me or something?" "He sure did," replies Film Star.

"Oh yeah that's right. I remember now he said he liked my hands and my movies and he wrote me that he liked my hair and he asked for a slice of it, then he wrote in another letter how he wanted to marry me, but that ended when Louis B. Mayer found out. He wasn't keen and nor was mother. I got scared in case Mussolini came over here and tried to kidnap me or something. My father was cute. He reassured us that Mussolini wouldn't get as far as Beverly Hills before being noticed."

Anita coos as she touches my cheek, drawing her face close to mine, almost toppling from her seat. "You *are* him and you're not," she says, laughing nervously. "He wanted to marry me too…" "Who?" we all ask?

"Novarro… he wanted to marry me, oh yes he did. He asked me once or twice you know, but it didn't happen. Mother wasn't keen and said, NO WAY! Mother said NO WAY to Billy Haines too and he was a real dish." She turns to Film Star, "That's right isn't it, baby? I was going to marry William Haines?"

"It wouldn't have worked Baby Doll," he assures her whilst mouthing the word 'gay' to us, and then laughs.

"Yeah, they all wanted to marry me. When the fan magazines keep writing how famous you are, then you have to believe it. I'm big, baby!"

The role play leaves us in limbo for the rest of the day. Half playing up to Anita so as to cushion her into feeling completely at ease in our presence, whilst trying to be ourselves, which on this occasion seems surprisingly difficult.

The sounds of a metal gate slamming makes each of us turn to the direction from which we came. A slim attractive woman in her fifties appears, her hair platinum blonde and as acrylic as her nails, which are like her

How Joan Crawford Keeps Glamorous

What's Behind the MacDONALD-EDDY "FEUD"?

Joan Crawford and Anita Page both received their first big break with *Our Dancing Daughters* (1928). *"But she wanted to outshine me,"* recalled Anita. *"She did try to hold me back during filming to make sure she shone. Her nasty little ploys didn't work – I could be smart too, and she knew it – I respected her, but we'd never be friends."* Joan would go on to become one of the greatest stars Hollywood ever had.

mother's, long and well manicured; long tanned legs emerge from short shorts finished off with three-inch high wedges. This is Linda, Anita's daughter. Slowly she bats her long false eyelashes, seducing us with her soft tones. She approaches Howard and strokes his cravat, "Oh you look like the Duke of Windsor." Howard beams. "I think Mother knew him." In a flash her voice changes as she screams, "Hello Mama!" into Anita's ear and sits on a bar stool beside Film Star. Linda isn't alone, she's brought with her a friend of Film Star's called Mike, who is equally as rotund. The Page party is now complete.

Howard and I are surrounded now as we sit on the concrete in the shade. It is obvious that Film Star cares deeply for Anita. As he pours us some water into glasses neatly positioned on a gilt tray, he reminds Howard and I

(left) On set in 1934. Two years later, the career Anita had worked so hard to build would be over.

(below) Anita Page and William Bakewell appeared together on film only once, in director Charles Reisner's *Reducing* (1931). The pair were romantically linked by MGM. *"He was so cute, we were just good friends, but never lovers."*

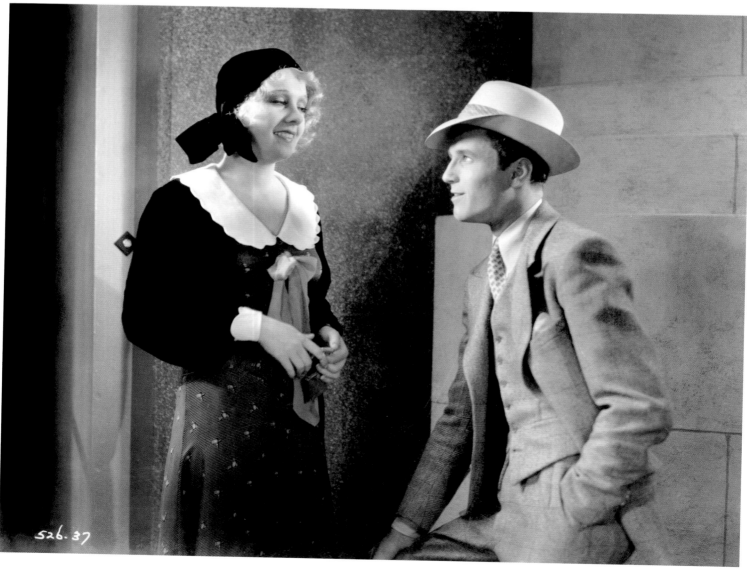

of the first time we met him with Anita over dinner at the Hollywood Roosevelt. He chats about how he first met 'Miss Page' as he refers to her, and fell in love with her and, moreover, the movies she appeared in and the famous stars she called friends. And, he explains, how *she* fell in love with Film Star, taking his caring nature as a sign of his true love and, therefore, making him husband material.

"She's proposed to me at least six times. I mean, honey, she's keen…" he lit a cigarette and took a drag.

Film Star is for all intents and purposes Anita's bodyguard-cum-carer. To Anita he is her fiancé. He has his own fascinating past and, unlike Anita Page, now enjoys a greater pedigree. He tells us how he was raised up on a diet of 'Old Hollywood', ditching the family's Kentucky homestead and a great tobacco farming empire for the trappings of Hollywood. In contrast, Anita was born into a lower middle class family from Flushing, New York. When the sound era conquered Hollywood, Anita's thick Brooklyn accent seemed quite at odds with her petite frame, marking the beginning of her steady downfall. Visits to his ailing grandmother, Frances Malone, had paved the way for Randal's career in showbusiness: on stage in nightclubs and doing stand-up, as well as TV appearances in the hit show *Singled Out*, in particular the Norma Desmond-esque comedy character 'Film Star', from which he got his nickname. He oozes old style glamour with his chalk-white face, black drawn-in eyebrows and a raven black wig that outdoes Anita's and Linda's in quality and sheen.

As I watch Film Star, I could picture him playing Roscoe 'Fatty' Arbuckle, such is his stature, his familiarity with Hollywood of yesteryear, his comic timing and charm. He repeats again how he met Anita Page in the early 1980s as she stepped from a Hollywood eatery. He recalls how, star struck, he approached her, reeling off a list of her film credits and male co-stars. He remembers how she stood there, frozen, almost weeping on the spot. His own eyes are filled now with tears at the memory.

He speaks more quietly now about his other friends: Ann Miller, Ginger Rogers, Margaret O'Brien and Gloria Pall, each one a blast from Hollywood's Golden past. "The late Miss Lucille Ball and I played backgammon twice-weekly right up until she died," he says as he wipes away a tear. For dramatic effect he dabs the corners of his eyes with a white handkerchief and then, spotting that Anita is looking over, warns in hushed tones: "Shhh! Don't mention those gals to Miss Page. She gets so jealous." Anita is now straining to hear our conversation.

"I've asked him to marry me. Oh yes I have, one or three times and still he says 'NO', don't you baby…" giving Film Star dagger looks. "No, my Baby Doll. I'm too busy right now with work," rolling his eyes at us. "Well, I'm gonna ask again." Anita turns to Linda now, "Mama needs to pee."

Our film crew of three arrives now. I'd told the guys a little about Anita, of what to expect; though nothing could really prepare them. Our director, Peter, had been very matter of fact with Howard and I the night before in our cameraman, Dickie's garden. He'd listened to my description of Anita Page. "Sounds like home, my mama is kinda goofy," he told us. "She met Elvis once and on re-telling the story you'd think they were hitched."

Our sound recordist, Maz and Peter are holding cameras, lights and other equipment, both staring at Anita; Dickie, at Linda. Film Star greets them and warmly introduces Anita as if she were the Queen. "Now gentlemen, it gives me great honour to introduce to you the Hollywood star, Miss Anita Page."

Anita is all smiles as Linda looks the guys up and down, she lingers the longest over Dickie. Within minutes they are flirting; Dickie showing her his tattoo, Linda showing her own assets.

"That's fresh," says Anita, her eyes looking Dickie up and down like search lights. "I say young man," Dickie stands to attention. "I'm the talent here!" Anita still vampish then focuses on Film Star, "That's real nice of you saying all that now, honey," she pauses dramatically, "Now listen, I really gotta pee!"

Film Star asks us men to gather round and steps away from Anita. "Now guys, there's plenty of us here now. You see we need to get her upstairs because that's where I suggested to Austin and Howard that we should film Miss Page. The interiors are beautiful: Art Deco Hollywood and the light complementary to Miss Page, ethereal and muted." Film Star lights a cigarette and looks about him, "Besides there's too many people likely to snoop around if you film down here." He takes a pull on his cigarette and delivers the punchline, "… and boys, there's no elevator and no way she's gonna make the stairs."

All heads turn towards the apartment and back at Anita – who probably weighs 145 pounds – and back at the apartment. Howard suggests we lift her up the stairs in a chair. "Oh got it," says Film Star. "She'll like that, ascending a grand staircase as if she is on a throne." He clicks his fingers. "Great, got it, good," and wanders

(left) Anita Page in 1929. *"Talkies were terrible! The microphone picked up everything - even the sound of me filing my nails, eating my lunch or reading the newspaper."*

(below) In *The Broadway Melody* (1929) Anita Page and Bessie Love play two sisters who try their luck on Broadway. Trouble occurs when both fall for the same man (played by Charles King).

M-G-M's GREAT HIT OF **1929** **"BROADWAY MELODY"**

Charles King, Anita Page, Bessie Love

back over to Anita whilst Mike is already heading up to the apartment for a chair.

Uprooted from the plastic chair and resettled in an elaborate dining chair with carved lion arm rests, Anita Page is ready to ascend: Linda to the left of her, Film Star at her right.

"Baby, where we going?" she asks. She listens intently as Film Star gives her direction. "Miss Page you are the Queen of Sheba and these gentlemen are taking you to your palace." We each look at one another and say nothing, sweat dripping off the end of Peter's nose.

"Oh really, oh well, oh yes, YES! I see it, yes I do, I see it now," she says in a dramatic voice and then right back out of character turns to Film Star, and with a look of disgust says: "Listen baby, I'm no old Queen, honey, that's Norma Shearer. I'm the Princess."

The narrow stairwell makes the journey perilous, with Anita Page tossed one way and other. "Oh baby, I'm all at sea here – I'm on the *Titanic*," she cries with glee. As we turn a corner, more than one of us scrapes our knuckles on the rough plastered walls. "Come on boys," she cries, "I really need to pee now!"

Film Star is ahead of us in the doorway of the apartment, his hands clasped under his chin. "We made it, baby!"

Now at our destination, Anita is carried through the hallway and helped out the chair and into a bathroom by Linda and Film Star. Howard and I join the guys in the kitchen, each one of us is puffing and gasping for breath.

As I drink a long glass of water, I marvel at the palatial surroundings so at odds with the exterior and surrounding run-down neighbourhood. There are mirrors everywhere, onyx, gold and crystal lamps. Walnut and gilt cabinets house what look like *objets d'art*. I look closer and realise the cabinets are actually housing an array of glass, marble and Perspex dildos! Dickie pulls a face.

"Wow. The mind-boggles!"

Film Star and Linda help Anita from the bathroom and crisscross the hall into a small bedroom. He calls Howard to show off a selection of gowns he has brought with him, pulling from a bag a Lurex black and silver dress with a plunging neck-line, various furs, two hats and a large make-up bag. "I'm gonna get to work," he says licking his lips.

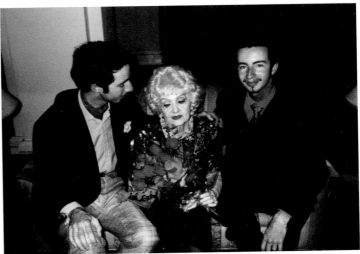

(top) Super Fan: Anita Page with Randal 'Film Star' Malone, Hollywood Roosevelt, September 1994.

(middle) Dining Out: Anita Page with Austin (right) and Howard at the Hollywood Roosevelt Hotel, 1994.

(bottom) Stepping Out: Anita Page arrives in Beverly Hills, 2001.

Dear Austin and Howard
May all your dreams
come true!
with much love,
Marion Shilling

(left) 1930s ingénue Marion Shilling attended Anita Page's 21st birthday, *"Anita was a sweet dear girl. She is still living as if that world was still here, where she was a big star. For her it has never stopped."*

(page right) Anita Page takes to the air with Regis Toomey in *Soldiers of the Storm* (1933).

(below) *"There was no romantic feeling towards Clark Gable. He'd give me a ride home after filming and that was it – I didn't want to marry him."*

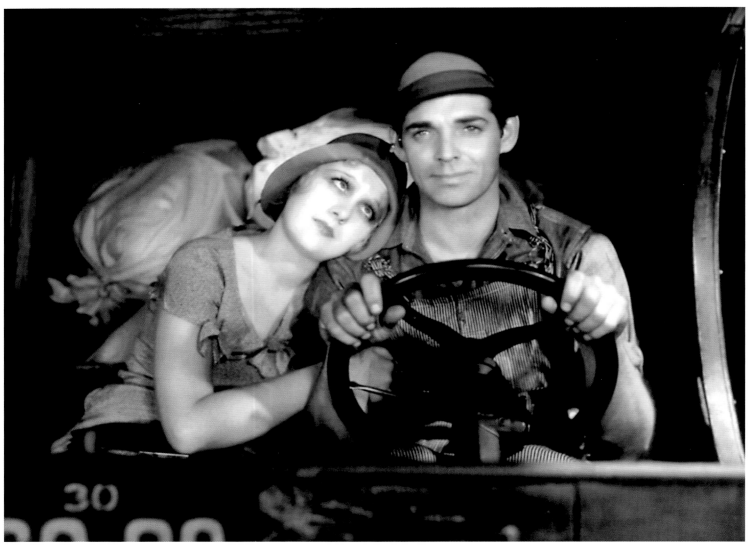

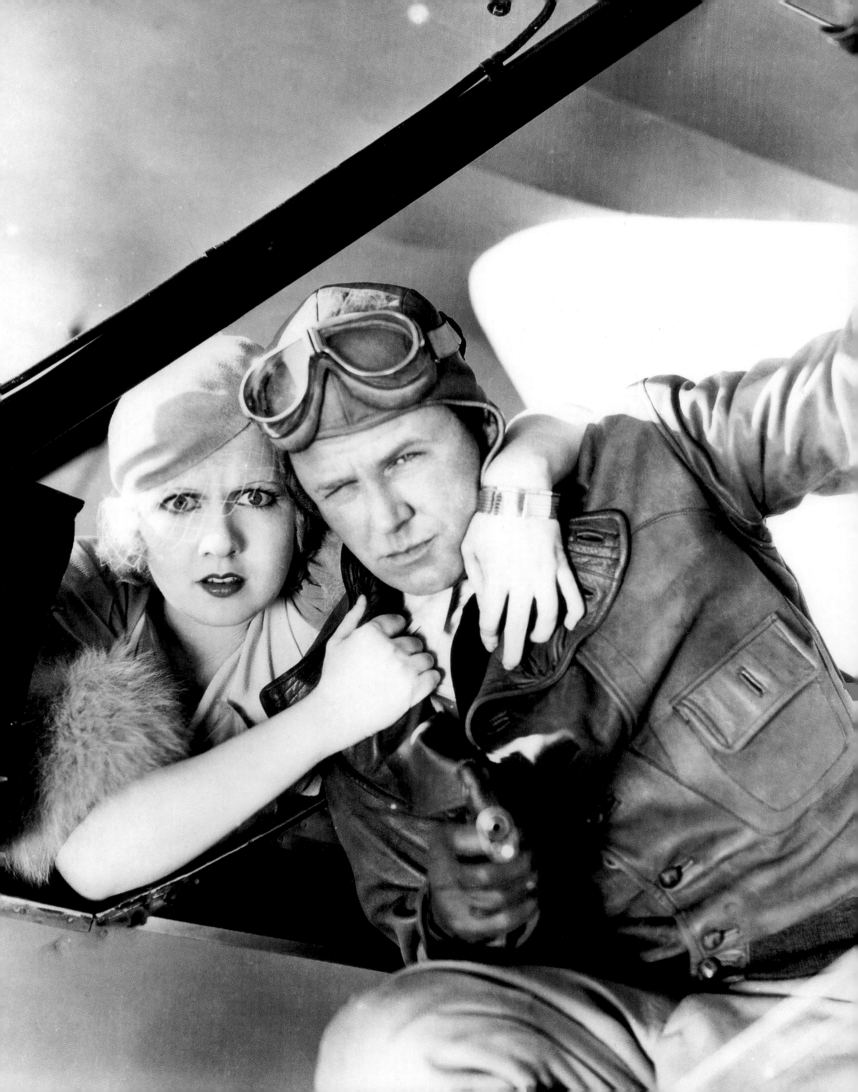

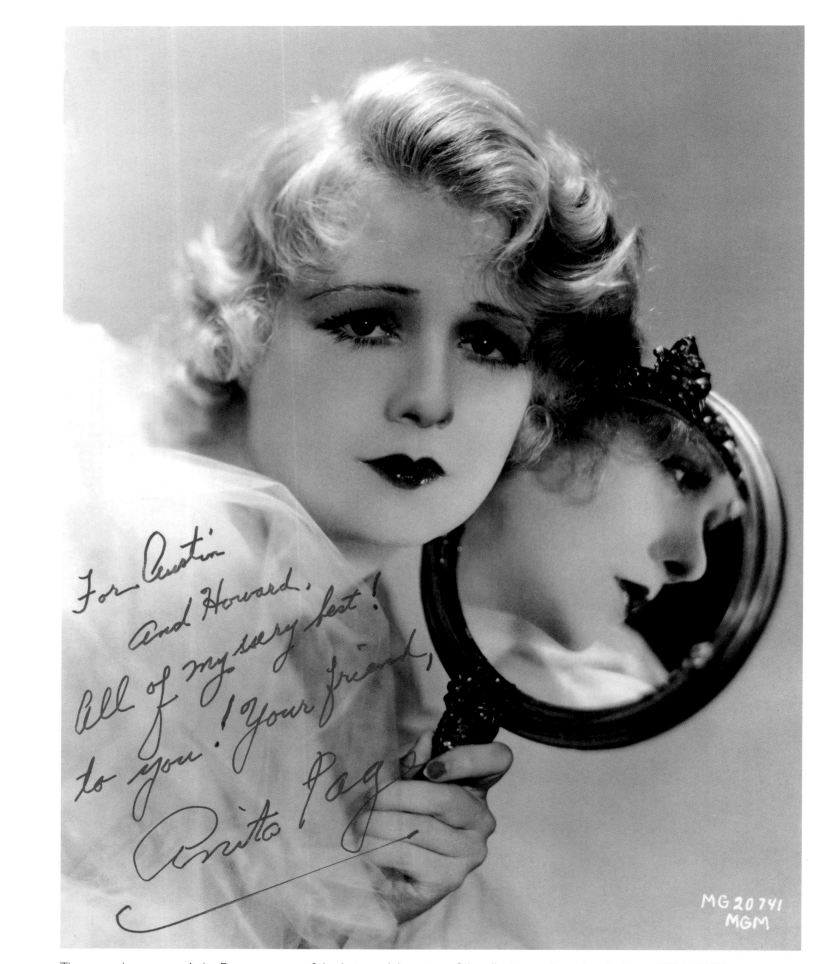

For Austin
and Howard,
All of my very best!
to you! Your friend,
Anita Page

The ever glamourous Anita Page was one of the last surviving stars of the silent era when she died, aged 98, in 2008.

One hour later and with the crew back outside enjoying the sun, Anita Page emerges with the help of Linda and Film Star and is ready for her close-up. Linda squeals, alerting the crew that the star is finally ready. With the guys back in the living space and the cameras already in place, we all marvel at Miss Page. "Now that's why she is still the greatest of them all," says Linda, happy with Film Star's handiwork.

Anita Page looks like a collision between Barbara Cartland and 'Baby Jane Hudson'. The make-up is trawled on as if with a spade, the eyelashes long and seductive, the dress clinging to her in all the wrong places. She's wearing black stockings and bracelets running the length of her gloved arms, her earrings like mini crystal chandeliers.

"Oh I'm happy about all this, yes I am, I'm happy about this. Are we ready to roll?" asks Anita, and then asks, "Are we silent?" "No Miss Page," answers Film Star, "This is going to be a talkie." "Oh well," she sniffs. "Silents are my favourite. I prefer silent film," she pulls a grimace.

"Oh honey-doll," shouts Anita as we record for sound, "I want Sandra to see this." Film Star leans to Howard and whispers into his ear. "Sandra is Anita's other daughter." Howard looks towards the front door, still ajar. "Oh, no sir," says Film Star. "Sandra is dead. We never told Miss Page, the shock would have killed her. I keep everything pure for her so nothing upsets her. I cut all the bad news from the papers so she only sees the good stuff. At home she sits and watches her movies like she's seeing them for the first time. Sometimes we all get dressed up real pretty, like it's a premiere – she likes that – and occasionally we take her out to the Hollywood Roosevelt for a soda. She *loves* that – the hotel is where they held the first Oscars. Anita was there."

Out of sight, Linda has side-stepped back into the bedroom. Within minutes she reemerges wearing a brown wig and a different dress now, standing just far enough away as to pretend to her poor-sighted mother that she is infact Sandra.

"Oh my baby!" cries Anita. "Look at Mama. I'm a Princess! Film Star is here and Linda is here. If only your poor dear daddy were here too, it would be bliss, pure bliss, just to have everything back as it was. Mama is shooting a picture, so hush now!"

"You are beautiful Mama! You are the greatest of them all and I love you!" says Linda as 'Sandra'. "Well if you say

so... Yes I am! I am better than Joan Crawford." The thought of Joan gives Anita a new vigor. "When I heard what she'd done to my fan mail, I was sick for three years!"

Anita's rivalry with the sexually voracious Crawford caused increasing tension between the pair at MGM. "I loathed Joan Crawford," she barks. "She hit on me at the Chateau Marmont and when my mother saw the sex aids in various shapes that Joan kept in her medicine cabinet, she refused me to see Joan again, except on set."

Film Star looks sheepishly at the cabinets housing sex toys and can't help but smile. In a low voice he whispers, that the 'Daddy' she is talking about now was the girls' father, Anita's late husband, Herschel A. House, who died in 1991. The room is still as Anita talks to 'Sandra'. You could hear a pin drop.

"Oh yes, I am," she says to herself now patting her dress flat. "Mama is better than Joan Crawford?" she pokes out her tongue as if Joan were standing opposite her.

'Sandra' walks behind her mother and gives her a hug, wrapping her arms around her shoulder giving her a kiss. Linda is crying now at her own loss. 'Sandra' blows us all a kiss as she makes her excuses and leaves the room. Nobody moves. We discover later the apartment belonged to Sandra as did everything in it and her own daughter, Anita's granddaughter, is in prison for a drug-related crime. Anita, of course, knows nothing about this either. I picture her reading the daily paper that surely must resemble a paper doily.

"I'm ready when you are Mr. DeMille." The crew take their places. I ask Anita some questions on her career, how she first arrived in Hollywood and her first impressions, her co-stars and the trappings of fame. Anita gets muddled, then angry with herself when she can't remember who she married or dated. Once in a while there are flurries of lucidity.

"Were you a victim of the casting couch?" I ask. "Who me? No way! No they wouldn't dare! I picked the men I wanted to sleep with. They didn't pick me!"

After 30 minutes, Film Star asks for a break. I join Howard in the kitchen. He raises his eyebrows and sighs. Everyone, including Anita is pretty exhausted by the day's events. I step away, out of the apartment and pop down to the pool. Maz is there, he says nothing for a while.

"You did good up there Austin," he says motioning towards the apartment. "That ain't easy. I mean we've all been in two worlds ain't we, hers and theirs and ours; theirs is sorter ours too but only sometimes, right?" He pulls out a cigarette and lights it. "I mean, it's kooky." Linda appears beside us both. She's wearing a silver bomber jacket swinging a small handbag on a gold chain. "I just loved that – what a great interview," she looks at Maz, "And you guys have been so generous to Mother – awesome isn't she." Neither of us answers for a moment.

"It ain't ended for her – the silent films, the career," observes Maz as he passes Linda a cigarette. She waits for him to light her up. "It won't ever." She tosses the cigarette to the floor after three puffs killing it with the sole of her glittery gold mule. "Okay that's me. I gotta get to work." She grabs my face with both hands and plants a kiss. I taste rose-scented lip gloss. "Bye Austin, have a good life and keep shining."

Maz and I watch motionless as she wiggles down the path and onto the street. She catches the attention of two guys on the opposite side of the street, they call out to her, she blows them a kiss and disappears from view.

"Austin!" calls Howard peering over the railings above us, "We're back on." I wave and head back up. I feel tired. The day almost over, the experience everlasting. I walk through the apartment door. There is Anita still in position, Film Star and Mike standing behind her, Howard seated next to her, silent as he listens to more stories…

"Well Johnny Mack Brown loved me, oh yes he did… he had these big eyes…oh and Mr. Gable's wife told me he had suits made to cover his large behind," she laughs expansively.

I watch and I think. I think about what Linda has said. I think about the hermetically sealed world in which she and the others have cocooned Anita, with its own rules to keep the lights twinkling brightly, the cameras rolling; each colluding with the other, creating a caricature of what they believe her life back in the days before they were born might have been like, the entire scenario a Hollywood hallucination. Watching Howard with Anita Page I wonder how many former stars we've kept going: our fan letters feeding their egos; from their replies, it seems that we've invigorated them, made them happy. But it isn't until now, until spending an entire day with Anita Page that I ask myself if we too are not unlike Film Star.

For a moment I think how tragic it all is. But then I remember Doris Lawrence – a friend of my grandmother's – once so regal, so elegant. Now she's living in an old people's home, her hair unkempt, her dignity stripped away as she sits in a twilight world half remembering her past, not remembering the present. Now that is tragic! Anita Page has a crowd around her who care, who help to keep her in an era where she was indeed 'big'. Today she believes she is still the biggest star in the world and everything else, the day-to-day life going on around her, is completely inconsequential. Anita Page is still in her own limelight, where the fame hasn't yet faded. She is still waiting for that telephone to ring, to invite her back to MGM.

Four hours later and we are almost done. Anita decides to finish on a song, 'You Were Meant For Me', penned by her then husband Herb Nacio Brown and Arthur Freed, the lyricists, for the early musical *The Hollywood Revue of 1929*.

You were meant for me
And I was meant for you

Nature fashioned you
And when she was done
You were all those good things
Rolled into one

You're like a plaintive melody
That never lets me be
I'm content the angels must have sent you
And they meant you just for me…"

Anita hums the rest. Film Star comes up and holds her hand, leaving just enough pause before she accepts our applause and Peter shouts, "Cut!"

"I was good, wasn't I baby?" she asks.

"The greatest," Film Star replies. "The greatest!"

(page right) Anita Page, photographed by George Hurrell in 1930. *"It was always a production with George. He took as much time as a director shooting a picture."*

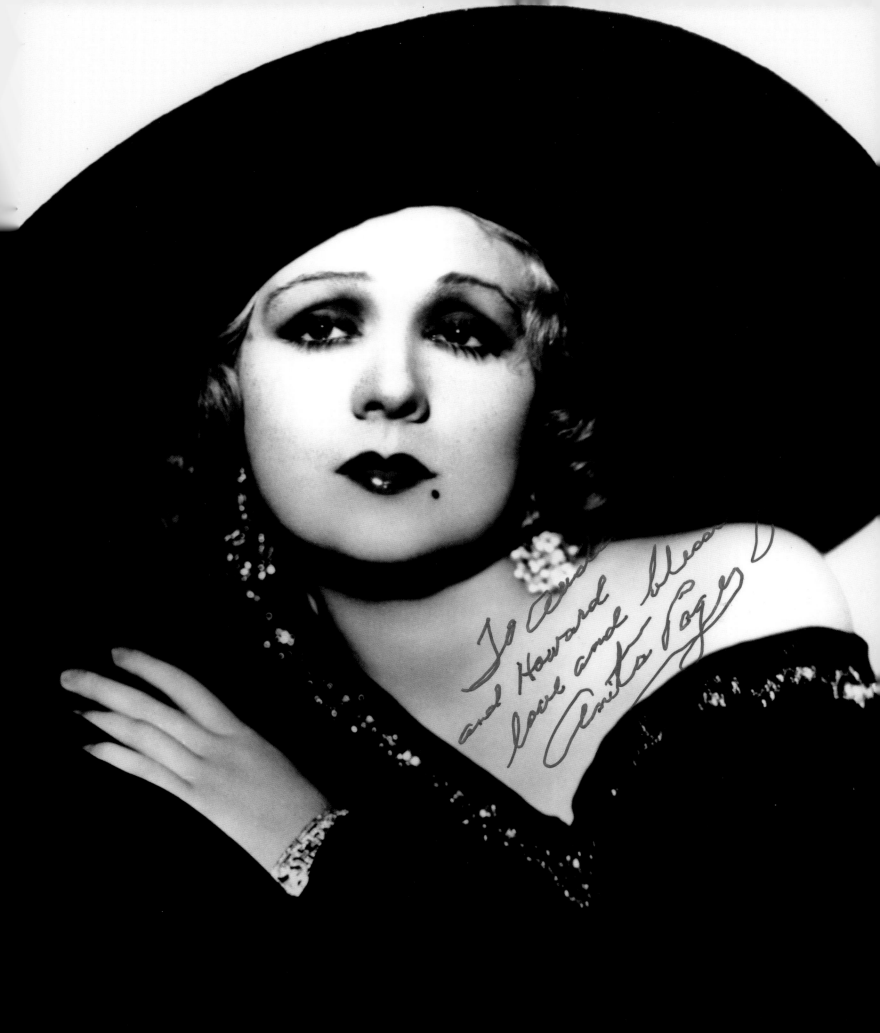

Hollywood on Set

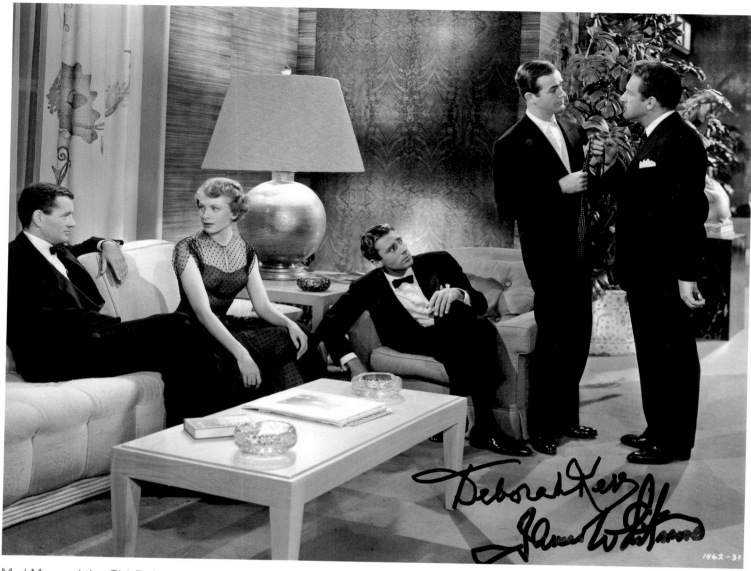

Mad Men and the Girl: Deborah Kerr, James Whitmore, Peter Lawford, Robert Walker and Mark Stevens in *Please Believe Me* (1950), a minor romantic comedy directed by Norman Taurog. The film was made primarily to promote the quintessential English Rose, Deborah Kerr, who had been poached by MGM in Hollywood.

Flying High: During the 1930s, Hollywood starlet Toby Wing had more publicity photos taken of her than any other actress – including Marlene Dietrich – under contract to Paramount Studios.

Silence PLEASE! Eddie Quillan learned his craft under the guidance of director Mack Sennett who put him to work in a series of two-reel comedies during the mid-1920s. It was this experience that he put to good use during his 60 year career, appearing in more than 150 films and TV shows.

(above) Comic Capers: Frances Lee starred in a plethora of silent pictures mostly for the director Al Christie opposite Bobby Vernon (pictured here). Her films included *Slippery Feet* (1925), *Chicken a La King* (1928), and as 'Doris Whitely' in *The Carnation Kid* (1929).

(right) Dotty! Hollywood ingénue Grace Bradley made a string of lightweight mostly forgettable films during the 1930s. In 1937 she married William 'Hopalong Cassidy' Boyd, and quit acting some years later. A striking beauty into her 90s, Hugh Hefner described her as, "*Ageless. Grace Bradley has that hint of Mae West, but with a lot more class.*"

(above) Citrus Queen: Mae Clarke is best remembered for this scene with James Cagney in *The Public Enemy* (1931). Clarke recalled the scene was just a gag dreamt up by Cagney to entertain the crew. She never thought it would make the final cut. Ironically it would go on to define her career.

(left) June MacCloy – tall, blonde and glamourous – made her film debut with the arrival of talking pictures, working with the likes of Douglas Fairbanks Sr., Jack Oakie and The Marx Brothers.

Girl Power: Described by Jack Warner as "The Thoroughbred of Warner Brothers Stable", Beverly Roberts was the only woman inducted into Humphrey Bogart's original Rat Pack of the late 1930s. "There was no funny business. We – Bogey, Spencer Tracy, Pat O'Brien, George Jessel and I – were just great friends; I liked their company, spirit, intelligence and love for their craft, and they enjoyed mine."

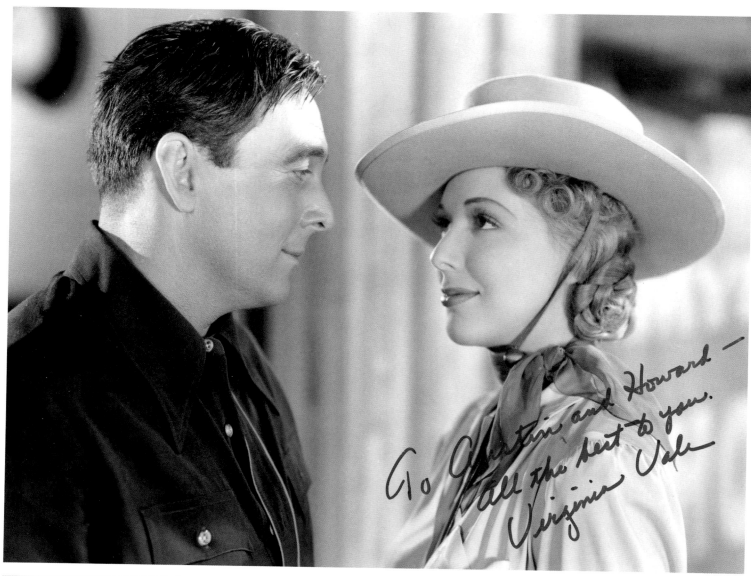

(above) Riding High: Virginia Vale rode the range in six Westerns made for RKO Pictures co-starring George O'Brien, including this, a scene from *Marshal from Mesa City* (1940).

(left) Silver Spurs: Gene Autry was the original singing cowboy for a generation growing up at the Saturday morning pictures. Behind the saddle and spurs, he was a shrewd business man who became a multi-millionaire with investments in real estate, radio stations and the California Angels professional football team.

(above) Happy Trails: Cowboy and cowgirl stars and real life husband and wife, Roy Rogers and Dale Evans made the Western musicals their own during the 1940s, before making the lucrative move into TV and subsequent merchandising.

(right) All Eyes on Me: Jane Russell's revealing costume as 'Rio', the buxom beauty, in The Outlaw (1943) set millions of men's hearts racing and caused church and parental groups to protest. The film made her an international star.

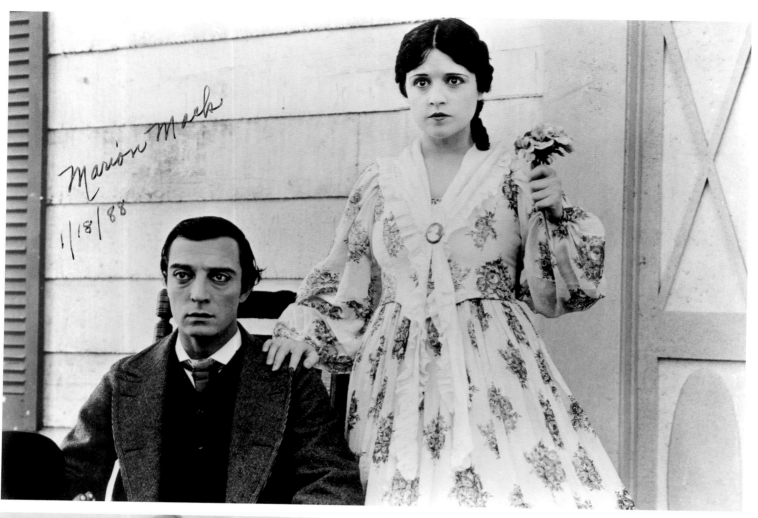

Marion Mack
1/18/88

(above) Marion Mack blossomed opposite her leading man
Buster Keaton in *The General* (1926). The film received poor
reviews and didn't fare well at the box-office when it was
originally released, but over time has become highly regarded
as one of Keaton's greatest masterpieces.

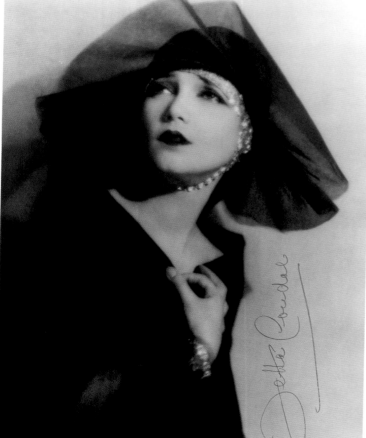

(left) The vampish and exotic Jetta Goudal made her name
during the silent era and was celebrated for her dual role as
wife and gypsy girl in Cecil B. DeMille's *The Road to Yesterday*
(1925). "*I was never attractive, but my hair, my skin, my hands
were beautiful. In that department, I was the tops.*"

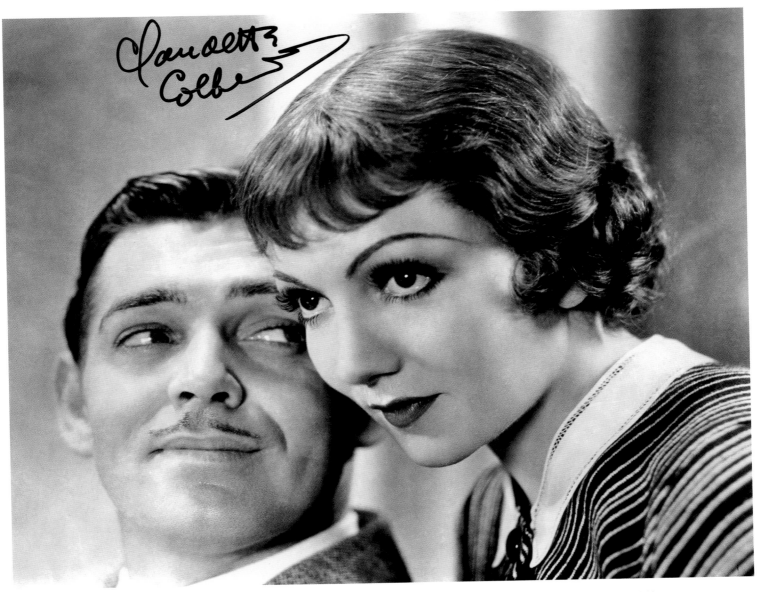

The Look of Love: Clark Gable makes eyes at Claudette Colbert in Frank Capra's *It Happened One Night* (1933).

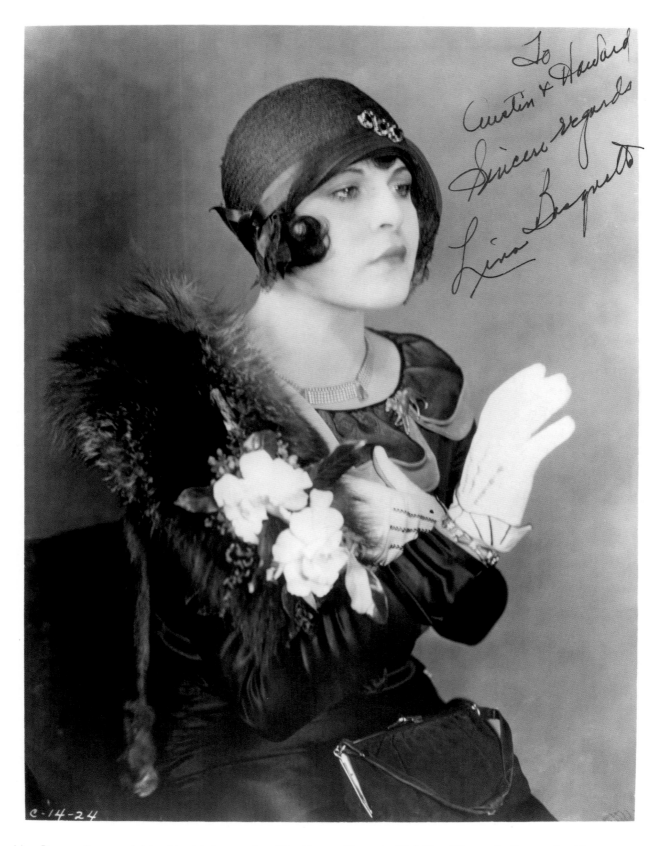

Lina Basquette was dubbed by Hollywood as 'The Screen Tragedy Girl'. The title perfectly matched her own private life: she married nine times (being widowed twice) and was embroiled in bitter legal battle with the Warner brothers – loosing custody of her daughter by late husband Sam Warner. There were suicide attempts, numerous affairs, battles with alcoholism and crashing disappointments with her career. Her number one fan was Adolph Hitler, who was mesmerised upon seeing her performance in Cecil B. DeMille's *The Godless Girl* (1929). In 1937, she was flown to Germany where she met the Führer. "*He had this terrible body odour and these strange penetrating eyes. When he got too fresh, I kicked him in the groin! In retrospect I was lucky to get away alive.*"

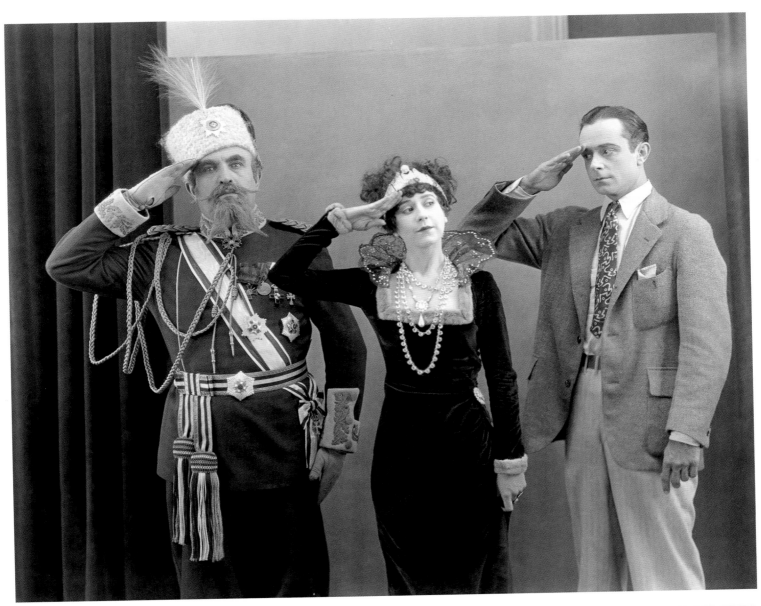

(above) Alberta Vaughn broke into films in 1922, before becoming one of Mack Sennett's most popular leading ladies. She appeared in more than 130 films in just over 10 years. By the mid-1930s, she was riding the range in a series of low-budget Westerns, including *Randy Rides Again* (1934) with John Wayne. During the 1940s, when she resurfaced, it was revealed that she had fallen on hard times – having been jailed twice – and had battled with alcoholism. Here in *The Vanishing Armenian* (1925).

(right) David Rollins, wavy-haired and handsome, was a popular juvenile lead during the early talkie era. He later recalled meeting the film director F.W Murnau on his first day in Hollywood. "*I was invited by a school friend to his home in Beverly Hills. He asked me to drop my trousers, then swim naked in his pool. I thought this was the way one got ahead in Hollywood!*"

Esther Muir: *"Hold me closer! Closer! Closer!"*

Groucho Marx: *"If I hold you any closer I'll be in back of you!"*

Scene from *A Day at the Races* (1937).

Carroll Borland was a forerunner for such ghoulish characters as 'Vampira' and 'Lily Munster'; unlike these TV stars of the 1950s, her career didn't materialise much further than her role as 'Luna' in director Tod Browning's *Mark of the Vampire* (1935). She arrived in Hollywood via the stage, playing a minor role in *Dracula* with Bela Lugosi in the title lead. In 1932, she signed to MGM, where she played a series of minor roles, including in *Pack Up Your Trouble* (1932) with Laurel and Hardy. Her film career declined by the late 1930s, leaving show business for academia. She later taught child development studies at UCLA. She died in 1994. Here with Bela Lugosi in *Mark of the Vampire* (1935).

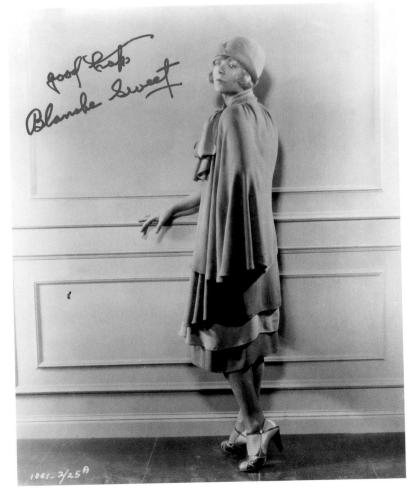

The Pioneer: Blanche Sweet, began her career in the earliest days of film under the direction of D.W. Griffith; most notably in *The Lone Operator* (1911), in which she fearlessly fights off a bevy of evil bandits. Following *Judith of Bethulia* (1913), she and Griffith parted company in favour of Lasky Film Company. By the late-1910s, she had risen to become a contender for Mary Pickford's haloed crown, signing to the newly-formed MGM, where she played the lead in the first film version of *Anna Christie* (1923). Later, she scored box-office success with *Tess of the d'Urbervilles* (1924) and *The Sporting Venus* (1925). With the advent of sound, her career began to wane as audiences looked beyond the silent screen stars for something new. During the 1960s, she could be found as a sales clerk in Bloomingdales, New York. She died in 1986, aged 90.

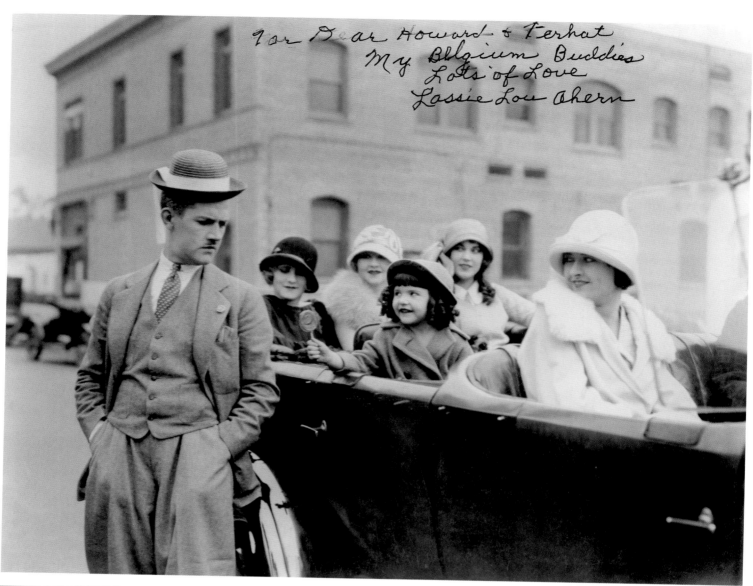

For Dear Howard + Ferhat
My Belgium Buddies
Lots of Love
Lassie Lou Ahern

(above) Saccharine Sweet: Lassie-Lou Ahern (middle) was a popular child star in Hollywood during the early 1920s, who worked under such film directors as Hal Roach, Alfred J. Goulding and Erich Von Stroheim. The 'Lassie-Lou doll' was one of the top five Christmas gifts for girls in 1925. Five years later, the teenager quit Hollywood to pursue her studies. "*Hollywood changed with the advent of sound. The studios were after something different. Big splashy musicals were all the rage. My screen persona was no longer what the public wanted.*" During the 1930s, she toured in vaudeville with her older sister, Peggy.

To my friends,
Dustin + Howard —
Best regards,
"Baby Peggy"
(Diana Serra Cary)
8/1/96

(left) Star Turn: Baby Peggy was one of the giants of the silent screen. In one year alone she received 1.2 million fan letters and was the first child star to have a doll made in her likeness.

102

Taking Turns: Frankie Thomas (front) gives his stunt double the runaround. A blonde juvenile lead of Depression Era America, Thomas secured cult status on TV for his role in *Tom Corbett – Space Cadet* during the early 1950s.

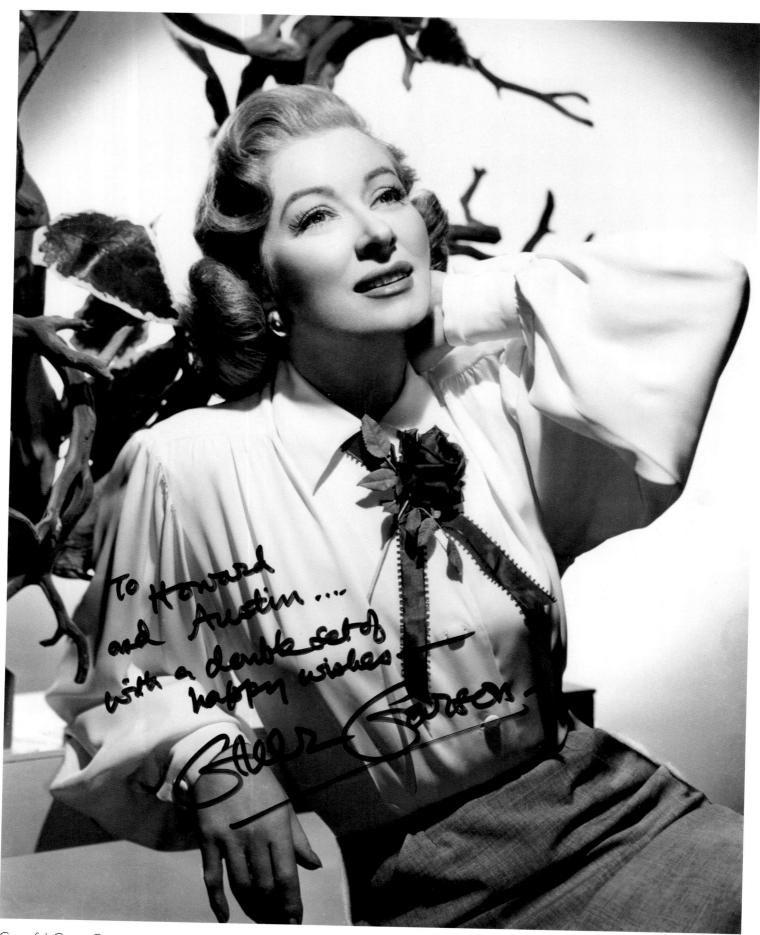

Graceful: Greer Garson was heralded as one of Hollywood's biggest box-office draws during the 1940s, including *Goodbye Mr. Chips* (1939), *Pride and Prejudice* (1940), *Mrs. Miniver* and *Random Harvest* (both 1942).

For star glamour, no one was more important than one's make-up artist: Shirley Temple was undoubtedly the most famous child star of all time and remains one of America's most beloved stars. "*I stopped believing in Santa Claus when I was six. Mother took me to see him at a department store and he asked for my autograph!*" During the Academy Awards 75th programme, it was she who received the loudest applause. Here with make-up artist Karl Herlinger, Jr.

(left) Rocket Romance: Margie Stewart was a popular actress during the 1940s as well as being the only official Poster Girl for the American Army during WWII. In fact, there were more posters printed of her than Hollywood pin-ups Ann Sheridan and Betty Grable combined, with an estimated 94 million circulating between 1943 and 1945. Here with Richard Martin on the set of *Bombardier* (1943).

(below) When Cary Grant walked into a room it was taken for granted that, 'men wanted to be him and women wanted to be with him'. He was also without question the best looking man in uniform. Here with Mildred Shay and Colonel Bill Duncan (right) on the set of *Road to Victory* (1944).

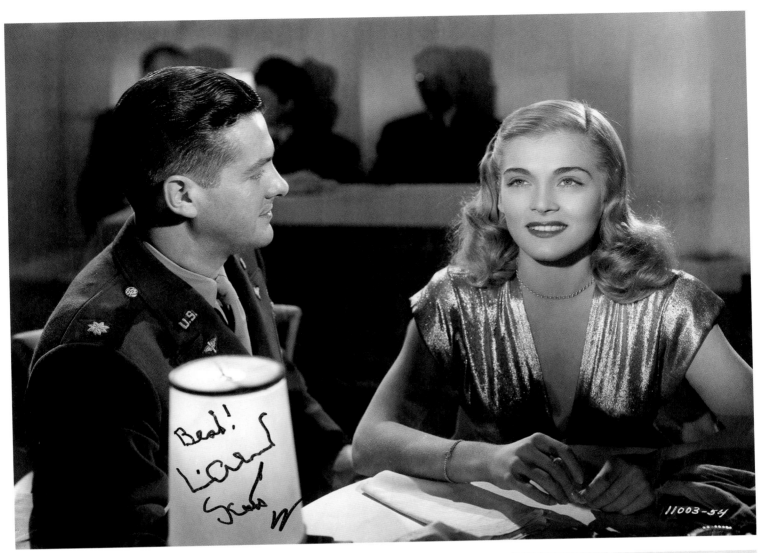

(above) Bright star: Lizabeth Scott was one of Hollywood's most enduring onscreen vamps and unquestionably the most beautiful face of film noir during the 1940s and '50s. An alluring blonde with a husky, come-hither voice, she was tagged, 'The Threat' by Paramount Pictures, under which she had a lucrative film contract. She resembled screen contemporary Lauren Bacall (who was dubbed 'The Look') in persona, voice and stature, even winning a role opposite Bacall's off-screen husband Humphrey Bogart in *Dead Reckoning* (1947). Scott's other leading men included, Kirk Douglas, Burt Lancaster, Richard Widmark and Victor Mature. Here with Robert Cummings in a scene from *You Came Along* (1945).

(right) Thomas Beck, played the juvenile lead in several *Charlie Chan* and *Mr. Moto* films during the 1930s. He came to Hollywood via the New York stage. He made his screen test opposite Katharine Hepburn at 20th-Century-Fox. *"Katharine and I did the screen test and everyone liked it. We got along famously, she was about to do the play, The Philadelphia Story, and wanted me for a role, so I went to the studio and asked if they would let me go to do it. They refused, saying I was needed at the studio right away. I ended up sitting around at the beach for six months before ever working on a film"* Thomas left Hollywood in 1939 after a row with mogul Darryl F. Zanuck who tried to reduce his wages.

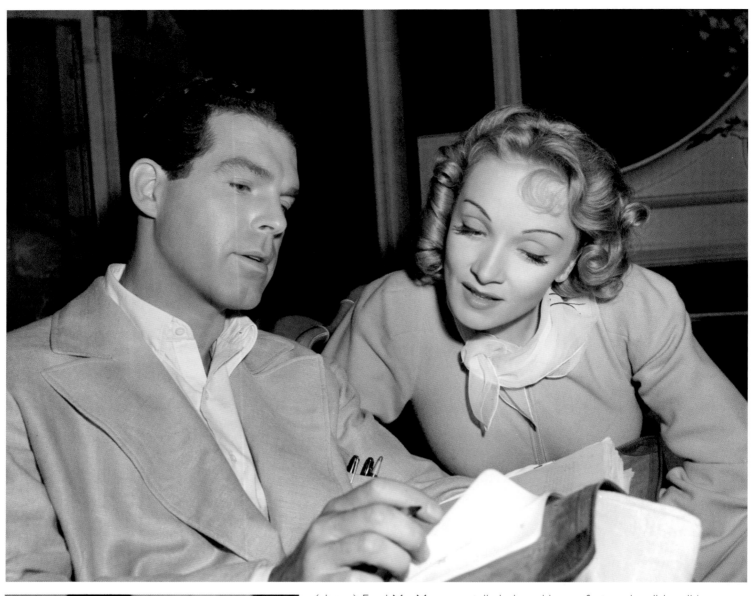

(above) Fred MacMurray – tall, dark and heavy featured – did well in a series screwball comedies, but is best remembered for his role as 'Walter Neff' in *Double Indemnity* (1944) playing opposite a superb Barbara Stanwyck. He later shone as Shirley MacLaine's adulter boss in *The Apartment* (1960). Here with his co-star, Marlene Dietrich, on the set of *The Lady is Willing* (1942).

(left) Mae Madison studies for her role as Ginger Malloy opposite John Wayne in *The Great Stampede* (1932). "*John was a tease. He knew when I got the role in the movie that I had never been anywhere near a horse. When the time eventually came for me to get on the beast, John whacked its rump, causing it to bolt. I went one way and the horse went the other. John thought it hilarious. We became good friends.*"

Say Cheese! Actors June Travis, Rosalind Marquis, Carole Hughes and Frank Prince on the Warner Brothers lot, 1936.

Look of Love: Lona Andre, was signed to Paramount Pictures in 1932, but did little other than look sexy and seductive in a series of publicity photos for fan magazines. Her stint at Paramount was short-lived, and before long she was reduced to bit-parts at minor studios. Here with Cary Grant on the Paramount lot, 1933.

Best to Austin + Howard
Hugh Allan

(above) Front Line Fashion: Maurice Ryan (left), Hugh Allan and Bessie Love are all smiles in director Donald Crisp's *Dress Parade* (1927). Hugh Allan's career in Hollywood was brief, appearing in just over 22 films. Years later, he became a successful businessman as the President of the Dover Elevator Corporation.

To: My friends —
Austin and Howard —
Good luck forever —
Ethlyne Clair

(left) Silent Beauty: Ethlyne Clair, one-time Mrs. Ernest Westmore of the renowned Westmore movie make-up dynasty, starred in a string of comedies, Westerns and serials during the 1920s. She failed her initial voice test for talking pictures, thereby cutting short her career. "*I never stopped missing it though,*" she wrote in 1993.

The Comeback: Gloria Stuart returned to the screen following a 48-year hiatus to play 'Old Rose' in director James Cameron's *Titanic* (1997), winning her a Best Actress Academy Award nomination in the process. Her career dated back to the early 1930s, appearing in *The Old Dark House* (1932), *Secret of the Blue Room* (1933), *The Invisible Man* (1933) and seen here in *Roman Scandals* (1933).

(above) Ice Ice Baby: Tony Martin and Phyllis Brooks take direction from Norman Taurog on the set of *You Can't Have Everything* (1937). Following Cary Grant's divorce from Virginia Cherrill, he and Phyllis were a permanent fixture in Hollywood.

(left) Peggy Cummins had several suitors during her brief sojourn in Hollywood during the mid-1940s, including Cary Grant, Huntington Hartford – heir to the A&P supermarket fortune and budding film mogul – and Howard Hughes.

FH-115

Three's Company: Mary Astor was best known for her role as the treacherous 'Brigid O'Shaughnessy' in *The Maltese Falcon* (1941) opposite Humphrey Bogart as detective 'Sam Spade'. She won an Oscar for *The Great Lie* (1941), the memorable tear-jerker in which she stole every scene from Bette Davis. Pictured here with Davis and George Brent.

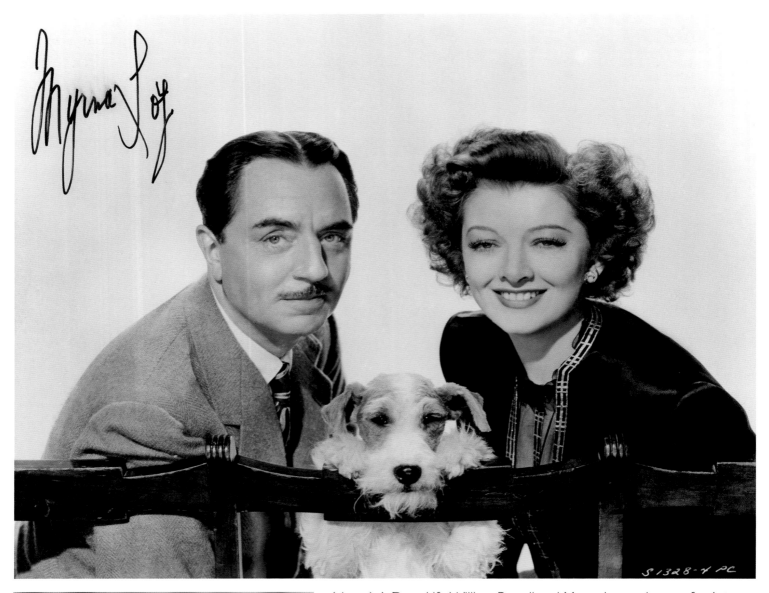

(above) A Dogs Life: William Powell and Myrna Loy make way for Asta, their canine co-star during the popular *Thin Man* film series.

(left) Priscilla Bonner found fame playing opposite comedian Harry Langdon in *The Strong Man* (1926) and Clara Bow in *It* (1927). She retired in 1929 without ever having her voice tested for sound.

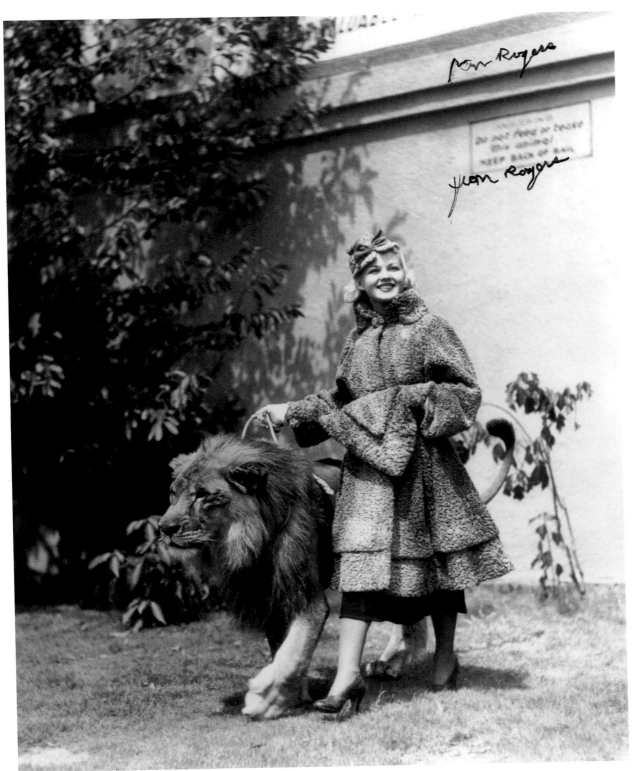

(above) Walkies! Jean Rogers, best remembered for her role as 'Dale Arden' in *Flash Gordon* (1936), takes Leo the MGM lion for a stroll over the Culver City back lot.

(right) The Price of Fame: fees for a signed photo.

TWENTIETH CENTURY-FOX STUDIOS

Beverly Hills, Calif.

Dear Friend:
 Your recent inquiry regarding my photo is sincerely appreciated and I wish it were possible for me to send it. As you can realize, the number of such requests received makes the cost prohibitive, I hope you will not mind helping defray part of the expense.

 Many thanks for your interest and best wishes to you.

 Sincerely,

 Jean Rogers

5X7" Photo.....10¢
8X10" Photo.....25¢
11X14"Photo $1.00
8X10" Tinted.$1.00
11X14"Tinted.$3.00

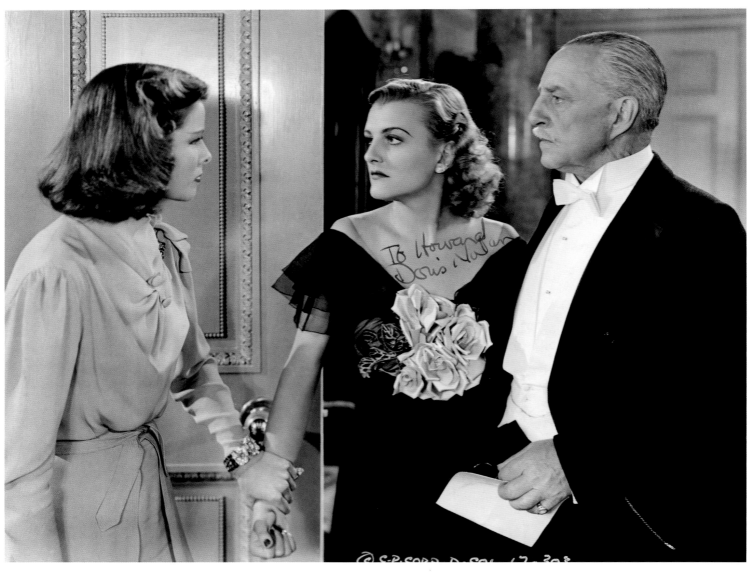

Katharine Houghton Hepburn

III - 18 - 1993

Dear Austin and Howard Mewse -

 Thank you very much - I'm fine

- All exaggerations -

(above) Hands off! Doris Nolan (centre) came to Hollywood via Broadway where she scored good reviews as a supporting player. Her film credits never matched her stage work, though she did shine playing Katharine Hepburn's high society sister in the romantic comedy *Holiday* (1938). Here with Katharine Hepburn and Mitchell Harris in George Cukor's *Holiday.*

(left) Letter from Katharine. Katharine Hepburn was not the classical Hollywood type, instead rather a handsome beauty. Her boyish figure – she was one of the first Hollywood leading ladies to dare wear trousers in public – won her a legion of fans and the wrath of the studios. Her physical presence was distinctive, her voice imitated by a countless number of stand-up comedians. She will no doubt be best remembered for her comedic performances in *Morning Glory* (1933), *Bringing Up Baby* (1938) and *The Philadelphia Story* (1940), as well her dramatic roles in *The African Queen* (1951), *Guess Who's Coming to Dinner* (1967), *The Lion in Winter* (1968) and *On Golden Pond* (1981).

118

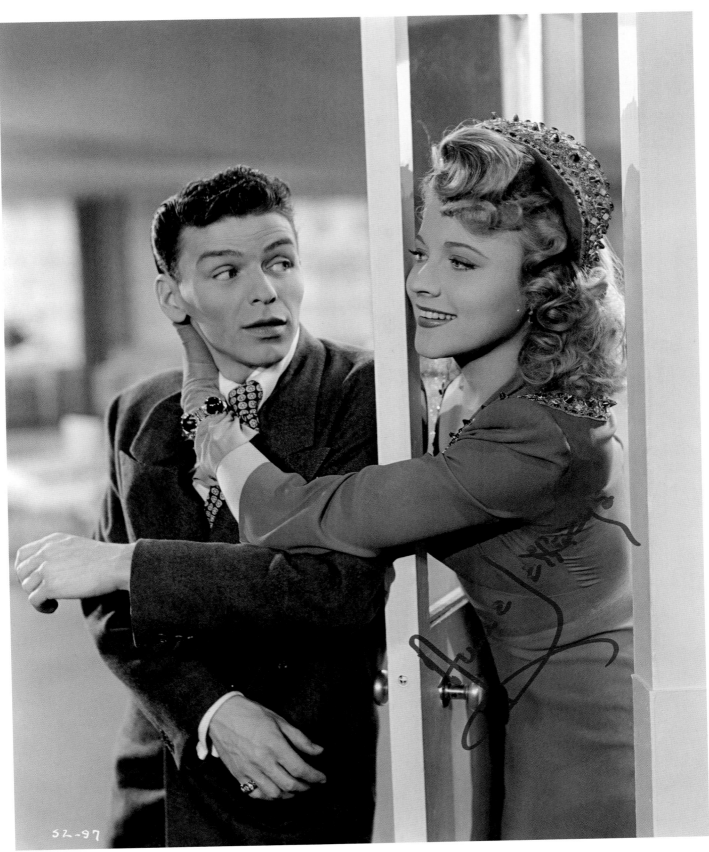

Spirited Anne Jeffreys was a vivacious blonde star of the 1940s and 50s who began her career with the prestigious John Robert Powers modelling agency in New York, before being lured to Broadway. Unfortunately, her magnificent voice was never utilised in Hollywood, though she did shine between film engagements in *Kismet* and *Camelot* on Broadway. Anne was first signed to RKO Pictures, before being loaned out to Monogram for the top-rated crime thriller *Dillinger* (1945) with Lawrence Tierney. During the 1950s, she combined her film work with television, finding lasting success as 'Marion Kerby' – 'the ghostess with the mostest' – in the hit fantasy-comedy series *Topper* with Robert Sterling (whom she married in 1951). Here with Frank Sinatra in *Step Lively* (1944).

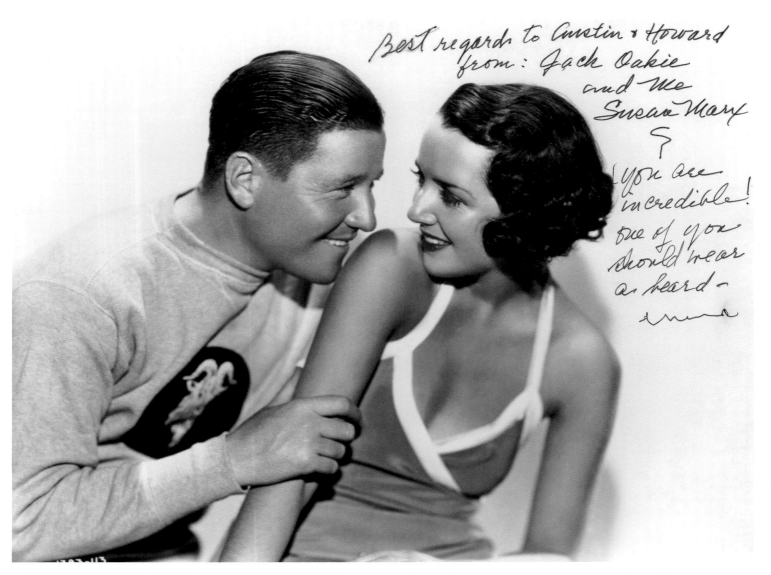

Best regards to Austin + Howard
from: Jack Oakie
and Me
Susan Marx
? (You are
incredible!
one of you
should wear
a beard -
Susan

(above) Susan Fleming retired after just a handful of films to become Mrs. Harpo Marx. She often accompanied him and The Marx Brothers on tour. "*I was my husband's valet. He'd go into a spin if I hadn't cleaned his trademark curly wig!*" Seen here with Jackie Oakie in *Million Dollar Legs* (1932).

To Austin + Howard,
Sincere best to
you both!
Lucille Lund

(left) Ice-blonde, Lucille Lund, won a US nationwide beauty contest and subsequently caught the attention of Universal Studios, who cast her in a series of horrors. Her most memorable was *The Black Cat* (1934) starring Boris Karloff.

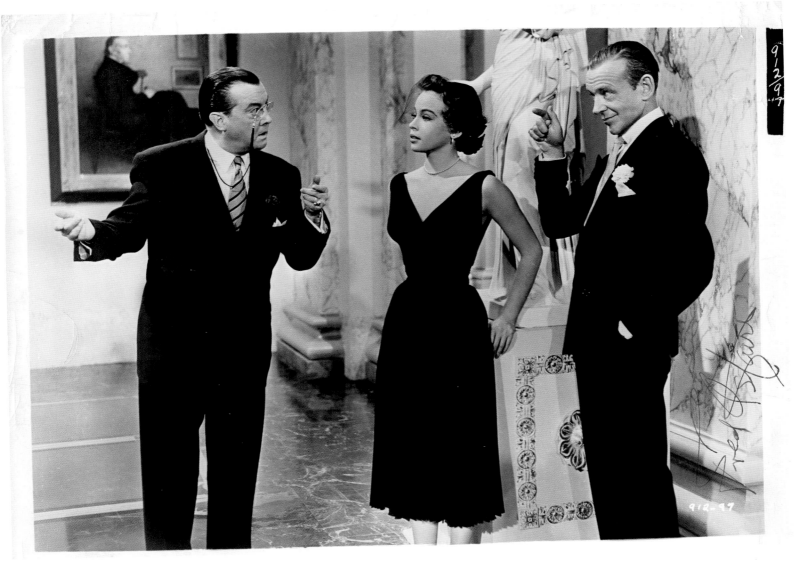

(above) Dance Man: Fred Astaire (right), here with Leslie Caron in *Daddy Long Legs* (1955). The film did well at the box-office, winning favour for its dynamic dance sequences, proving that Astaire – then aged 56 – hadn't lost his touch.

(right) Gene Kelly is to the Hollywood musical what John Wayne is to the Western. An acrobat, a ballerina and showman, Kelly's boundless energy and comic timing made him a favourite of cinema goers throughout the late 1940-50s; none more so than for his starring role in *Singin' in the Rain* (1952). Ranked number one on the American Film Institute's '100 Years of Musicals' list, it was Kelly's directing and performance in the film that defined the notion of the Hollywood musical.

(above) Harold Lloyd with Frances Ramsden on the set of director Preston Sturges' *The Sin of Harold Diddlebock* (1947). The film didn't fare well at the box-office or with critics. *The New York Times* described it as, "*painfully dull*".

(page right) Read It Here First: Burt Lancaster amuses Shelley Winters, while recording a show for NBC in 1955. Years later, Shelley would admit that she only ever loved two men in her life: her first husband Paul Meyer and Burt Lancaster.

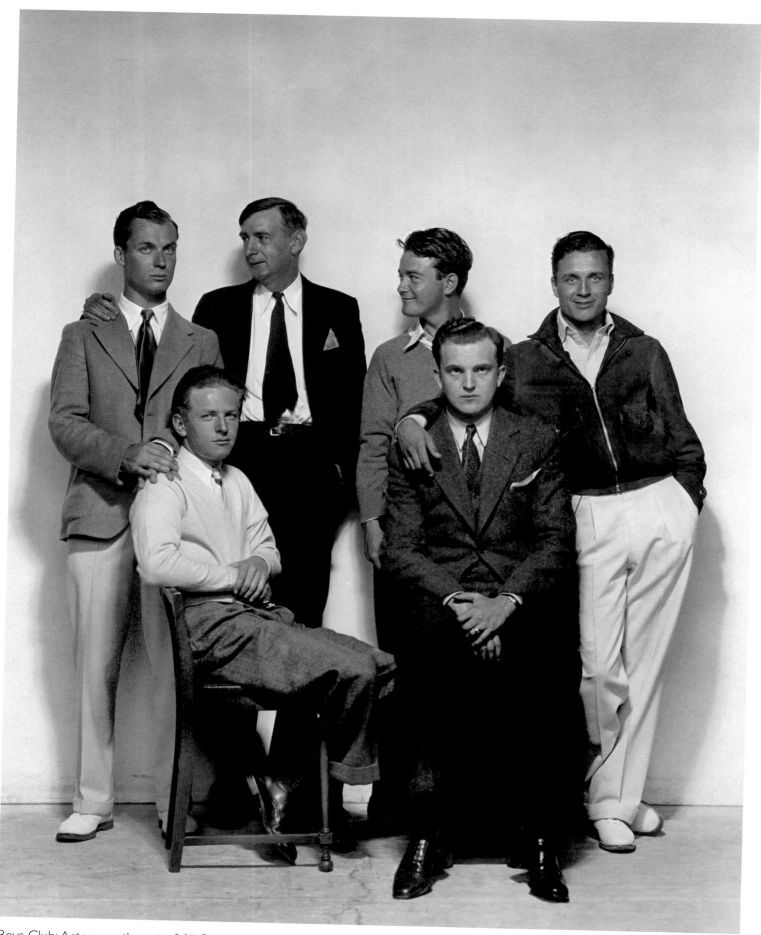

Boys Club: Actors on the set of *All Quiet on the Western Front* (1930) (back row) Russell Gleason, Slim Summerville, Lew Ayres, William Bakewell and (front row) Ben Alexander and Walter Browne Rogers.

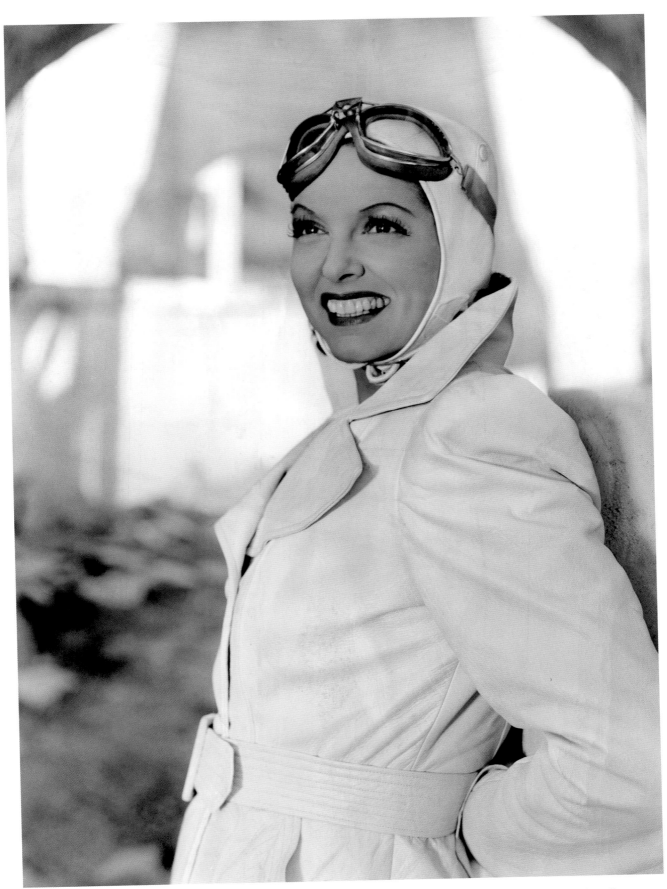

Chocks Away: Gale Sondergaard earned a reputation as an actress of exceeding quality who could easily manipulate or terrorise any number of her co-stars. At the height of her career, she won the first Academy Award given for Best Supporting Actress for her role in *Anthony Adverse* (1936). 10 years later, she became a victim of the McCarthy era witch-hunts in Hollywood – her husband Herbert Biberman was one of the 'Hollywood 10'. She too was blacklisted and her career never really recovered.

(left) The striking blue-eyed blonde June Lang enjoyed a steady career as a B-movie leading lady during the 1930s. It was, however, her marriage to Johnny Roselli that generated the most headlines. Unbeknown to her at the time, Roselli was a major player in the Mob. The union lasted less than two years. Unfortunately, the damage was already done, her association by marriage was the death knell to her career.

(below) Regis Toomey, Natalie Moorhead and William Powell on set for *Shadow of the Law* (1930). Hairstyles have always made headlines, and Nathalie Moorhead's was no exception. Her 'Baby Cyclone' bob worn in George M. Cohen's Broadway production of the same name caused a sensation and was much imitated.

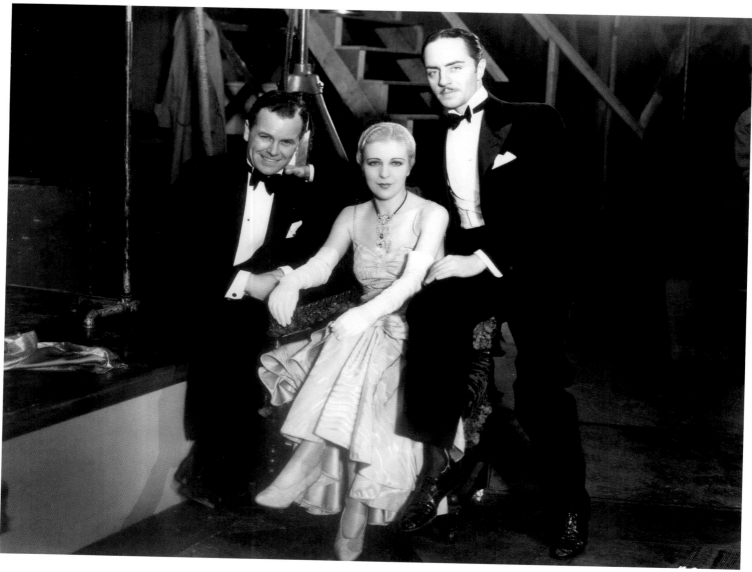

Falling in Love Again: Marlene Dietrich exuded allure, glamour and sexuality as one of the most popular screen icons ever.

Young Love: Peggy Cummins and Robert Arthur on the set of *Green Grass of Wyoming* (1948) for 20th-Century-Fox. A successful actress in her native England, Peggy Cummins was brought out to Hollywood by studio mogul Darryl F. Zanuck, and stayed for three years before moving back to London in 1950.

(right) Breakout: An MGM publicity portrait of Elizabeth Taylor for director Clarence Brown's *National Velvet* (1944). It was a runaway success for the 11-year-old actress and her co-star Mickey Rooney, earning them both the best reviews of their careers thus far.

(below) Studio Pass: Jack La Rue was a handsome hard-nosed film gangster of the 1930s, appearing in over 100 films and several Broadway plays. His off-screen life was, however, more colourful: he married and divorced three times and was frequently at the other end of the law. On one occasion, he was heard to yell to an arresting police officer, *"I'm the gangster you see in movies. I'm a tough guy."*

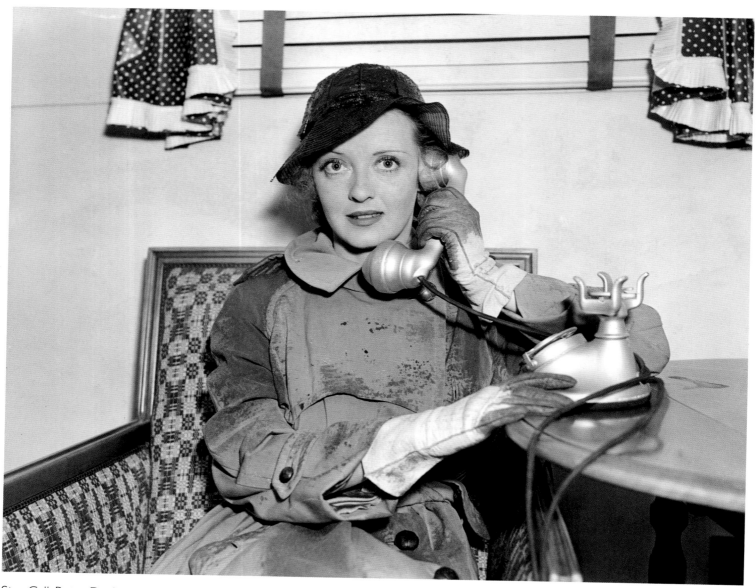

Star Call: Bette Davis on the set of *That Certain Woman* (1937). By the time of the film's release, Bette was already taking action against Warner Bros. for better parts. Simply put, Bette felt the recent string of mediocre film roles provided by the studio was ruining her career; Mogul Jack Warner disagreed. Though Bette lost her case, she still came out on top, since by 1938, she was at her prime, winning an Academy Award for the lead in *Jezebel*.

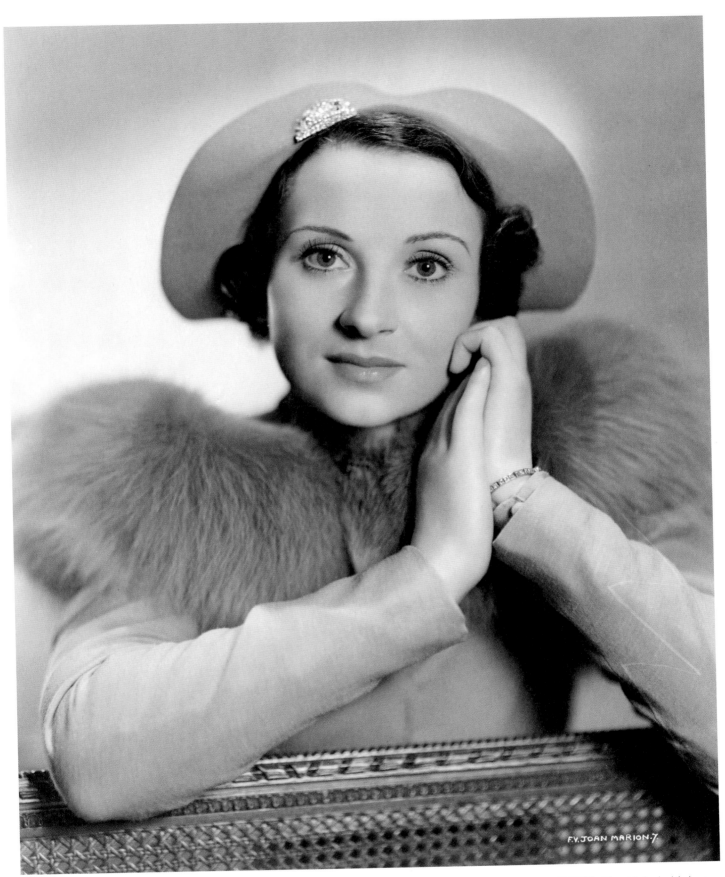

In the Wings: Joan Marion, leading lady of the West End stage, triumphed in *Lord of the Manor* (1933), *The Melody Maker* (1933) and *Tangled Evidence* (1934), filmed at Warner Bros. in Teddington, England. When Bette Davis wouldn't play ball with the studio bosses, Jack Warner sent for Joan as a threat to Davis. The early court settlement between Davis and the studio meant Joan Marion didn't get much further than a Hollywood screen test. "*Frankly, I didn't like him one little bit. He was a horrid little man. I knew by the very fact Jack Warner was to be my boss, that I wouldn't like it. I was scared too, to give up a glittering West End stage career for the unknown in Hollywood.*"

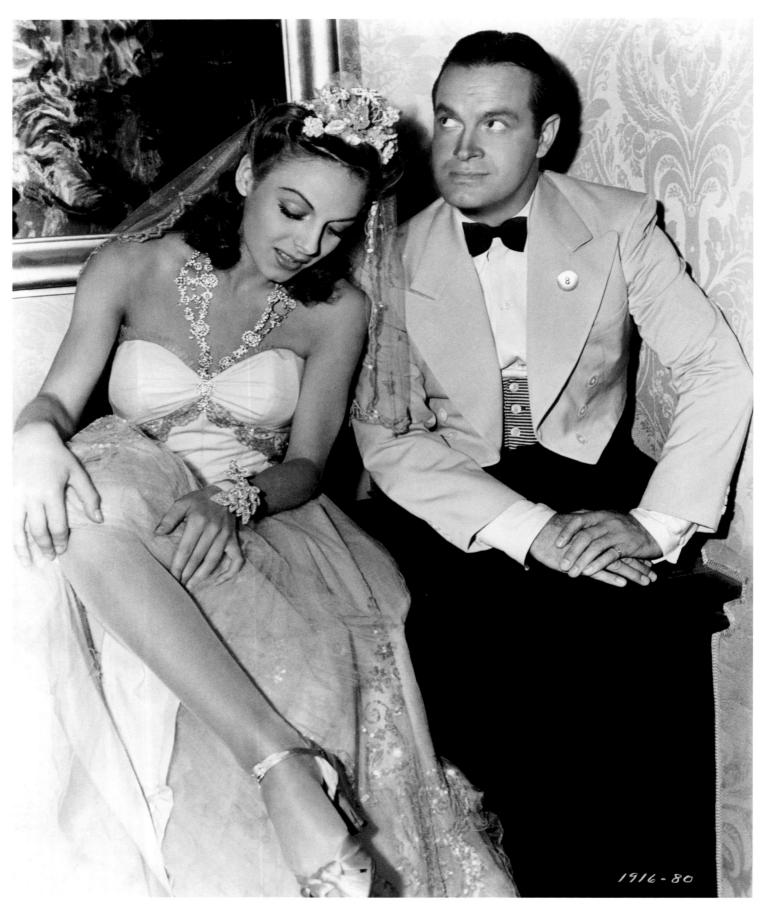

Look Away Now: A woman of many talents, but her critics would argue a master of only one. She was a leading lady, choreographer and artist, though it was her early work in Europe as a ballerina that earned Vera Zorina her best reviews and praise. As a film star it was argued that she was perhaps, "The Worst Actress of all Time". Here with Bob Hope on the set of *Louisiana Purchase* (1941).

(right) June Knight reflects on a career that saw her make a name for herself on Broadway in *Hot Cha!* (1932), before a brief career in Hollywood.

(below) Alice Faye raises eyebrows as she is stripped bare for a Fox Studios photo shoot, 1934.

(above) Wash Out: Lana Turner with Fred MacMurray on set of *The Rains of Ranchipur* (1955), which fared well at the box-office but received mixed reviews from the critics.

(page left) Cut Above The Rest: George Murphy, pictured here in the MGM barber shop in 1934, proved he was more than just a song-and-dance man. With confidence gathered as a leading man in Hollywood during the 1930s and '40s, he sought an active political career. He preceded fellow Republican Ronald Reagan into public office by two years, and served one term in office as Governor of California.

DL-2036

(above) Strike a pose: Dorothy Lovett enjoyed a brief four-year career whilst under contract to RKO Pictures, retiring in 1943.

(page right) Legend: Film stars don't come much bigger than James Stewart. One of cinema's greatest stars, his role as 'George Bailey' in *It's a Wonderful Life* (1946) is a timeless holiday classic.

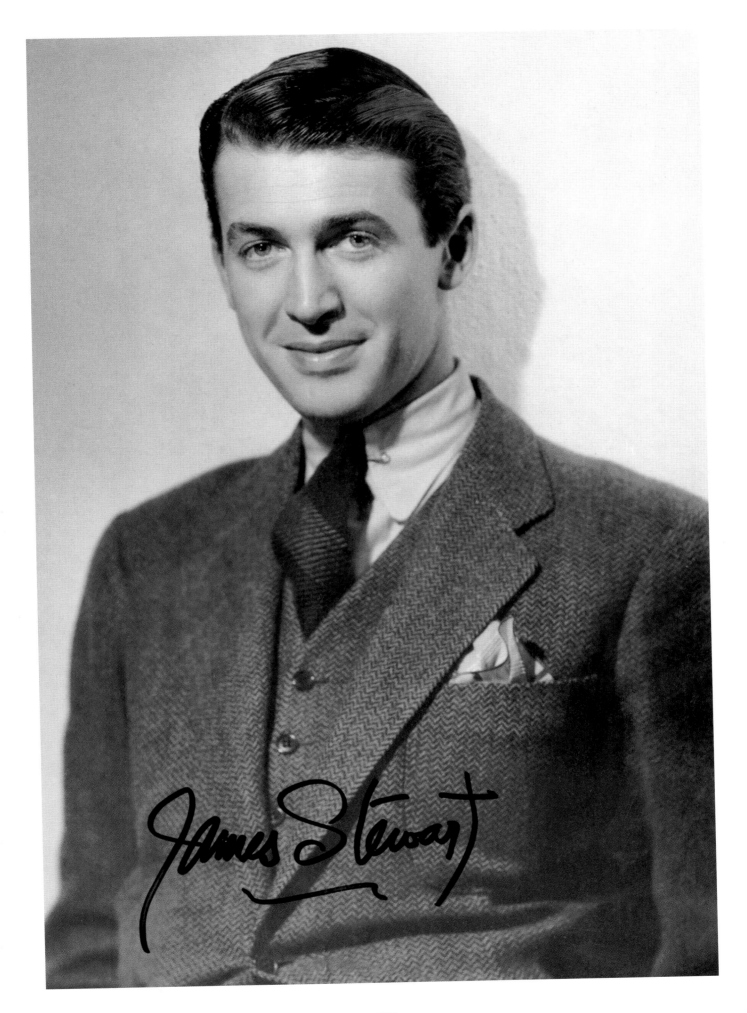

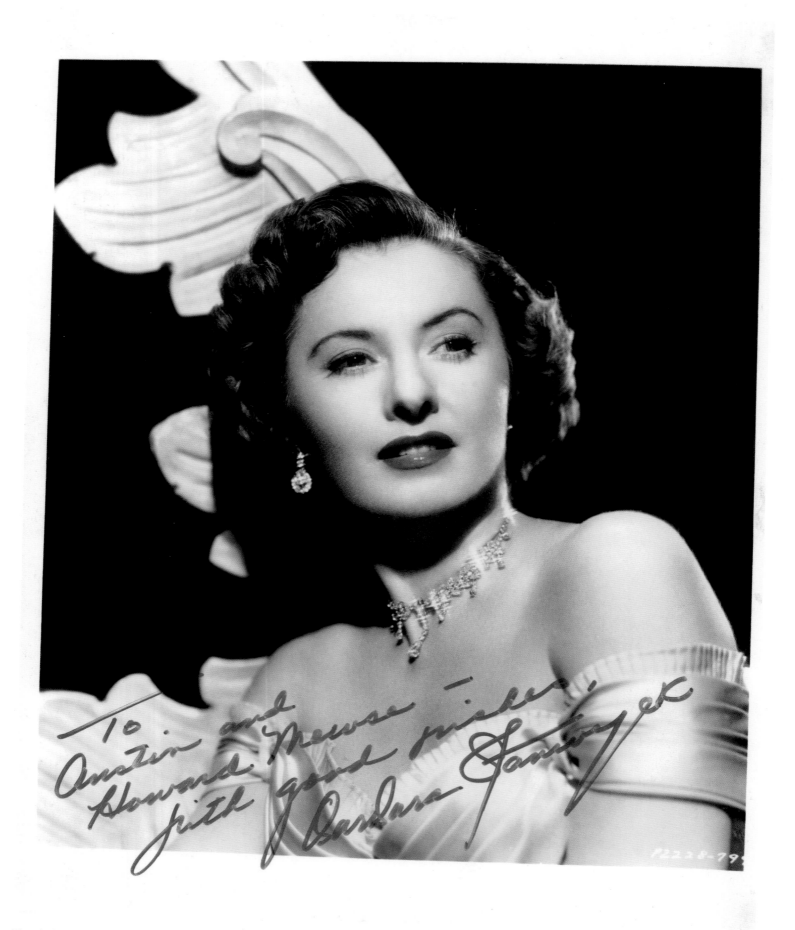

To
Austin and
Howard Meuse —
with good wishes
Barbara Stanwyck

Tough Act: Barbara Stanwyck made a career out of playing hard-boiled broads and lustful vixens. Every leading man in Hollywood agreed they'd met their match playing opposite her.

(above) Leatrice Joy with the cast of *First Love* (1939). Heavily promoted by Cecil B. DeMille during the silent era, Leatrice rose to become one of Hollywood's prominent film actresses. By 1930, her career was in decline; some would suggest due to her thick Southern accent. Her film roles thereafter were few and far between.

(right) B-grade Femme Fatale: Ann Savage starred in a string of second features during the 1940s. Her most famous role was as 'Vera' - the predatory vixen - in Edgar G. Ulmer's critically acclaimed film-noir *Detour* (1945).

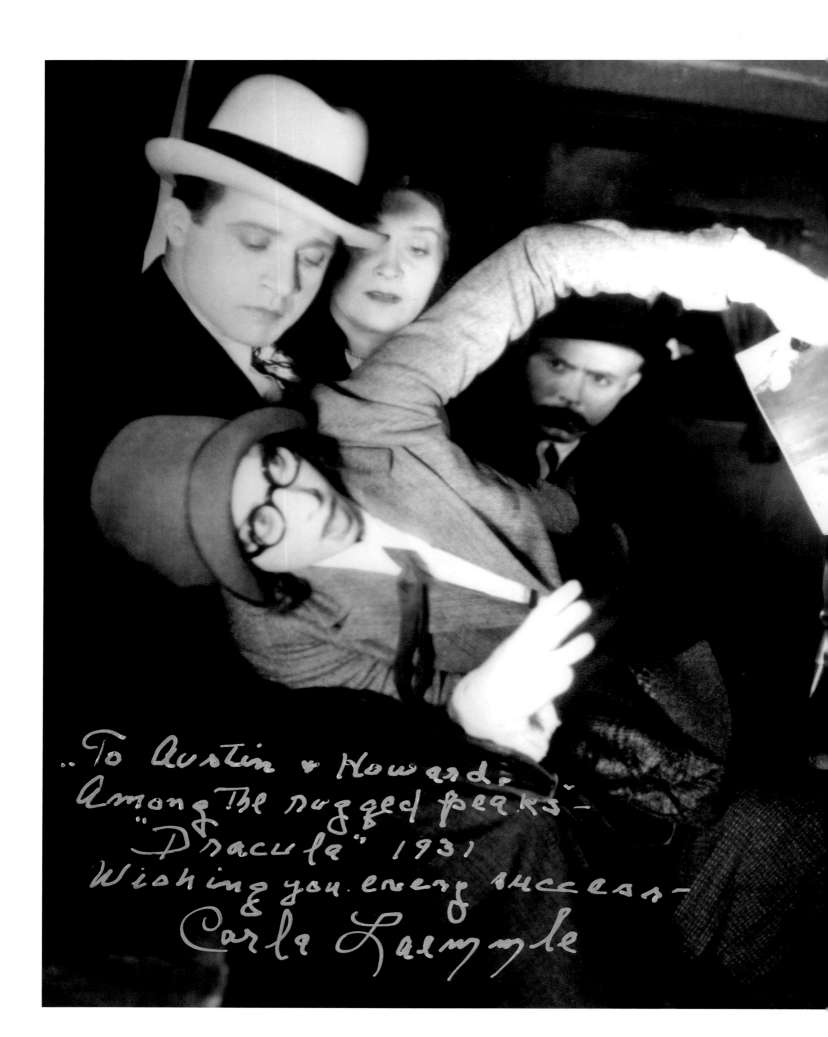

"To Austin & Howard,
Among The rugged peaks -
"Dracula" 1931
Wishing you every success -
Carla Laemmle

(above) Survivor: Arthur Gardner, Hollywood juvenile lead turned film producer, was responsible for reviving the flagging careers of John Wayne, Chuck Connors and Barbara Stanwyck, as well as making stars out of young hopefuls Lee Majors and Burt Reynolds. He began his own career as an actor during the tail-end of the silent screen era at Universal following a successful screen-test opposite Carla Laemmle, the studio mogul's niece. In 1942, Gardner switched instead to a career behind the camera. A decade later he formed Levy-Gardner-Laven with friends Jules Levy and Arnold Laven, producing dozens of TV shows, including *The Rifleman* and *The Big Valley*. Aged 103, Arthur is still visiting his offices on Wilshire Boulevard every week and taking Carla Laemmle on lunch dates.

(left) Steady As She Goes: Carla Laemmle spoke the first line of dialogue in *Dracula* (1931), Hollywood's first 'talking' supernatural thriller, "*Among the rugged peaks that crown down upon the Borgo Pass, are found crumbling castles of a bygone age.*" Already a veteran of silent films – her uncle, Carl Laemmle, built Universal Studios in 1916 – Carla Laemmle's career continued for a further eight decades. Aged 104, she is the oldest working actress in Hollywood, most recently appearing in the Web series *Broken Dreams Blvd*, written and directed by Kevin Jordan.

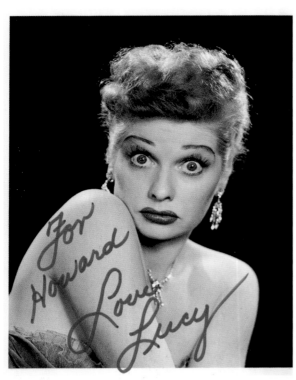

(left): Queen Of Comedy: Lucille Ball began her career as a 'Goldwyn Girl' and went on to become the most internationally famous woman on TV during the 1950s with *I Love Lucy*, which co-starred her real-life husband Desi Arnaz.

(below) Munchkin Love: Margaret Pellegrini pictured with Judy Garland as 'Dorothy Gale' and Billie Burke as 'Glinda the Good Witch', in a scene still from *The Wizard of Oz* (1939). "*Judy was the sweetest kid I ever knew; Billie Burke was not and something of a diva.*"

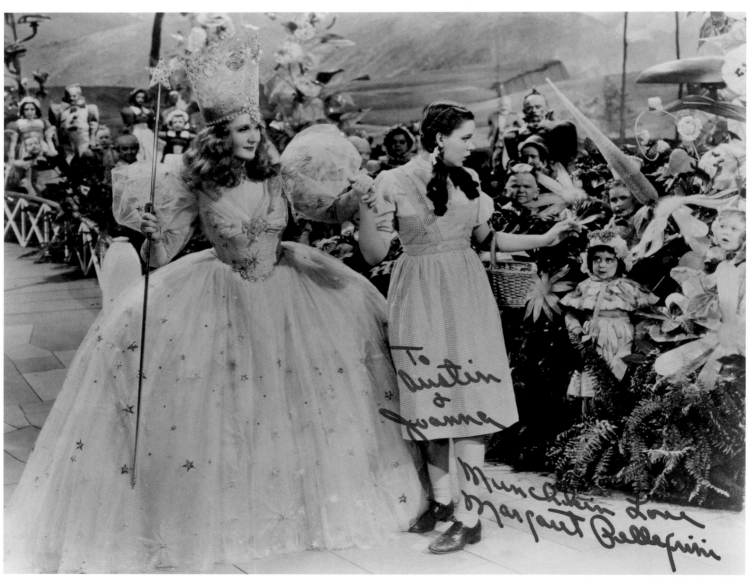

Russian Roulette: Barbara Barondess' life story was far better than any role she played on-screen. She was born on Independence Day, 1907, in Brooklyn; six months later, her parents returned to their native Russia. The family home and everything they owned was confiscated during the revolution, but they managed to escape – her father being shot through the shoulder – back to New York after fleeing across Europe. In 1921, Barbara made her first headlines as the only American citizen to be detained on Ellis Island; it was only because she was born in America that her family was allowed to stay. Later she won a beauty pageant and was crowned 'Miss Greater New York'; her trophy was a screen test. Hollywood beckoned and after a string of minor film roles, she began her second successful career as an interior designer; the Reagans, Greta Garbo and Marilyn Monroe (Barbara acted as the troubled star's big sister) were among her clients. "It's been a strange life", she mused shortly before her death in May 2000. "Some people things happen to. Some people things never happen to."

(above) Space invaders: Constance Moore as 'Lt. Wilma Deering' joins Larry 'Buster' Crabbe (middle) as 'Buck Rogers' in fighting crime 1930s space age-style.

(left) Jean Rogers was the most famous of *Flash Gordon's* girlfriends. As 'Dale Arden' she joined Larry 'Buster' Crabbe on Mars battling against the evil 'Ming the Merciless' during the mid-30s. "*The costumes and the sets were fantastic. There wasn't very much nudity in those days and I have to say my costume was a little brief in the first serial. I don't think the Hayes Office [censorship board] paid much attention to what went on in serials.*"

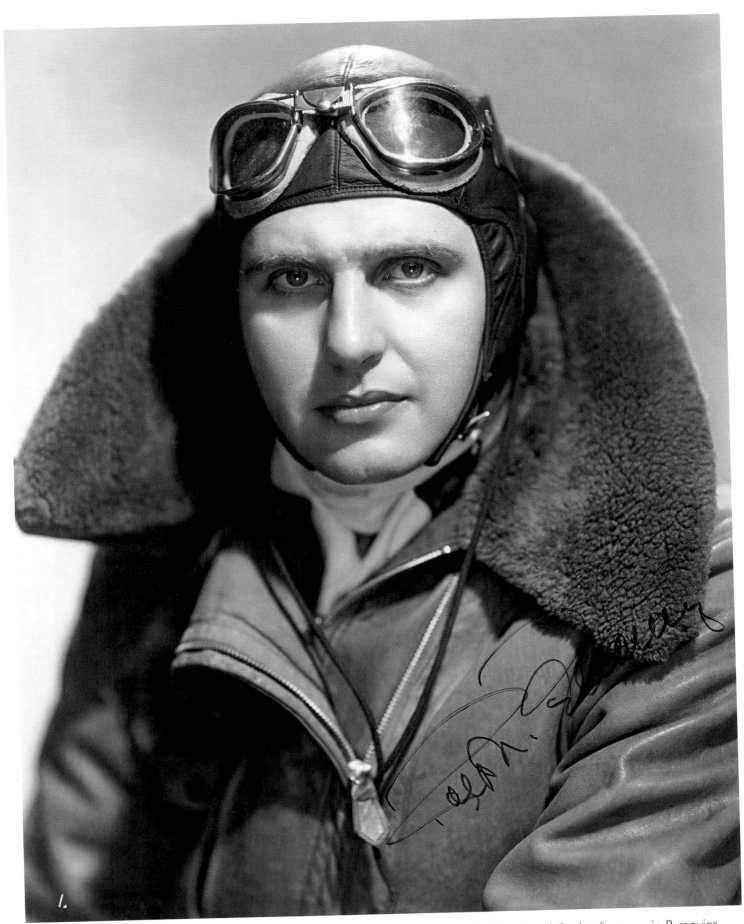

The Reliable: Ralph Bellamy made over 100 films in a career spanning six decades. He played the leading man in B-movies and supporting roles to the likes of Cary Grant. He was a founding member of The Screen Actors' Guild, championing the rights for his fellow actors. Such was his contribution to the industry, he won an Honourary Academy Award in 1987.

A scene from the 20th Century-Fox production
"CHARLIE CHAN AT THE OLYMPICS"
Layne Tom, Jr.

To Austin — Best Regards! (Better Late than Never!) Layne Tom Jr.

(above) Layne Tom Jr. featured in four of the popular *Charlie Chan* films in different guises, but always as one of the famed detective's four sons: as 'Charlie Chan Jr.' in *Charlie Chan at the Olympics* (1936) with Warner Oland; as 'Tommy Chan' in *Charlie Chan in Honolulu* (1938) with Sidney Toler; as 'Willie Chan' in *Charlie Chan Murder Cruise* (1940); and partnered again with Toler as 'No. 4 son' in *The Jade Mask* (1945). He was signed to MGM first, before moving to 20th-Century-Fox. His other screen roles include parts in *The Hurricane* and *The Good Earth* (both 1937). A US Navy veteran, Tom served with the Pacific Theatre during WWII.

Lois Wilson

(left) The Friend: Lois Wilson was considered a favourite amongst film stars and film-goers alike, appearing in over 100 films. Lois did a stint as a primary school teacher before winning a beauty contest in 1915; the prize, a bit-part in *The Dumb Girl of Portici* (1916) starring ballerina Anna Pavlova. She remained in Hollywood for four decades becoming a favourite of directors Cecil B. DeMille and John Ford, and shared the screen with Rudolph Valentino, Conrad Nagel and John Gilbert. She is best remembered for *The Covered Wagon* (1923), *Monsieur Beaucaire* (1924), and as 'Daisy' in *The Great Gatsby* (1926).

(left) Ruth Hall came from the back of the chorus line to appear in a handful of film musicals. Her career was short-lived, retiring in the mid-1940s. Her husband was the cinematographer Lee Garmes. Here with Robert Young as the love interest in Leo McCarey's mad-cap musical comedy *The Kid From Spain* (1932), starring Eddie Cantor.

(below) Charles Bickford is making eyes at Lupita Tovar, in George Medford's jungle adventure film *East of Borneo* (1931). Lupita arrived in Hollywood just as silent films were dying out. She is best remembered for her role as 'Eva' in the Spanish language version of *Drácula* (1931) with Carlos Villarías reprising the Bela Lugosi role. In 1932, she married producer Paul Kohner, who later became a top agent in Hollywood.

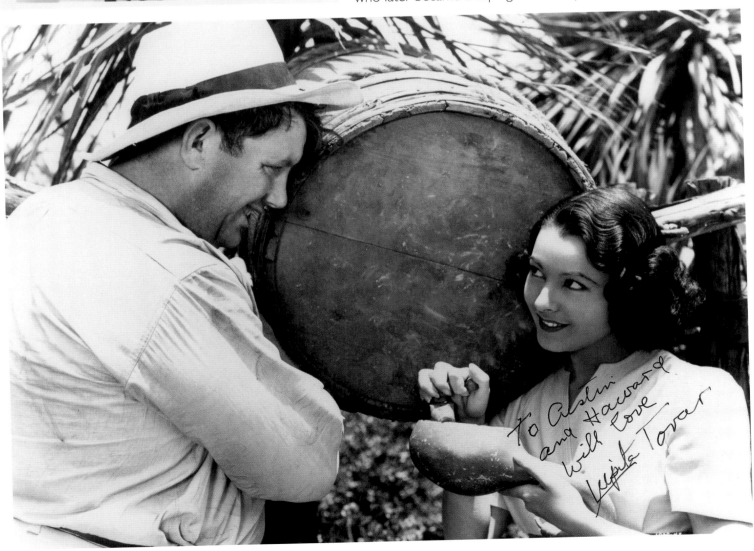

Gilbert Roland

(left) Dashing: Gilbert Roland became Hollywood's best known Latin lover after the death of Rudolph Valentino in 1926. Following the advent of sound, he steadily worked as the debonair playboy (both on and off-screen) to a legion of actresses. Later, as a character actor, he rode the range in numerous Westerns before embarking on a successful career in television.

(below) Good Measure: Kirk Douglas with Jan Sterling – as the scheming reporter 'Chuck Tatum' as and 'Lorraine Minosa' – in Billy Wilder's film noir classic *Ace in the Hole* (1951).

Drop It Now: Jack Palance steps over the dame (Barbara Lang) for a shoot-out in the MGM thriller *House of Numbers* (1957). Palance made his career out of playing gangsters, sinister villains and tough guys. In 1992, four decades after his film debut, he won an Academy Award for Best Supporting Actor for his role in *City Slickers* (1991). Walking on-stage to accept the Oscar, he promptly dropped to the floor and performed a series of one-handed push-ups. Not bad for a guy then aged 73.

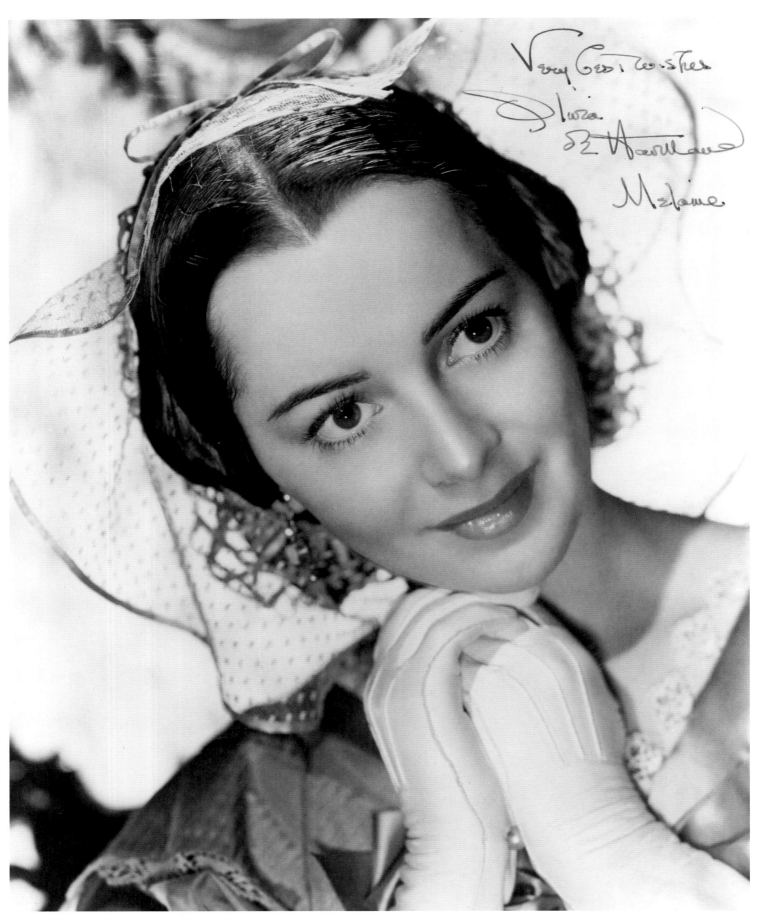

Very best wishes
Olivia
de Havilland
Melanie

Olivia de Havilland will always be associated with her role as 'Melanie' in David O'Selznick's *Gone With the Wind* (1939), which earned her an Academy Award nomination as Best Supporting Actress. "*I had this conviction that* Gone With the Wind *would have an unusually long life as a film, and by golly it has!*"

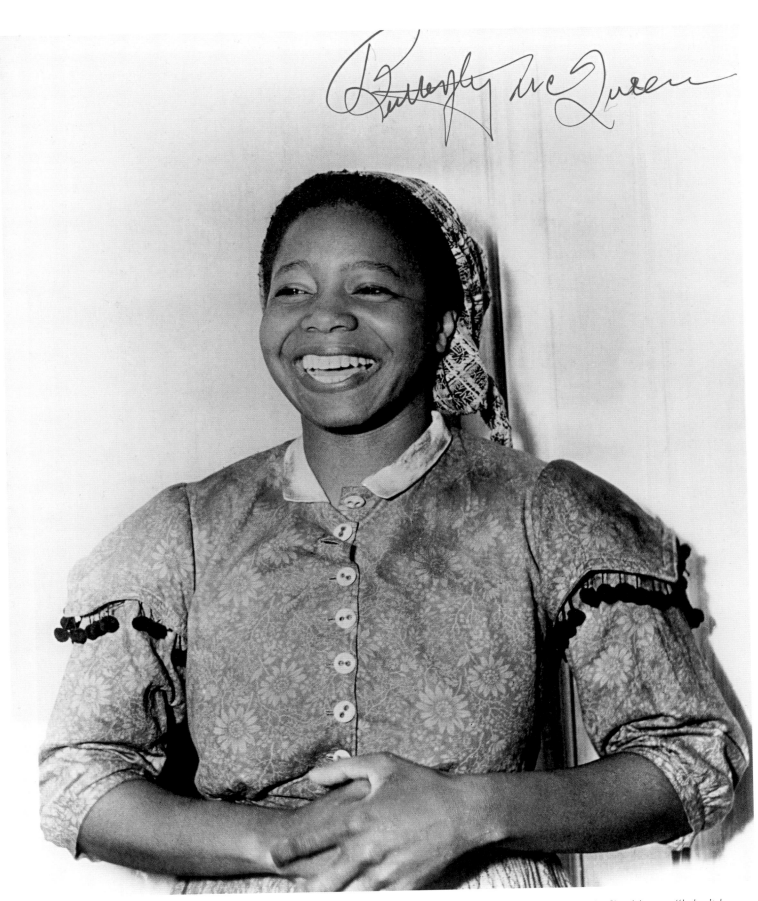

As 'Prissy' in *Gone with the Wind* (1939), Butterfly McQueen spoke one of the most memorable lines in film history, "*I don't know nothin' bout birthin' no babies, Miss Scarlett.*" Her squeaky and high-pitched voice became her trademark, though her career didn't progress how she wanted, always typecast playing the scatterbrained maid. "*I played the same roles over and over and resented it. I didn't mind being funny, but I didn't like being stupid.*" Butterfly could not attend *Gone With the Wind*'s premiere because it was held in a whites-only theatre, but was the guest of honour at the 50th anniversary celebration in 1989.

(above) Hard-Boiled Blonde: Audrey Totter, arguably one of Hollywood's premier 'bad girls' and manipulative man-eaters appeared in a string of film noir thrillers, including *The Postman Always Rings Twice* (1946), *The Lady in the Lake* (1947), *The Unsuspected* (1947), *Alias Nick Beal* (1949), *The Set-Up* (1949) and *Tension* (1949). Here as 'Dr. Ann Lorrison' in the tense crime thriller *High Wall* (1947) co-starring Robert Taylor.

(right) Call Me Irresistible: Ann Savage, a popular starlet at Columbia Studios during the early 1940s, was groomed to look like its biggest star Rita Hayworth, "*But I came out looking more like Ann Sheridan.*"

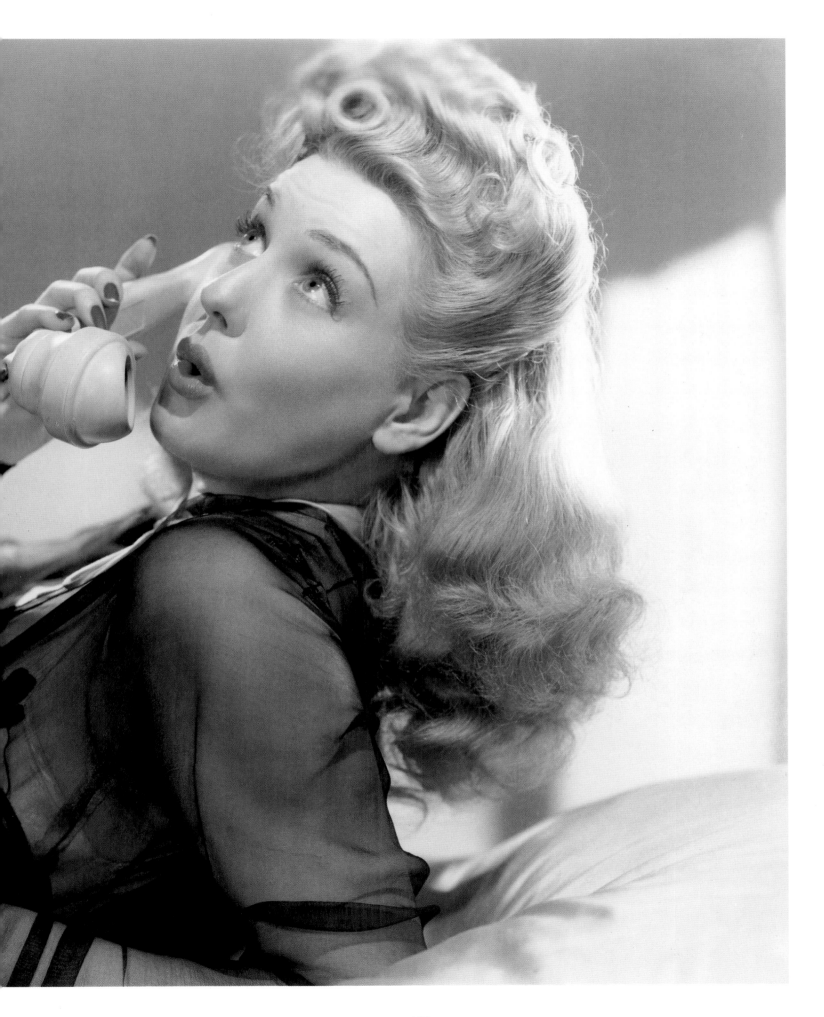

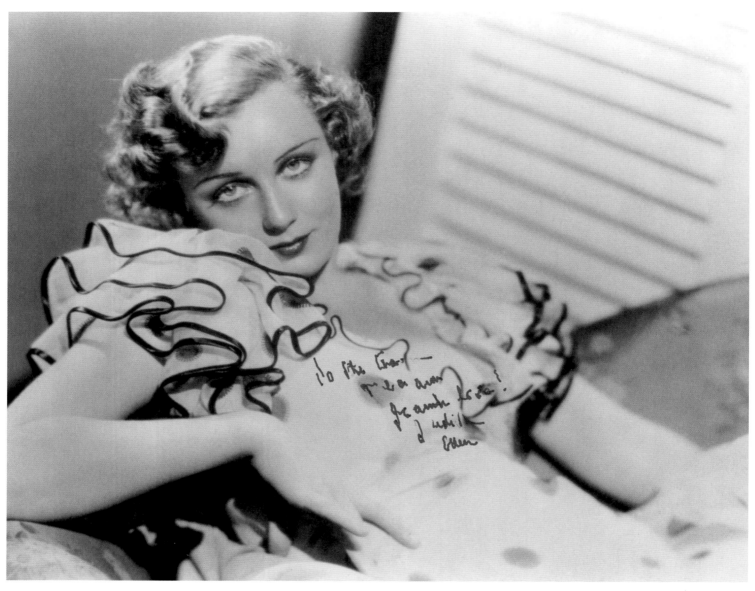

(above) Ruffled: Judith Allen was signed to Paramount in 1933 to star in Cecil B. DeMille's *This Day and Age* (1933). Other prominent roles soon followed, including in *Too Much Harmony* (1933) with Bing Crosby, *The Old Fashioned Way* (1934) as W.C. Fields' daughter, and *Bright Eyes* (1934) with Shirley Temple. Her star status began to wane by the late thirties. Undaunted, she hit the saddle in a series of low-budget Westerns before retiring in 1952.

(right) Wide-Eyed in Hollywood: A fast-talking brassy blonde, Iris Adrian made her name in a countless number of films, mostly comedies, during the 1930s and '40s. Known for her wry sense of humour, during an interview in 1989, she quipped that the only thing she did not like about growing old was that she could no longer attract gangsters.

To Ferkat & Howard, Fondly! Shirley Chambers.

(above) Got Any Change? Shirley Chambers (left) and June Brewster try their luck finding a husband aboard RKO Pictures' romantic comedy *Melody Cruise* (1934). Here with Chick Chandler as the ship's steward 'Hickey'.

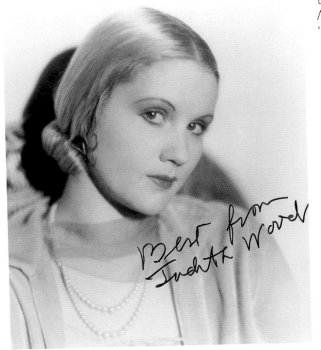

Best from Judith Wood

(left) Look Familiar? Judith Wood began her career under her real name, Helen Johnson, before her early career was cut-short by a serious car accident. Her recovery time gave her the opportunity to reflect on her life, thus deciding to return to Hollywood under a different name and start a-fresh. Initially the name change proved positive – she starred in six films in 1931 – but it didn't last, and by 1936 it was all but over.

To
Austin and Howard
Kind wishes
Gene Raymond

Take Off: Gene Raymond and Dolores del Rio may have received top billing in the 1933 musical, *Flying Down to Rio*, but it was their co-stars Fred Astaire and Ginger Rogers – paired together for the first time – who scored the biggest hit with the fans.

To Howard of
Austin
warmest of blessings

1991

Ginger Rogers was already a veteran of some 20 films before being paired opposite Fred Astaire (pictured here) in *Flying Down to Rio* (1933). She went from mousey-brown to platinum blonde, adding sizzle to her already glamourous Hollywood image.

(above) W.C. Fields with Louise Carter (left) and Joan Marsh (right) in *You're Telling Me!* (1934). Critics have called it one of Fields' best films, showcasing his ability and skill as a physical comedian as well as a verbal one. The film also showed Joan Marsh (who played Fields' daughter) as a promising star, though she never won the roles she deserved.

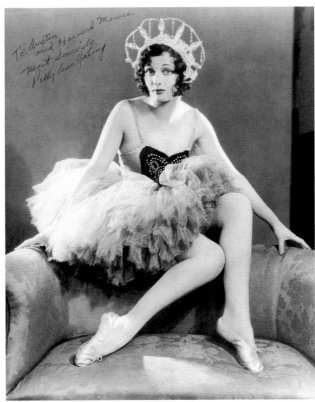

(right): Polly Ann Young, one of five siblings of the more famous Loretta Young, began her career in the silent era . Unlike Loretta, who had the security of a major studio contract, Polly Ann freelanced, appearing in mostly B-grade films during the 1920s and '30s.

Joel McCrea, tall and ruggedly handsome, he enjoyed a successful film career as a leading man, mostly in Westerns. Such was his passion for horses and the sagebrush – he owned and operated his own ranch in Camarillo, California – that he listed his occupation as 'rancher' rather than actor.

(left) Don't Panic! Eddie Bracken, had been an actor since the 1920s, but didn't come into his own until the 1940s, finding his niche playing a series of long-suffering comic heroes. His films include *Caught in the Draft* (1941), *The Miracle of Morgan's Creek* (1944) and *Hail the Conquering Hero* (1944). Eddie was, as *The New York Times* called him, "*the embodiment of the warm, vulnerable young American.*"

(below) Going Nowhere: Rebel Randall was one of many glamour girls of Hollywood during the 1940s and a popular pin-up during WWII, though her career never received as much attention as her publicity pictures. Here with Chick Chandler in *Seven Doors to Death* (1944).

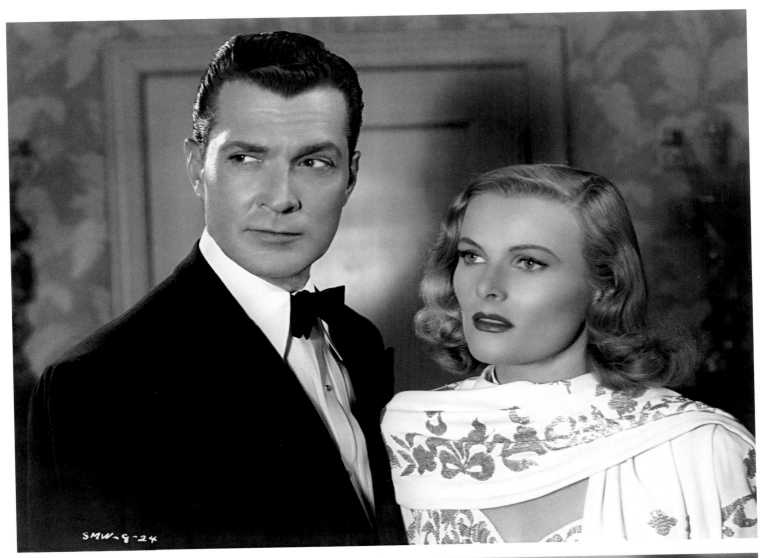

(above) Kent Taylor with Louise Currie were two of Hollywood's popular B-movie stars of the 1940s. Both shared equal amounts of talent and screen presence, yet never achieved the lasting fame of their A-list contemporaries Humphrey Bogart, Robert Mitchum, Lauren Bacall or Veronica Lake. Here together in the film *Second Chance* (1947). Kent Taylor died in 1987. Long retired, Louise died in September 2013, aged 100.

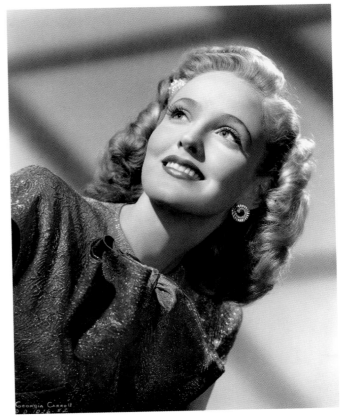

(right) Model Star: Georgia Carroll started out as a fashion model on the covers of *Vogue* and *Cosmopolitan* before Hollywood beckoned with a contract to Warner Bros. Later she became the lead female vocalist for bandleader Kay Kyser, whom she married in 1944.

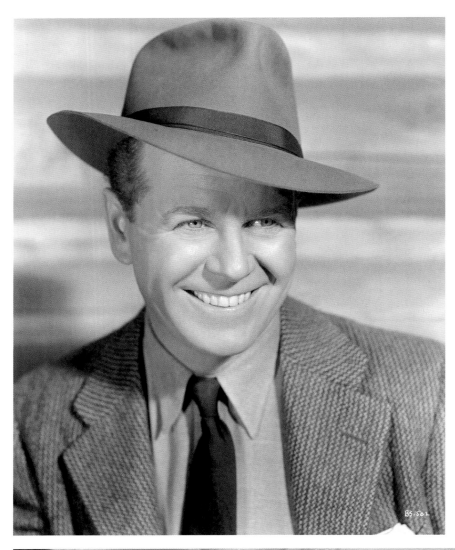

(left) Staying Power: Regis Toomey, held the record for the longest screen kiss of 1941 – 185 seconds – with Jane Wyman, his co-star in *You're in the Army Now*.

(below) Star Rally: Cary Grant may not have seen active service during WWII, but he was hard at work on the national war bonds drive, raising millions of dollars for the US war effort against the Axis powers. Here with Mildred Shay at the Gilmore Stadium, Los Angeles, 1944.

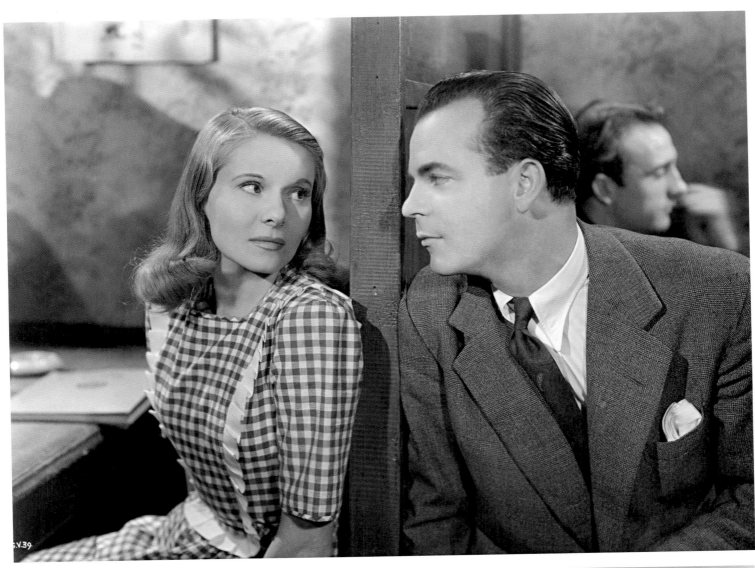

(above) Ann Todd was a pretty blonde actress who graduated from playing the ingénue to become a much-loved leading lady in such films as *The Seventh Veil* (1945), *Perfect Strangers* (1945) and Alfred Hitchcock's *The Paradise Case* (1947), in which she played Gregory Peck's long suffering wife. Columnists quickly compared her to the reclusive Greta Garbo. She then became the first British film star to receive a one million dollar film contract, though reportedly still did her own grocery shopping. "*Hollywood thought I was a very odd actress. I enjoyed it though very much. I'd invite Frank Sinatra for tea.*" Here with Hugh McDermott in *Perfect Strangers* (1945).

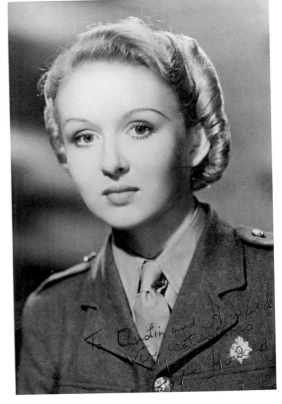

(right) British Invasion: Joyce Howard was a popular leading lady on stage and screen during WWII. She was arguably Britain's answer to Hollywood's film noir femme fatales Lauren Bacall, Lizabeth Scott and Audrey Totter. Her most notable performances were as the lead opposite James Mason in the crime thrillers *Terror House* (1942) and *They Met in the Dark* (1943).

(above) At Ease: Cary Grant gets a visit from Colonel Bill Duncan, at Paramount Studios, 1944. In 1947, Cary was a recipient of the King's Medal for Services in The Cause of Freedom for his service towards the British war effort; he donated his salaries from two films.

(left) Alexis Smith, tall, stately and attractive, she missed the chance to become a big star, even though she took the lead opposite Errol Flynn in *Dive Bomber* (1941) and Cary Grant in *Night & Day* (1946). "*I typed myself – I was the same in everything I did, I knew no better.*" Hollywood dubbed her and husband Craig Stevens as 'Hollywood's Happiest Couple' – their marriage in 1944 lasted until her death in 1993. Her later work included a recurring role in TV's *Dallas*, and as Louisa in *Age of Innocence* (1993), her final film.

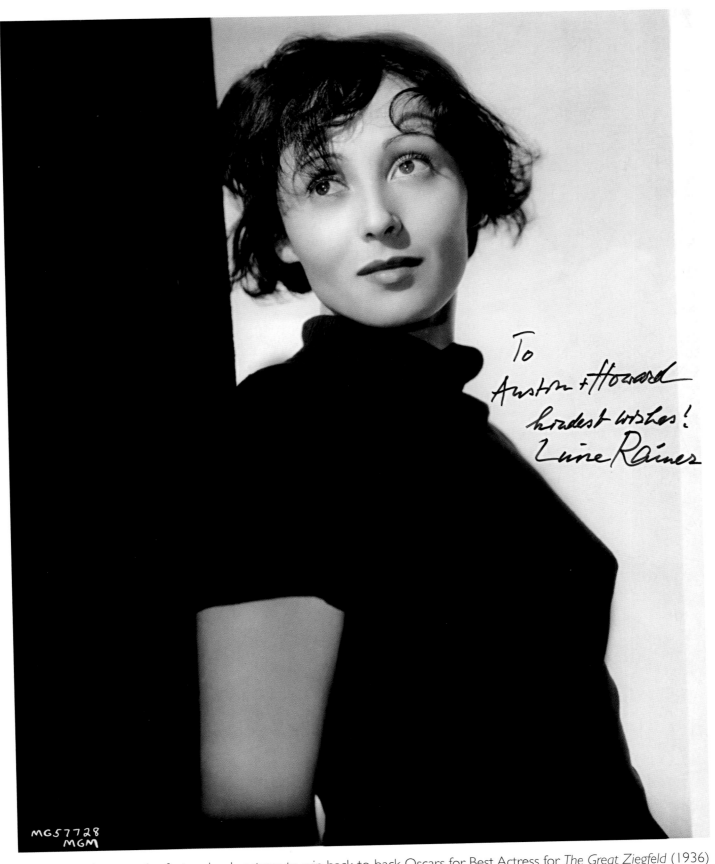

To
Austin + Howard
kindest wishes!
Luise Rainer

MG57728
MGM

Luise Rainer, became the first and only actress to win back-to-back Oscars for Best Actress for *The Great Ziegfeld* (1936) and *The Good Earth* (1937). A surprise for some as, with her thick Austrian accent, the soulful eyed, quivering wide mouthed and repetitively fragile Rainer was something of a misfit. Her tough off-screen persona was at odds with her appearance. When MGM mogul Louis B. Mayer threatened her that if she quit the studio, he'd ruin her, she turned tail and quit anyway, "*He said he made me. I told him, he did not, that God made me. That made him as angry as hell!*" she said. Rainer made two more films away from MGM, married a second time (her first husband was the playwright Clifford Odets) and headed straight for the stage. Today, Luise resides in Belgravia, London.

For Ferhat and Howard —
My best wishes for your happiness !
Rosella
Towne

Peggy Shannon

THE ADVENTURES OF JANE ARDEN ~ A Warner Bros. Picture

(above) First Lady: Rosella Towne, was tall and dark with radiant good looks and starring opposite many of the biggest actors of the 1930s, including Humphrey Bogart and Ronald Reagan. *"When I first met Ronnie [Reagan] it never crossed my mind that one day he would become the President of the United States. He was quite shy back then. Bette Davis would call him, 'Little Ronnie Reagan', we all did. Fate has a strange way of dealing with things."* Here with Peggy Shannon (left) and James Stephenson, in *The Adventures of Jane Arden* (1938).

Best
wishes
to:
Austin
& Howard
from
Ruth Hussey

(left) Second Fiddle: Ruth Hussey, began her career as a fashion commentator on radio before making a career in Hollywood. In 1939, she was signed to MGM, usually playing the second female lead. In 1940, she was nominated for an Academy Award as Best Supporting Actress for her role as 'Elizabeth Imbrie', the cynical magazine photographer, in George Cukor's *The Philadelphia Story* (1940).

Playtime: Risë Stevens was arguably more at home on stage as one of America's leading Mezzo-sopranos with the Metropolitan Opera, than in Hollywood. She performed with the Met for more than 20 years, including 124 performances as *Carmen*. Her most memorable Hollywood musical was MGM's *The Toy Soldier* (1941); pictured here with Nelson Eddy, "*He really could have had an operatic career, but he just made too much money in Hollywood, too soft and too easy.*"

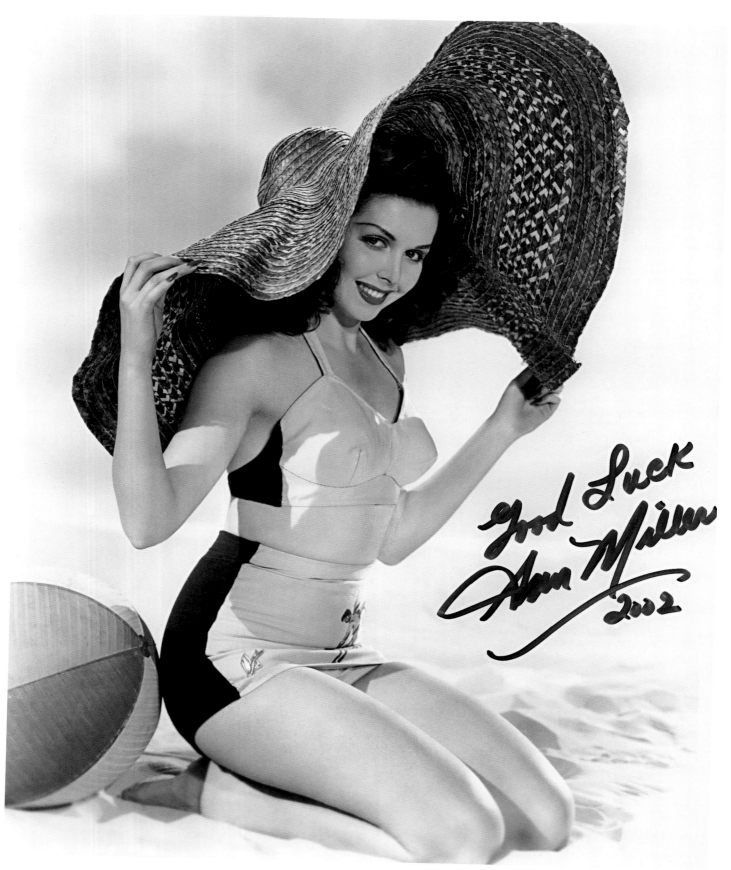

Good Luck
Ann Miller
2002

Ann Miller, a brunette with more oomph than most of Hollywood's silver screen dancers put together. She began her career with a small bit part in *Stage Door* (1937), before joining Columbia playing in a series of supporting roles. Studio mogul Harry Cohn promised Ann much more, but after failing to follow through, she quit in favour of MGM and never looked back. Her most memorable films include *Easter Parade* (1948), *Kiss Me Kate* (1953) and *Hit the Deck* (1955). Away from the big screen, she was a constant figure on Broadway; winning awards and rave reviews playing the lead in *Mame*, then later opposite Mickey Rooney in *Sugar Babes*.

(right) Jane Nigh was discovered in 1944 whilst working in a factory, before 20th-Century-Fox studios gave her a contract and transformed her into a pretty blonde. She found her niche playing in film musicals, including *State Fair* (1945) and *Give My Regards to Broadway* (1948), before being released from contract. Undaunted, she signed to Monogram where she rode the range with Tim Holt in *Border Treasure* (1950) and Rod Cameron in *Fort Osage* (1950).

(below) Felix Knight, is best remembered for his role as 'Tom-Tom' in Hal Roach's *Babes in Toyland* (1934) with Laurel and Hardy. An accomplished singer, he signed to Warner Bros. in 1935. His films include *Carnival Day* (1936), *Pick a Star* (1937) and *Bohemian Girl* (1937), again with Laurel and Hardy. Here with Charlotte Henry on the set of *Babes in Toyland* (1934).

(above) Pola Negri and the director Ernest Lubitch were an impressive team. She, the jet-black haired and alabaster skinned Polish beauty; he a German-born son of a tailor. When she arrived in Hollywood, the publicity men dreamt up a bitter rivalry between her and Gloria Swanson. When Gloria stepped out with painted finger nails, Pola went a step further, painted her toe-nails and walked down Hollywood Boulevard wearing tiger skins with a cheetah on a leash. Film fans couldn't get enough of her; she was engaged to Charlie Chaplin, then seduced the ultimate Latin Lover, Rudolph Valentino. When he died in 1926, Pola took her own share of the headlines. She maintained they were engaged to be married and wore $3,000 worth of widow's weeds at his funeral. She found it hard to maintain her star status following her early film triumphs of The Spanish Dancer (1923), Forbidden Paradise (1924) and A Woman of the World (1925). Her thick accent failed to record well for sound, so she returned to Europe. In 1941, she returned to America penniless to try and pick up where she had left off, but she was from another age and audiences had moved on from the silent screen vamp. There were a couple more films, including Walt Disney's The Moon-Spinners (1964), and subsequent offers (Steven Spielberg tried her for a role in The Sugarland Express (1974). She lived her final days in San Antonio, Texas, where at the time of her final illness she informed a young medic at a local hospital who had failed to recognise her, "I was the greatest of them all!" Here with Adolphe Menjou in Hi Diddle Diddle (1943).

(page left) George Raft shows off his sales technique to Joyce Compton, here as the 'Curly Blonde Shopper' in You and Me (1938). Joyce was nothing if not durable: she was still playing chorus girls well into her 30s.

I'm Still Big

IT'S THE ROOMS THAT GOT SMALL

Muriel Evans was under contract to MGM where the slogan ran: *"More Stars Than There Are in the Heavens"*.

I park the hire car by the entrance shield from the winding Mulholland Drive behind a wall of shrubbery. We've driven for what seem days from Palm Springs to Woodland Hills – I look at my watch, it is still early, just after 10am. Howard has flowers for Rose Hobart. I look at the bunch on his lap wrapped in pink tissue and cellophane; I know they'll have wilted by the time we reach her.

I get out the car first stretching my legs as I walk up and down the tarmac. Howard all but leaps from the passenger seat, looking at his watch now as he heads straight for our 10.15am appointment with Rose. I am three paces behind. I stop and look to my right, reading the words 'The Motion Picture & Television Country House & Hospital' in large gold letters, the morning sun making each shine. This is where Rose has been living since the 1980s, a retirement home for old Hollywood movie stars; the glaring gold letters seem very appropriate.

Two giant smoked-glass automatic doors part slowly, the rush of cold air from the air conditioning welcomes us into the lobby. An elderly gentleman in a Stetson is sitting directly in the doorway. He has white stubble and longish hair in a short ponytail. He is in a wheelchair, both his legs amputated from below the knee. He greets us by lifting his Stetson. "Howdie there," he says. "Hello" we reply. "Hey fellas, can I bum a fag off one of you two nice boys?" I reach into my pocket for my packet and hand the old guy a cigarette. "Much obliged to you, sir. Much obliged. The name's Bob."

I reach for a lighter and bending down, light his cigarette. As he exhales, a small cloud of smoke surrounds my face. "What you guys doing here, visiting your mama?" he asks looking at the flowers. "Oh no. We are here to see Rose Hobart," replies Howard. "Oh boy, she's a Communist!" he barks. "She's as red as they come."

Before he can muster more, Howard informs Bob that we hope to also visit with Fayard Nicholas. "Hmm. The little black dancer. Nice guy. Real nice. Who else you know?" he asks. Howard tells Bob who else we have corresponded with "We've been writing to old stars since childhood. We write to Muriel Evans, Regis Toomey and Anita Garvin and..."

Bob butts in, "Now you are talking. Muriel was so beautiful – once. They all were…" his voice drifts off. "It's all over now…" And then comes back again and smiles with a "The name's Bob," repeating himself. Howard and I take it in turns to shake his hand. "Rose is

okay, really," he says more calmly and then looking around him. "There are other bastards in here a lot worse than Rose. You ever meet Mae Clarke? You'd know her? She's dead now. Mae Clarke was the bitch who got the grapefruit shoved in her face by Jimmy Cagney in *The Public Enemy*. I'd have liked to sock her right in the goddam smacker! Thought she ran the place, she did. Hell, did you say you knew her?" he asks and before we have time to answer carries on "Well she was a bitch and that's it." Bob takes a hard drag of his cigarette.

"Who else you know here?" he asks again. Howard laughs and out of Bob's ear-shot says to me "Blimey, it's like we are being initiated!" He tells Bob a bit more about our letter writing and a couple of the films we like. He jokes that whilst our friends at school were watching *The Terminator*, we were watching Harold Lloyd movies. "But we'd watch current films too," Howard tells Bob. "You have to join in, don't you."

"Wouldn't know, kid," says Bob. "Been my own man. Had me a horse and some land out in the desert. Had me two wives, both bitches, and now I'm here and I'm lucky apart from can't chase no skirt anymore." He points to where his limbs once were. "Who else you know, boys?"

Howard tells Bob about replies to our letters from Viola Dana, Mary Astor, Ruth Clifford and Laura La Plante. "Laura La Plante!" he shouts, almost choking and repeats as if reminded of an old friend. "I knew Laura La Plante when she was at Universal Pictures. I worked with her. She was so pretty, so cute and really a good actress, the best. And funny, she was funny. You see her in *Butterfly*? Well, it is a silent film and Laura La Plante is the star with the other woman you just said you knew." "Ruth Clifford," says Howard.

Bob didn't hear. "You know her. She is cute as hell and is in *Butterfly*. You said her name, not Viola, the other one." Howard shouts louder, "Ruth Clifford." "You got it! Yep, that's the dame. Ruth Clifford. She goes by Ruth Cornelius now." Bob winks. "So ya do know *Butterfly*, then. Yeah, Ruth Clifford. Funny they should both end up here. Ah, but Laura La Plante. She's gone silent just like her pictures. She's in the hospital here and a mute most the time. Just like the films she starred in."

Bob drifts off again and then tells us of people he's known in the Home. "You know The Three Stooges were here? Well, one of them at least and Virginia Bruce? Well, she was here too. She's dead now, some ten years or more I guess. And then there was that fat female

comic, Babe London. Only when she got here she was thin and nobody recognised her as Babe London no more. The Negro fella was here, played butlers and chauffeurs in pictures. Shit, by the time he came here he couldn't lift a goddam tea cup. Stepin Fetchit, his name." Bob drops his finished cigarette to the floor. "He was a gentleman. Hmm, let me think, who else? Ah, well," he says, rising up higher in his wheelchair, "Miss Norma Shearer was in here. Now, she was real class!"

We knew about Norma Shearer living her final days out at the Home. "Oh boy she went gaga, insane. She'd sit near to where I am now and ask passersby if they were her dead husband Irving Thalberg. You heard of Irving Thalberg?" We nod. "Anyways, Norma Shearer was a real fruitcake with this long white hair and thick glasses. She'd gone blind and was as deaf as a post too and wore mostly her nightclothes. It's sad, what a way for Norma Shearer to finish up – from film star to fruitcake." He laughs.

Howard takes a few steps forward leaving me to bid farewell to Bob. He stops me for another cigarette and tucks it behind his ear. "Hey fella, you were pissed over what I said about Rose being a Commie. Sorry." "Okay Bob, I appreciate it." I'm happy he'd noticed. "Always has a big mouth. Gotten me into big trouble." He removes his hat and fingers the rim. "Tell Rose Hobart 'Bob says Hello'. I like Rose." He holds out his hand and I shake it. "Good grip you got there boy," he says. "Now run inside. Don't keep Miss Rose waiting. She's hot on good manners," he laughs, "but hell, sure she still likes 'em rough too." He gives me a salute. I walk away and say to myself "I like Bob".

Inside, Howard has asked a receptionist at the desk if he knows where we'd find 'Miss Rose Hobart'. We wait as the young Filipino man in a white nurse's uniform looks at an activities chart. "She knows you're coming?" he asks. "You meant to be here?" Howard holds the roses aloft and I nod. He looks us both up and down. "I'll phone her room," he says still giving us both the once over.

We turn away, our backs now towards the desk to face a reception area. Pink upholstered chairs and round occasional tables are dotted about the large expanse. There's a large sofa with a couple in their sixties sitting on it. He notices me and smiles, she – in giant spectacles – doesn't. I look the other way, people milling about the place, some in uniforms. My eye catches a writing desk with a telephone on it and a letter rack with neat rows of paper, envelopes and a pot of biros. I wonder if that's where the stars sit to reply to fan mail. Alongside are

Eva Novak (right) here with her sister Jane, shared the screen with cowboy stars Tom Mix and William S. Hart in dozens of Westerns in the 1920s. She became a resident in the late 1980s. Jane won recognition as Harold Lloyd's first leading lady.

two wing-back chairs, their inhabitants two elderly women both wearing hats. I watch them as they chat to one-another and take it in turns to stare over. I smile, suddenly my eyes widen, my jaw drops as I recognise the larger of the two as Yvonne De Carlo. She smiles and gives me a little wave. I wave back. How I loved watching her in *The Munsters*.

My gaze is broken by a woman in a wheelchair criss-crossing and passing right infront of Yvonne De Carlo and now heading straight towards us. Probably in her late 80s, I watch as she speeds across the tiled floor. Her face is China-white, framed by a mean-looking bob, her lips sparkling scarlet and, as she almost squashes my toes bare in flip-flops under her wheels, I notice her wide green saucer-like eyes. I jump back, "Way-hey there!" She comes to a dramatic halt.

"You look lost fellas?" she asks fiddling with switches on her arm-rest like she is Davos the Dalek in *Doctor Who*,

(right) Anita Garvin's career spanned from silents into the sound era, retiring in the early 1940s. She is best remembered for her roles opposite comedians Charley Chase and Laurel and Hardy.

(below) Anita Garvin with Laurel and Hardy, as 'Mrs. Culpepper' in *From Soup to Nuts* (1929).

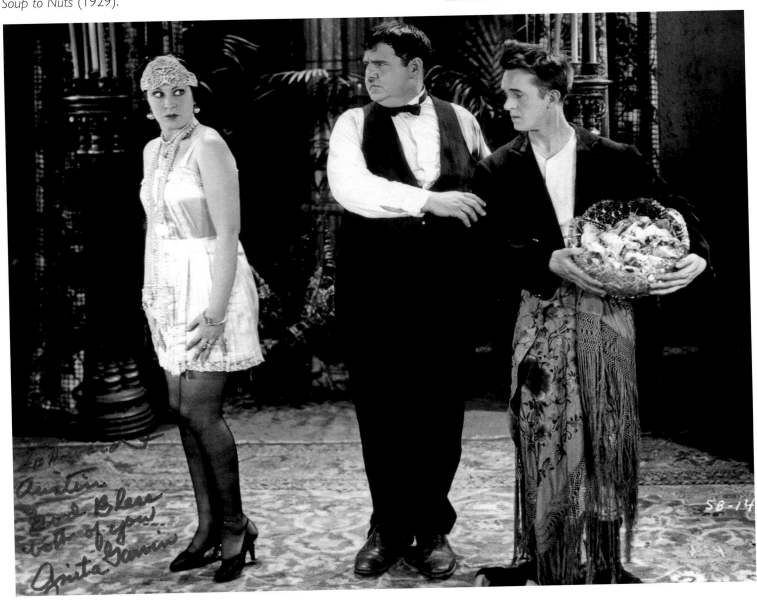

(left) Laura La Plante was as famous for her shingled hair-style as she was her comedic roles at Universal Studios, where she was under long-term contract during the 1920s.
She moved into the Motion Picture Home following the death of her husband, producer Irving Asher, in the 1980s.

(below) The Motion Picture and Television Country House and Hospital opened its doors in 1942 with accommodations for 24 retired film workers. It now houses 400.

"I saw you come in. I haven't seen you here before. Are you lost?" "No, but thank you. The gentleman at the desk is locating Miss Rose Hobart for us," replies Howard.

"Oh, how do you like that you're English. I've got good hearing and I know an accent when I hear one and boy, do I love your accent. We Yanks make English sound so trashy," she says. I mention we are from Surrey; New Malden, close to Wimbledon. "You know, where they play tennis?" I say. She just stares as I tell her my father is from London and we have an older sister, Rowena. I tell her my grandfather taught at St. Martins' and that it must be in the genes as we are at Art School too and, lastly, that there's a girl on the course I like, "Her name is Toni but she's with another guy." She is still staring. I ask myself 'Why am I sharing this stuff?' Howard looks at me as if reading my mind.

She smiles "Oh now, I'm kinda getting into you two, so say some more." Howards offers, "We have been corresponding with movie stars for a long time. The legends and the lesser known stars; both are equally as interesting to us. The roles they had. The parts they played. Austin noticed Miss Yvonne De Carlo sat over there. What a star!" We both turn round to look at where she'd been sitting, she's disappeared.

She looks over to the empty void too and then back at us as she tidies her hairdo. "Oh well, gentlemen, she's gotten so fat," she taps her stomach then looks at Howard, "Well my name is Anita Garvin Stanley. You won't have heard of me of course," her mouth in a comical childish downturn. "I do know you," says Howard. I recognised you when you came over just now. We've written to you. You were a comedienne and worked with Laurel and Hardy. "You've written to us too."

Anita pulls a face of slight disapproval. "*Is* a comedienne!" She wobbles her head and plays with her hands and acts the clown and then, placing a mask over her face, takes a long pull from her oxygen cylinder fastened to the back of her chair. "I was in 400 pictures," she repeats "400" in a dark dramatic tone, coughing a little. "You say you write to me?" she asks. We nod. "Well ain't that just swell? I do get visitors and people write to me when I am found to be still alive and kicking. I was re-discovered by Laurel and Hardy fans and they brought me back to life. Are you both with one of the fan clubs who come out here to see me?" she asks. "No, we are just fans of old films," says Howard.

"Well, you'll do well here. Everyone's old or dead. Or fat or too thin." Her voice trails off as she stretches to see whether Yvonne De Carlo has reappeared and

Virginia Sale, a resident at the Motion Picture Home from the mid-1990s, played more than 300 character parts on screen. Tall and aquiline, she debuted in silent comedies, her career concluded in the 1970s.

then, satisfied she has not, looks back at us. "Oh, so you write me. That's just the most darling thing I've heard and now you are here to see me." She looks at us. "Hmm, and you are young and handsome too." She looks at me as I give her a look that I suggest says, 'Oh no, I'm not'. I watch her eyes move up and down like a searchlight. "Do yourself a favour honey and shorten your sideboards and the beard; it's hippy and that's not British is it?" Anita isn't looking for an answer.

"I like the beard," I tell her, but Anita is too fixated on what's going on around her to listen to either of us in any detail. The fact we know her is good enough. She's on a high at being remembered and is acting up. She glances towards the clock beside the reception desk as if waiting for someone. She looks at us again.

"The ascot is a nice touch. I like it," she says to Howard

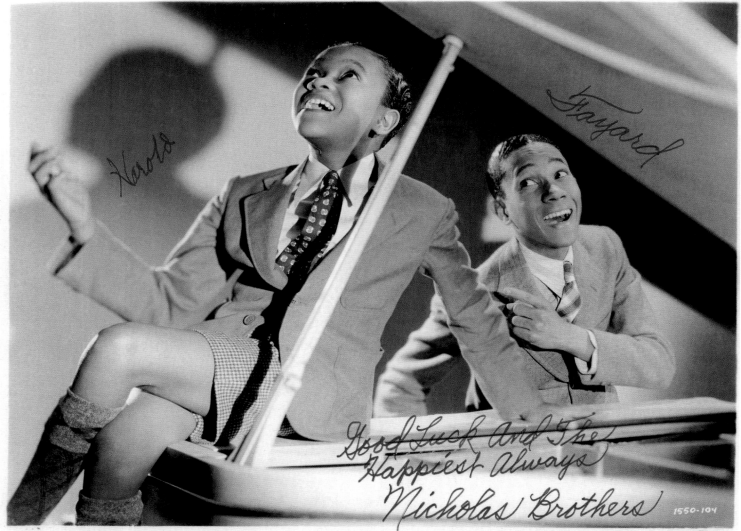

"THE BIG BROADCAST OF 1936" with Jack Oakie, Burns and Allen, Lyda Roberti, Wendy Barrie, Henry Wadsworth and specialties by the following: Bing Crosby Amos 'n Andy, Ethel Merman, Ray Noble and his band, Mary Boland, Charlie Ruggles, Bill Robinson
A Paramount Picture

Made in U.S.A.

(above) Fayard Nicholas (right), who, with his brother Harold, wowed the world of tap dancing with their astonishing athleticism. *"My brother and I used our whole bodies, our hands, our personalities and everything. We tried to make it classic. We called our type of dancing classical tap, and we just hoped the audience liked it."*

(left) Fayard Nicholas with Mae Clarke, the pair moved into the actors retirement community during the late 1970s. Mae died in 1991. Fayard moved out in 2001 to a house on Toluca Lake, following his third marriage to dancer Katharine Hopkins.

and turning to me, grins, "You should get your brother there to dress you." She fiddles with the cuffs of her blouse and looks back at us and grins again widely and then back to the clock. I ask if she has a visitor coming today. Anita looks at me completely straight-faced and says, "Yeah baby, the Grim Reaper." I laugh, Howard does too. "Ha Ha!" she exclaims eyes still wide and comical. "I just made you laugh. You see, I *am* a comedienne." She moves higher in her chair now, as if preening herself.

A woman dressed in blue overall over cream trousers and trainers with red hair and a South London accent comes up behind Anita. "Come on my love, I've been looking for you." The nurse introduces herself to us. "My name is Ann Dunne," we then introduce ourselves.

"Oh boys, Rose says you are visiting her today. Oh my loves, how great to meet you!" she says giving us a hug. "Oh my lovely boys. Your letters to the residents are so lovely. I read them out to Rose, Muriel Evans and Anita. She adores you, don't you my darling?"

"I like good looking men," says Anita. I laugh off the compliment. "Anita doesn't like the beard much," I tell Ann. "Well that's okay," says Ann. "I think it's smashing". She gives us both another hug and a wink as she motions towards Anita who has her head down looking inside her handbag. "God, I need lipstick," she says in a loud whisper as she hunts amongst the jumble of tissues and tablets.

Ann asks how we are enjoying California and how long we'll be staying. She opens up more now, comfortable with our being English and therefore familiar. She tells us about her husband Joe and how they met in Brixton. Work was so hit-and-miss during the mid-60s, he decided to try his luck in Hollywood and has never been out of work. So Hollywood worked for us," she smiles. "The Hollywood dream, you could say," she says brightly.

"Dreams are well and good and then you wake up," barks Anita. "Well it worked for us and our son Matthew," Ann rolls her eyes. Anita pays us more attention and turning to Ann asks, "Are those two twins?" she points at us. "He looks older." I fiddle with my moustache. Anita pulls a long face in disgust.

No Beige! (from top) Anita Garvin, pictured in 1991; Billie Dove moved into the Motion Picture care facility in 1995; Joyce Compton, actress and comedienne, took up permanent residence in the early 1990s; Ruth Clifford was one of the facility's oldest residents when she died in 1998, aged 98.

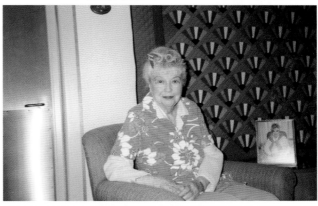

"Yes, they're twins. They are Howard and Austin. They have written to you, Anita," says Ann. "We wrote back to them, remember?" "Oh, well I like the idea of a matched pair," she says, giggling. "You don't like beards," I remind her.

She looks about the reception and spies Bob waving from his wheelchair. "Honey, in this place it's slim pickings." She draws our attention to a lady sitting beside the reception desk. Joyce Compton had been a beautiful bubbly blonde comedienne during the 1930s. She is made-up – her hair in a beehive. I watch her as she dozes, her legs hidden under a patchwork blanket. "Joyce hates it here," Anita whispers as we watch and stare. Anita coughs loudly. Our attention is on her again. "Hey," she says after a few moments, louder now, "The darling won't be in this place forever."

I look about us, the reception resembles a scene from the film *Cocoon* and I know what Anita means. Ann winks at us both again before returning her attention back to Anita.

"You seeing anyone else apart from Rose?" asks Ann. "Yes, Muriel Evans," says Howard. "Oh yes, she told me that," says Ann smiling. "Muriel? She's like catnip. Watch out!" snorts Anita. Ann whispers to us that both women fell out over a man. "Oh right. Okay," I say finding it funny that these rivals should now be under the same roof. Ann pats Anita on the shoulders.

"Actually, it's because of this little lady I'm here at all. My brother Del is a member of the London Laurel and Hardy fan club and introduced me to Anita, and then I started to come to this place and visit her and then became a volunteer. Volunteering has made my life so rewarding. I've met the most wonderful people in the world and love them all. Don't I, my love," she says looking down at Anita. "They call us volunteers 'Blue Angels'."

Anita isn't paying attention. She's looking towards the door where someone is making a delivery. A young man laden with boxes and packages walks close by, struggling with his heavy load. Anita clears her throat, sticks out her hand and shouts, "Hey fella! You got a match?" The man looks at her trying to work out how he could pass Anita a match whilst loaded down. The man give a hearty laugh. Anita stares straight at Howard "... *is* a comedienne – Ha!" Her expression remains completely deadpan. "I'm still good."

"Working opposite Laurel and Hardy has left its mark, hasn't it my love," says Ann. "Her timing is still sharp. She was Laurel and Hardy's straight-man... er, sorry, straight woman and also worked with Charley Chase. Hal Roach,

who produced their films, loved her." Ann smiles, patting Anita's tiny shoulder. "She was tall then, with a platinum pageboy haircut."

"I wasn't blonde darling!" snarls Anita "I was jet black and boorish; now I'm a mess." She takes another hit of oxygen, adding to the affect. Ann, chuckles and, from behind Anita, mouths, "Oh, sorry", while raising her eyebrows to us.

Anita fiddles with her gold hoop earrings now. "Stan was the funniest out of the two and the brains behind the outfit and the nicest really," she tells us. "When I did a scene with him, we had to keep re-taking it. He'd break me up in stitches just by looking at me. The other one was very sweet but lacked Stan's sense of comic timing. But he could dance beautifully for a big man." "You were just fantastic," I tell her.

Ann agrees. She places her hand tenderly on Anita's white cheek. Anita smiles broadly and takes a hit from her oxygen. "She's my 'Honeysuckle Rose', It's my nickname for Anita and her favourite song. Anita's late husband was the band leader and trombonist, Clifford 'Red' Stanley.

"Haven't you someplace to go, fellas?" asks Anita, "Or are we gonna be a threesome and play some," she winks, her heavy false eyelashes batting as if in slow-motion. "Yes, we are visiting Rose Hobart," answers Howard still holding the roses.

"She is a nice lady. Used to write for the paper here but she's a bit muddled now and writes everything now – everything. She doesn't miss a trick either. Oh brother, she was a darn good actress though. One of the best oh my, she is strong on screen and off. She was one of Bogart's favourites you know because she is no-nonsense. I read that someplace... Well boys, you'd better meet your date. Catch you later." With that she's off as fast as she can in her wheelchair; Ann follows behind her.

"Come and find me," says Ann, "Pedro on reception will page me. We can chat some more and then maybe you can come to the house at some point and meet Joe and my Matthew," she shouts the last bit, almost running to catch up with Anita. "Yes, great," I shout. "Catch you later!" As Ann and Anita fade, Rose Hobart appears arms aloft, "Ah boys you are here, that's wonderful."

Rose is slim and wearing a blue shirt un-tucked flowing over white jeans, a handbag and sneakers. Her hair high off her face in the style she wore during the 1940s. She is regal, pale with red cheeks. I notice fellow residents almost bow to her as they pass her by. She has an air of

grandeur to her. She has a clipboard tucked under her arm; she means business.

Looking at the clipboard, Rose announces that we should make a plan. "I say we'll have a coffee, talk some and then I thought we could lunch. Do you mind paying for yourselves? We both shake our heads. Well that's very good. Right this way boys. Follow me."

We follow Rose through the reception and towards glass doors that open onto a terrace and gardens. Howard still has hold of the roses, by now the heads have drooped. I spy Anita Garvin sitting alone. Before we leave through the doors, she is joined by an elderly gentleman wearing a striped shirt. I recognise him as Grady Sutton. Grady waves to Rose. She nods in recognition. Howard whispers that we'll try and find him later. We walk through the gardens and into another low-rise building. We are in a long corridor. The walls are covered with framed photographs of movie stars. I spy Rosalind Russell's portrait in a giant gold frame and Johnny Weissmuller next to her and, as I turn round, photos of Elsa Lanchester.

"Miss Hobart, I have these roses for you," Howard hands her the flowers. Rose Hobart smiles, "Oh, roses for Rose." She smells them, smiles and struts ahead. Howard looks surprised. "I thought them the perfect flowers," says Howard.

She stops, looks at them, then at the walls and back to the flowers, "Oh but they are dying," she gives the bunch a shake, pink and white petals fall to the floor. Look, they are dying, they are like everything else here, aren't they. Once great beauties and now faded and falling apart". Howard is silent. "It is the way of all things," she says.

Rose bends down and picks up the fallen petals and pops them in her pocket. "Water, they and we too need water or we'll surely die here." She walks, we follow. She clutches her clipboard in her left hand; more petals scatter on the floor. We leave them where they fall. Rose stops at a large black and white photo and turns to face us. "Do you know Gale Sondergaard?" she asks "Yes, we wrote to her here for a short while." Rose lets out a weak cry and then a laugh and then a sort of snort.

'Well I never. I didn't think anyone now would remember her. I never knew her at all, not really and sure she's dead. But when she and I were blacklisted by McCarthy, I came to be associated with her. It was our common bond, being blacklisted, and so we had a mutual respect for each other."

Rose moves closer to look at Gale's gallery. "Oh yes, look, there she is with Bette Davis," she says reading Bette's name on a card under the photo. "That's a nice one of her with an Oscar. Gale was proud to be a pioneer. Proud to be the first to win an Oscar for Supporting Actress. But then that was it; she was then like me and was *persona non grata*. Nobody would speak to us. There were others too."

Rose looks at more imagery of Gale and talks whilst wiping her finger across the top of a silver-colour frame, dust gathering on her index finger. "I should clean this," she makes a note on her clipboard; the pencil hanging loosely on a piece of string, "I should clean this for Gale, she'd like that."

I ask Rose what happen to her during the McCarthy Era. "Me?" she asks. "Yes, you Rose. What happened to you?" I ask. "Well I didn't follow the pack ever, and my pro-union stance caused me to be blacklisted. Everyone was commie-mad, Ginger Rogers' mother Lela one of the worst for pointing the finger. It was like a fever with people, brainwashed into looking for 'reds under their beds'. There was a book call *The Red Channels*, it was on every producer's desk and there was an article about me in that book. So that was it, I was finished, I couldn't work in pictures," she sighs. "You remember Lee J. Cobb?" We both nod. "Well he was a big star. Anyway, he told the Committee of Un-American Activities that he attended a meeting at my house. He was lying, of course. The night in question I was in Washington giving birth to my son." Rose looks at us both silent, listening to her story.

"Ah boys!" she sighs. "This is better than an hour with the shrink," she smiles. "Dear me, I feel I may get some bile off my chest today if we continue down this route." She scribbles some notes on her clipboard. I catch her scribble the words 'McCarthy' and, with a red pen she locates in her pocket, mark the word with a giant tick. "I did so much more but I'm remembered for the end of my career. But that's fine."

She drifts off a little before looking at her notes. "Ah well... now boys, I have coffee and lunch written down here. What's to be achieved first?" She looks at her watch and at the pair of us. "Don't ask me to remember who is who. I can't do it. I'll call you 'My boys'. I do adore you both."

"That's good. We like you too," says Howard beaming. "And I've got the beard," I add. "Well that's good." She writes down 'beard'. "Which one are you?" "Austin."

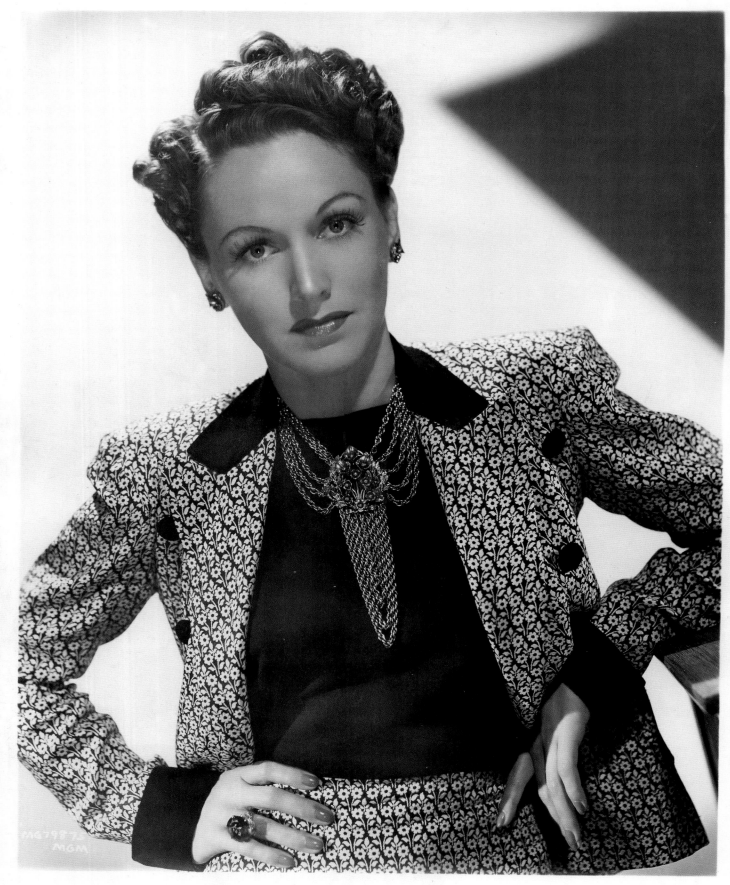

Rose Hobart, a Broadway actress during the 1920s-30s, who later went to Hollywood to act and fight for actors' rights in the Screen Actors Guild. She was later blacklisted during the McCarthy Era for her pro-union stance.

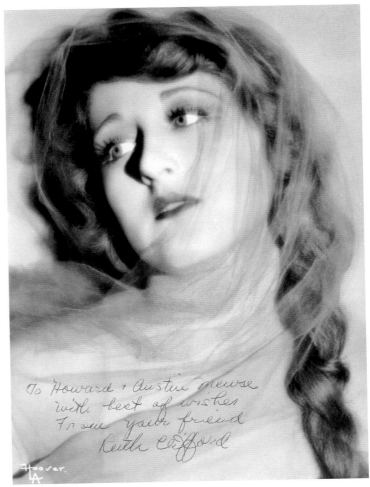

(above) Rose Hobart in costume on the set of *Tower of London* (1939) starring Basil Rathbone and Boris Karloff.

(top right) Ruth Clifford was a silent film leading lady in Hollywood during the 1920s and later a character actress. *"If you take me out of the 'home' and drive me in your car to Hollywood, I'll show you where all the stars lived."*

(right) Viola Dana first appeared as an infant on Broadway before debuting on-screen, aged 10, with sister Shirley Mason in Edison's *A Christmas Carol* (1910). Viola returned to the stage and then to Edison again where another sister, Edna Flugrath, was making waves. Viola starred in *The Stone Heart* (1915), married her director John Collins and featured in all his subsequent films. Devastatingly, he succumbed to the Spanish Flu epidemic of 1918. Her talent had by now secured her a place in Hollywood with credits such as *The Willow Tree* (1920), *Merton of the Movies* (1924), and one of Frank Capra's first films *That Certain Thing* (1928). Talkies proved her downfall: *"We were not casualties of sound because we couldn't talk,"* she said later, *"We were simply ignored, put on the shelf."* Viola moved to the Woodland Hills facility in 1977.

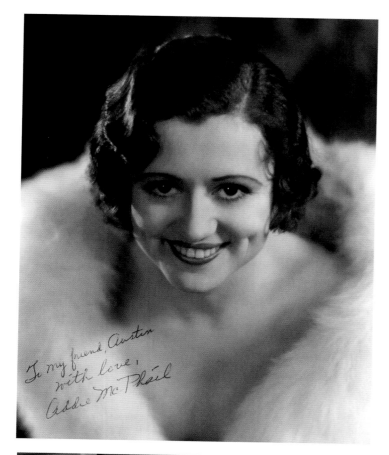

(top) Addie McPhail was the wife of silent comedian Roscoe 'Fatty' Arbuckle from 1932 until his untimely death on the eve of their first wedding anniversary. She had married Arbuckle a decade after the scandal involving the death of film starlet Virginia Rappe; though he was acquitted of her manslaughter, he never recovered. Addie was a budding film starlet when they met on the set of *Up a Tree* (1931), which he was directing. It was love at first sight. "*Roscoe had been in the wilderness for 10 years. The Stock Market Crash of October 1929 hit him hard. He attempted a comeback as a film director under the pseudonym of William Goodrich; that is when we met. He rarely spoke about the scandal to me, I know he didn't want me to feel any sympathy for him and I didn't. Roscoe neither needed it or wanted it.*"

(bottom) Rose Hobart with Howard in her cottage within the grounds of the Motion Picture Country House and Hospital, 1994.

She writes my name next to 'beard'. She then glances at the clipboard and seems hesitant. We are still standing in the corridor. Rose looks up, smiles and, as if searching, looks back down. "I made notes but I've forgotten what for." She appears slightly panicked so I make a decision for us and suggest we have an early lunch. "Yes, let's do that," she says, obviously relieved. "It's only the dining room and a buffet." "Oh not Ciro's then," jokes Howard, making reference to a once-famous Hollywood haunt.

"Oh no, dear. I think that eatery has gone now. Besides, we are not quite in Hollywood here. This is a sort of an anomaly of what I was once a part of, but somehow," she says looking at her notes, "I feel like I've never left, only now I feel like it's all escaping me."

"Come on Rose, let's go and have a good tuck in." She smiles at me as we walk together now, the clipboard at her side, towards the dining room.

Standing at the entrance Howard and I are confronted by a sea of grey and white hair. There is a low hum. I pick up fragments of conversation as we follow Rose to the buffet. The chat is pure Hollywood, pre-1950. Heads turn, Rose whispers that it is not especially because we are strangers, "It's your youth," she explains. Rose puffs out her chest and links her arms in ours, "For now you are all mine."

She smiles at a few residents and, turning to one woman, introduces us as, "My friends from England." I spot Anita Garvin sitting with two elderly gentlemen, one stouter than the other, and a woman with blonde curls.

Seated now with our lunches of honey-roast ham and salad with sides of fries, Rose shoves the roses in a water jug on the table as she points out other residents who may be of interest. As Howard and I look about the room, Rose delves into her handbag and pulls out salt and pepper cellars. She gives me a look. "These are from my house. I don't leave them in here every day, which causes confusion. The cellars identify one's table". She hands me the pepper. I look about me, every table has a matching pair, each different to the next. Rose watches a woman in the far corner. "Boys, see the woman in the corner behind the piano?" Howard and I turn independently of each over trying not to stare. "She is Greta Garbo's stand-in." The elderly woman is wearing a big floppy hat and sunglasses, which must make eating her lunch in the darkened room quite a challenge. "She also sits alone." The woman spies us looking at her and pushes her sunglasses higher up her nose and pulls her hat lower to increase her disguise. She looks like someone on a stake-out, comical and unconvincing, like she wants to be noticed.

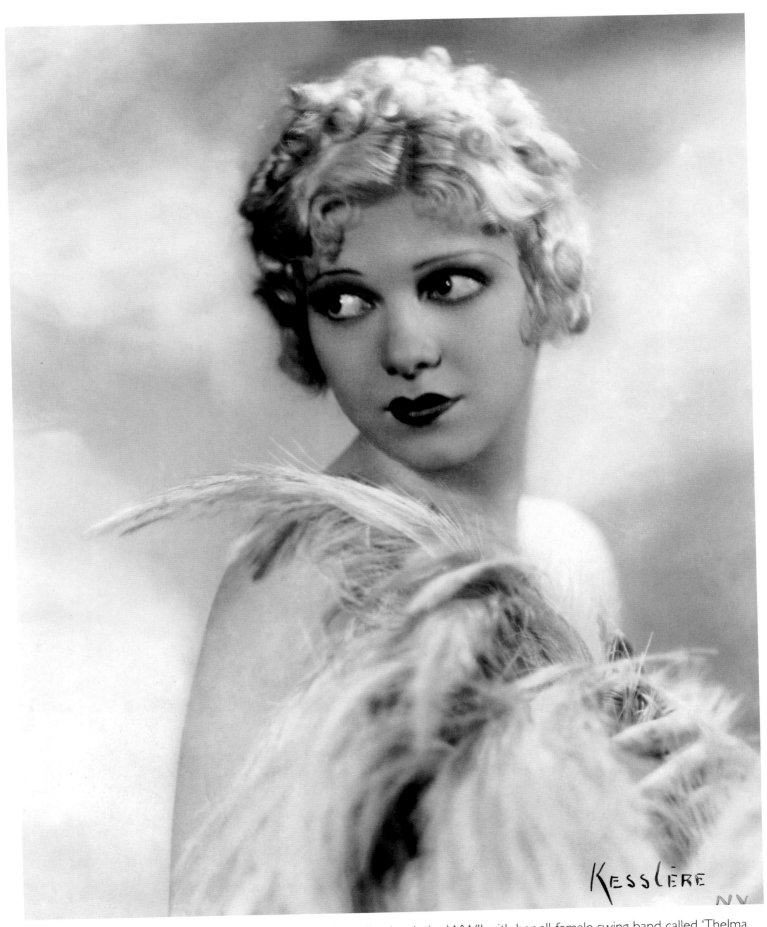

Thelma White, American film and radio actress-turned-bandleader during WWII with her all-female swing band called 'Thelma White and Her Girl Orchestra', which took her to Alaska and the Aleutian Islands on several occasions with Carmen Miranda and Rose Hobart.

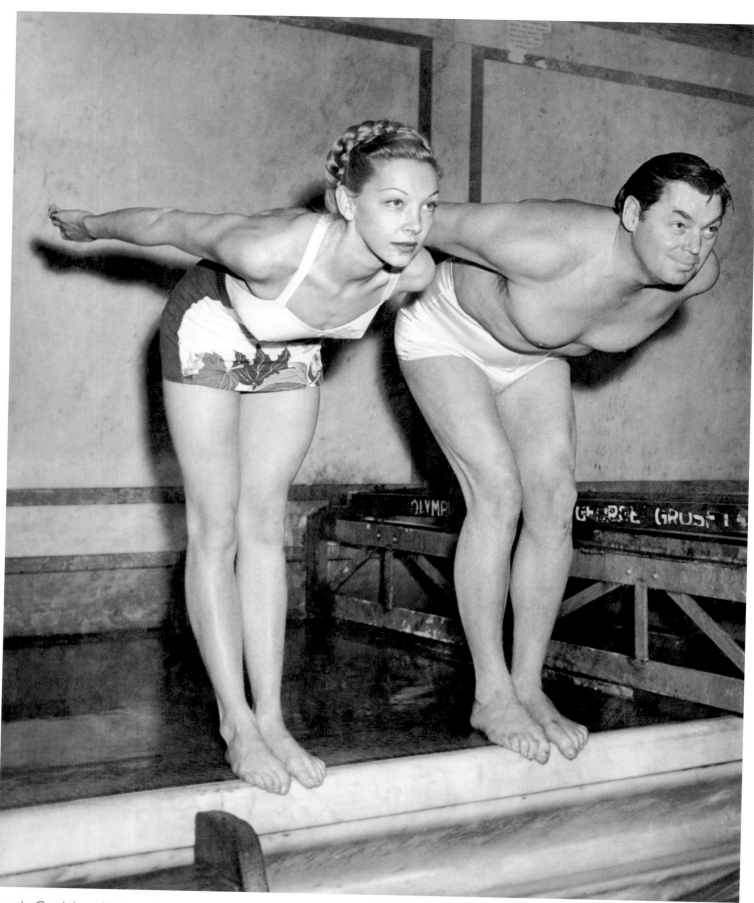

Jungle Cry: Johnny Weissmuller was perhaps one of the facility's most famous residents, moving to Woodland Hills in 1979 after suffering a series of strokes. Rumour has it the actor, famous for his role as 'Tarzan', would chase nursing staff nude around the swimming pool whilst letting out his famous roar! His stay was brief, moving to Acapulco, Mexico, with his sixth wife Maria Bauman. Here with ice-skating star Belita, London, 1948.

The pianist plays show tunes. I recognise 'Yankee Doodle Dandy'. He sees Anita Garvin now and plays 'Honeysuckle Rose'. I look over at her: she is crying. The gentlemen with her are tucking into their lunch and take little notice of her tears, like it's an everyday occurrence. A lady leaning on a metal stick with three claw feet stops by our table to ask if Rose will be playing bridge later. Rose chews on her ham, swallows and looks up. "No dear. I have friends from England with me." Howard and I introduce ourselves. The lady is wearing pale lemon with a cardigan around her shoulders and a poorly looking silver fox fur perched on one shoulder. She greets us warmly but gives no name. There's an awkward silence as I expect Rose to tell us who she is. She doesn't. The lady waits for what seems like an age, balancing her tray precariously on the metal walker, shrugs her shoulders and wanders off back towards the buffet.

"Who was that?" asks Howard. Rose blurts out, "Thelma" and with a surprised face becomes quite animated. "Oh goodness look at that, her name came just like that and yet I didn't know it at all. Thelma was in comedies I think." Rose hesitates with her pen hovering momentarily, her eyes follow Thelma but her hand fails to add Thelma's name to her list.

With our lunches finished, a waitress dressed in a blue apron clears our plates and asks if we'd like coffee. Rose accepts on behalf of us all. I get up and return to the buffet for some fruit. I look back at Howard who motions for me to grab him something too and something for Rose. Thelma comes up behind me. "I don't suppose a young gentleman like you would remember the name 'Thelma White'?" I look at her. I do. Her most famous film is *Reefer Madness*. I think I actually watched it when I was at school as part of a 'Don't do Drugs' drive aimed at teenagers. I remember all the boys laughing at it. The film was black and white and therefore seemed ancient to the teenage audience.

Thelma is looking at me almost pleading. "Yes, I do know you Miss White." She beams. "Oh, but please don't mention *Reefer Madness*," she says. "Just don't remind me of it for heaven's sake. I didn't want to make the darned film anyway and now it's all I'm known for." "Well, Miss White, I have seen *Reefer Madness* and it's funny." Her smile is even wider. "Well that's fine I suppose. I'm a comedienne." "Well you made us laugh. We watched it in school." "Oh, with other children?" she asks. I nod. "Oh, I like that. A new audience. But it is a racy film. I was a floozy." "We were sixteen or maybe older," I tell her.

"Oh, for a moment I thought you'd watched it as kiddies. Oh my, well how do you like that, handsome sixteen year

(top) Stepin Fetchit's 'lazy man' persona was nothing but racist; onscreen from the 1920s, the roles he played (most memorably with Will Rogers) were each a recurring stereotype of a black man – nervously cringing and stupid. Off screen he was the first black star to make a million dollars. By 1945, he was broke, accepting whatever work was offered. He later made headlines by converting to Islam and joining the Civil Rights Movement, until a stroke robbed him of his speech. He died in 1985.

(bottom) Muriel Evans, with Howard (left) and Austin in the Motion Picture Home library, 2000.

olds watching me! And English, yes?" I nod. "Oh, English cultured sixteen-year-olds." Her smile fades. "But I didn't want to really make a drugs flick, no I didn't." She looks at me, "But now I see it has its positives." She reaches into her handbag hanging from the crook of her arm. She pulls out a few photos in a small album. There are snaps of her dressed as a flapper with a short platinum bob. She was gorgeous. She shows me another of her parents and tells me they were both carnival and sideshow artists. There's another of her with W.C Fields and a magazine clipping of her with Jack Benny.

"Austin," calls Howard, and then louder "Austin!" I look over. Rose's face tells me I'm expect back. I thank Thelma and grab three apples. Thelma holds me back. "I've got lots more stories. I have more photos too and I'd like for us to chat some more." "I'd like that, Miss White." "Oh, call me Thelma," she says re-adjusting her fox, all coquettish, and taking a bite from an apple. "Call me Thelma."

I dart back to our table. "Thelma White" I say to Rose and Howard, Rose doesn't answer. She pulls out a lipstick from her pocket and reapplies, then fusses with her clipboard squeezing it into her handbag along with her condiments, which she wraps in a napkin. Rose's eyes follow Thelma. "She was a terrible actress," Rose laughs in a short series of snorts. She has the same reaction that Anita had when Howard mentioned Yvonne De Carlo. "Blimey," I say to myself, "It's still there, the Hollywood rivalry."

She looks at her schedule. "I have singing classes. I shouldn't go as you are here but if I don't I'll be letting everyone down. I have the only descent voice," she coughs for affect. "Come by my place now as I have my book for you both."

The room is small but neat. Photos hang about the walls and on top of heavy oak furniture. A set of French doors lead to a patio. The phone rings and Rose answers it.

"Hello, yes the English twins. Yes, yes, okay right... okay." She hangs up. "The English lady... er, now names..." "Ann," we both say in chorus.

"Yes her. Well she's spoken with Fayard Nicholas and he'd love to see you both. Ann says he's in the theatre. Now, before you disappear and I forget you were here, please write your names down on my pad and I'll make sure I leave a copy of my book at the reception for you to collect when you leave."

Rose walks towards the door but then blocks it keeping us back a little while longer. Next to her on the wall are several pictures. "That's me with Humphrey Bogart. He taught me structure and the importance of getting things just right. He was always in charge and if a director didn't know what he was doing then Bogie would take over." We stand admiring her gallery. Me wondering how long we should stand still before politely taking our leave.

Rose looks at her achievements, "You had to work darn hard to get your name on the bill," she stares at her name on the film poster of Susan and God, "Lord, these days even the TV weather girl gets star billing – crazy." She snorts and looks at her watch, which to me indicates our time is up. She steps aside and lets us pass. We kiss her and promise to visit again. "You do that and write to me," she says picking up her clipboard and reading our names out aloud to herself.

We are back outside, standing in the sensory garden, there's a powerful aroma of purple flowering lavender and thyme. A signpost points one way to the Frances Goldwyn Lodge, another to the Louis B. Mayer Theatre and to the John Ford Chapel. We walk straight ahead through a rose garden named after Merle Oberon and past a row of bungalows each with a name beside the front door telling who lives inside.

"Look over there, Austin," says Howard pointing to my right. Across the garden but still amongst the lavenders sits Muriel Evans in a wheelchair. We both walk over to her. She has a patchwork blanket covering her legs; she is still blonde like in her 1930s comedies and melodramas; her pale blue eyes wide and sparkling. She's wearing a burgundy pant-suit with matching lipstick, her nails perfectly manicured.

"Good afternoon Muriel, it's Austin and Howard" "Oh I was wondering when you'd come and see me. Everyone is talking about you. You have caused quite a stir with your letters and now your visit." I turn to Howard and then back to Muriel, "Really?" "It's your calling card. Your ages. The very fact you are twins and from London. How glamourous." "And there I was thinking you were the glamourous ones!" I joke. Muriel fiddles with her page-boy haircut.

"Not anymore," she says scrunching up her nose. I did go to the hairdresser for you but they don't do it the way I like it." She sighs. "I had a stroke so I decided to come here. I was a Blue Angel and now the Angels are looking out for me." She looks up at us from her chair "Did you leave me till last?" Howard protests and kneels before her, "Oh no, of course not. Besides we'll be coming back here before we go back to London." "Take me with you to London," she says. I now join

Howard on the patio, bees buzzing around my head eager for the lavender. "I would like that very much," she giggles quietly, "I'm joking of course. The stroke means I'm stuck but this isn't a bad place to end up. We all know one another here." She spots Anita Garvin coming towards us, and even though she doesn't stop, Muriel's voice is a whisper now. "Yes we all know one another even if we aren't the best of friends." She returns her gaze to us, "Kjære meg, kjære meg…"

"I'm sorry?" I ask. "Kjære meg. It's Norwegian for, well let me see, ah for 'dear me'. My family were Norwegian. The big boys at Metro-Goldwyn-Mayer loved my accent and loved my Grandmother's even more so. They would call the house just to hear her voice. It didn't matter much at the studio because I was in silent films first, but my voice recorded well and since it has a nice pitch to it, MGM liked it, and I liked MGM."

A nurse appears. "I need to take Muriel for her therapy class now gentlemen." "Oh sorry. Sorry to hold you up," says Howard. "Oh don't be, it's dull and you are both dear to me. Walk with us won't you". We walk alongside Muriel as she talks. She holds Howard's hand and he hers even though it means he's on and off the path sometimes and has to tackle shrubs that have invaded the walkway. I follow a step behind the nurse, she pushes Muriel at a snail's pace.

"You have written me lovely letters and I've kept them all and the gifts for my birthday. How sweet of you both. I'm so happy you came to California, to my home." She's smiling, "Do you like Westerns?" "Yes we do," I tell her. She tries to peer round. Howard moves closer, "Austin and I particularly like *The Searchers*, back home the BBC shows episodes of *The Lone Ranger*."

"Oh that's a popular series over here too. Hey, stop Gloria," instructs Muriel with her hand. "Boys, look down at your feet." Gloria is also looking about her.

"Do you know what's funny about living here?" she smiles. "This land is where we shot all the Westerns I starred in with Buck Jones and John Wayne." "John Wayne liked me because I could ride. So many bits of fluff he worked with couldn't even ride a bicycle." She laughs a little. As we all move off again, she shields the afternoon sun with her tiny hand. It quivers with age.

"You'd sit in a carriage and wave," says Howard, as she searches for his hand again. "What!" she says releasing her grip and seemingly quite robust. "Oh dear me no, Howard! I'd go horseback riding again I loved it". We

come to a halt again as Bob, still in his Stetson, crosses our path. "Howdy, Bob," says Muriel. "Howdy, Miss Muriel," he replies. She looks at us both, me beside Howard now. "This place is like a Western's graveyard," she laughs.

We reach a door marked 'Clinic'. "Oh one story has just come to me boys. Wait please, Gloria will you?" Gloria does as she's bid. "Not long though, Miss Evans" "Yes, yes, yes, ja, ja, ja," says the multilingual Muriel. "Have I told you about working with Clark Gable? He has a secret."

We knew the story but let her tell it again "Oh, you don't? Oh, this is good," she says licking her lips. "We were making the picture together, *Manhattan Melodrama*. He was so handsome, such a dish. 'Mr. Gable,' I said, 'How does it feel to be God's gift to women?' He looked at me, smiled and said, 'Muriel, you wanna see?' He then takes a piece of candy from his pocket and bit into it," Muriel re-enacts the scene. "Then, to my horror, when he withdrew the candy, his false teeth were stuck fast, embedded into the gooey sticky toffee!"

She's animated. "Ah and my boys, what was left in his mouth were brown stumps. It was these that gave him the bad breath that Vivien Leigh complained about whilst filming *Gone With the Wind* opposite him". She waves her hand in front of her nose. "Phewy! He was a Hollywood big man but scared stiff of the dentist." She laughs quietly. "Imagine!"

"I've seen you in *Manhattan Melodrama*," Howard tells her enthusiastically. "It was shown on the BBC about a year ago." "Oh, really? Yes, it's a good film." She plays with her hair again. "I can't stand what they've done to my hair and with my having you here too."

"Times up boys," says Gloria. "Oh, of course." We give Muriel a kiss. "*Farvel* my boys. That's 'Goodbye' in my mother tongue. Come back and don't wait too long now." We watch Muriel disappear, the door closing behind her.

As Muriel fades into the shadows we both look at one another smiling. "Isn't she fantastic, Howard?" He nods, "Absolutely, and she does still resemble the photos she's sent us from all those years ago."

We walk towards the theatre for our last encounter of the day: Fayard Nicholas.

Compared to everyone else we've met today, Fayard is a firecracker. Diminutive, with a loud high-pitched voice. We stand in the doorway. He has his back to us. He is

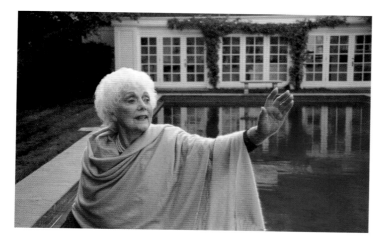

(top) Busby Babe: Mae Madison, poolside at the home of Barbara Broccoli, Beverly Hills, 2000.

(middle) Mae Madison (second left) with fellow Sam Goldwyn Girls. When Mae's acting career took a nose dive in the mid-1930s, she joined the back of the chorus.

(bottom) Golden Girls: Silent stars Billie Rhodes, Mary MacLaren and Ruth Hiatt at the bedside of Estelle Winwood in 1984. Estelle had just celebrated her 101st birthday.

wearing a shining navy-blue jacket with 'Nicholas Brothers' embroidered on the back in red and gold. He's telling one of the 'Blue Angels' a story.

"I remember when the film *Down Argentine Way* opened, audiences in the movie theatres went wild, shouting and screaming and stomping their feet and giving orders for the projectionist to rewind the film and play it over again! Hee, hee hee. Oh boy. The Nicholas Brothers were big!"

"You have visitors," says the 'Angel', who's been waiting patiently and watching us. "I do?" he asks turning round, spinning on his heel. He smiles wide; his teeth, sparkling white. "Oh, Ann fixed this, right?" Yes, you guys write me from London. You is the twins, right?" He takes a step back. "Hell, you just gotta be twins." He looks at me. "You better keep the beard," he laughs.

"We were listening to your story," says Howard, "Sounds amazing." "Yeah. They asked for the film to run again. They loved The Nicholas Brothers." Fayard gives a little soft-shoe shuffle.

"So, you here on a vacation?" asks Fayard. "Yes, we are on a summer break from art school. We came a year ago and stayed for awhile and so decided to come back and re-visit some friends and come here to the Home too."

"Well that's swell. Yep, swell. And you is young and so you can absorb all this stuff. All my stories. That's good. You know The Nicholas Brothers' work?" he asks. We each chime-off two or three films and enthuse about his dancing skills.

"Tallulah Bankhead said had we'd been white, we could have danced with Ginger Rogers." "That must have pissed you off," I say. Fayard nods and shakes his head, "Yep, it do. It does," he claps his hands in front of him. "We was at a hotel and the manager had pinned onto the back door, 'No Irish, No Dogs, No Blacks'. We wasn't allowed through the front door."

"How awful, Fayard," says Howard. "You whites have no idea. Ah well, times are a changing. One day there'll be a black man in the White House." He laughs but looks serious —hopeful even.

"But the kids they ain't interest in anything but rap, but that's okay some of it ain't all that bad. I like Michael Jackson. I know he ain't no rapper, but I don't mind some of it. It's how the kids voice their shit and that's fine, but that ain't gonna get a black man in the White House. They gotta get them an education." He laughs. "Not that

The Nicholas Brothers had much of schooling. We grew up in a travelling circus."

Howard asks where, exactly. "Hollywood. The Nicholas Brothers classroom was Hollywood!" He grins. "Boy, I have stories. Gene Kelly and Fred Astaire were our biggest fans."

I ask if, as one half of cinema's greatest black dance duo, whether he found it hard to create an identity for himself. He turned round. "No way! This is me! I am The Nicholas Brothers!" And then, in a lower tone, tells us that his brother Harold is in New York.

We move from the lobby into the theatre. Despite there being chairs, we don't sit down. Fayard is just below the stage but dancing as if to an audience – sliding one way and the other, giving it an 'Oh, yeah baby' as he goes, and clapping his hands in syncopation with his tapping feet. He spins round and does a fragile jump.

"I used to do the splits at that point," he says. "I'd like to do it now but it hurts!" "Oh no, please don't," says Howard. He turns to me, "It could be dangerous."

A volunteer pokes his head around the door. "Hey, Mr. Nicholas. We need the place clear for the performance later. Oh, and you have a visitor." "Me? A visitor? Oh boy, three in one day." He looks at us in front of him, "Oh boy, I's better re-wind and play it over."

I all but beg Fayard to rest up. He does one more spin, which takes him unexpectedly but fortuitously towards a chair, where he flops exhausted.

"Hello, hello," comes a high-pitched voice. "Fayard, they told me you were in here," the visitor, a delicate blonde in her 80s, kisses Fayard. He introduces her to us as "Miss Mae Madison".

Mae Madison grabs our hands and shakes them enthusiastically. "How lovely to meet you. Are you family or friends of Fayard?" she asks. "Friends. We love old movies and there's no better dancer than Fayard," says Howard.

"You mean The Nicholas Brothers," interrupts Fayard. "We were a team, my brother Harold and I. One couldn't cut it without the other."

"Oh sure, oh yes, oh my," says Mae. "I am a dancer too. Well, I was a leading lady first, then a dancer. An all-rounder that's me, 'Mae Madison'." She is hugging Fayard. "We were in the picture *Kid Millions* in 1934

together at Warner Bros. and this man, well he's as cute as ever, and he ain't changed a bit!"

"Mae, I can't dance like I used to. It hurts!" says Fayard still smiling. "It does? I dance every day." Then, as if on cue, Mae lifts the hem of her pastel pink dress just above her knees and, singing 'The Breakaway', begins to tap dance. Fayard struggles to his feet and joins her, both singing:

Let's do the breakaway
Hot foot and breakaway
Let's do the breakaway bye and bye
Hot foot and shake away
Let's do the breakaway
Let's do the breakaway bye and bye.

Tapping beside each other they remember the words like it is yesterday. By the second chorus Fayard is clinging to Mae, but continues to shuffle and sing.

"What a pair of hoofers," says Mae when they finally finish after a further two choruses. They beam widely as Howard and I give them a loud round of applause. There is clapping coming from behind us as well. Two female volunteers, who had been cleaning the chairs at the back of the theatre earlier are cheering too, one even whooping. Fayard has flopped back into a chair, it's then I notice his trousers – a natty pair of grey flannels – becoming darker, the patch widening across his crotch and down his right leg. All that activity has caused Fayard to wet himself.

"Come on Mr Fayard, you are wearing these boys out," says one of the volunteers. Fayard rises to his feet. All eyes are on him below the waist. But nobody mentions his obvious accident. I cut Howard a look, he motioning his eyes towards Fayard. We too say nothing. We all leave the theatre with Mae still singing and waving to her daughter Mara, who is walking through the doors. Mara tells us she too is an actress, whilst her husband Marty only complains about having driven around for ages trying to park before deciding to enter the Home.

"Oh deary, you missed us dancing," says Mae to Mara in a disappointed tone. "Oh, we couldn't get parked mother and now I'm devastated." She looks upset but that changes as she greets Howard with smiles. "They are from England and friends of Fayard." "Oh, that's wonderful. England. How lovely!"

"And now we've met your mother and watched her dance," smiles Howard. He turns to Mae and asks, "Do you live here?" "No, but I wouldn't mind one bit," she says.

"Oh, I take care of Mae," says Mara. "Mae is just the greatest. I love her," she says, holding Mae's hand. "We are best friends and buddies. She made a lot of pictures with big movie stars. I've done TV and I write," says Mara proudly. Fayard then grabs her attention. "Oh dear," she says loudly, noticing Fayard's wet trousers. "He spilled a glass of water over himself," says Howard quickly. "Oh right, oh dear. How?" says Mae. Nobody answers.

Fayard is outside the theatre now. There is a golf buggy at the ready to take him back home. As he gets in the front seat the sun catches the back of his jacket. The words 'The Nicholas Brothers' burning bold, big and bright. He looks very happy.

"That was nice fellas," he smiles. "Come and see me later," placing a baseball cap on his head. "There's a show at five and The Nicholas Brothers are on the bill." He is still waving as he drives off.

We chat with Mae, Mara and Marty for a while longer, Mae telling us how Fayard would jump into the air and land in full splits and how Fred Astaire had called them two of the screen's all-time favourites. "Michael Jackson is a fan," says Mae, "fancy that."

We bid our farewells and leave the three of them at the theatre: Marty moaning about having to hang around for the show, Mae and Mara wondering whether they should stay put where they are to make sure they get the best seats. Howard and I wander back to where we've arranged to meet Ann Dunne on the patio by the Merle Oberon Rose Garden. She is sitting with the actor Whit Bissell, beside him is a bronze bust of George Burns. Howard quickens his pace. "Let's go and chat with Whit," he urges.

I watch and wait, exhausted from being, well, 'on stage' myself, but at the same time the audience. I am loving my day with the old stars but there is hardly time to breathe. Howard is by now in the midst of movie memories. I feel like Tim Robbins in the opening of Robert Altman's *The Player*. Like life imitating art, I watch one scene transmogrify into the next as I meet one star only for them to step out of frame to be replaced a moment later by another, each crisscrossing the next.

Howard is standing and listening. At first I stand silent as I watch him, joined by other old-timers, each over-lapping the other with their own Hollywood stories. I join them now. Nobody asks either of us a question about who we are or our life experiences. Howard and I are young and enthusiastic, pleasant and eager and, like sponges, absorb the great torrent of escaping memories.

I make my excuses and, just before 5pm, find a spot alone across from the John Ford Chapel to sit quietly for just a moment. I smoke a cigarette as I mull over the day and shake my head in disbelief at the thought of the amazing people we've met and how, in old age, they are still living a life in pictures. My solitude is soon interrupted by Fayard calling me from the passenger seat of a golf buggy. "Hey! Hey!" he yells. "Twins, hey! Hey I don't know which one you are." He is shouting louder now and still on the move. "Come to the theatre. There's a show on at five and I'm in it!!"

"Hi Fayard. I'll be there," I shout in return. Like the Pied Piper, people are drawn to Fayard. I watch as the winding paths are filled with a menagerie of men and women, some with walkers others with canes, some in wheelchairs. I see Rose Hobart striding freely at the front with a tall man behind her and actress Anne Gwynne leaning on his arm. There is Ann pushing Anita, who's dressed up in a black sparkling gown with a pair of high heels and lashings of red lipstick. Mae Madison is in the throng too with Mara and Marty, who is looking at his watch and at least six paces behind. He reminds me of my Dad, who like Marty, made it so obvious if he didn't want to be somewhere.

From my vantage point I can see the theatre steps, where film stars Howard Keel and Kathryn Grayson are waiting to make a guest appearance in the show, which is a fund-raising event for the Home. Their names are on a giant poster beside the main theatre entrance and, unlike many of the residents, they're still big names in the outside world.

I stay put. There are stars jostling to the right of me and to the left and I can see Howard, towering over the happy throng. We laugh as we spot each other in the stampede. He is calling for me to join him.

As I stand up and watch more names from the old days of movie making pass by, it comes to me that there is no need to watch the 'performance'. I am already watching it… No! We are *in* it: starring in a movie with no end, no roll of the credits, no fade to black. I can see the back of Howard's head now; Ruth Clifford to his right, Whit Bissell to his left.

This is an all-star cast of yesteryear on a constant loop. A place where movie stars and former screen rivals live with their one-time film crew. The Home – a blissful security of something that reminds them all of the motto I noticed this morning at the entrance: 'We Take Care of Our Own'.

Anne Gwynne, one of Universal Studio's top stars during the 1940s, when she was billed as the "TNT girl" (Trim, Neat, and Terrific). She moved into the Motion Picture Home in the early 1990s, after suffering a paralyzing stroke.

Hollywood on the Town

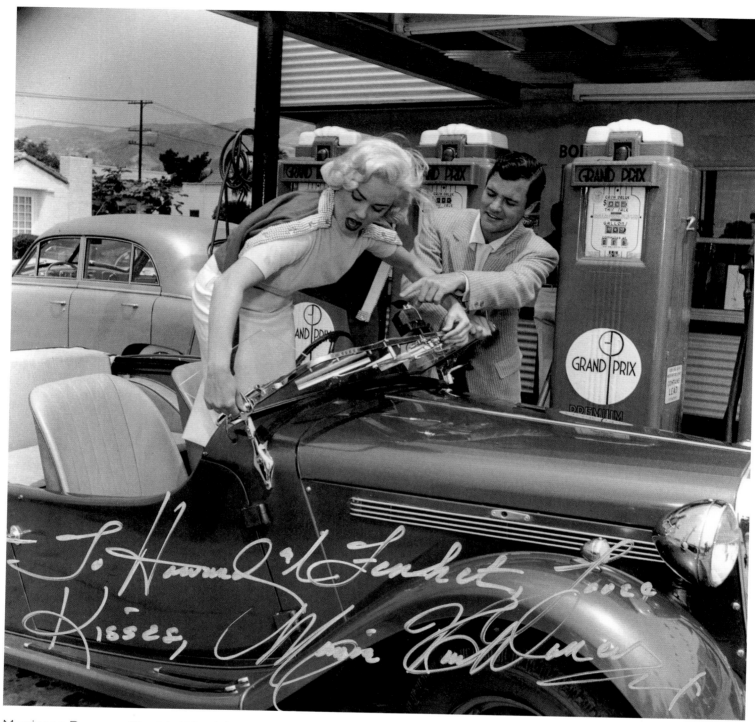

Mamie van Doren, or 'the third blonde' as she has become known, came close on the heels of Marilyn Monroe and Jayne Mansfield, yet never quite matched their star appeal. Her time came later in the platinum blonde bombshell stakes, holding her place there long after both her contemporaries were dead. Mamie was launched on-screen via repertory theatre and a modelling career. Her early work was under the careful management of producer Albert Zugsmith, who showed off his stars' assets to their best potential in a string of forgettable movies at MGM. She followed on from these to appear with husband Ray Anthony in a string of z-grade teen-dramas set to exploit the late 1950s moral code, including *High School Confidential* (1958) and *The Beat Generation* (1959), with Mamie as the epitome of 'good girl turned bad'. The deaths of both Monroe and Mansfield gave Mamie the chance to take her newly acquired 'siren of sleaze' persona to a whole new level by way of personal appearances, her own website and a series of frank 'kiss-and-tell' press interviews during which she talks about famous conquests and lovers (Tom Jones, Elvis Presley and Frank Sinatra amongst them). A successful businesswoman (she owns and operates a vineyard in Southern California), Mamie has found longevity where others more than half her age have failed, with the adage, *"You have to be smart to play dumb"* never far from her surgically enhanced lips.

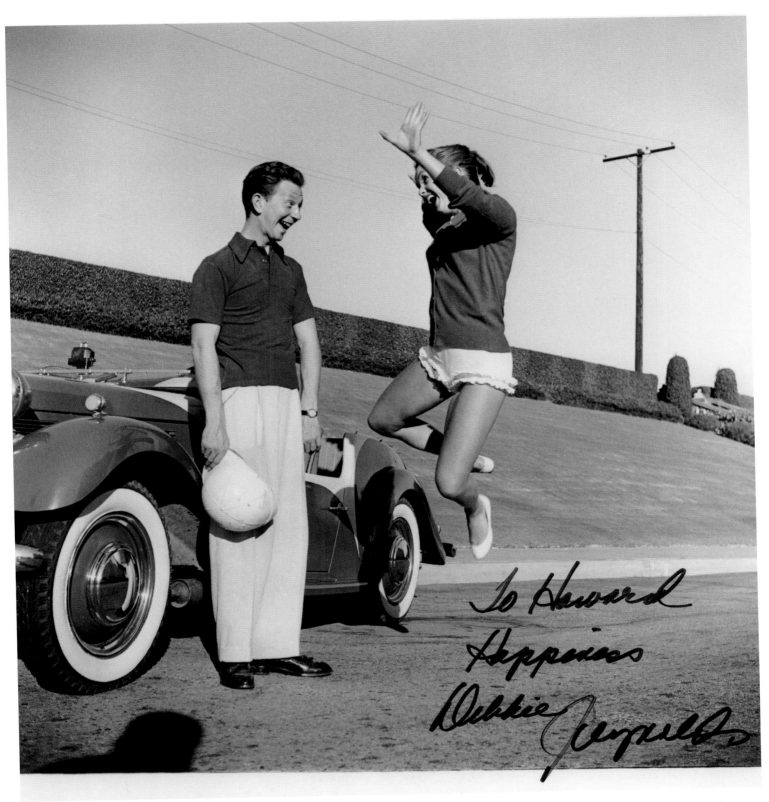

To Howard
Happiness
Debbie Reynolds

Fast Track to Fame: Taking a break from filming, *Singin' In The Rain* (1952), Donald O'Connor and Debbie Reynolds are on the road in Hollywood. *"Dancing with Gene Kelly and Donald O'Connor was a real task for a girl of 17 years of age, who had never danced before; to learn to keep up with these brilliant dancers took courage. I think I did a good job."*

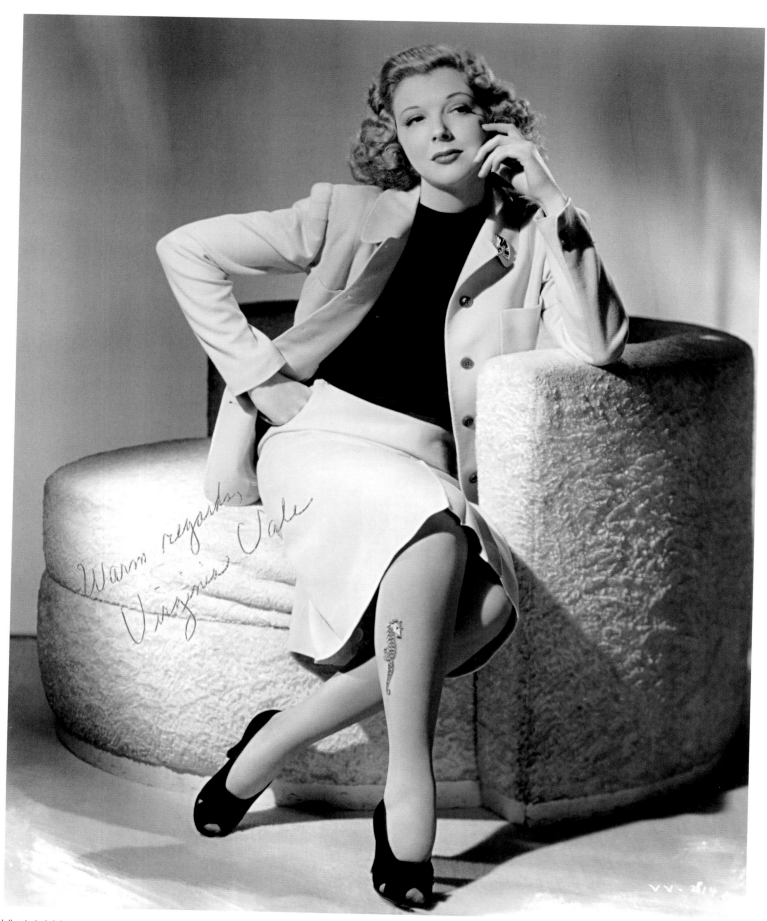

Warm regards,
Virginia Vale

Virginia Vale appeared in more film fashion magazines than the average cowgirl during the 1940s. Critics said she could have done more with her career. *"I never played the Hollywood game. I always lived a sheltered life, and that is the only reason I didn't go further than I did."*

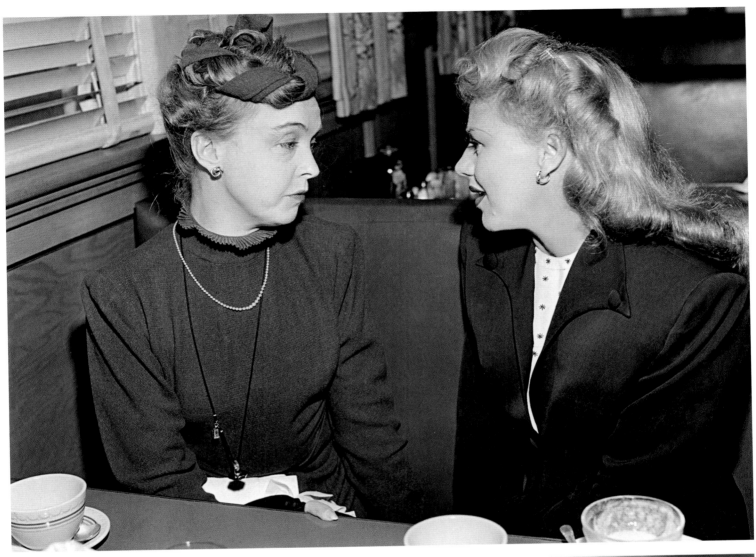

(above) First lady: Lillian Gish made her film debut at the dawn of film making and her 'legend' under the direction of D.W. Griffith, who asked her to risk life and limb whilst filming *Way Down East* (1920). She was Griffith's greatest creation illuminating his work - *Birth of a Nation* (1915), *Intolerance* (1916), *Orphans of the Storm* (1921). She had nothing if not staying power in a career that lasted eight decades, her other credits include: *The Wind* (1928), *Duel in the Sun* (1946), *Night of the Hunter* (1955), *Unforgiven* (1960), *A Wedding* (1978) and *The Whales of August* (1987) with Bette Davis. Here with Ginger Rogers (right) at the Selznick Studios, 1944.

(right) Joseph Cotton became an established star after his appearance in Orson Welles' *Citizen Kane* (1941). His other highlights include *The Magnificent Ambersons* (1942), *Shadow of a Doubt* (1943) and *The Third Man* (1949).

(above) Douglas Fairbanks Jr. married Joan Crawford at the age of 19, only to divorce her four years later after discovering her affair with Clark Gable. *"Clark was such a nice guy that even in my private distress I couldn't blame him."* Douglas and Crawford remained friends up until her death in 1977. *"Work to her was the only reality."*

(left) Hilda Campbell-Russell began her acting career on stage as an 'Indian brave' in *Peter Pan* (1920) with Gladys Cooper. A successful life in the British theatre followed with the occasional film role. The stage was her true passion, Hilda always insisted that there was nothing better than performing to a live audience; in repertory theatre she was performing in a different town every week. Her film credits include *Java Head* (1934) with Anna May Wong, *His Majesty and Co* (1935), as Charles Buddy Rogers' secretary in *Weekend Millionaire* (1935), *No Escape* (1936), *2000 Women* (1944), *No Highway* (1951) and *The Knack* (1964). Her sister was the actress Patricia Russell. In their youth the pair were notorious on the London scene; they were two of the first women to play polo. The newpaper headlines ran, "Women Conquer Another Field". Patricia retired to raise a family in 1939, whereas Hilda never gave up the greasepaint. Both lived their final years in Hampshire, England. Hilda died in 2002, Patricia in 2004.

(right) Joyce Mathews was more famous for her seven marriages (she married impresario Billy Rose and the comedian Milton Berle twice) than her screen career. She arrived in Hollywood and joined the back of the chorus, but was promised more by Paramount Studio executives. However, her career never developed much further than playing bit parts. Joyce was a constant figure for the gossip columnists, such was her extravagant lifestyle and string of lovers. Milton Berle often joked that Joyce was, *"the only girl I knew who went to Tiffany's with a shopping list!"*

(below) Hot Date: John King and Joy Hodges dine out at The Brown Derby, Hollywood, August 1937.

Marlene Dietrich's lawyer was quoted as saying that at the time of her death in May 1992, she'd been looking at photographs of herself. A fan of her own performance, she would frequently play recordings of up to 10 minutes of the applause she received following her stage appearances – preferably to male journalists.

(above) Mae Clarke was signed to Fox Studios after a talent scout spotted her on Broadway in 1929. Brought out to Hollywood, she endured in a career that lasted for almost 30 years; blonde and pretty she never quite made the same success as her friend Barbara Stanwyck. Here with director Edgar Selwyn, MGM commissary, 1933.

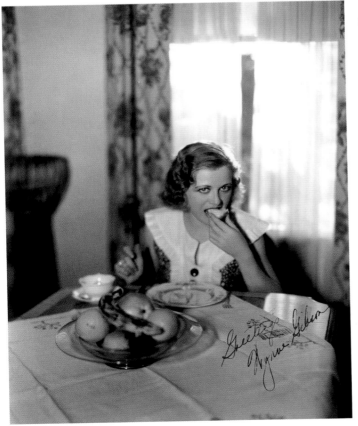

(left) Wynne Gibson was a Broadway flapper in musical comedy before arriving in Hollywood, playing the female lead in mostly B-pictures during the 1930s. In retirement she set up home with actress Beverly Roberts in Laguna Niguel, California.

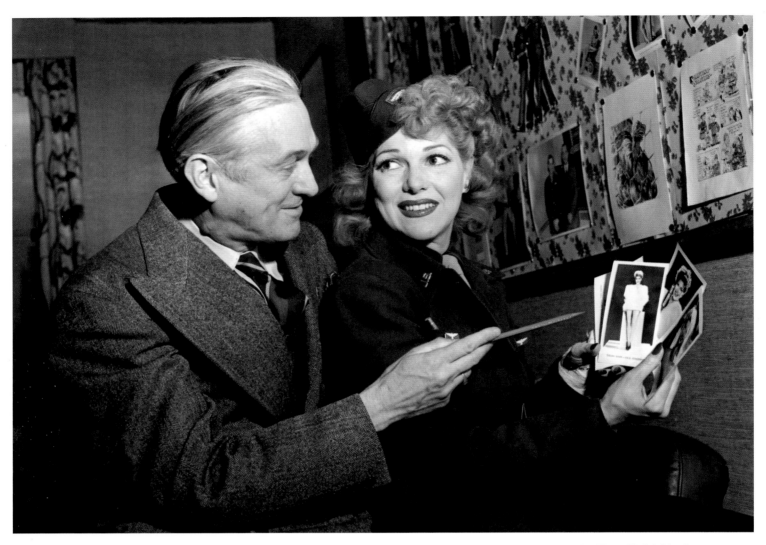

(above) Thelma White earned the title 'The Girl With the Unkempt Hairdo' during her long reign in show business. Her film career never really matched her success on stage as bandleader with 'Thelma White's All-Girl Orchestra' and as a comedienne. Later she became a Hollywood agent with a host of stars, including Charles Coburn and Robert Blake. Here at The Hollywood Canteen, 1944.

(left) Jane Powell began her film career at the tender age of 15, starring in *Song of the Open Road* (1944) in the role of 'Jane Powell'. MGM thought the name suited her perfectly, signing her to a long-term contract, putting her to good use in a series of lavish Technicolor musicals, including *Hit the Deck* (1955) and *Seven Brides for Seven Brothers* (1957). The following year her contract was dropped simply because their 'cute golden blonde' had grown up. Here with Hedda Hopper before performing on Hedda Hopper's *Hollywood Show*, 1945.

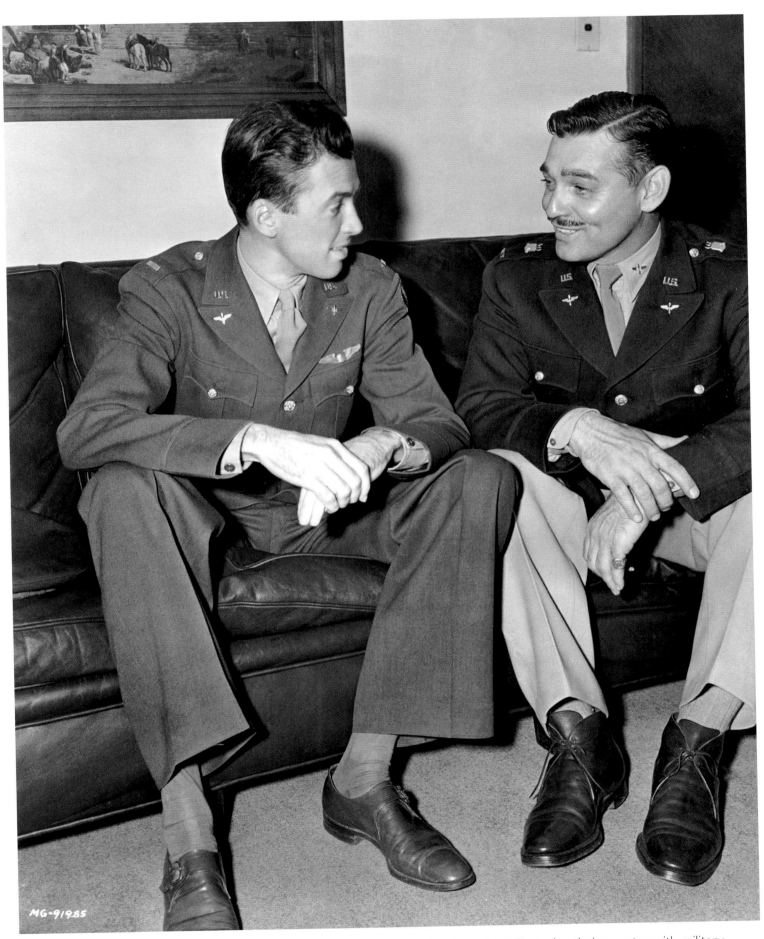

Active Duty: James Stewart with Clark Gable. Both men saw active service during WWII, serving their country with military honours.

Girl Power: Shirley Chambers made her film debut in the chorus of *Whoopee!* (1930) starring Eddie Cantor, before going on to appear in a series of lightweight dramas and musicals. *"Hollywood worked us gals from dawn till dusk — to be crude they worked our arses off. But on-screen it just looked as if all we had to do was stand there and look beautiful."* (from left) Ruth Hall, Shirley Chambers, Mae Madison and Geraldine Barton try their hand at bicycle polo, February 1932.

(right) Animal Magic: Eddie Quillan performed with his brother John and sister Marie on stage, before making their break in films during the mid-1920s. It was Eddie who had the biggest success out of the trio. Here with 'Mutt' his Great Dane and 'Jeff' his French bulldog, March 1931.

(below) Hitch a Ride: Frances Lee and Bobby Vernon take a wrong turn. In 1933, her career virtually over with the arrival of sound, Frances lost out on the role of 'Ann Darrow' in *King Kong* (1933) simply because Fay Wray could scream the loudest! Later she taught deportment classes to the daughters of Richard Nixon.

(above) Sophia Loren was just about the hottest actress in the world. *"Take that anyway you want,"* wrote Tab Hunter in his 2006 autobiography *Tab Hunter Confidential*. *"Loren arrived in Hollywood in 1955 with the powerful force of producer turned husband Carlo Ponti managing her every move."* Here with a guest at Angelo's restaurant in New York, 1953.

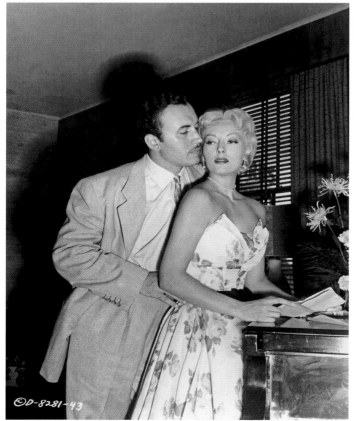

(left) Hollywood's Most Provocative: Helene Stanton was 25 years old when she married Kenneth Harlan – 33 years her senior. He had been married five times before. The marriage didn't last, divorcing less than four years later. She told a Hollywood newspaper at the time, *"It is too bad it didn't last. He is very nice. I'd like to take him out to lunch."* Her career didn't last either, and in 1957, she married again to physician Morton Pinsky. Their son is the renowned TV reality star Dr. Drew. Here with Michael Ansara on the set of *New Orleans Uncensored* (1954).

Whit Bissell holds a special place in the hearts of horror fans of the 1950s for his 'mad scientist' portrayals in such cult classics as *I Was A Teenage Werewolf* and *I Was A Teenage Frankenstein* (both 1957). Whit originally began his career on stage, before hitting Broadway and then Hollywood.

Star Rally: Dorothy Lamour, American actress and singer, is best remembered for appearing alongside Bob Hope and Bing Crosby in the *Road to…* film series. She began her career as a big band singer. Here with Gary Cooper and Ginny Simms (left) at the Lakeside Country Club war bond tour, 1944.

Ding-Dong: Back in London after a brief stay in Hollywood, Peggy Cummins married businessman Derek Dunnett in 1950. Her dress was designed by The House of Worth (and Paquin) with shoes by Edward Rayne. The couple remained married for 50 years, until his death in 2000. Recently, Peggy has been on the film festival circuit. In 2012, she was honoured at the Turner Classic Film Festival in Hollywood, where she told a packed house at The Egyptian Theatre, "I came to America in 1945 and stayed for five years. I haven't been back since, so it is lovely to be here. If I look back now, I feel so sentimental because everyone I knew – the stars and I mean stars, are now dead."

(above) Randolph Scott was the quiet-talking and versatile leading man who will be best remembered for his work in Westerns. He starred in more than 20 in as many years, including *Santa Fe* and *Fort Worth* (both 1951). He began his career in musicals at RKO, supporting Fred Astaire and Ginger Rogers in *Roberta* (1935) and *Follow the Fleet* (1936), and Cary Grant in *My Favourite Wife* (1940). Between 1950-53, he was one of Hollywood's top box-office draws. Here with Hollywood columnist Sheilah Graham (left) and Claire Trevor.

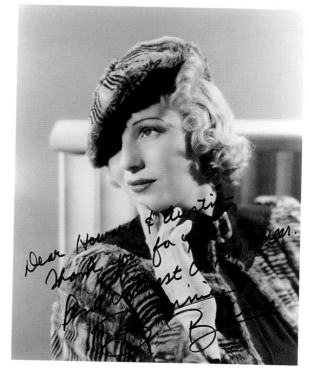

(right) Binnie Barnes' biggest break came when she was cast as 'Catherine Howard' in *The Private Life of Henry VIII* (1933), which won Charles Laughton an Academy Award for his role, and Binnie passage to Hollywood. She quickly cut a career for herself playing the wise-crack friend of the female lead in more than 75 films across four decades.

Marjorie Lane arrived in Hollywood with her mother during the mid-1930s, where she quickly attracted the attention of Louis B. Mayer whilst performing at the Trocadero Club on Sunset Boulevard. She was immediately signed to contract as a voice recording artist, most famously dubbing the singing voice of Eleanor Powell in a string of movies, including *Broadway Melody of 1936*, *Born to Dance* (1936) and *Rosalie* (1937). In 1936 she married actor Brian Donlevy (pictured here), settled in Beverly Hills, and then retired in 1942 to raise their family. The couple divorced in 1947, after which she married twice more. Away from the spotlight, she remained in California until her death in October 2012, aged 100.

Flower Power: film personality Shirley Jones was a former beauty contest winner who went on, via Broadway, to star in a number of Hollywood films, including *Elmer Gantry* (1960). She found fame, however, on TV playing the mother in *The Partridge Family* during the 1970s.

Banana Splits: Kim Novak (left), sensuous and seductive, gave her finest performance in the dual role of 'Madeleine' and 'Judy' in Alfred Hitchcock's *Vertigo* (1958). Her other roles of note include *Pal Joey* (1957), *Strangers When We Met* (1960) and *Kiss Me, Stupid* (1964). Here with Debbie Reynolds (right), Hollywood, 1955.

(left) Joyce Compton gave audiences the 'come on' in a series of comedies and lavish melodramas during the 1930s and '40s, earning her the title of 'Hollywood's Dumb Blonde'.

(below) Beach beauty: Dorothy Granger left them laughing in a career that saw her feature in a series of comedies alongside W.C. Fields, The Three Stooges, Charley Chase and Laurel and Hardy.

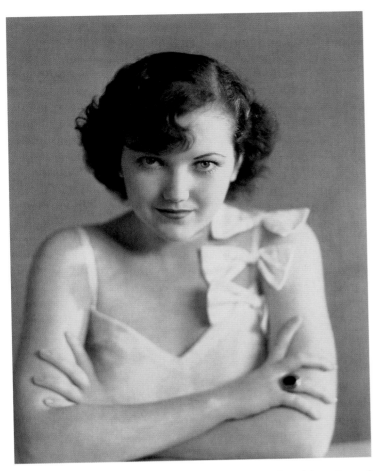

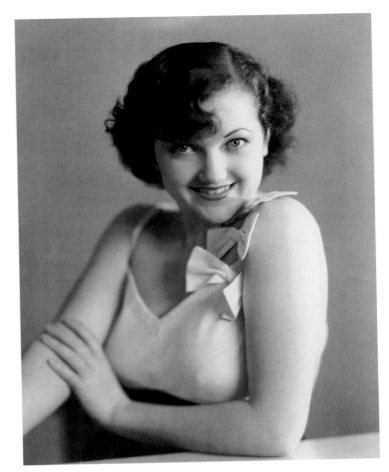

Double Take: Lois January, was a perky, round-faced heroine of B-movie Westerns, whose actual claim to fame was her uncredited role as the redhead manicurist who tends to the 'Cowardly Lion' (played by Bert Lahr) in the Emerald City sequence of *The Wizard of Oz* (1939). During her film career in the 1930s-40s, she worked for practically every studio in Hollywood, appearing in, among other films, *Susie's Affairs* (1934), *Stolen Harmony* (1935), *Skull and Crown* (1935) and *Courage of the West* (1936). Later she appeared on stage, radio and television – mostly in commercials. In 1981, she was unceremoniously killed off by a Los Angeles newspaper, which ran her obituary; typically, she laughed it off. During the early 2000s, she launched her own website chatting to fans of 'Oz' online. Lois died in August 2006, aged 93.

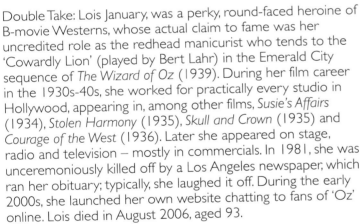

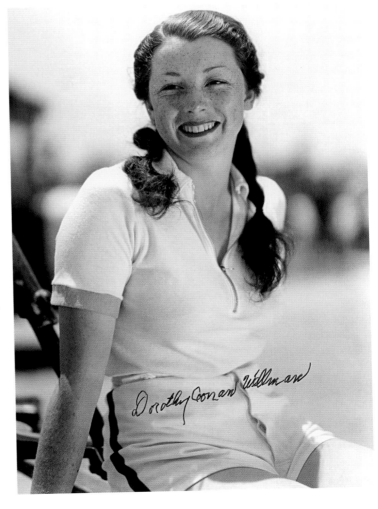

Home-maker: Dorothy Coonan, was a Hollywood ingénue who enjoyed a brief career on film during the 1930s, before becoming the fourth wife of famed film director William Wellman. The couple met and married shortly after he directed her in one of his most famous films, *Wild Boys of the Road* (1933), dressing her up to play the film's principal female character, a tomboy called 'Sally'. William was a tough hard drinker. Coonan is credited as saving Wellman from 'a life of self destruction'. *"I was no easy walk-over by any means; with me, Bill had met his match!"*

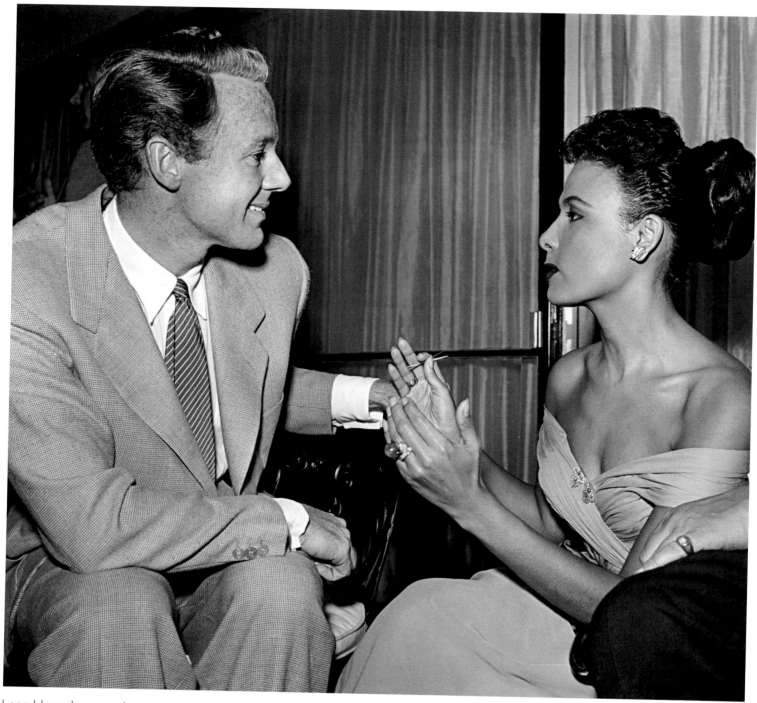

Lena Horne's career began as a dancer in the Cotton Club; her dark and sultry looks brought her to Hollywood, where she was cast in Vincent Minnelli's *Cabin in the Sky* (1943), followed by *Stormy Weather* (1943). Her phenomenal singing voice gave her longevity, entertaining new generations long after her screen career was over. Here with Van Johnson, at a house warming party for Mr. and Mrs. Harry Jameson, 1953.

(right) Retail Therapy: Frances Drake was the subject of a bidding war when she arrived in Hollywood; Fox wanted her, as did Universal, but Frances held out with the smart set in London, before she got what *she* wanted – a star contract with Paramount. Her first film assignment was *Bolero* (1934) with George Raft, Carole Lombard and Sally Rand. Here with Gracie Allen on a shopping spree in Hollywood, December, 1933.

(below) The much-married Renee Torres – here with Universal Studio mogul Carl Laemmle Jr. in 1936 – made only a handful of films, far fewer than her more famous sister, Raquel Torres.

(right) Hitched up for a ride: Vivian Austin, petite, brown-eyed with fair skin, arrived in Hollywood by way of a series of beauty contests, including Miss Hollywood, which she won in 1943. She had earned her stripes performing in local theatre around Los Angeles, which helped her garner a contract to Universal Studios, where she played supporting roles in B-movie serials, dramas and Westerns.

(below) Beatrice Lillie was a mad-cap comedienne who made her debut on the London West End stage, before making her name in America. In 1920, she married Sir Robert Peel, only to combine a career on Broadway and on film. Here with Sherman Billingsly, owner of The Stork Club, New York, 1943.

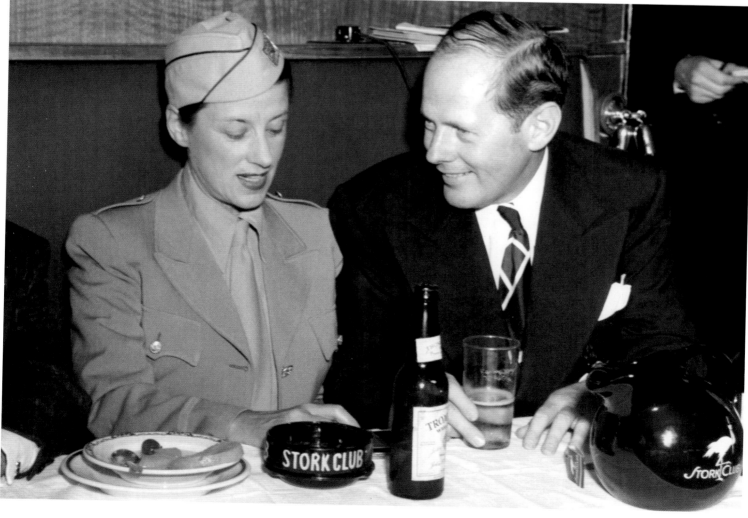

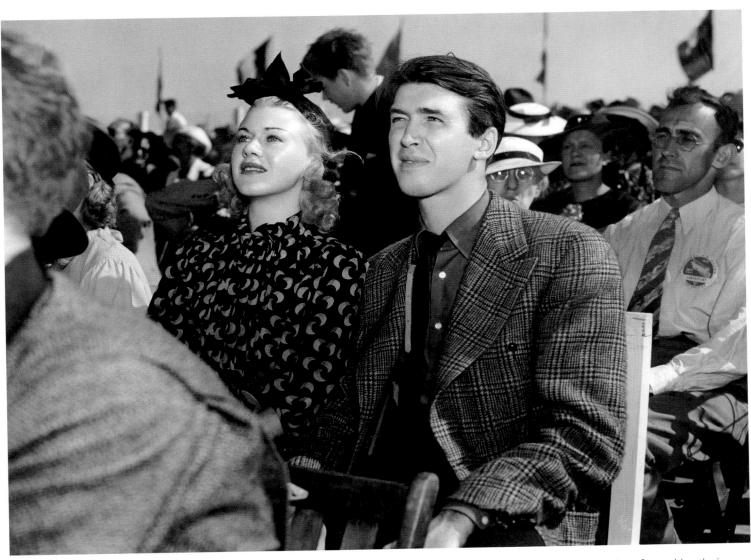

Winning Team: Ginger Rogers and James Stewart formed an early friendship in Hollywood, which was further forged by their duel win as Best Actress and Best Actor at the 1940 Academy Awards: hers for her role in *Kitty Foyle*, his for his portrayal as 'Macaulay Connor' in *The Philadelphia Story*. Here at the National Air Races, California, 1936.

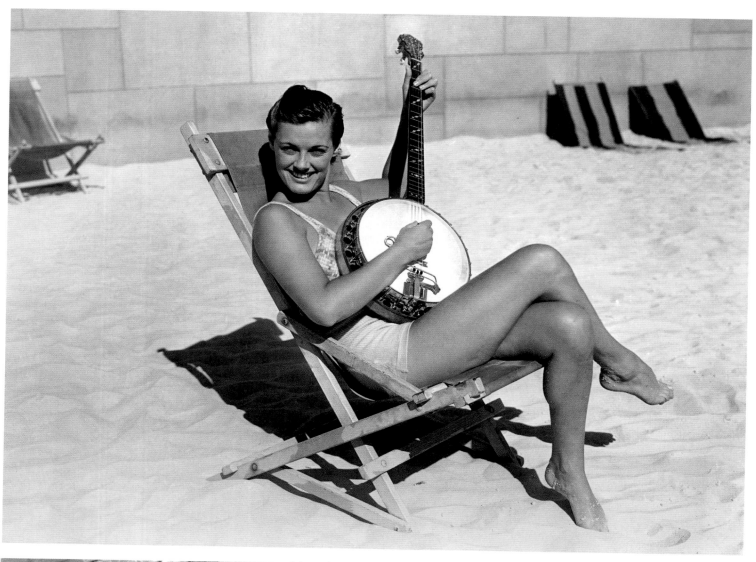

(above) Hollywood Champion: Eleanor Holm turned down theatre impresario Florenz Ziegfeld to concentrate on becoming a champion swimmer: she was a member of the US Olympic team in 1928 and 1932. Four years later she qualified again only to be thrown off following a quarrel with Olympic Officials over smoking cigarettes, drinking champagne and shooting craps on board a liner bound for Berlin. *"This episode worked in my favour since it made me a bigger celebrity than before,"* she said.

(left) Under her Umbrella: Sally Blane began her career in silent films both as a child and a teenager, before progressing to ingénue roles during the 1920s. Her career, however, never equalled that of her more famous sister, Loretta Young.

(left) Sybil Jason with her beloved Scottie dog on Hollywood Boulevard in July 1935. The popular child star was set up by Warner Brothers to rival Shirley Temple.

(below) Dubbed 'The Pint Sized Mary Pickford', Virginia Davis (centre wearing glasses) was Walt Disney's first 'live' star, in the *Alice Comedies*, which ran between 1923-1925, earning Disney the resources to pen Mickey Mouse. She later worked as a chorus girl and supporting actress across Hollywood.

A.C. Lyles (here with Vera-Ellen in 1949) arrived at Paramount Pictures as office boy to studio mogul Adolph Zukor. An ambitious lad, he didn't stop there for long and quickly rose through the ranks to become one of the studio's brightest film publicists and producers. He particularly found his niche in Westerns, and was instrumental in bringing *Rawhide,* with a little known actor called Clint Eastwood, to our TV screens. More recently, he has been a champion for HBO's *Deadwood.* In August 2013, he looked back on celebrating 85 years at Paramount. *"I get the same thrill walking onto the Paramount lot as I did the first day I came here in 1928. When people ask 'Who owns Paramount?' I'm tempted to say 'I do'."* A.C. Lyles died in September 2013, aged 95.

First Lady: Jane Wyman appeared in 40 films during her first nine years in Hollywood; most were less than memorable. In *Tugboat Annie Sails Again* (1940), she co-starred opposite Ronald Reagan and subsequently married him. From the mid-forties things improved; she supported Ray Milland in *The Lost Weekend* (1945), was given an Academy Award nomination for her role in *The Yearling* (1946), and won the coveted Oscar two years later playing a deaf mute in *Johnny Belinda* (1948). Her acceptance speech is often cited as one of the Academy's best ever, *"I won this by keeping my mouth shut,"* she said, *"and that's what I'm going to do now!"* The same year she divorced Reagan. In the 1950s, she scored highly for her performances in director Douglas Sirk's *Magnificent Obsession* (1954) and *All That Heaven Allows* (1955). During the 1980s, she switched to television, playing the family matriarch 'Angela Channing' in the primetime soap opera *Falcon Crest*. Here with Peter Lawford, out in Hollywood, October, 1948.

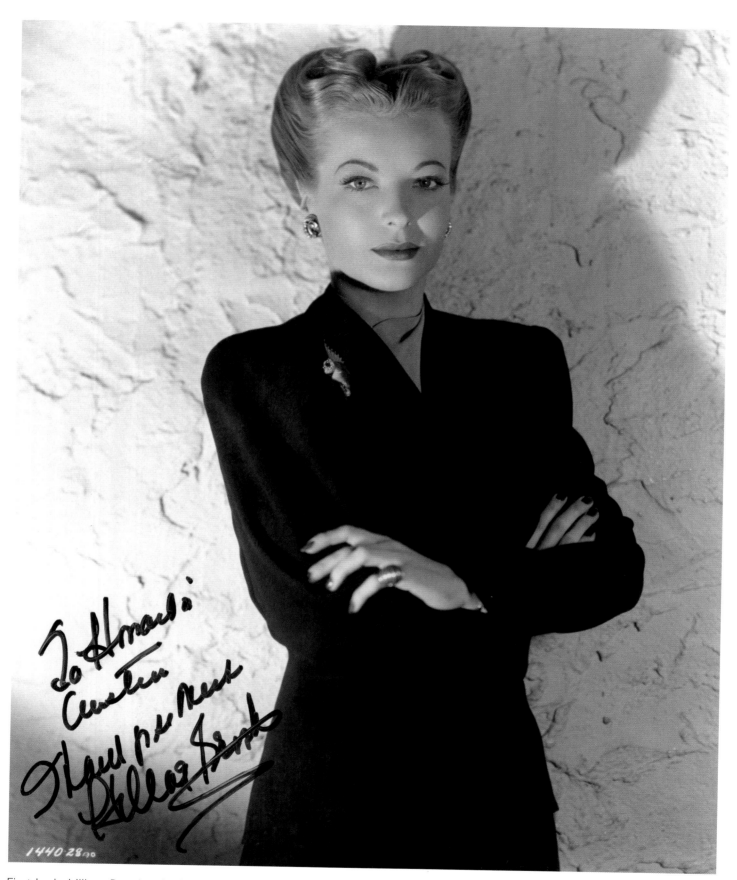

First Lady: Hillary Brooke, the ice-cool blonde, played the female lead in a few B-movies, but was mostly a character actress specialising in wicked ladies or callous wives. She was striking but never sexy, which, she later said, gave her career its longevity. She joined Cary Grant and Katharine Hepburn in *The Philadelphia Story* (1940), Orson Welles and Elizabeth Taylor for *Jane Eyre* (1943), co-starred with Bob Hope in *Monsieur Beaucaire* (1946), and featured on TV in *The Abbott and Costello Show*, *I Love Lucy* and *Perry Mason*. Twice married, she looked back on her career admitting that, "I neither liked it or loathed it." She was awarded a star on the Hollywood Walk of Fame during the 1990s.

(right) Linden Travers, was equally at home playing in light comedies or in dramas as the femme fatale. An exquisite beauty, she was England's answer to Hedy Lamarr in looks, poise and grace. Unfortunately her career never developed in the way it should have. Her most famous role was in Alfred Hitchcock's *The Lady Vanishes* (1938). Her own favourite was *No Orchids For Miss Blandish* (1948), in which she reprised the title role she played on the London stage some six years earlier. She later retired to St. Ives, Cornwall, where she studied psychotherapy and qualified as a hypnotist.

(below) Sister Act: Rita Lupino, came to Hollywood on the coat-tales of her elder sister Ida Lupino, though her career never matched her longevity or success. She made her film debut in England whilst under contract to B.I.P Studios; including the Renee Gadd comedy *Money for Nothing* (1932), *Sleepless Nights* (1933) and *Brazil* (1944) with Tito Guizar and Virginia Bruce. Here with Ida (left) at The Brown Derby in Hollywood, December, 1942.

Vampira

A HOLLYWOOD HORROR STORY

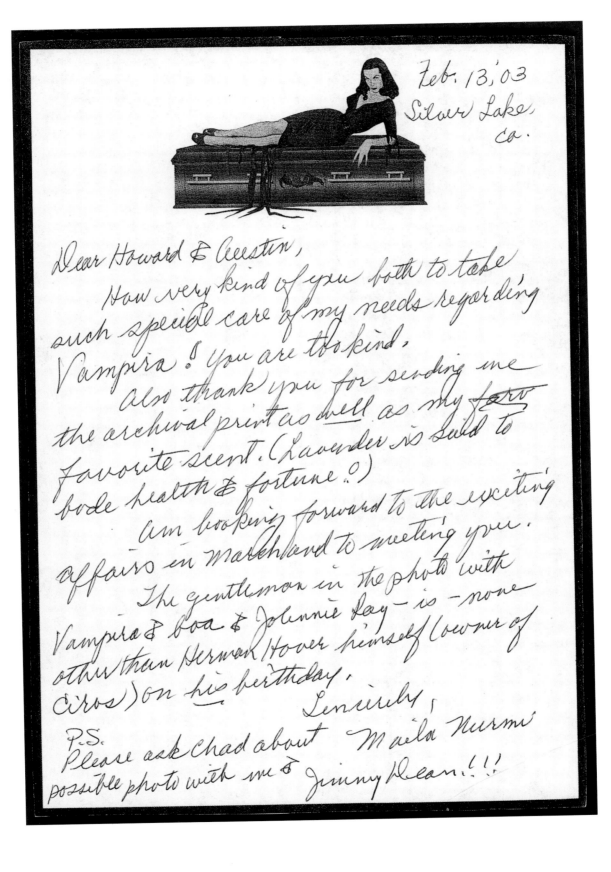

Feb. 13, '03
Silver Lake,
Ca.

Dear Howard & Austin,

How very kind of you both to take such special care of my needs regarding Vampira! You are too kind.

Also thank you for sending me the archival print as well as my <s>favo</s> favorite scent. (Lavender is said to bode health & fortune.)

Am looking forward to the exciting affairs in marchland to meeting you.

The gentleman in the photo with Vampira & boa & Johnnie Ray — is — none other than Herman Hover himself (owner of Ciros) on his birthday.

Sincerely,

Maila Nurmi

P.S. Please ask Chad about possible photo with me & Jimmy Dean!!!

Well I haven't been invited to anything in Hollywood for an age and so you boys are *dahlings* to think of me," says Maila Nurmi, her accent Finnish but also exotic. "Oh but my dahling, nobody will remember me. Everyone I knew is dead, but that's okay," she adds rather mournfully. Then with a sigh of acceptance, "I was a rebel in Hollywood along with Jimmy Dean and Brando. I knew Marilyn Monroe when she was a strawberry blonde called Norma Jean. We danced and modelled in all the wrong places," she laughs. "Oh and Elvis and I were really close… And now there's just me."

We've been on and off the phone for a week. I've invited Maila to a Private View at Sotheby's on Wilshire Blvd celebrating the work of a Hollywood photographer she'd once posed for called Frank Worth.

"What do I wear to the party?" she asks, slightly aloof. "Is it long or short dress or is it modern Hollywood where everybody dresses for the beach?" she hisses. "A mix of both," I say, unsure. "Okay! Well honey that's fine. I'll create something – it's what I did when I invented 'Vampira' – I've a wild imagination," she thanks me and hangs up.

I have visions of Maila in fancy dress. A crazed get-up like the one she created for 'Vampira', her alter-ego back in the 1950s when she was the toast of the early days of TV land. As 'Vampira' she wore a Charles Adams-inspired costume over bondage gear; an up-lift bra and leather belt – her measurements, a mind boggling 38-17-36. Her natural blonde hair covered by a raven-black wig with fake 9-inch scarlet talons stretching from each finger. She smoked from a foot-long cigarette holder.

I have arranged for a car to collect Maila from her apartment. She doesn't want me to visit her there. "Oh, don't come for me," she says over the phone, pleading. "Don't. I'm not in a classy neighbourhood in Hollywood," she continues. "It's trashy. I have cats, lots of cats and no money," her tone gets higher pitched to emphasize her reduced circumstances. After several more calls we iron out the final arrangements.

"So it's a date, Austin," she says. "I will be there as the sun sets and the moon rises. I will be there." She gives a sort of howl and hangs up.

I go to find Howard who is making coffee. We are in Palm Springs and leaving shortly to drive the long hours to Hollywood for the event. "Maila's on for tonight," I say standing in my shorts.

"I heard you," he says. "I think she is going to come as 'Vampira'," I laugh, a little nervously. "You may laugh, Austin but it's the only way she'd be recognised," says Howard.

I knew he was right. "Yes," I say, "but I wouldn't want people to laugh at her dressed in costume. In mean, the 'Vampira' of half a century ago had the jugular pulse of an entire generation of men pumping wildly – Vampira is now in her 80s."

Howard turns to face me, "You have it wrong Austin. Maila is actually one of the most normal people we know – look at the actors who played the 'Munchkins' from *The Wizard of Oz*. Some of them were in costume pretty much to the end. It told people who they were, they were holding onto something, but certainly weren't bonkers. In a way they were giving fans what they wanted."

"Well she's talking about the moon coming up," I say. "She's pulling your leg," says Howard, calmly drinking his coffee. We look at one another. "Well Howard, one way or another, I think we're in for a treat."

I am at Sotheby's by 5pm, an hour early. Smartly dressed in a Spencer Hart suit, I stand outside at the entrance, smoking a cigarette, waiting for her car. Howard is already inside. The driver has my mobile number to warn me of her imminent arrival. I watch new and old Hollywood sashay past me: Sharon Stone, James Woods, Noreen Nash, Shirley Jones, Mary Carlisle… Then I get the call. "Mr. Austin," says the driver, "We are here."

I watch Maila step out of the limousine. I rush over to assist. "Oh, I made it," she says rather out of breath. At first I mistake this for nerves but she isn't nervous, she's excited.

She is dressed in dark colours: flowing top, wide flares over ballet-pumps. Her eyes are the palest blue off-set by heavy raven-black mascara. Her thin, long bottle-blonde hair is tied back to extenuate her china-white face, her impressive cheekbones are well-rouged, her lips red and her eyebrows drawn-in high and arched.

She takes my hand as we move a few steps forward and then onto the red carpet. I feel her starting to loosen her grip and she begins to react with childish glee as behind crash-barriers people, fans, started to call the names of the stars surrounding us, some just screaming for the hell of it.

"I love screams," she says smiling, her eyes widening. "Maybe I'm scaring them?" She edges forward slowly; tiny steps. She is obviously feeding off the atmosphere. She

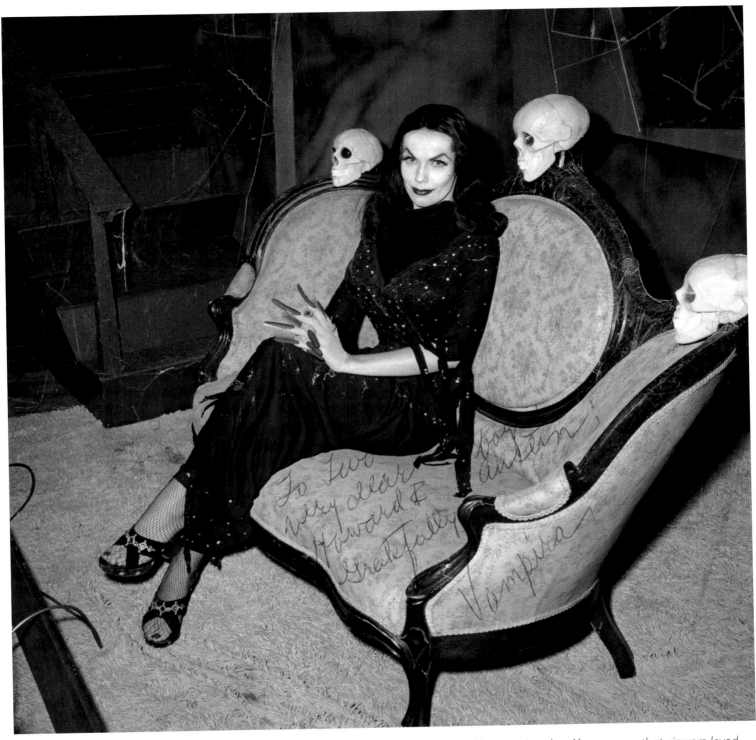

James Dean's 'Black Madonna': *"My dresses were so tight they looked as if they had been painted on. You can say that viewers loved me. I had mountains of fan mail, mostly from men; one could say I encouraged it."*

waves at fans and blows kisses. A photographer comes in close and blinds her with his flash.

"What's the name?" he asks, a small pad and pen in hand. "*Vampira!*" she screeches dramatically. Puzzled, he looks at me. "Did she say 'Vampire'?" "No," I say, still holding her hand but Maila looking the other way, "Her name is 'Vampira' – she was a star of Horrors."

"Well whatcha know – I remember her – hell, I thought she was dead." He writes her name down but not before he's shot her some more: Bang! Bang! Bang! Maila eats it up.

Other photographers are calling out "this way" and "over here" – she lets go of my hand again and waves at the photographers, their flash-bulbs invigorating her. Fans, six deep in places and surrounding us along the red carpet, are cheering even louder – if it were possible, 'Vampira' has ascended into heaven. "Oh, how wonderful," she says as we reach the entrance turning round again for another wave.

"Your name, sir?" asks a girl with a guest list. "Austin Mutti-Mewse and Maila Nurmi."

"Oh, now that's splendid!" says the girl, a red-head in her twenties. I read her name badge: 'Maxine'. Maxine shakes my hand and all but curtseys to Maila. Maxine turns scarlet – she seems flustered. "Oh, good evening M'am. I'm a fan. Well I'm not a fan, but my father is a fan." Maila just stares, her smile stuck in a wide grin from her red carpet experience. "You see," Maxine carries on, "I just spent the weekend with my folks and I had the guest list with me for this party and my Daddy read your name 'Vampira' and wonders if he'd be able to have your autograph?" She giggles nervously as Maila stands rigid-like. "Ah, you were like his first crush."

"Oh, that's swell." Visibly touched, Maila takes the piece of paper from Maxine's hand, fumbles in her handbag for a pen. Instead she pulls out a red lipstick and signs with confidence: 'Vampira.' She hands it to Maxine.

"I would be asked for autographs on my TV show and I would insist on writing epitaphs – it was part of my act, part of my make-up."

"Oh that's nice. Well, my Daddy was hooked on you," she smiles. "I had that power," nods Maila. "I'd look down the camera lens into the souls who watched me on TV. The press around the world felt it and commented that I had viewers in a trance." Maxine is wide-eyed as she stares at Maila. "I feel it," she says and lets us pass.

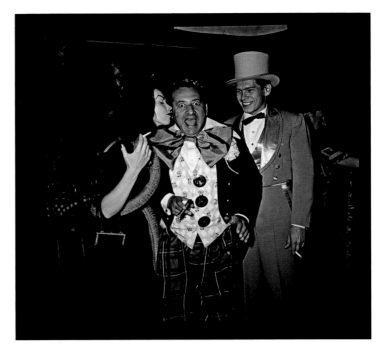

(top) 'Vampira' with Herman Hover (centre) and Johnny Ray at a themed Halloween party in 1955. Herman was the manager of Ciro's nightclub from 1942 until it closed its doors in 1957. *"Hollywood thought Jimmy Dean and I were useless bums and unruly. If one didn't go to Ciro's or the Mocambo, but some other joint instead, it was frowned upon. The studios didn't like it."*

(bottom left) Ciro's restaurant menu, from the early 1950s.

(bottom right) Reverse of the menu signed by actor Van Johnson. Vampira and Johnson died within a few months of one another in 2008.

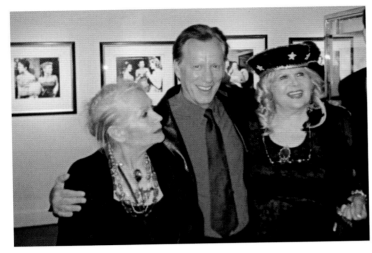

(top) Young Blood: James Woods is sandwiched between two cult TV stars from the 1950s: 'Vampira' (left) and Gloria Pall.

(bottom) During the mid-fifties, Gloria — aka. 'Voluptua' — caused as much sensation as her ghoulish counterpart. Capitalising on the success of 'Vampira', executives at KABC-TV (Channel 7) cast Gloria as the hostess of a love-themed movie programme. Dubbed 'The Eyeful Tower', her steamy on-camera antics earned her another moniker: 'Corruptua'. After just seven weeks, the plug was pulled on her show.

Inside, the walls are covered with images of movie stars, mostly from the '50s and early '60s. Maila goes up to a photo of Liberace. "Well, hello stranger," she says giving the photo a kiss. A waiter offers us a tray of martinis. "I worked with him — he employed me and we worked in Las Vegas — we got on just beautifully," she says. "Oh cool," says the young waiter. Maila takes a healthy gulp. "Yeah, he asked me to Las Vegas and I was in his act as 'Vampira'. He played the piano, whilst I vamped it up and looked sexy as hell." "Did Mr. Liberace like it?" asks the waiter. "Yes, but I think I scared him."

Next to Liberace is Doris Day — "Oh cute" — and next to Doris a photo of Marilyn Monroe posing beside a very ordinary car with an all-smiling Sammy Davis Jr. and Frank Sinatra. "He was a naughty boy," she giggles.

She spots a shot of Elvis Presley, "The first time I saw him he was wearing turquoise mascara and was a frightened kid," she shakes her head in remembrance. "Oh the poor beautiful boy had been booed off stage because he hadn't a voice — he told me he needed God to speak to him before he could sing, but he hadn't heard God that night and so he couldn't perform; I knew he'd be alright. He invited me to his place. I could make it sound glamorous but we didn't have an affair — I tell the truth. I couldn't make up what happened to me. The Hollywood publicity machine made up some crap sometimes but I didn't lie — I didn't have to."

"Gosh, you turned Elvis down?" I ask, surprised. "I was 33, I was with a no-good guy called Chuck Beadles who was a dead ringer for James Dean, but I didn't want to complicate everything. Elvis needed a friend, not a lover."

As we move further into the party, Maila's appearance turns heads. With most other female guests in glitz and gold, big hair and fake breasts, Maila looks, well, Gothic; onlookers are transfixed. Drinks refreshed, we find ourselves next to James Woods, whom I'd seen arrive earlier. Enjoying the photographs on display, he is all smiles, chatting with Sharon Stone's father. "Hello," says Maila recognising him. "Hello," says James politely but taking little notice before acknowledging me.

"Mr. Woods," I say, "May I introduce you to Maila..." She grabs my arm and stops me. "No Austin. NO!" And looking James Woods straight in the eye, she extends her hand towards his and says, "The name is *Vampira*."

Woods' eyes widen. For a split second he is lost for words and then blurts out "No way!" "It's true," says Maila, her tone dark and dramatic and both eyebrows

arched. "I know you," he says and, almost tossing his glass at me, embraces 'Vampira', spilling her martini in the process. "I love you. Shit! I can't believe you are here. I mean, you are famous. I mean, you worked with Ed Wood!"

I expect Maila to be excited by the recognition. If she is, she doesn't show it. She is poised and graceful and, although standing on the spot, moves dramatically as if in slow motion; her hands, so expressive. I don't get it but James Woods does. She is being 'Vampira'. She may as well claw him; he is lapping it up.

"What's your poison?" she says, looking at me holding the dregs in Woods glass. "Oh, love it!" he embraces her again. "I love it!"

Vampira has Woods in the palm of her hand and he is eating it up. She hands what is left of her drink to Howard, who has joined us. She delves into her handbag again and pulls out a glove made of rubber latex with scarlet talons attached to the finger tips. She puts it on. "It was part of my costume, part of 'Vampira'." She smiles at me. "I made it for my TV show, I thought you'd get a kick out of it." She stands, hand aloft, turning her hand one way and then the other, "I hope you've had a terrible week," she says in character.

"Love it!" says James Woods, frantically looking about him for a photographer. "Did you invent 'Vampira'?" he asks. "I did. The show I hosted screened old Hollywood horrors that would have appeared dull had I not added the sex element to death; audiences went wild," she says, admiring the glove in more detail. "Frank Sinatra told me he left a gig early once so not to miss me."

James Woods is loud and people are looking over. A man in his 60s nudges Howard. "Who is she?" "She is 'Vampira'," says Howard. "What is he saying, Ed?" asks a woman in a silver dress and blonde hair; his wife, as it turns out. She was looking Maila up and down, "Who is she?" "Oh, that's Vampira? Hell! She was about the sexiest woman on TV, Barbara," says Ed.

"Vampira was a Horror Hostess on late night TV in LA during the fifties," explains Howard, standing next to Barbara. "She'd introduce mostly Z-grade movies to men like your husband, who were embracing a new world of TV..."

"...oh and TV dinners," interjects Ed, laughing. He is rubbing his hands one minute, hands in his pockets the next and is staring at Maila like an excited school boy. "Oh Barb, she was hot and a hoot. Her show would start with organ music from Holst's The Planets, she had this pet spider on a giant web and then she'd appear clawing the air with these nails, these long red nails." Ed was demonstrating the act to Barbara and Howard. "She'd say, 'Hope you've all had a terrible week'. And she was sassy and had all these double entendre jokes; my mother hated her."

Barbara is looking at Maila, who has convinced James Woods to try on the glove. "You don't say? Where did she go afterwards? I mean, her show is not on now right?" "No, Vampira was killed off. She was a sensation but parental groups blasted the network, calling her sadistic. They demanded her removal from the screen."

Howard interjects: "She owned 'Vampira' and didn't want the network meddling with her act, so she was fired. This was before Yvonne de Carlo in The Munsters and Carolyn Jones as 'Morticia' in The Addams Family. Kids loved her."

"Yep, we did and our Dad's too." "You telling me Ed that your father liked her?" says Barbara, a little incredulous. "Sure. Everyone did," he states emphatically.

I look over at the couple, Barbara and Ed, with Howard. Barbara mouths "Just love her," and gestures towards Maila. I smile back and mouth, "Thanks". Maila and I are still with Woods. With Sharon Stone in arm's reach, he grabs her.

"Sharon," says Woods. "It is my pleasure to introduce you to 'Vampira'." Sharon Stone's face tells me she has no idea what her friend is on about. James sees it too. " 'Vampira' was the greatest thing on TV, introducing us kids to Horror movies on TV and she worked with Ed Wood."

"Oh, Ed Wood!" says Maila. "He wanted me for Plan 9 From Outer Space – the dialogue was so dumb that I refused to speak, so I was mute throughout!" "Oh, really? Well the film is a cult classic," Sharon shakes Maila's hand, "It is indeed a pleasure to meet you, Miss Vampira." Maila stares back. Sharon looks uneasy. "You're not going to bite, are you?" she jokes.

"I might," says Maila showing us all her toothless smile. "My name is Maila. 'Vampira' was an invention, a sort of ghoulish being I created when I was on TV as a horror film hostess. I wore a shredded black dress."

She takes the glove from James Woods and shows it to Sharon. "My nails were painted hemorrhage red – LIFE Magazine devoted six pages to me and I was put forward for an Emmy Award – a chauffeur drove me along Sunset Blvd. in the back of a hearse. I had my umbrella up, hoping for gloom."

"Oh, that's great. You must have been attractive 'Vampira'," says Sharon. "I'll take that as a compliment," says Maila. "Well I got everyone hooked. Zsa Zsa Gabor dressed up as 'Vampira' for Sonja Henie's party at the time I was at my hottest – she did the wig, the nails, the works."

"Oh, amazing," says James Woods, adding, "Hey, didn't you used to be friends with James Dean?" "You know that? Well fancy!" she says, visibly happy to be holding court. "Yes, Jimmy and I were friends. We spent just about every moment together and each one I'll treasure."

"How, wonderful," says Sharon Stone now. Fascinated in Maila. "What was he like – I mean his name has become a legend, right?" "He was a little boy who missed his mother. A little boy who didn't have anything in common with his father, who'd lost his mother and didn't know where else to find love."

Sharon Stone and James Woods are all ears. "Jimmy was a symbol of anguished youth but his mother hadn't abandoned him, she'd succumbed to cancer but Jimmy saw it as abandonment." "Oh I didn't know that," says Sharon.

"Yes it's true and I'm psychic so I saw it all. I saw that he loved women but slept with men if he thought it would get him ahead. He slept with people he wanted to sleep with, women most the time, but he was open about it all and that was brave of him - today we'd say rebellious wouldn't we," she drinks what is left in her glass and a waiter offers her another martini.

"And then he died," says Howard. "That must have affected you badly." Sharon Stone looks at Howard and then back at Maila.

"Jimmy haunted me. There'd be an ashtray in my apartment that suddenly went up in flames and I'd say to whoever was with me, 'It's Jimmy, it's a sign'. And there'd be other happenings too."

"Oh really?" says James Woods. "Yes, my mother was a witch but not a practicing one and I have psychic capabilities and have witnessed paranormal activities that perhaps were buried inside me that came out when I gave birth to 'Vampira'."

"So you saw James Dean after he died?" I ask. "I felt him. I called his name and moments later things in my apartment would move. We'd been soul mates. He'd phone me most evenings after my show wrapped because he didn't want to be on his own and then when he came over, didn't have a thing to say. Jimmy, Marlon

Austin (left) and Howard with Maila, W-Hotel, Brentwood, California, March 2003.

Brando and I were all rebels. We wouldn't kowtow to the powers that be and so it got us in hot water. It got my show cancelled and Blacklisted, it got Jimmy killed, and it messed up Marlon."

"Marlon Brando and James Dean were close?" I ask. 'Vampira' stops for a moment as Sharon Stone and James Woods edge away from us. "They were."

"I gave Austin my number and you call me," says James Woods. "We'll do lunch." He gives her a kiss. "Hey, you're paying," says Maila. "Yes, yes – would love it. Sharon would too." "Oh sure," she says as her agent presses Sharon to meet other guests and, with that, they both vanish.

Howard, Maila and I find a table with two chairs situated beside a large framed photo of 'Vampira' on the set of her show squeezed between a black and white photo of Marlon Brando and one of James Dean on the phone while taking a pee. Maila sits as does Howard, whilst I stand. She admires the photo of herself as she removes her latex glove, putting it back in her handbag.

"You mentioned Marlon Brando," I say. "Did you hear from him over the years?" "Yes, just once. Fuelled by the death of James Dean, the Beat Generation of teenagers that he, Jimmy and I and others like us had helped to create, turned on me. I'd receive outlandish love poems from one fan and death threats from another, believing that I got Jimmy into drugs and in some way was responsible for his death at the wheel of his Porsche Spyder. I never had time to grieve and I know that's why

he came to me. Jimmy came to me for six months after his death and it helped me through."

She sighs. "Oh Marlon Brando! Well he was so extremely handsome and knew it. He was being chased by Ursula Andress at that time, even though Ursula was dating Jimmy," she says, reaching behind her to look at his picture on the wall.

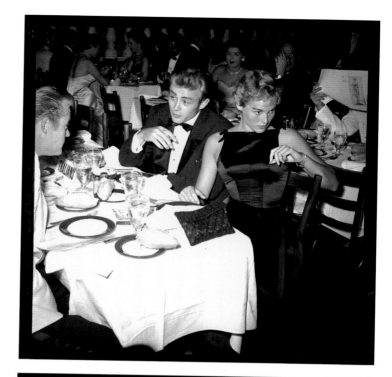

She turns back, motioning Howard to move in closer, whilst I crouch beside her. "I've never told a living soul this before but, you see, we were very similar and yet we were oceans apart. He tolerated me because he loved Jimmy and he knew we were inseparable. I was with Anthony Perkins when I heard about Jimmy Dean's death. We decided then to drive to Ursula's place as we wanted to break the news to her," she confides.

"Someone had beaten us to it. We were still in the car when Marlon jumped out of the bushes across the street. Ursula had seen the car and apparently telephoned Marlon as she'd seen my hearse outside and thought she was next to die. Marlon said he was sorry to me and then never spoke to me again. He blamed me for Jimmy's death, which was ridiculous. The thing that frightened me most was the wreath of flowers Brando sent me. He wrote on the card, 'You're dead too'." Maila shuddered. "I have no feelings now Marlon has gone."

"And you never spoke about this — about the card, the threats?" I ask. "No, Brando was still an important force in Hollywood, even at the end." Maila sat back in her chair. "You know, I'm at peace and that's rare in this town." As the night comes to a close, Howard and I escort Maila to her car.

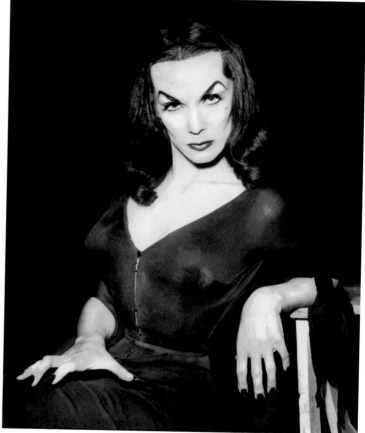

" 'Vampira' vanished and now she's back — well for tonight, for just a heartbeat and that's fine. I'm ready for her to go now."

We drove for 20 minutes and then stopped outside an apartment block. "That's me," she says. "Don't look too closely, please! It's not ritzy in any way." We wait in the car. As she gets out a cat comes bounding over to her.

"Hello, my dahling," she says. She bows with her head looking in at us through the open car window. "I was always at odds with 'Vampira' — I had compassion for those who needed it most — all God's creatures." The cat jumps into her arms. "You mean, James Dean?" I ask from the front seat.

"Ah, yes — I've been collecting strays all my life."

A Little Less Conversation: Vampira gets assaulted by Elvis Presley! She was in Las Vegas appearing with Liberace in his stage show, while Elvis was across the street performing at another casino.

(page left, top) "James Dean was a rebel – we both were, but underneath it all he was an emotional boy. He wanted to be loved by Ursula Andress (pictured here), Pier Angeli and others however nobody ever filled the void left by the death of his mother. He could turn on me for no reason and then ring me in tears afraid he'd lost me as a friend. Dean was a heartthrob but in truth he was a fraught kid crawling around on the floor".

(page left, bottom) Portrait of Vampira. "Marilyn (Monroe) told me, 'Being a failure in Hollywood is like starving to death outside a banquet hall with the smells of filet mignon driving you crazy'."

Hollywood after Dark

SOUVENIR OF

The Stork Club

3 EAST 53RD. ST. NEW YORK 22, N.Y.

Telephone PLAZA 3-1940

$1.50

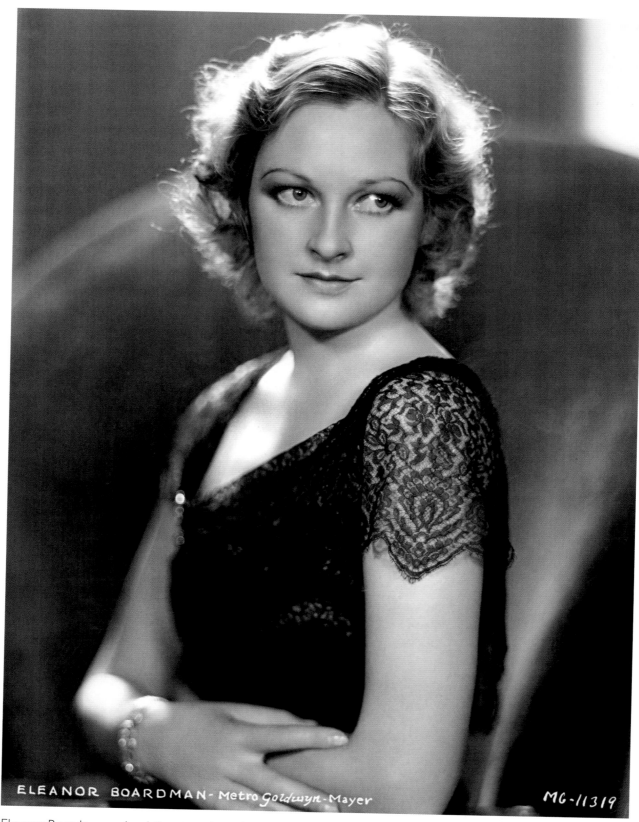

ELEANOR BOARDMAN – Metro Goldwyn-Mayer

MG-11319

Eleanor Boardman, gained the attention of Hollywood as a model for the Eastman Kodak Company. As the "Kodak Girl", she graduated to the silent screen, playing in *Vanity Fair* (1923), *Souls For Sale* (1923), *So This Is Marriage?* (1924) and *Tell It to the Marines* (1926) among others. It was her leading role in *The Crowd* (1928), however, directed by King Vidor (whom she married in 1926), for which she is best remembered. Her later screen credits never matched her earlier successes. In 1933, she and Vidor divorced. The following year, Eleanor moved to Europe, where she met and married the French director Harry d'Abbadie d'Arrast. Over the next 12 years, the couple and her two daughters by King Vidor settled in Biarritz, then Spain. During the 1950s, she worked as a correspondent for *Harper's Bazaar* in Paris, but returned to the U.S. in 1968, settling in Montecito, California, where she died in 1991.

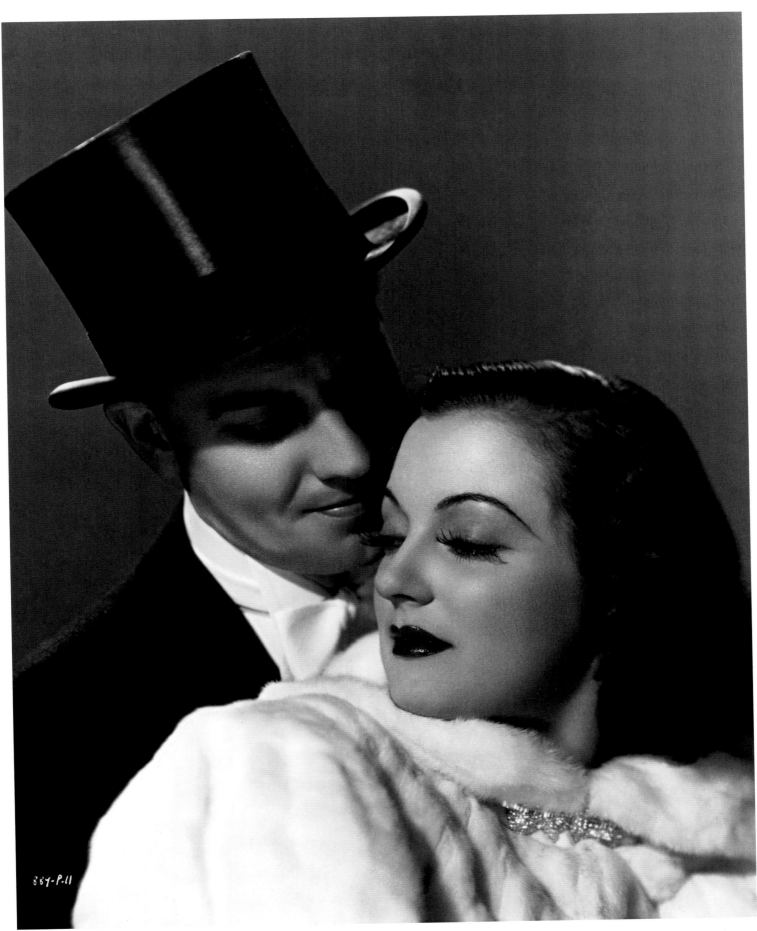

John King was happier in the saddle riding the range than in splashy film musicals whilst under contract at Universal during the 1930s. In retirement, he opened and ran a waffle shop in La Jolla, California. Here with Joy Hodges in *Merry-Go-Round* (1938).

(above) Vintage Glamour: Ava Gardner (right) projected a unique combination of earthiness and glamour with a cutting repartee in a series of memorable films. Elaine Shepherd, however, eventually abandoned her brief film career to become a successful journalist. Here together at the Mocambo nightclub.

(right) Swashbuckler: Cornel Wilde was a former member of the US fencing team, which put him in good stead as the hero in such titles as One-Thousand and One Nights (1945) and Bandit of Sherwood Forest (1946).

Socialite: Tobacco heiress Doris Duke out in Hollywood with Gilbert Roland. She reportedly had affairs with some of Tinsel town's leading men, including Errol Flynn.

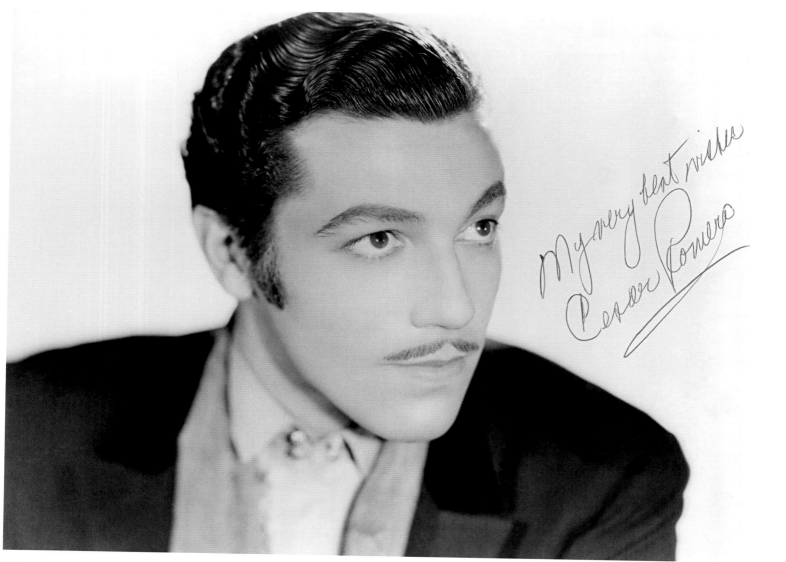

(above) The Joker: Cesar Romero, suave leading man of Spanish origin, made his film debut in 1932. However, for a entire generation he is best known as the inane comic giggling arch-enemy of *Batman* (Adam West) in the sixties TV series.

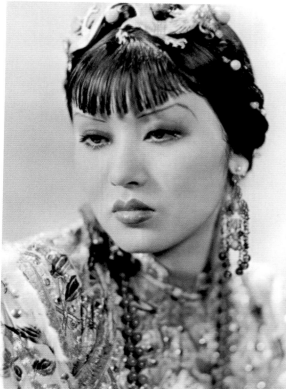

(left) The Exotic: Toshia Mori began her career as a bit player in Hollywood during the pre-Hays Code 1920s. A striking beauty she struggled to get the parts she deserved at first; with the arrival of sound she fared better. In 1932, she was signed to Columbia Studios, winning a leading role as 'Mah-Li' in Frank Capra's *The Bitter Tea of General Yen*. Hollywood described her as an 'Oriental Toby Wing' – Paramount's resident chorus cutie – certainly she was photographed nearly as much and publicised to be a great star. It wasn't to be, however, since within three years she was reduced to a string of minor roles in *Charlie Chan at the Circus* (1936), *Charlie Chan on Broadway* (1937) and *Port of Hate* (1939).

Xavier Cugat with his wife Abbe Lane (centre) share a joke with Carmen Miranda at the Mocambo Club, Hollywood, July 1952.

The handwritten inscription on the photo reads:
To Austin + Howard, Greetings from the old 'Stork Club' — what memories. Jane Kean

(above) Jane Kean, star of Broadway, film and TV, is best remembered for her role as 'Trixie Norton' in *The Honeymooners*, opposite Jackie Gleason. In a career that spanned 60 years, she counted Ed Sullivan, Lucille Ball, Marilyn Monroe and columnist Walter Winchell amongst her closest friends. *"I was Lady Gaga of the Stone Age!"* she said recently. Here with Eddie Mayehoff at The Stork Club, January 1944.

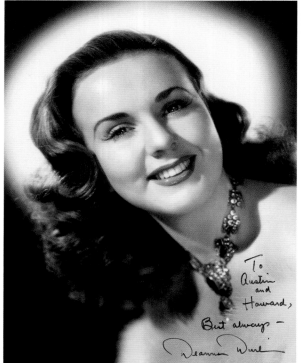

The handwritten inscription on the photo reads:
To Austin and Howard, But always — Deanna Durbin

(left) Deanna Durbin was one of Hollywood's biggest box-office stars during the 1930s and early '40s. At one point she was the highest paid star in the United States, but retired in 1948 aged just 27. She became Europe's answer to Greta Garbo — the world's most famous recluse.

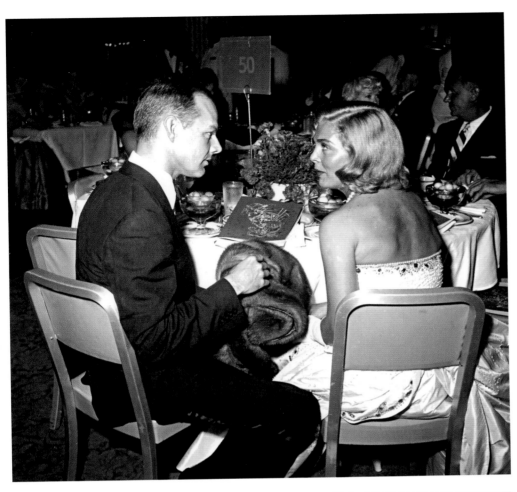

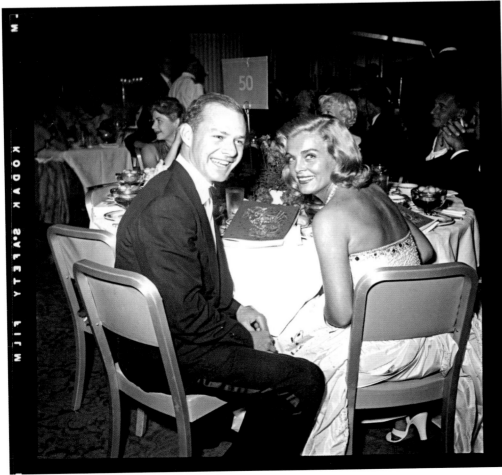

Say Cheese: Lizabeth Scott was one of Hollywood's favourite pin-ups, as much admired for her glamour as her acting ability. She had one of the best voices in film history… forever remembered as the ultimate bad girl. Here on a date in Hollywood, 1953.

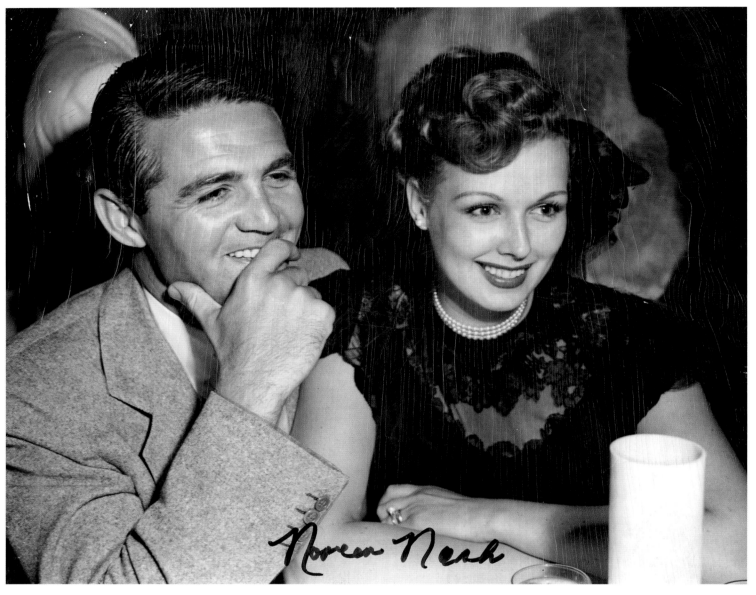

Noreen Nash

(above) Call the Doctor! Lee Siegel, 20th-Century-Fox staff physician or 'doctor to the stars', got pulses racing from the moment he walked through the studio gates in 1955. Here with his wife, actress Noreen Nash, at the Stork Club, November 1947.

(left) The V.I.Ps: Farley Granger, Hollywood leading man of the 1940s-50s, is best remembered for his starring roles in Alfred Hitchcock's *Rope* (1948) and *Strangers on a Train* (1946). Here with Gloria DeHaven, arriving at Ciro's nightclub, November 1949.

Happy Couple: Olga San Juan – dubbed 'the Puerto Rican Pepperpot' – sang and danced her way through Hollywood during the 1940s. Here with her husband, actor Edmund O'Brien, at the Mocambo Club, shortly before their wedding in May 1947.

Weird Science: Hedy Lamarr (left) arrived in Hollywood from her native Austria in 1933 and proved she was much more than a pretty face. Away from the glamour of MGM, where she was under contract, Hedy masterminded the basic patents that would help make GPS, Wi-Fi and radio-guided torpedoes a reality. Recognition came late, when in 1997, she was honoured by the Electronic Frontier Foundation for her inventions, she quipped, *"…and about bloody time!"* Here with her third of seven husbands, actor John Loder, and comedienne Gracie Allen at the Mocambo club, 1945.

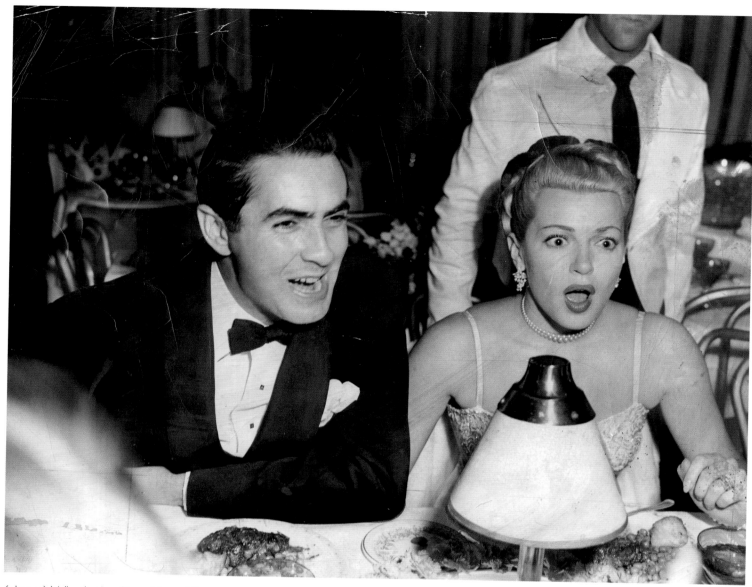

(above) What's the Story? Lana Turner earned a reputation in Hollywood as one of its premier pin-ups of the 1940s. Her vital statistics awarded her the title 'The Sweater Girl'. Away from the spotlight, Lana was much more modest. *"I wasn't really a hotsy-totsy broad. Sex was never really me, more it was an image the Hollywood publicity machine wanted to convey on me."*

(right) Gene Tierney was unquestionably one of Hollywood's great beauties of the 1940s. *"I dated dozens of young men, had fun with all, made commitments to none."*

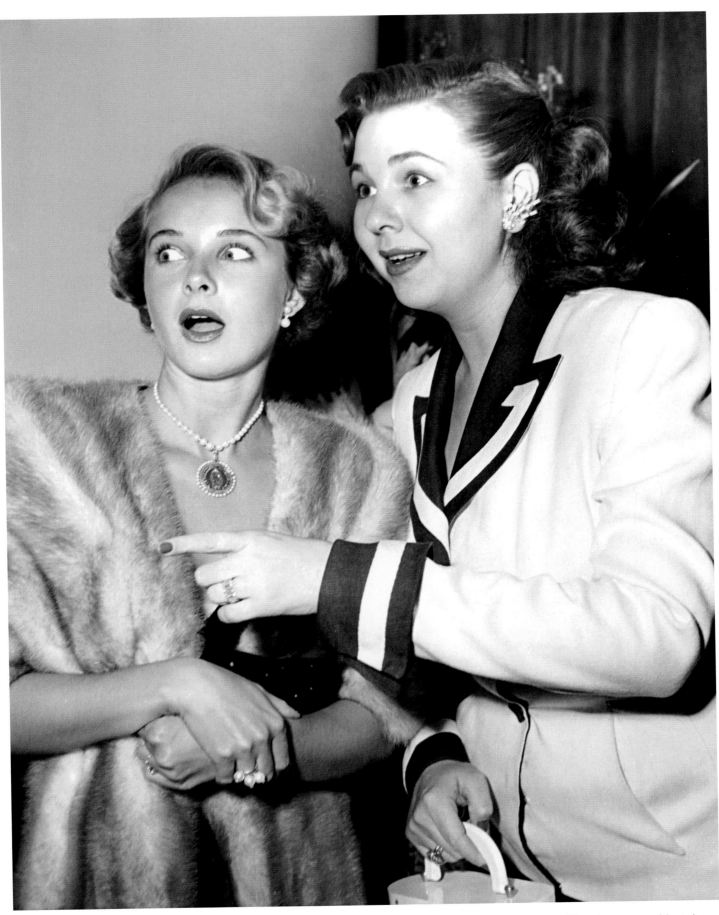

Mona Freeman (left) was one of Paramount Studios' stable of screen beauties during the 1940s-50s; she counted hotel heir Nicky Hilton, singer Vic Damone and Frank Sinatra among her more famous admirers. Here with Jane Withers in the lobby of the Mocambo Club, June 1951.

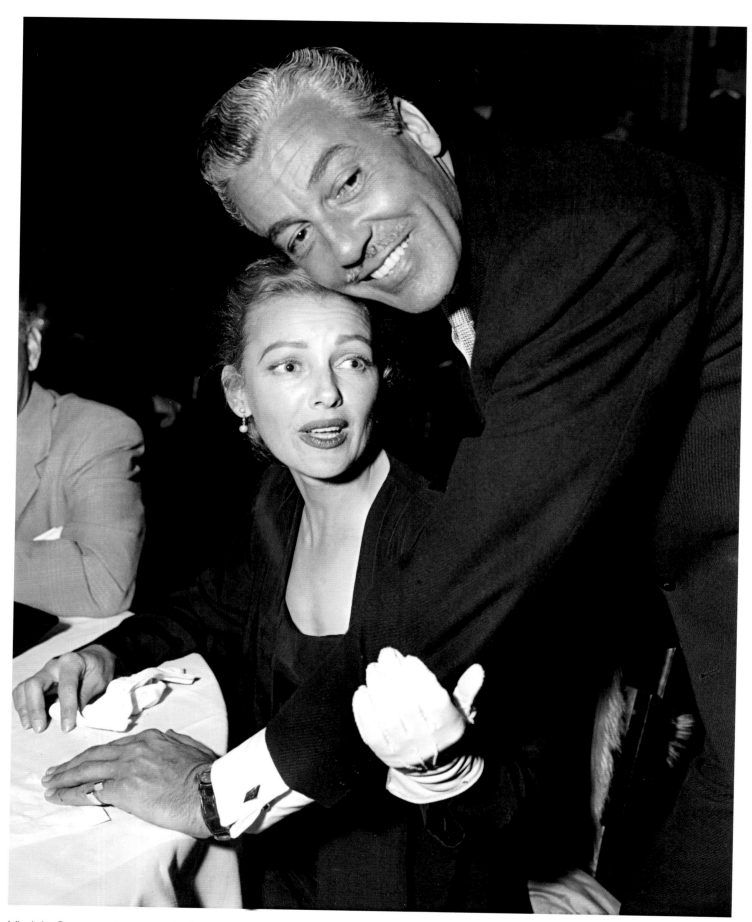

Virginia Grey spent a career before the cameras hoping for a role that would catapult her to international stardom; but she never showed the spark that launched her contemporaries Ruth Hussey and Laraine Day. Here with Cesar Romero at a cocktail party in the Rodeo Room in Beverly Hills, April 1955.

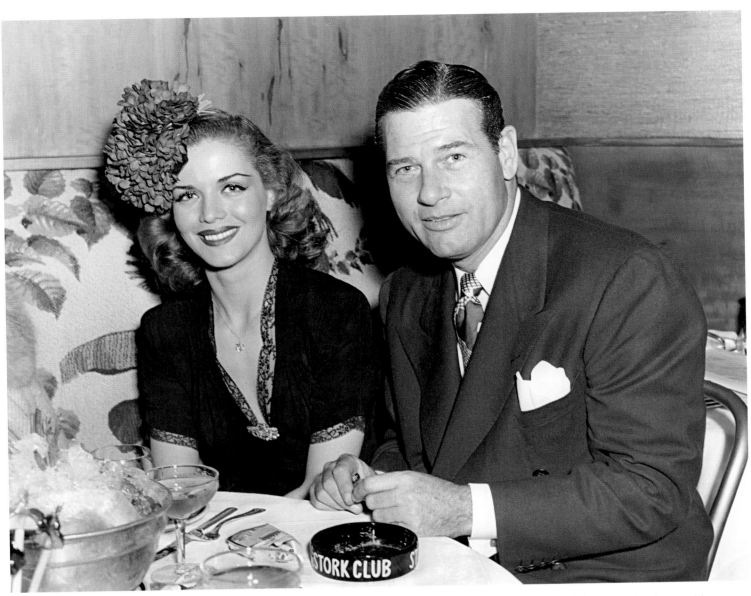

(above) Pit Stop: Carol Bruce was a talented singer and actress with an unforgettable voice who made her Broadway debut in *Louisiana Purchase*, especially written for her by Irving Berlin. Here with Richard Arlen at the Stork Club on their way back from Palm Springs, May 1942.

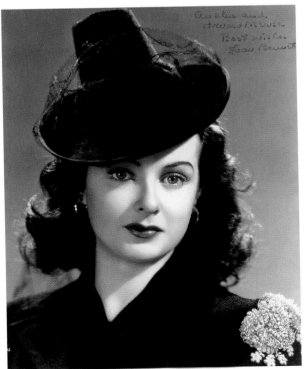

(left) Sibling Rivalry: Joan Bennett had her career eclipsed by her elder sister Constance, only to come into her own as 'Elizabeth Collins Stoddard' in the 1960s cult series *Dark Shadows*. "*I didn't think much of most of the films I made, but being a movie star was something I liked very much.*"

(above) Queen of the B's: Ann Sothern was just as at home playing comedy as she was cast in serious film roles during a career that spanned 60 years encompassing film, radio stage and TV. Ann was never happy with the way film producers responded to her. Aged 79, and on the eve of her only Oscar nomination for her role in *The Whales of August* (1987), she said, *"I think Hollywood has been terrible to me. It doesn't respond to strong women. I was too independent."* Here with actor Jim Davis, New Year's Eve, 1948.

(left) The Party's Over: Tony Curtis' greatest popularity came during the 1950s-60s, as a leading man in a series of comedies and light dramas, including his most memorable, Billy Wilder's *Some Like It Hot* (1959).

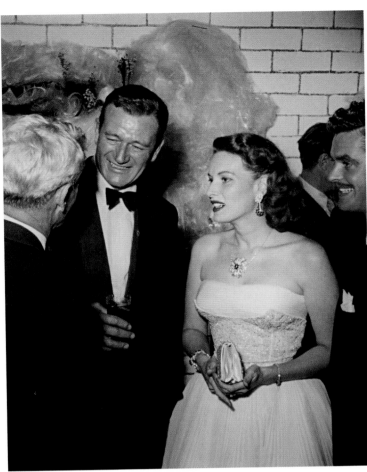

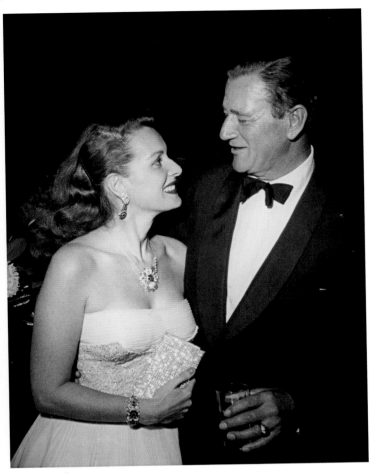

(above) Irish Eyes: Maureen O'Hara, the beautiful Irish red-head, was dubbed 'The Queen of Technicolor' during the 1950s. A star in England before she moved to Hollywood, she will be best remembered for her roles in Alfred Hitchcock's *Jamaica Inn* (1939), opposite Lon Chaney in *The Hunchback of Notre Dame* (1939) and for her role as 'Angharad' in John Ford's *How Green Was My Valley* (1941). Later she was partnered to perfection opposite John Wayne (pictured here together in 1957) in *Rio Grande* (1950) and *The Quiet Man* (1952). In 2013, she attended the ground breaking ceremony for the John Wayne Birthplace Museum in Iowa. *"I was tough. I was tall. I was strong. I didn't take any nonsense from anybody. John Wayne mirrored that. I adored him so much."*

(right) Hot Gossip: Maureen O'Hara with Marlon Brando, Hollywood, 1956.

Mary Brian (left) earned the title 'The Sweetest Girl in Pictures' during the silent era. Whilst she did not rank a supernova aside her contemporaries Clara Bow and Mary Pickford, she did prove to be a worthwhile box-office draw in such films as *Peter Pan* (1924), *The Virginian* (1929) and *Front Page* (1931). Here with comedian Jackie Oakie and Oakie's mother Evelyn Offield at a banquet for Emanuel Cohen at the Beverly Hills Hotel, 1933.

(right) Molly O'Day showed promise as a leading lady in Hollywood until the desperate measures of MGM forced her to undergo a primitive form of cosmetic surgery, which resulted in her early retirement, *"They put the slices to me. The recovery meant that my career in Hollywood was over."*

(below) Scream Queen: Fay Wray enjoyed a career that spanned more than 50 years with 118 film credits, yet her name has entered popular culture for her role as 'Ann Darrow' – the heroine in the 1933 classic, *King Kong*.

(above) Chili Bouchier (left) was England's first screen sex symbol – in answer to the original 'It Girl' Clara Bow. She was successful transitioning from silent film to Talkies, making a name for herself in *Carnival* (1931), *The Blue Danube* (1932) and *Gypsy* (1937). A career move to Hollywood with Warner Bros., however, proved disastrous since there wasn't any film work readily available. Back in England, she worked hard to maintain her image and was seldom out of the public eye. *"I always knew I was going to make it in films. I wanted to take people out of their dreary lives."* Here with Bruce Lister and Laura La Plante at an event hosted by Warner Bros. executive Irving Asher, New York, January 1938.

(left) Loretta Sayers was a platinum blonde ingénue in the same vein as Jean Harlow. Unfortunately for her, that is where the similarity ended. Columbia Studios came calling after reading her good reviews on Broadway, wanting to turn her into a musical comedy star; instead she was sat in the saddle with Buck Jones in three forgettable Westerns. It was all over by 1938. *"But she never forgot her time in pictures and never stopped missing it,"* wrote her daughter Lindsay Golter, after finding our fan letter on the day of her mother's death in 1999. *"She would have been thrilled to have been remembered."*

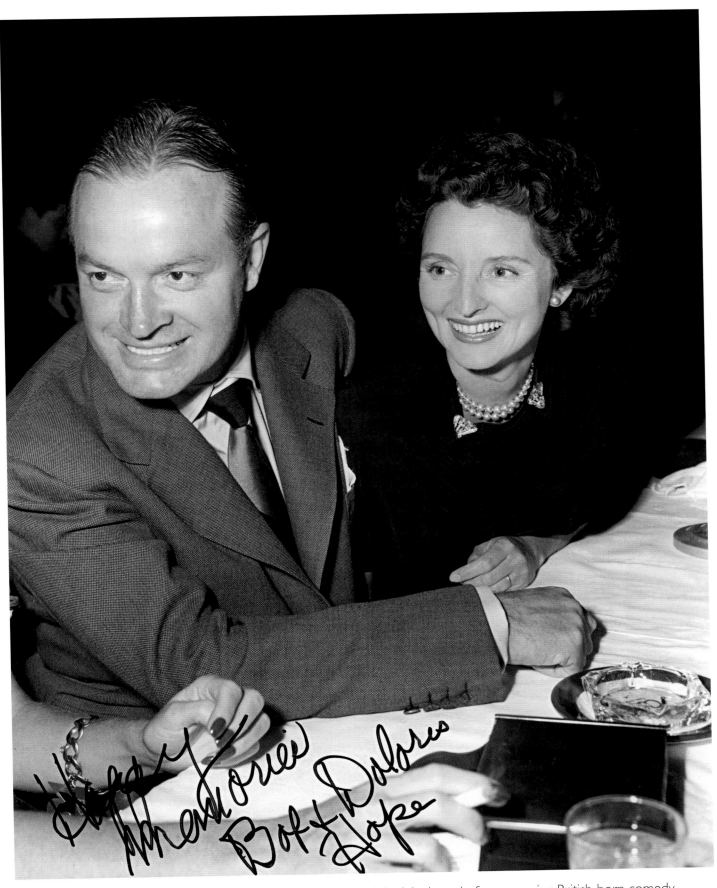

The Mrs.: Dolores Hope, was a fairly respectable Bronx-born nightclub singer before marrying British-born comedy legend Bob Hope, becoming one of show business's most famous wives. Upon their marriage, following a whirlwind courtship, she gave up her own career for a life 'on the road', joining her husband in many war-torn countries entertaining US troops and Allied Forces. Later, in her 80s, she became a successful recording artist in her own right. Here with Bob Hope at Ciro's nightclub, 1949.

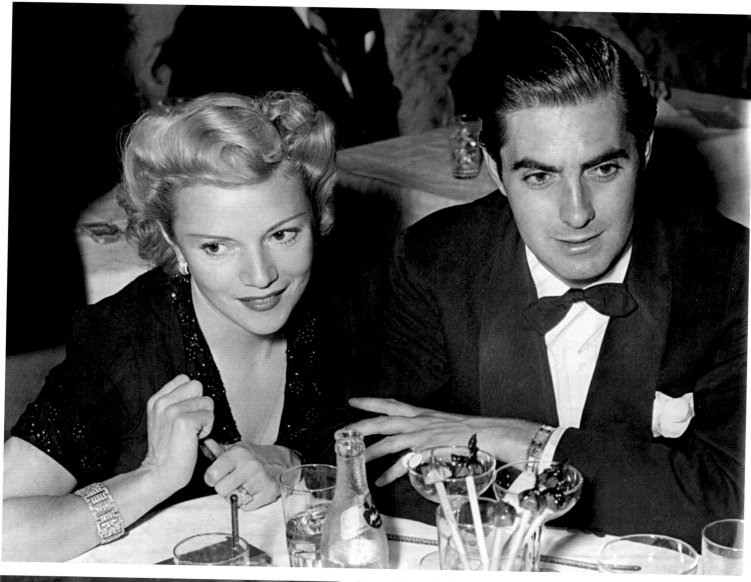

(above) Annabella was one of France's favourite exports to Hollywood, enjoying a steady film career in America and Europe during the 1930s-40s. In 1939, she married Tyrone Power, although theirs was a tempestuous union, she remained loyal despite of his affairs, before finally divorcing him in 1948.

(left) Adeline Shay, younger sister of actress Mildred Shay, tried her hand in Hollywood, and although her screen test at Paramount was a success, she pursued other avenues. Here with socialite Verone Bernheimer (left) and Mildred Shay (right) at The Plaza Hotel, New York, 1950.

Aristocratic: Frances Drake, raven-haired beauty with large hooded saucer-like eyes, will be best remembered for her role as the beguiling 'Yvonne Orlac' opposite Peter Lorre's beast in *Mad Love* (1935). In 1939, she married Lt. Cecil John Arthur Howard, Earl of Suffolk. *"He forced my hand at retirement, since he despised the picture business."* Here with Cecil B. DeMille, Hollywood, January 1934.

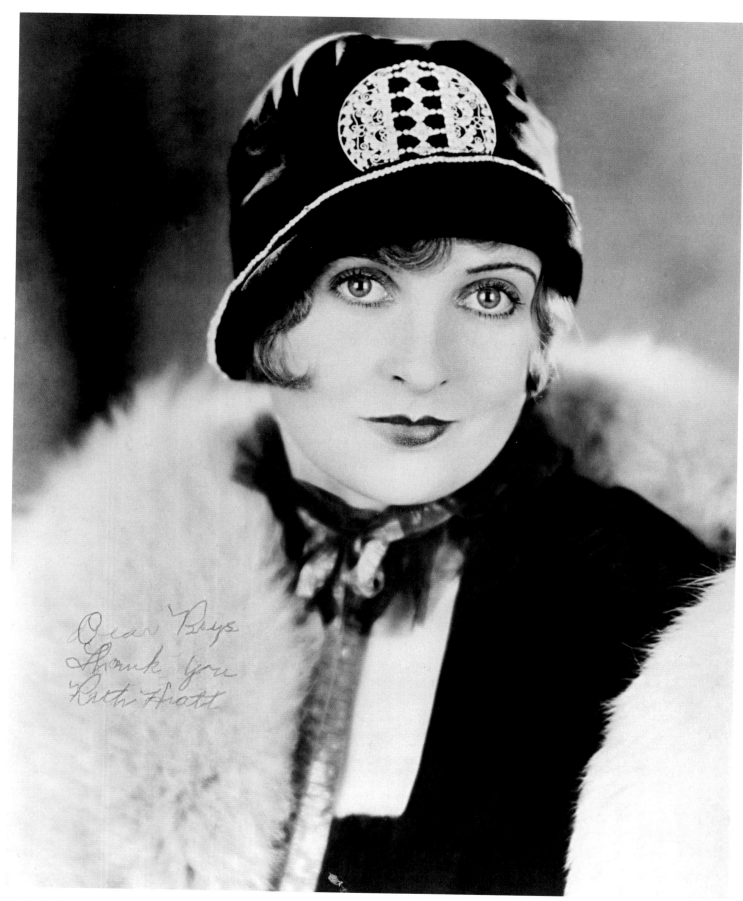

Ruth Hiatt rose to fame in comedies during the silent era under Mack Sennett Studios appearing in more than 70 short films. Her career floundered with the arrival of sound, appearing alongside The Marx Brothers in *Duck Soup* (1933) and with The Three Stooges. During the late 1930s, she retired to operate a professional make-up business, maintaining a home close to her old studios up until her death in 1994.

(above) Clothes Horse: Virginia Cherrill, started life as a simple girl from Chicago who enjoyed mediocre success during the tail end of the silent screen era before leaping to fame as the blind flower girl in Charlie Chaplin's *City Lights* (1931). In 1934, she married Hollywood's most eligible bachelor Cary Grant. The marriage didn't last, however, and by 1937 she was married again to Lord George Child-Villiers, 9th Earl of Jersey. With a healthy bank balance, Virginia was nothing but generous, allowing her dressmaker, Hardy Amies the means to buy his fashion House on Savile Row in 1945. In return she got her seasonal wardrobe for free. Here with Cary Grant at The Savoy, London December 1934.

(right) Record Breaker: Joan Marion was the only actress to star in two London West End plays simultaneously, *Without Witness* and *Men in White*, both 1937.

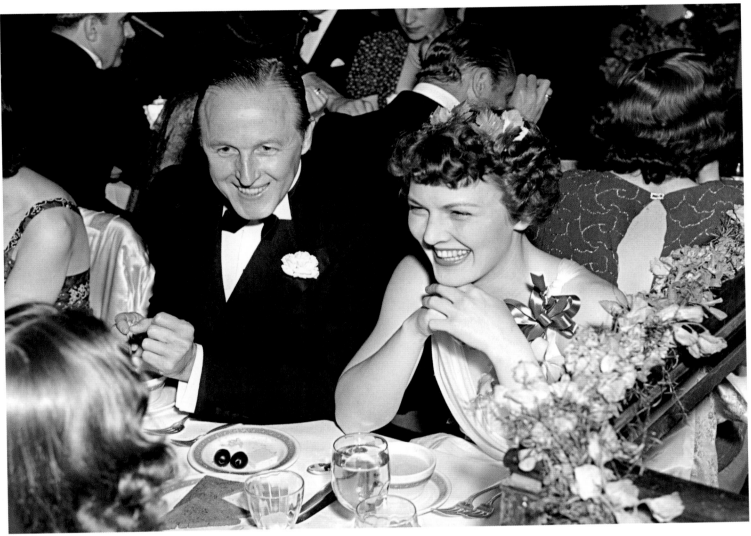

Beverly Roberts arrived in Hollywood when she was 21 years old, and brought a worldliness to her screen characters that exceeded her actual years. *"I was no fool, and quickly learnt the trappings of fame."* In 1934, she was signed to contract at Warner Bros. on the same day as Errol Flynn. *"Errol Flynn was a ladies' man. He was gorgeous and handsome. A lot of women wanted to sleep with him and he didn't always say no. He wasn't the most talented of actors either, but he had star quality by the bucket load."* Here with William Keeley at the Warner Bros. dinner dance, The Biltmore Hotel, May 1937.

(page left) Sheer beauty: Marlene Dietrich was worshipped by both men and women for her haunting, illuminated face and body, most commonly sheathed in sequins, silks and furs.

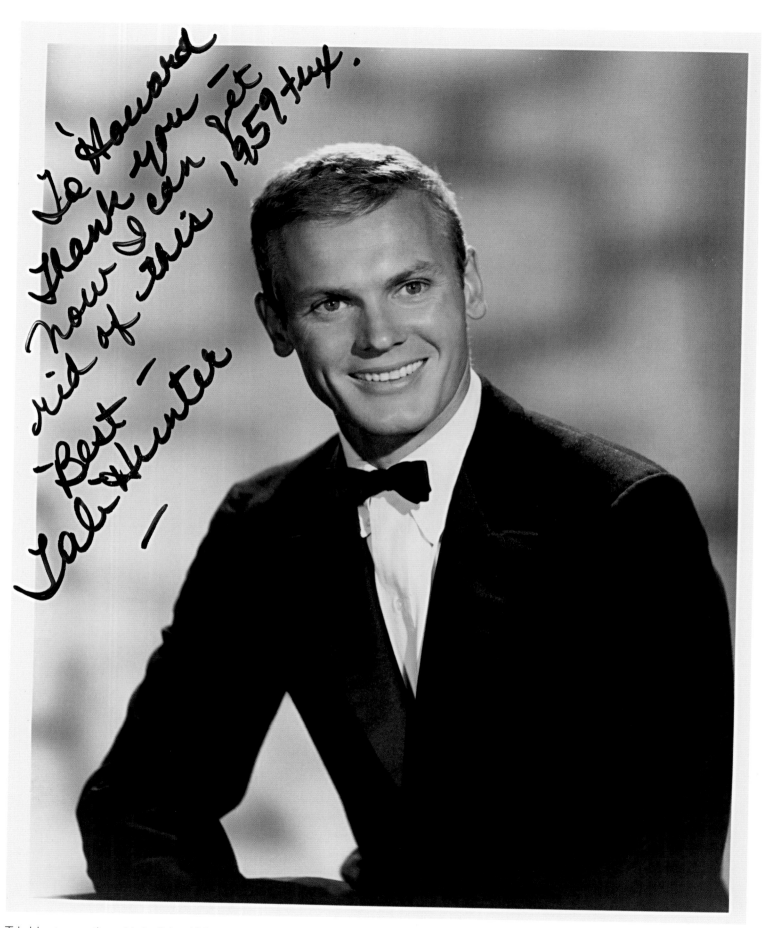

To Howard —
Thank you yet
now I can get
rid of this 1959 tux.
— Best —
Tab Hunter

Tab Hunter, matinee idol of the 1950s, whose popularity was rivalled only by James Dean, Steve McQueen and Paul Newman. Tab maintains that he wanted to be an actor, not an idol. However, his personal style has become an inspiration for many men's fashion brands, since his look remains timeless.

"She's got the legs, she knows how to use them," sang rockers ZZ Top about Cyd Charisse — the screen's favourite dancer — who it was said 'Put the Move In Movies' in such films as *Ziegfeld Follies* (1945), *Singin' in the Rain* (1952) and *The Band Wagon* (1953). Here with husband Tony Martin at Hollywood's Mocambo Club, May 1952.

Joan Collins has long established herself close in the hearts of British film-goers. On-screen even before she left RADA, she was soon tempted by Hollywood and from the mid-50s was put her flaming wide eyes and glamourous looks to good use in *Land of The Pharaohs* (1955), *The Virgin Queen* (1955), *The Opposite Sex* (1956) and *Road to Hong Kong* (1962). By the end of the sixties, she was mostly on TV playing the 'Siren' in the campy *Batman* series followed by a decade-long slog in horrors, in which she faced killer ants, or as the aging sex symbol in soft-core outings, *The Stud* (1978) and *The Bitch* (1979). TV rescued her and catapulted her to worldwide stardom as 'Alexis' on *Dynasty*, after which Joan was often called upon to spoof the rich, much-married bitch on talk shows. A successful author, Joan Collins is one of the last of the glamourous movie stars from the Hollywood contract system days – her appeal is still boundless, her energy unwavering.

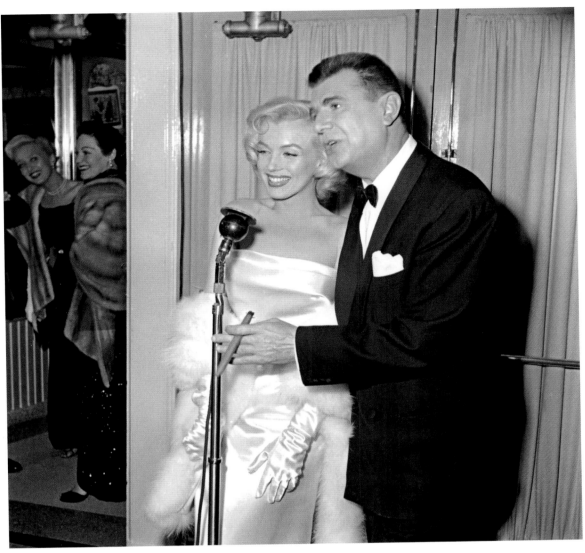

(above) Ken Murray began in vaudeville before embarking on a career in Hollywood during WWII. But his best known accolade was *Ken Murray Blackouts,* an old-fashioned revue show that ran at the El Capitan Theater on Vine Street in Hollywood to a packed-out house most nights for seven years. Here with Marilyn Monroe and Celeste Holm (in the wings) as the MC for the premiere party for *Call Me Madam,* Hollywood, 1953.

RICHARD ALLAN

(left) Richard Allan was a handsome boy-next-door type best known for playing Marilyn Monroe's boyfriend in *Niagara* (1953). That same year he was tipped as one of Hollywood's most promising newcomers; the publicity did little, and after only a handful of films, mostly in Europe, he disappeared from view. Later he took up odd jobs: a nightclub act performer, a masseur and a greeter at the supermarket store Walmart (in his hometown of Louisville, Kentucky).

Relative Values: Carla Laemmle began her film career at Universal Studios during the mid-1920s, under the watchful eye of her uncle Carl Laemmle. *"I wasn't that naïve that I didn't know my uncle was held in high esteem in Hollywood, and my being his niece helped to propel my career chances. But I wouldn't say that I was given any special privileges. I can recall attending a party at Uncle Carl's where I heard Jack Warner chatting to Albert Einstein about the theory of relativity. 'I have a theory about relativity too,' joked Warner, 'I never employ them'. Uncle Carl shared a slightly different perspective on it."* Carla's screen test was directed by Erich von Stroheim in 1928, and from then on she and her parents lived in a house on the studio back lot. Here with Carl Laemmle at the premiere of the musical *Sally*, at the Music Box Theater, Hollywood, 1928.

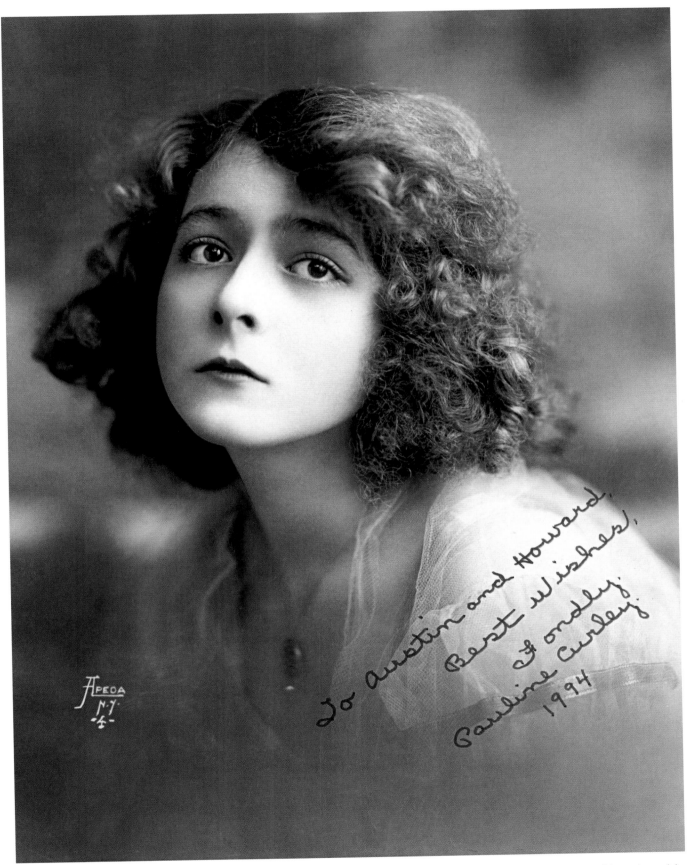

To Austin and Howard,
Best Wishes,
Fondly,
Pauline Curley
1994

Pauline Curley appeared in more than 40 films as a leading lady at the dawn of motion pictures, working alongside such early matinee idols as Wallace Reid, Antonio Moreno and Douglas Fairbanks Sr. Her career was mismanaged by her mother Rose, jealous of her daughter's fame. Rose increasingly demanded from directors and producers; as the power struggle climaxed, Pauline's career began to take a nose-dive. By the late 1920s, it was all but over and, after a series of unbilled parts, she quit. *"When one is billed below the horse and the rancher's dog, one knows it is time to go."*

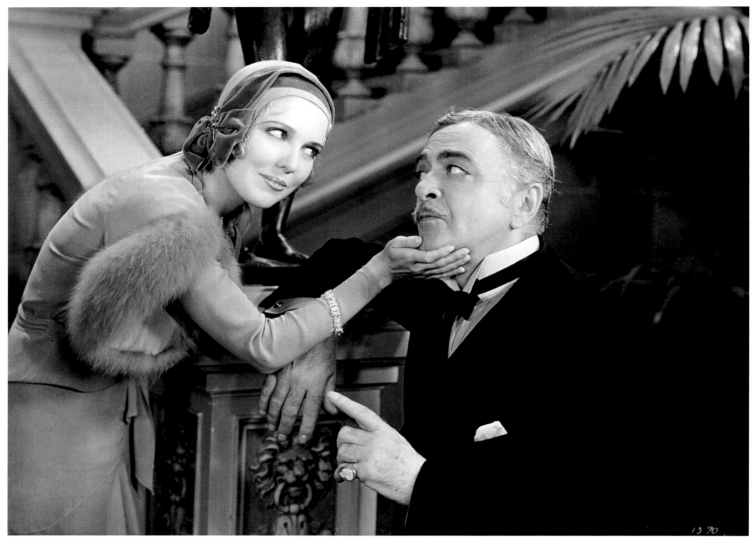

(above) Miriam Seegar was an elegant blonde screen actress whose career bridged the gap between silent films and early Talkies. During her short film career, she played the female lead opposite such early screen matinee idols as Richard Dix and Reginald Denny. Later she married renowned director/producer Tim Whelan and became a successful interior designer, counting Robert Taylor, Ronald Reagan, Billy Wilder and Fred Astaire amongst her more famous clients. Here with Robert Edeson in a scene from *Big Money* (1930).

(left) Gloria Stuart was one of a bevy of beautiful Warner Bros. glamour girls of the mid-1930s, though she failed to pack the same punch as Joan Blondell or Kay Francis.

(above) High Hopes: Promising screen personalities of the future. This lovely line-up of 1930s starlets were chosen as the WAMPAS Baby Stars of 1932. Back row: Toshia Mori, Boots Mallory, Ruth Hall, Gloria Stuart, Patricia Ellis, Ginger Rogers, Lilian Bond, Evalyn Knapp and Marian Shockley. Front row: Dorothy Wilson, Mary Carlisle, Lona Andre, Eleanor Holm and Dorothy Layton.

(right) Anita Page in close-up for her role in the all-star spectacular *Hollywood Revue of 1929*. It was MGM's easiest excuse to sound-check each of their star contract players with the arrival of talking pictures.

277

Lisa Kirk and Ricardo

Best- Ricardo Montalban

Ricardo Montalban – tall, dark and handsome Mexican matinee idol – was for several years MGM's chief rival to the studio's other Latin Lover, Fernando Lamas. A stage-trained Broadway actor, Ricardo made his screen debut during the early 1940s, before finding enduring fame as a character actor, most notably in *Border Incident* (1949), *Sayonara* (1957), *Cheyenne Autumn* (1964) and *Madame X* (1966). Between 1978-84, he played the ubiquitous 'Mr. Roarke' in TV's *Fantasy Island*. Here with actress and singer Lisa Kirk, Hollywood, 1955.

Ursula Thiess was a popular Hollywood brunette, voted by *Modern Screen Magazine* as 'The most promising star of 1952' alongside Marilyn Monroe. Four years later, following her marriage to actor Robert Taylor (pictured here in 1955), she retired from the screen with only a handful of credits to her name.

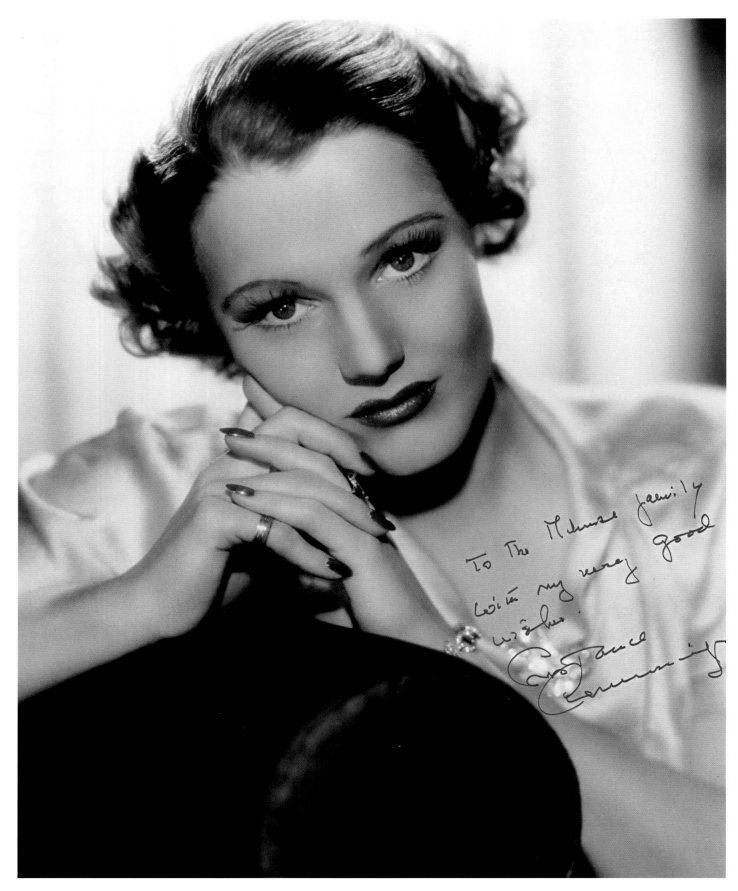

Constance Cummings gave remarkable performances on-screen for over five decades, notable amongst these was as 'Mary Sear', the complex twin-personality ingénue in Harold Lloyd's *Movie Crazy* (1932) and her portrayal of Rex Harrison's second wife 'Ruth' in the enchanting screen version of Noel Coward's *Blithe Spirit* (1945). A highly talented actress, Constance made over 20 films in Hollywood before settling in England in 1933 upon her marriage to successful British playwright Ben Levy.

(above) X-Factor: Vera Van, dubbed 'The Girl with the Golden Voice', took Broadway by storm in January 1935, with her passionate performance in Sigmord Romberg and Oscar Hammerstein's musical hit *May Wine*. Her reviews went nationwide; she had a voice and the persona to match, which the critics, like the people, instantly warmed to. She then became a regular at The White House, singing to President Roosevelt and various dignitaries; Vera could almost move FDR to tears! Naturally, Hollywood came knocking and, in 1935, she was placed under contract to Paramount Pictures. Here with George Jessel in New York, 1931.

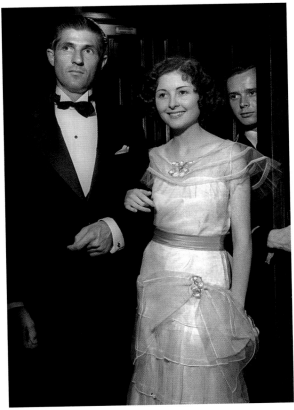

(right) Marion Shilling arrived in Hollywood with talking pictures, first at MGM, before moving briefly to Paramount in 1931. The death of her agent killed her career chances, and before too long she was out on the range appearing in a series of minor Westerns. Here with Wayland Gilbert at the Hollywood Roosevelt Hotel, July 1933.

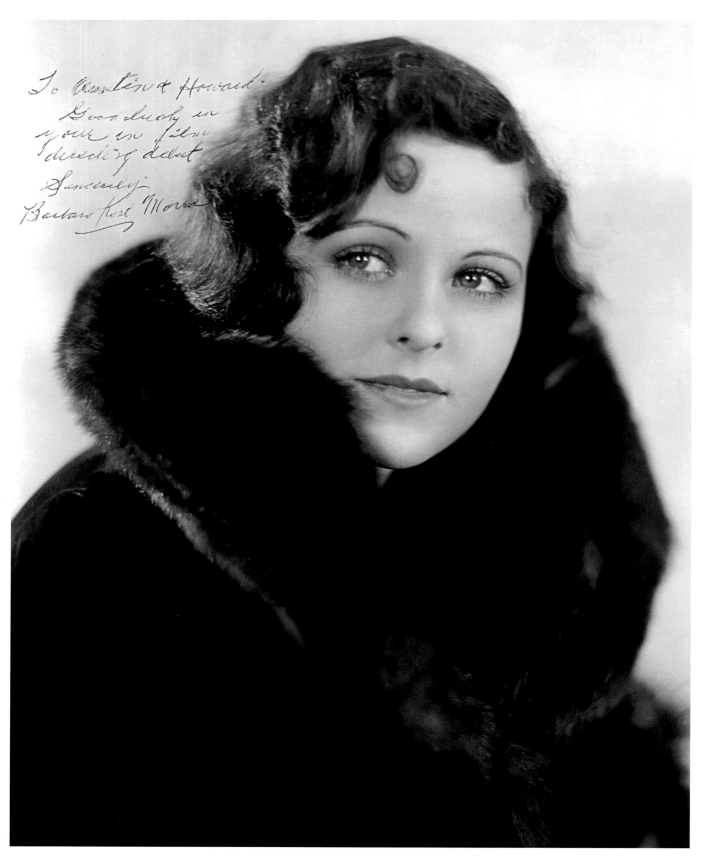

To Quentin & Howard.
Good lucky in
your in film
directing debut
Sincerely
Barbara Kent Monroe

Barbara Kent, diminutive and understated, was one of Hollywood's most delicate screen beauties during the late 1920s. A leading lady to Harold Lloyd – *Welcome Danger* (1929) and *Feet First* (1930) – Douglas Fairbanks Jr. and Oliver Hardy, she could play both comedienne and siren with ease. She made her breakthrough role in 1926 in *Flesh and the Devil*, in which she was pitted against Greta Garbo's femme fatale. Barbara's transition to talking pictures was effortless; however, following a couple of stand-out performances in *Vanity Fair* (1932) and *Olivier Twist* (1933), she retired from the screen. She was still flying planes in her 80s, and playing golf well into her 90s. Barbara Kent died in October 2011, aged 103.

(right) Esther Ralston was dubbed 'The American Venus' after the 1925 film of the same name, in which she triumphed. Her career got off to a quick start under contract at Paramount, where she became one of the studio's premier stars. By the mid-1930s, her star power began to fade. By the 1960s, she was working in an electrical supply store in New York, where no one remembered her name.

(below) Mae Madison, the Hungarian-born leading lady whose voice was likened to 'Betty Boop after one too many martinis', arrived in Hollywood with the arrival of sound and was promptly signed to Warner Bros. Her career got off to an impressive start opposite Douglas Fairbanks Jr. in *Chances* (1931) and she was billed above the newcomer Bette Davis in *So Big!* (1931). She found herself broke upon her divorce from film director William McGann; but as luck would have it, friend Busby Berkeley picked her up and put her to work as a chorine. Here with John Barymore in *The Mad Genius* (1931).

Cocks and Cocktails

Hair Style of The Women at M.G.M.

I'm on the front steps of a 1930s Art Deco apartment block on Cundy Street off Ebury Street in Belgravia. I've rung the bell four times. It's July and warm. The concrete canopy over the building's entrance shields me from the sun. I remove my sunglasses. I check my watch: 11.45 - dead on time. Finally she answers. "Hello, Hello… HELLO!"

"Miss Shay. MISS MILDRED SHAY" I shout. "IT'S AUSTIN" "What's that?" "MISS SHAY, IT'S AUSTIN. I've come to interview you. MISS SHAY, I'm at the main apartment door!"

"Wait a minute… well these darn… hold on… who is it? Oh shit these… Oh honey," she laughs. "AUSTIN you say?! Oh come up, darling, come up, I'm flat 18 – almost the penthouse."

She buzzes me into the lobby. Its tiled floor is grey, the wall ice blue and cold. There's a winding staircase to my left and a lift to my right. I press the button flats 18-21. The doors open. I step out, my journey begins.

Mildred is dressed for an evening out in a black sequin batwing dress and tiny high-heel black peep-toe sling-backs over fishnet tights, her painted toes escaping through the front of each shoe. She is tiny and heavily made-up: her face is orange; her lips, scarlet. A diamond bracelet catches the light from the low bulb hanging overhead – it, like its owner, dazzles.

"Hello Austin. Come in. Come in." Like a searchlight, she looks me up and down in slow strokes. Mildred holds the door open wide. Resting on the top of my bag is a small bunch of flowers I'd bought her moments before from a florist on Orange Square. "These are for you Miss Shay," I say, handing them to her. "Oh darling, you shouldn't have," she sniffs them. "But oh, I love the attention!" Her accent is mid-Atlantic, cultured one minute and almost trashy New Yorker the next. She drops the flowers on a low wooden cabinet. "I'll fix those later."

The flat smells of Giorgio Beverly Hills perfume, hairspray and cats. The cream discoloured walls are covered by picture frames. I follow behind Mildred as she leads the way. Peeking either side of us from behind dirty and mottled glass, I spy faded photographs in large frames of a young, petite and beautiful woman, whom I presume to be Mildred in Hollywood. She's on a film set with Cary Grant, at a cocktail party with a young Natalie Wood, with Dame May Whitty and George Raft... There are once-glossy 8x10 black and white shots of Joan Crawford and Rudolph Nureyev; both stare out at me, their gaze obscured by grime. On another section of wall I spy a photo of Greta Garbo, of Roy Rogers on his horse Trigger and a be-jewelled Mildred flirting with John Garfield. She stops at the latter. "You know he died whilst screwing some actress?" she laughs. "God, I haven't had sex in 17 years. Isn't that awful?" With that she winks, "Oh gawd, you must think I'm terrible." For a moment I'm lost for words.

"Shit!" I mutter under my breath but still couldn't think of a better answer. I'm shocked at her brashness. I'm laughing to myself now, flabbergasted as she spins around precariously on her three-inch heels and takes the lead again. In my mind I'm saying, 'This woman is extraordinary'. She must have read my mind. "I'm a mean old broad," she giggles.

For me this journey through the apartment is a treacherous one: electrical wires stretch from room to room across the corridor; delicate occasional tables buckle under the weight of old newspapers, junk mail and empty Whiskas tins; a tartan-covered shopping trolley with its contents of laundry spills over the floor; bras hang from door knobs; and, on the floor, are two neat piles of recently deposited cat faeces.

As I follow, I notice how she almost dances as she walks, her blonde coiffure like a giant spaceman's helmet appears wider than her shoulders. I discover her enormous hairstyle disguises hearing aids that whistle loudly.

We come to a large living room; bright but with a haze of neglect hanging over it, "I have everything but money." Mildred gestures towards a probably once gleaming silver kettle on a decorative stand and then gestures the other way to bookshelves next to a pair of French doors that lead onto a balcony, the sunlight blocked by what probably amounts to years of encrusted dirt on the glass panes. The shelves are crammed with silver, vases, ancient feather and lace fans, crystal and fine china. On closer inspection cups have handles missing and plates are cracked and flowers have dried to death in chipped vases. The silver is tarnished black; the photos, bleached. I turn around – there are more photos on the window ledges, more photos hanging on the walls, on the dining table and atop the TV… dozens of photos are all of the same three people: there's Mildred, a man – not too dissimilar to David Niven – and a female in varying degrees of maturity from girl to womanhood. Mildred picks one of the photos up, probably from the 1960s.

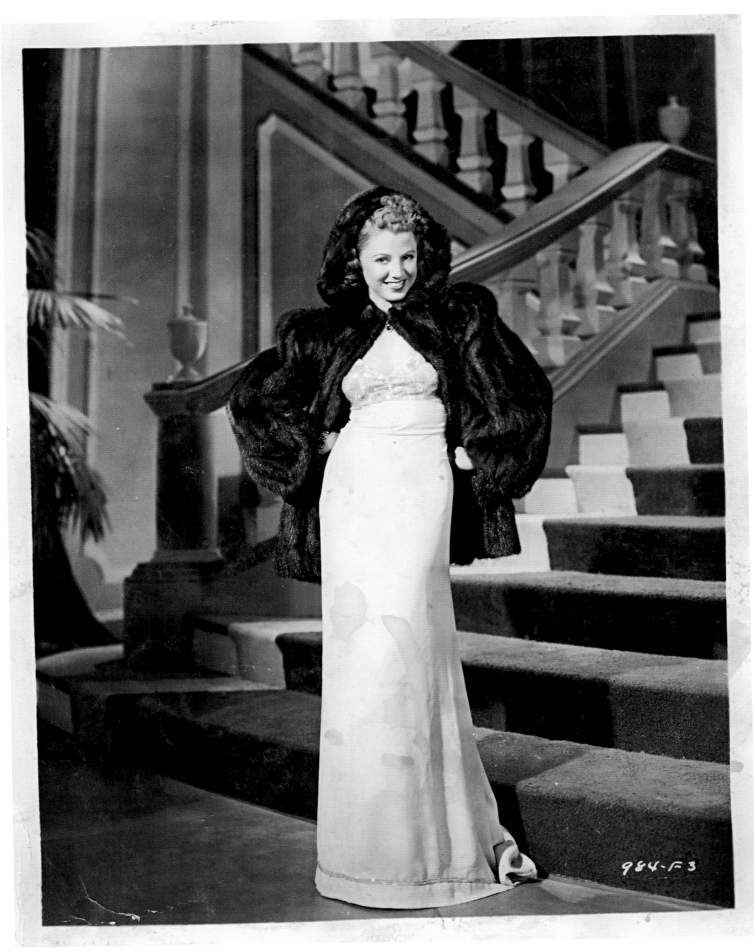

Marvellous Mildred: Hollywood's 'Pocket Venus' strikes a pose, Hollywood, 1939.

(above) Movie Memories: Mildred Shay shows off her Hollywood past, The House of Hardy Amies, Savile Row, London, 2004.

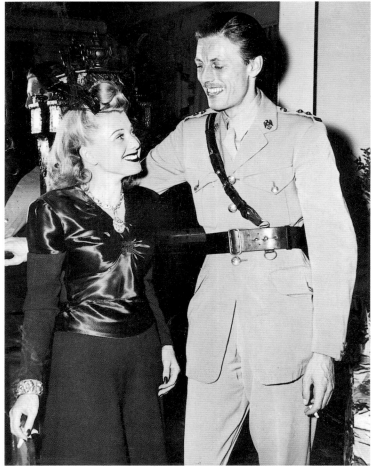

(left) In the spotlight: *"Groucho Marx wanted to make me his comedy stooge. I refused. I wanted to be a serious actress. I wanted to be the next Sarah Bernhardt!"*. Here with Geoffrey Steele, Hollywood, 1944.

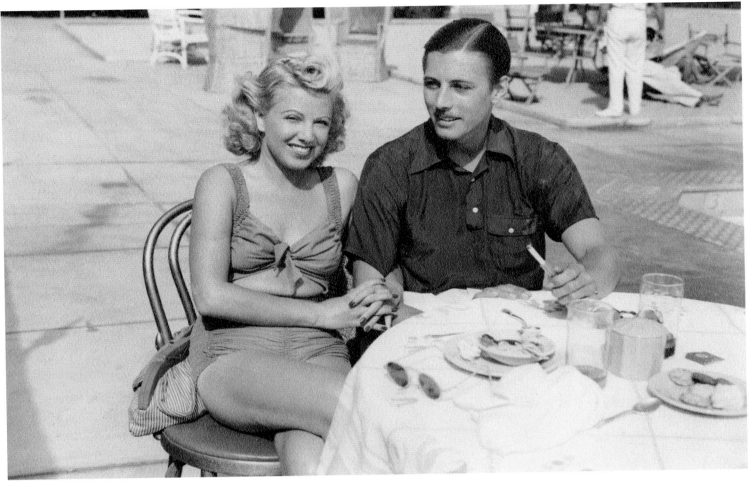

Third time lucky: *"They said it wouldn't last and took bets on the marriage failing,"* said Mildred of marriage number three to army officer-cum-actor, Geoffrey Steele. The Steeles were married for 46 years, until his death in 1987.

"This is me and that's Baby," she says pointing to an attractive blonde. She whimpers, "Baby is my beautiful little girl, Mama's pride and joy, Mama's world, Mama's reason for being; reason for living."

Mildred clasps her hands and then reaches for a frame. "Oh and my Geoffrey [Steele], my wonderful beloved husband. We'd been married for eight-and-a-half years, we made love every morning, then in 1949, God blessed us with this gorgeous, beautifully clever angelic angel of a baby girl." "Oh, well, that's great" I say looking at the photo. "Did your daughter act too?" I ask as she passes it to me.

"No darling, Georgiana [Steele-Waller] was a model. They called her 'America's Twiggy'. She became a stunt woman after that. But someone in the know once said that her I.Q. was such that she could have been a quantum physicist or something else brilliant!" I laugh. She doesn't. Her eyes narrow. I've offended her. "No darling, honestly she is one in a million. She is really quite brilliant! She lives in my poor baby sister's beautiful house on a mountain in Glendale, California. Oh my poor baby sister….." Mildred

fades off as she looks about her, "Surely I have a photo to show you of my little baby sister Adeline?"

"Your daughter is very attractive and so were you," I tell her, still holding the photo. "Well she's gorgeous darling. She loved her beautiful daddy so much. He was a Captain with the Blues & Royals and was all man. Sadly he never saw our baby married and that killed me. She did get hitched though, to a pop star." Mildred's eyes roll to the ceiling. "Gawd, she knew The Beatles, Roger Daltry, Rod Stewart, oh just everybody… he's a good sort really – her husband, Gordon Waller, I mean. He calls me 'the old bag'," she laughs, adding, "Oh, but in a kinda nice way." She takes the frame from me and kisses the glass leaving behind a red lipstick smudge. I look at the frame clutched in her hands; there are traces of previous affections on the glass, some more faded than others.

She tosses the frame onto a faded beige sofa-bed, sighs, takes a step or two to her right and she falls back into her large recliner; dust flies. "Sit down fella." She smiles

pointing to a red velvet wing-back chair and then crossing her legs and pulling her dress up just enough to show off her knees says, "Meet my pussy, her name is Rosebud." She roars at her own saucy innuendo and points to her cat. Rosebud trots over from her hiding place to where I am sitting. I'm not much of a cat lover, but on Mildred's instance reach down to stroke her, "She won't hurt you, go on, that's it... stroke her – look she wants to play."

"Hello kitty-cat." Rosebud hisses and in a flash she's clawed me. "NO! Wow-ho!" I shout, blood swelling on my hand. I grab a tissue from my pocket and wrap it round my thumb. I go to suck it and then looking about me think better of it. Rosebud makes a run for it under the dining table.

"Oh no! Naughty baby Rosie, be nice to Austin," she says. "I spoil her. She'd be on my lap all day if I let her. But my neighbour, Lady Janet, Marchioness Milford-Haven told me not to stroke her too much, cats get over-sexed with too much attention! But honestly darling, Rosebud won't bite, she'll gum you to death."

"Oh, the flowers!" She gets up to retrieve them and shoves the tender stalks into a chipped blue jug that's already home to dried and dusty thistles. "Do I have to water them?" she asks. I look at her in amazement and nod.

"I never did anything. We had staff doing stuff like arranging flowers for us. My German Großmutter was the domesticated one, and could she cook! Oh darling, she made her own ketchup and bottled every variety of fruit to make jam." Mildred licks her lips at the memory. "I live on shit now delivered from Mr. Ali's the shop on the corner of Ebury Street. Tasteless crap that costs a fortune and is supposed to resemble something like chicken. It's shit darling, but what can I do? I can't go out alone and there's nobody who wants to take me." She looks saddened at her lost life. "I could pop to the supermarket. There's a Sainsbury's at Victoria Station." She hasn't heard me.

"Oh, I had friends darling. The Thalbergs [producer Irving Thalberg and his wife Norma Shearer] were my dearest friends, John Garfield, Jack La Rue – he was gorgeous, Douglas Fairbanks Jr., Bob Hope came to all my cocktail parties. I knew all the Kennedys. I was with Bobby Kennedy at The Ambassador Hotel the night he was shot. Or was I with Hitchcock that night and with Bobby the night before? No matter, both were my closest friends." Mildred stops to think and then feeds me with more names. "Frank Sinatra was a friend. I didn't screw him, darling. The truth is I didn't fancy him, well not in the beginning anyway. I did have an affair with Howard Hughes. Oh boy, was he ever a meanie with his money! Such a cheap date. Oh hey, I knew Garbo at Metro-Goldwyn-Mayer – we played tennis. Hell! I knew everyone at Metro-Goldwyn-Mayer. All the men at the studio wanted to screw me." She laughs. "And sometimes I didn't say no!"

She looks at me. "Oh, you must think I'm a filthy old broad." I shake my head. "No, it's Hollywood I guess." "That's true. Oh you are smart. Well everyone paints this pretty picture of Hollywood, but it was raunchy and full of sex. I tell no lies!" "Well Miss Shay, that's refreshing. Hollywood of the Golden Age is often depicted as being, well, golden."

"Honey, that white clapperboard MGM school house where Lana Turner, Judy Garland and all those little kiddies studied, well that too had a dark side to it – everyone wanted to make it big no matter the cost. I was hot stuff. The newspaper man Walter Winchell crowned me 'Hollywood's Pocket Venus'. I was like cat-nip and all the men wanted me to keep them warm." Mildred claps her hands.

"We'll have a drink and you can ask me your questions," she says directly. "So honey, you found me through my agent right?" I nod. "Well she's a sweet English *lay-die*," Mildred emphasizes the word 'lady' and sounds, well, like an American attempting a cockney accent, and badly. "Yes my dearie, she's a nice sweet *lay-die*," she giggles. "Oh gawd, Austin, I could be on Eastenders!" I realise she's serious when she grabs a jotter pad and pen and makes a note to remind herself to call her agent. I watch her scrawl the word Eastenders and underline it half a dozen times. She looks up from the pad, "I've been with June Epstein since the seventies. She got me the part of 'Janet Roscoe' in an *Inspector Morse* episode, oh listen honey, John Thaw thought I was just swell and the newspapers wrote that I was more boorish than him…imagine!" Mildred beams with pride. "Oh and then, before that, June got me in that marvellous Ken Russell film with Rudolph Nureyev. Um, it was, oh yeah, *Valentino* - you know honey? Well I'm so proud of that picture and everyone saw it. I told my darling beloved Geoffrey that Nureyev flirted with me madly and was so raunchy with me. I think Geoffrey was jealous." She bites her bottom lip and lowers her voice, "Nureyev followed me into the jon once… Oh gawd imagine it!" She says louder, with a wide grin, "Honey, I could have done a couple of rounds with him…" her laugh is thunderous now.

"Oh that's amazing – spending time with Nureyev – no, what I mean is being in *Valentino* and the *Inspector Morse* part." I think to myself 'Jesus, I'm like a bumbling idiot around her'. I fumble for my pen and pad in my bag. "Yeah," she says, pretending to be carefree, "But that John Thaw, well he seemed to be wherever I wasn't, so by the end of filming I thought 'screw him'. But Nureyev, well he was one guy I could have had an affair with." She tosses her head back, "Oh gawd, honey, let's have drinks, all that Nureyev talk and your being a meanie has gotten me thirsty."

"Oh I should have brought cake to eat with our tea" "What! Are you kidding? Cake! No darling, I have to watch my waistline. She strikes a pose, hand on hip again, this time giving it some oomph, "You like martinis, right?" "Yes please. I mean, SURE!"

"Well hell, tea is for nice ladies, and I ain't no nice lady." She leaves the room. I watch her wiggle into the kitchen. I'm alone. 'Blimey,' I say to myself, 'this woman is something else!' I hear her humming – so I gather she's calmed down and forgiven me. I call out, "So Mildred, thanks for agreeing to see me."

"Yep, that's it." From her answer I'm sure she hasn't heard me correctly. I repeat myself, she doesn't answer.

"So, June says you're writing something on Mr. George Cukor," she says calling from the kitchen whilst banging cupboards. She is talking to herself too... "Shit, now where is that, oh there you are..."

"Yes that's right, for *The Daily Telegraph*. Cukor would have been 100 this year." I'm still calling out from my seat. "I rang movie stars I knew who were in Cukor's films Miss Shay. Films like *The Women*. I rang Joan Fontaine in Carmel and Suzanne Kaaren. She lives on the Upper East Side..." "What's that?" "Suzanne Kaaren. I rang her and Joan Fontaine about Cukor, and Shirley Chambers and Jo-Ann Sayers. Miss Sayers told me her 'bit' was so minor that she failed to find herself in the movie when watching *The Women* back recently."

"You did?" "No, not me. Jo-Ann Sayers did." Mildred obviously can't hear me, so I keep quiet and wait for her to reappear. All the while Rosebud is eye-balling me. She hisses or claws the air with every movement I make. I mouth "sorry" to Rosebud. She stares me out and trots off into the kitchen.

Mildred's back now with our drinks on a tray and a dish of Ritz crackers, Rosebud is by her side. "So darling, you

have questions for me?" Rosebud settles at the foot of the recliner her tail flitting one way and then the other. Mildred flops now too.

"Miss Shay, I rented a copy of *The Women*, and I played and re-played your scenes as 'Helene' the French maid opposite Joan Crawford. Can I ask you about that Miss Shay?" "Well, Joan was a darling woman and my friend and a tremendous actress. We knitted, her and I, in her Winnebago between takes and Nelson Eddy often joined us... listen darling please call me Mildred. My poor beloved brother Arnold called me Cissie Shay, 'Cissie Shay come out and play', he'd say." She smiles at me and looks away, her bottom lip quivering at the mention of his name. She tosses aside the jotter pad and lifts a pile of paper from the floor next to her chair. "I dug this out from over there," she points to book shelves at the far end of the room stacked to the ceiling. The books' spines like everything else in here, apart from her, have faded.

Mildred gets up from her chair and hands me a large scrap-book from the pile. She puts on a pair of spectacles, there's a page marked. I turn to it. The photo is of Mildred sitting in the back of what looks like a Packard. She looks glitzy and rich. She points to another one of her on a lawn; she's baring her breasts.

"Frank Morgan crowned me president of the twin globe society! He said my tits were better than Hedy Lamarr's, better than Ann Sheridan's!" She squeezes her breasts together for me now and looks down impressed. "Well, hello boys!" She looks at me and then lifts them up higher. They drop as she lets go, "Come back little Sheba," she laughs. I feel like a rabbit caught in the headlights.

"Are you gay?" she asks standing upright again. "No." "Oh, is that so?" "Are you with someone?" "Yes, I'm engaged – her name is Joanna." "Hmm, too bad..."

She leans over me again. The book open on my lap. Her low-cut dress shows off her low-slung bosom, which she presses against my shoulder. She adjusts her glasses in order to look back at herself in the scrapbook. She points a long, painted fingernail at a shot of her with Alan Ladd. "So you don't want to screw me then?"

With that she turns tail and disappears into the small kitchen before I can make a lame excuse, but I call out to her anyway, "You were beautiful once," I shout and then, realising my mistake, rather shakily add, "You still are." There's no reply, only the sound of crystal-ware meeting the vodka bottle and the whistle of her hearing aids.

(above) *In Old Missouri* (1940) Mildred Shay played 'Mme Chee-Chee' who alongside her troupe of chorines, save 'Junior' (played by a youthful Alan Ladd seen here) and his father (Thurston Hall - right) from going broke by putting on a show. *"Oh Alan was fresh with me and his wife the actress Sue Carol – who was his manager – didn't like it. For a small man he was big and with a beautiful smile… it was decided by the Hollywood big boys that I was to be his leading lady on a series of pictures, but Carol put a stop to that. He was still a naughty boy; then in stepped Veronica Lake and the rest is history."*

(left) Mildred Shay, photographed by Max Munn Autry, 1940.

Star Attraction: Mildred Shay lusts after Rudolph Nureyev as the lead in Ken Russell's *Valentino* (1977). "Gay or not. I was in love!"

Upon her return, Mildred smiles politely. She's added more lipstick, which has gone above and beyond her lip-line and is smeared across her teeth. She's also sprayed herself with more perfume. I'm intrigued. I'm scared. I'm awestruck! She's smiling at me. I gesture with my own finger across my clinched teeth indicating the lipstick on her own teeth, she tuts, grabs her compact, opens it, looks into the mirror and using a tissue wipes the lipstick clean from her lips and reapplies again using a candy pink Bakelite brush. She holds the mirror to her right and to her left and waving the brush that she's clamped between her fingers like a cigarette, tells me that it was a gift from Max Factor himself. "Mr. Factor showed me how to wear make-up. I'm still using his method," she says. She downs her vodka martini in a couple of gulps and invites me into the kitchen to help her fix us another. I place the scrapbook on a small oak table next to me.

I watch as she squeezes a slice of lemon between cyclamen-pink polished talons into a martini glass. She swirls an ice cube around the glass and then I duck as she tosses it towards the sink. She then measures out the spirits; two jiggers of vodka to one vermouth. Her tiny hands shake with the weight of the litre bottle. She stirs the drinks with a plastic 'Playboy Bunny' stirrer. "I got this from the Playboy mansion. I liked Mr. Hugh Hefner very much. And I think he liked me too. He has a penchant for blondes." I move quickly as the bunny souvenir accompanied by a gold and emerald ring fly straight for the sink. I reach in, past mountains of dirty dishes, thongs hanging off the cold water tap and Wonderbras lying across the dish-rack, and retrieve it. Mildred hasn't even noticed the ring has come off. When I present her with it she laughs, "Ooh baby, we getting hitched?" Cocktails now ready, she steps over Rosebud's empty litter tray and wiggles her way back to the living room. Seated again, she takes a mouthful.

"I never drank in Hollywood," she says as she flips back in her recliner. "Oh, really, I thought everyone drank and smoked?" "Well I didn't," she says rather seriously. "I drank only milk or coffee. Honey, I was awake the whole time so I never missed out on a thing." She winks and stretching over to my chair from hers, rubs my knee. "You and I are going to get along famously," she smiles. I watch as she takes smaller sips now. "You're not in any hurry to go, are you?" she asks in a childlike voice. "I'm all lonely here, sniff sniff."

I look at my watch. "I'm meeting Joanna later. We are staying with my twin brother in The Oval." She's crest-fallen. "I don't have to leave for another half hour," I proffer as a compromise.

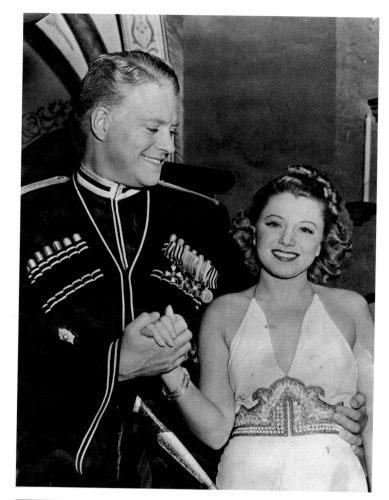

(top) The Eyes Have It: Mildred never had a problem with Nelson Eddy. "He never tried it on with me. I was safe with Eddy."

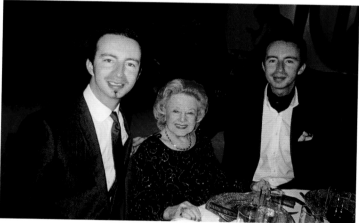

(bottom) Back in the Frame: Mildred, with Austin (left) and Howard, was back on the party circuit during Oscar Week, 2004. When asked about Hollywood today, Mildred replied, *"Hollywood! J-Lo has built her career on her ass! Hell, I've got an ass. We all have asses. What's so different about her butt?"*

"Ooh that's good, baby." Mildred flops back further in her recliner and takes a mouthful. "So there's another of you? Oh bring him over too and what does your little Joanna do?" "She's a teaching assistant at a school for children with special needs."

"Is that so? An assistant? Well I was a teacher. I taught Sunday school for a while. God, some of those kids were a pain in the ass. I remember Stacey Keach's boy, Junior, God, he had me on the run around. Oh Baby did too but, boy, she was so gifted. Her teacher said she could have been a rocket scientist. But my priest thought I smothered her. He turned to me once and said, 'I'm going to give that kid 10 dollars to get out of town'. I asked why and he said, 'Because you are mothering her to death'. I couldn't help it. She's my little baby girl!" She gazes at the dozens of frames on the window ledge beside her, "Oh my beautiful baby girl…" We sit in silence for a moment.

Suddenly there's a very loud growl – Mildred's stomach is rumbling. "Oh shit. The eats are in the fridge," she says, back on her feet and wobbling. I collect her empty glass and mine and follow her into the kitchen. She's standing before an ancient-looking, almost empty, fridge. Inside are two half-empty tins of cat food, a slice of lemon floating in a glass of Coke, one apple cut in two, a large opened pot of yogurt and the remnants of a meal: fish fingers and beans. On the middle shelf, set on a green and pink patterned plate, are six hard-boiled eggs cut in half and smothered in salad cream. She pulls them out.

"The joke is darling, I just don't cook – I've got all creative." I take the plate from her and pop one in my mouth. Tabasco hits the back of my throat. "God, these have a kick to them!" my voice, a wheeze. "I like a bite." Mildred smirks as she winks and slowly pops one egg in her mouth followed by a second, "yummy". I follow her back to the living room holding the plate with the remainder of the eggs. Moments later she's lurching forward in her chair and burping.

"Oh god, that's awful," she reaches down for a battered looking Christian Dior carrier bag next to her recliner. "I gotta take something for this. I have some Benylin in here… maybe that's not right?" She looks at me. "Maybe some Claritin? It's an antihistamine. Wait a minute. I have something here…" she lifts the bag onto her lap, the contents spill out. She picks up a huge box of Rennie, the size of a duty free carton of cigarettes, from the jumbled cardboard boxes on her lap. There are dozens of prescription pills, aspirin, bottles of medicine falling out onto the floor.

"Mildred, let me help you." I gather up the collection and find another bag to put them in underneath the chair. As I pull at it, cat hair fills the air. "Looks like you have Boots the Chemist on your lap there Mildred," I laugh.

"Oh darling, I don't take *that* much medication, nor am I a junkie." She giggles and burps, "Oh Gawd…I've been so sick. I have this dizzy condition, a hernia in the diaphragm, carpal tunnel syndrome, skin cancer and something else… now what is it?" She thinks for a moment and presses out two Rennies from their silver foil pockets and crunches on them. "Oh God, maybe I should call my doctor?" She looks at me. "Hmm, later." "Now have you asked me anything yet, Austin?" she says, still rubbing her chest and belching. "Yes, that's my plan." She takes little notice. "We were rich: a home in Cedarhurst and a house in Palm Beach. I lived in the Penthouse at the Beverly Wilshire Hotel once…. it's where I met that bitch Wallis Simpson. She had people bowing to her – the nerve! Oh well, I told you Barbara Hutton was a neighbour, right? She was a dear friend." Mildred takes a breath. My head's down. I'm hardly able to keep up with her – the names, the places, the attitude.

"I wanted to be in the movies and so I called my darling beloved Daddy and said, 'Daddy I want to be a movie star', and so he fixed it by phoning his friend L.B. Mayer. Daddy found a bungalow at The Garden of Allah apartments on Sunset for mother and I in Hollywood, and I started in the movies. I was the only starlet to have her own car and chauffeur. That left everyone at the studio speechless," she laughs. "Oh, but Mother wasn't keen on my being a movie actress. I had to make up all sorts of things to get past her at night, 'Mother I'm seeing Glenn Ford's etchings' or 'Mother, Mae Murray has a new puppy' that sort of thing. Hell, I should have listened though, then maybe Errol Flynn wouldn't have tried to rape me and Cecil B. DeMille wouldn't have made his advances."

"Oh God, Mildred – really? Errol Flynn!" I stare at her, my pen rolls off my pad and onto the rug. Rosebud pounces on it – neither of us take any notice as she plays with it.

"So, Errol had spied me at the Coconut Grove and asked me on a date. Errol made some excuse when he collected me from Allah about having to go to his place to make a call and, once inside, fixed me a glass of milk, then disappeared into his bedroom. When he came out, all I saw was his giant Johnny Dingle Dangle hanging below his shirt tails. 'Errol, just you stop that right now!' I said screaming as he chased me round the couch. I then sort of laughed, which made him uneasy – made him

feel small. I'm happy I've always had strong legs." She lifts her legs high in the air to illustrate her point, "See! Well anyways, when he caught up with me he came over my pretty green satin dress, I got up and shut myself in the bathroom and stayed there trying to get the stains out. He did back down and kept apologising and said he wanted to take me home. I took a cab." She took a sip of her drink. I took a gulp from mine.

"Did you tell anyone?" "Are you kidding?! We are talking Errol Flynn here. Oh and darling, well of course there was Johnny 'Tarzan' Weissmuller, he tried it on too – we were at 'Lovers' Lookout' up by the Hollywood sign when he groped me in the back of his car. 'Johnny,' I told him, 'I'm a nice girl'. I told him he should go back to his wife Lupe Vélez. He did, but not before he masturbated over the bonnet of the car." She pulls a face in disgust and then laughs loudly, "I never know how he kept *that* tamed behind his loin-cloth!"

I was dumb struck by Mildred's story and by her good humour. I hadn't written a thing, Rosebud was still in possession of my pen. I knew of course that Errol Flynn had a reputation but to hear of his attempted rape of the woman sitting in front of me was shocking. "Mildred, that's brave of you to tell me these things. You must have been so terrified. Did you tell anyone?"

"A few, I told my friends Arline Judge and Honeychile Wilder. My mother heard rumours and said nothing until 1960 when sat next to me at a set of stop-lights on Summit Ridge Drive in Los Angeles. She turned to me in the driver's seat and said, 'Mildred, you were nothing but a Hollywood whore'." "Oh god, really?" "I was a disappointment to Mother… Let's not dwell on all that." She smiles, patting the underside of her hairdo.

I grab the pen from Rosebud. She hisses. I looked at a blank page. "Oh Miss Shay… I mean Mildred. That's terrible… I don't know what to say…" Mildred looks shocked. "Don't say anything. Oh, I've lowered the mood: you look all sad. Listen, I knew what I was doing. I'm a tough old broad; a swinging chick!" Her smile was fixed, wide, like she was masking something.

I held my pen, poised and ready to go, "I'm fine. I just felt sorry for you." "Don't darling. That's Hollywood. Mother loved my baby brother and he died, and she liked my baby sister and mother never liked me – oh brother what is it Barbara Windsor says in *Eastenders*? Ah yes, 'Family!' Anyways, let's not talk about all that." "I'm sorry, Mildred, if you insist." "I do!"

"Mildred, may I ask, can I write anything of what you're telling me?" "Oh baby, yes! Print it." I scribble away, with Mildred interjecting with dates, with more names and with conquests. She's happy at the memory of it, sad it's all over. I look up at Baby captured in frames on the window ledge and wonder if she visits.

I think 40 minutes passes. She's talked non-stop. Mildred is determined I shouldn't leave. "Hey kid," she says, "there's a bed next door all ready." Then she smiles and, with shimmy of her shoulders, says, "That's if you don't want to bunk in with me…" I shake my head and laugh. Eventually, as I was trying to leave, she held me captive by the front door for a further 30 minutes pointing at more famous friends framed on the walls. She eventually gives in and opens the front door. Rosebud appears at her side – as if making sure I really am leaving.

"I hope I haven't bored you." "No, God no, the opposite Mildred." "Oh, that's good. Come back won't you, honey." "Try and stop me," I say as I give her a kiss on the cheek.

"Honey," she says with all seriousness, "Do an old lady a big favour and kiss me on the lips." I give her the briefest peck. "Boy, you've made my day!" I know she means it.

I'm over the threshold. I turn the corner and press the lift button. Mildred waves me off as the lift doors close. I hear her calling after me, "Oh Austin, Hasta la vista, baby."

My head hurts in disbelief of the past few hours. And I'm feeling a bit sick from the mix of martini and devilled eggs by the time I reach the ground floor. The bump of the lift hitting terra firma churns my stomach. But I'm smiling and it's not the effects of the booze, it's the realisation of what just happened. I'm smiling wider as I walk out on to Cundy Street. I look back up at the flat… which one is it? I count the floors, one, two, three, four… oh there it is, shredded curtains, the shadows of dozens and dozens of photo frames propped up against the dirty windows, yes, that's Mildred Shay's flat. A man walks in front of me, I want to grab his arm and point at the flat and tell him who lives there. My head aches from all the stories; I panic, hoping I've written them all down. 'No matter', I say to myself, I know I'll be back, just as she did. She said as much when I got into the lift. I repeat her line, 'Hasta la vista, baby!' Oh that's clever, I say to myself out loud, that's funny; *she* is funny. I repeat it again and again and smile and laugh out loud, 'Blimey, Cissie Shay, you've made my day!'

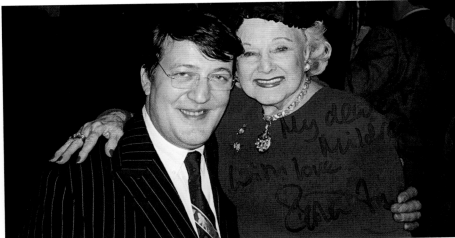

(top) Hollywood At War: Friends threw a party for the Steeles the night before they left Hollywood for England, where Geoffrey was to do his bit for King and Country. Mildred had her wardrobe made by British couturier Hardy Amies. Here with John Garfield (left), Geoffrey Steele and Geraldine Fitzgerald (right).

(above) Star Attraction: with Stephen Fry at her 90th birthday party, London 2001.

(left) Mommie Dearest: Wife, mother and church goer. Back home in Benedict Canyon, California, 1963. She continued to search for screen work until the end.

Filmographies

I Used to be in Pictures

Anita Page
Telling the World (1928)
While the City Sleeps (1928)
Our Dancing Daughters (1928)
Our Modern Maidens (1929)
The Broadway Melody (1929)

Randal 'Film Star' Malone
Sunset After Dark (1996)
Hollywood Mortuary (1998)
Bob's Night Out (2004)
The Curse of Lizzie Borden (2006)
Insignificant Celluloid (2011)

Palm Springs: The (Movie) Stars and (Zebra) Stripes

Joy Hodges
Follow the Fleet (1936)
Merry Go Round of 1938 (1937)
Service de Luxe (1938)
The Family Next Door (1939)
Margie (1940)

Bob Hope
Thanks for the Memory (1938)
The Cat and the Canary (1939)
Road to Singapore (1940)
The Paleface (1948)
The Facts of Life (1960)

Ginger Rogers
Top Hat (1935)
Kitty Foyle (1940)
The Major and the Minor (1942)
Roxie Hart (1942)
Lady in the Dark (1944)

Patsy Ruth Miller
The Hunchback of Notre Dame (1923)
The Breaking Point (1924)
So This is Paris (1928)
Hot Heels (1928)
The Fall of Eve (1929)

Frank Sinatra
On the Town (1949)
From Here to Eternity (1953)
Guys and Dolls (1955)
The Man with the Golden Arm (1955)
Oceans Eleven (1960)

Billie Dove
The Madness of Youth (1923)
The Air Mail (1925)
The Black Pirate (1926)
The Love Mart (1927)
Blondie of the Follies (1932)

I'm Still Big, It's The Room That Got Small

Anita Garvin
Their Purple Moment (1927)
From Soup to Nuts (1928)
Stepping Out (1929)
Blotto (1930)
Be Big! (1931)

Rose Hobart
Liliom (1930)
East of Borneo (1931)
Dr. Jekyll and Mr. Hyde (1931)
Susan and God (1940)
Conflict (1945)

Thelma White
Ride 'em Cowboy (1930)
Hot Sands (1931)
Reefer Madness (1936)
Spy Train (1943)
Mary Lou (1948)

Muriel Evans
Pack Up Your Troubles (1932)
Manhattan Melodrama (1934)
The Roaring West (1935)
The House of Secrets (1936)
King of the Pecos (1936)

Fayard Nicholas
Pie, Pie Blackbird (1932)
Kid Millions (1934)
The Big Broadcast of 1936 (1935)
Down Argentine Way (1940)
The Pirate (1948)

Mae Madison
Whoopee (1930)
Bought! (1931)
Her Majesty, Love (1931)
The Big Stampede (1932)
So Big! (1932)

Vampira: A Hollywood Horror Story

Vampira
The Vampira Show (TV) (1954)
Plan 9 from Outer Space (1959)
The Beat Generation (1959)
The Big Operator (1959)
Sex Kittens go to College (1960)

James Woods
Videodrome (1983)
Once Upon a Time in America (1984)
The Getaway (1994)
Casino (1995)
The Virgin Suicides (1999)
Straw Dogs (2011)

Sharon Stone
Total Recall (1990)
Basic Instinct (1992)
Casino (1995)
Sphere (1998)
Alpha Dog (2006)

Cocks & Cocktails

Mildred Shay
The Women (1939)
Balalaika (1939)
Ride, Tenderfoot, Ride (1940)
In Old Missouri (1940)
Valentino (1977)

Indexes

PAGE NUMBERS IN BOLD REFER TO IMAGES

THE CAST

Acker, Jean 28
Adrian, Iris **154**
Ahern, Lassie-Lou **102**
Ahern, Peggy 102
Alexander, Ben **124**
Allan, Hugh **111**
Allan, Richard **273**
Allen, Gracie 221, **252/253**
Allen, Judith 12, **154**
Amies, Hardy 267, 288, 297
Andre, Lona **110**, **277**
Andress, Ursula 238, **238**
Angeli, Pier 238
Anita Page **277**
Annabella **264**
Annenberg, Leonore 19, 33
Annenberg, Walter 19, 33
Ansara, Michael **210**
Anthony, Ray 198
Arbuckle, Roscoe 'Fatty'
(*aka* William Goodrich) 12, 186
Arlen, Richard **257**
Arnaz, Desi 142
Arthur, Robert **128**
Asher, Irving 178, 262
Astaire, Fred 17, 20, 24, 52, **121**, 156, **157**, 193, 194, 214, 276
Astor, Mary **114/5**, 175
Auer, Mischa **18**
Austin, Vivian **222**
Autry, Gene **94**
Autry, Max Munn 292
Ayres, Lew **124**

Bacall, Lauren 107, 161, 163
Bailey, George 65
Bakewell, William **39**, **76**, **124**
Ball, Lucille 77, **142**, 248
Bankhead, Tallulah 192
Bánky, Vilma 8, 27
Barclay, Joan (*aka* Geraine Greear) **60**
Barnes, Binnie **214**
Barondess, Barbara **143**
Barton, Geraldine **208**
Barymore, John **283**
Basquette, Lina 25, **98**
Bauman, Maria 188
Beatles, The 289
Beck, Thomas **107**
Belita **188**
Bellamy, Madge **4**
Bellamy, Ralph 31
Bennett, Constance **257**
Bennett, Joan **257**
Benny, Jack 190
Berkeley, Busby 61, **283**
Berle, Milton 203
Bernheimer, Verone **264**
Biberman, Herbert 125
Bickford, Charles **147**
Billingsly, Sherman **222**

Bishop, Julie (*aka* Diane Duval; Jacqueline Wells) **67**
Bissell, Whit 194, **211**
Blake, Robert 206
Blanche Sweet **101**
Blane, Sally **224**
Blondell, Joan 276
Boardman, Eleanor **64**, **74**, 242
Bogart, Humphrey **93**, 107, 115, 161, 166, 190
Bond, Lilian **277**
Bonner, Priscilla **116**
Booth, Shirley 49
Borland, Carroll 11, **101**
Borzage, Frank 4
Bouchier, Chili 262
Bow, Clara 116, 260, 262
Boyd, William 'Hopalong Cassidy' 91
Bracken, Eddie **160**
Bradley, Grace **91**
Brando, Marlon 232, 237-8, **259**
Brent, George **114/5**
Brewster, June **155**
Brian, Mary **260**
Broccoli, Barbara 190
Brooke, Hillary **228**
Brooks, Phyllis **113**
Brown, Clarence 129
Brown, Herb Nacio 84
Brown, Johnny Mack 84
Browning, Tod 54, 70, 101
Bruce, Carol **257**
Bruce, Virginia 175, 229
Burke, Billie **142**

Cagney, James **92**, 175
Cameron, James 112
Cameron, Rod 169
Campbell-Russell, Hilda **202**
Cantor, Eddie 147, 208
Capra, Frank 97, 185, 246
Carey, MacDonald **47**
Carlisle, Mary 232, **277**
Carol, Sue 292
Caron, Leslie **121**
Carroll, Georgia **161**
Carter, Louise 158
Chambers, Shirley **155**, **208**, 291
Chandler, Chick **155**, **160**
Chaney, Lon 28, 259
Chaplin, Charlie 11, 171, 267
Charisse, Cyd **271**
Chase, Charley 177, 182, 218
Cherrill, Virginia 113, **267**
Child-Villiers, Lord George, 9th Earl of Jersey 267
Christie, Al 91
Clair, Ethlyne **111**
Clarke, Mae **92**, 175, **180**, **205**
Clifford, Ruth 175, **181**, 194
Cobb, Lee J. 183
Coburn, Charles 206
Cohen, Emanuel 260

Cohen, George M. 126
Cohn, Harry 168
Colbert, Claudette **97**
Collins, Joan **272**
Collins, John 185
Compton, Joyce **170**, **181**, 182, **218**
Connors, Chuck 141
Coogan, Jackie 54
Coonan, Dorothy **219**
Cooper, Gary 74, **212**
Cooper, Gladys 202
Cotton, Joseph **201**
Coward, Noel 280
Crabbe, Larry 'Buster' **144**
Crawford, Joan **42**, 51, 70, **75**, 83, 202, 286, 291
Crisp, Donald **111**
Crosby, Bing 154, 212
Cugat, Xavier **247**
Cukor, George 166, 291
Cummings, Constance **280**
Cummings, Robert **107**
Cummins, Peggy 10, **113**, **128**, 213
Curley, Pauline 12, 25, **275**
Curley, Rose 275
Currie, Louise **161**
Curtis, Tony 12, **258**

d'Arrast, Harry d'Abbadie 242
Daltry, Roger 289
Damone, Vic 255
Dana, Viola 175, **185**
Davidson, Lawford **36**
Davies, Marion 73
Davis, Bette **6**, 11, **114/5**, **130**, 131, 166, 183, 201, 283
Davis, Jim **258**
Davis, Sammy, Jr. 235
Davis, Virginia **225**
Day, Doris 235
Day, Laraine 256
Day, Marceline 17
De Carlo, Yvonne 175, 177, 190, 236
de Havilland, Olivia 46, 48, **150**
Dean, James 56, 232, 233, 235, 237-8, **238**, 270
DeHaven, Gloria **250**
del Rio, Dolores **156**
DeMille, Cecil B. 12, 96, 98, 139, 146, 154, **265**, 295
Denny, Reginald 276
Dietrich, Marlene 11, 12, 32, 36, 74, 89, **108**, **127**, **204**, 269
Dix, Richard 276
Doll, Harry 12
Doll, Tiny 12
Donahue, Troy 57
Donlevy, Brian 215
Douglas, Kirk 107, **148**
Dove, Billie 12, 17, **26**, 32-33, **181**

Doyle, Jack 12
Drake, Frances **221**, **265**
Drew, Dr. 210
Dudley, Paul 24
Duke, Doris **245**
Duncan, Bill **106**, **164**
Dunne, Ann 181
Dunnett, Derek 213
Durbin, Deanna 55, **248**
Duval, Diane (*aka* Julie Bishop; Jacqueline Wells) **67**

Eastwood, Clint 226
Eddy, Nelson **167**, **291**, **294**
Edeson, Robert **276**
Einstein, Albert 274
Ellis, Patricia **277**
Eppling, Mary Lee 51
Evans, Dale **95**
Evans, Muriel **174**, 175, 177, **189**, 190-191
Everly, Don 40

Factor, Max 294
Fairbanks, Douglas, Jr. 6, **9**, 10, 11, 25, **50**, 202, 282, 283, 290
Fairbanks, Douglas, Sr. 26, 32, 51, 60, 92, 275
Fairbanks, Lucille 11
Farrell, Charles **31**
Farrow, Mia 41
Faye, Alice 17, **18**, **133**
Fellows, Edith **64**
Ferguson, Paul and Tom 73
Fields, W.C. 154, **158**, 190, 218
Film Star see Malone, Randal
Fitzgerald, Geraldine 297
Fleming, Susan (Mrs Harpo Marx) 19, **120**
Flugrath, Edna 185
Flynn, Errol 58, 67, **164**, 245, 269, 295-6
Fontaine, Joan **46**, 291
Ford, Betty 17
Ford, Glenn 295
Ford, John 146, 259
Ford, President Gerald 17
Francis, Kay 276
Freed, Arthur 84
Freeman, Mona **255**
Fry, Stephen **297**

Gable, Clark 10, 74, **80**, **97**, 191, 202, **207**
Gabor, Zsa Zsa 20, 24, 32, 237
Gadd, Renee 229
Garbo, Greta 11, 70, 143, 163, 186, 248, 282, 286, 290
Gardner, Arthur **141**
Gardner, Ava 41, **244**
Garfield, John 286, 290, **297**
Garland, Judy **142**, 290
Garmes, Lee 147
Garson, Greer **104**

Garvin, Anita 175, 177-194, **177**, **181**
Gaynor, Janet 31
Gibson, Wynne **205**
Gilbert, John 146
Gilbert, Wayland **281**
Gilford, Gwynne **55**
Gish, Dorothy 63
Gish, Lillian **5**, 10, 11, **63**, 201
Gleason, Jackie 248
Gleason, Russell **124**
Goebbels 27
Golter, Lindsay 262
Goodrich, William (*aka* Roscoe 'Fatty' Arbuckle) 186
Gorbachev, Mikhail 21
Goudal, Jetta **96**
Goulding, Alfred J. 102
Grable, Betty 106
Graham, Sheilah **214**
Granger, Dorothy **218**
Granger, Farley **250**
Grant, Cary 106, **110**, 113, 145, **162**, **164**, 214, 228, **267**, 286
Grayson, Kathryn 194
Greear, Geraine (*aka* Joan Barclay) 60
Grey, Lita 11
Grey, Virginia **256**
Griffith, D.W. 54, 63, 101, 201
Guerin, Bruce 54
Guizar, Tito 229
Gulliver, Dorothy 38
Gwynne, Anne 55, **194**, **195**

Haines, William 74, 75
Hall, Ruth **147**, **208**, **277**
Hall, Thurston **292**
Hamilton, George, **43**
Hammerstein, Oscar 281
Hardy, Oliver 282
Harlan, Kenneth 210
Harlow, Jean 70, 74-5, 262
Harris, Mitchell **118**
Harris, Phil 17, **18**
Harrison, Rex 11, 280
Hart, Lorenz 17
Hart, William S. 176
Hartford, Huntington 113
Hayworth, Rita 152
Hearst, William Randolph 32, 73
Hefner, Hugh 91, **294**
Henie, Sonja 42, 237
Henry, Charlotte **169**
Hepburn, Katharine 21, 107, **118**, 228
Herlinger, Karl, Jr. **105**
Hiatt, Ruth **192**, **266**
Hilton, Nicky 255
Hitchcock, Alfred **30**, 46, 47, 163, 217, 229, 250, 259, 290
Hitler, Adolph 27, 75, 98
Hobart, Rose 12, 175-94, **182**, **183**, **186**

Hodges, Joy 17-33, **16**, **18**, **20**, 27, **30**, 33, **203**, **243**
Holm, Celeste 273
Holm, Eleanor **224**, **277**
Holt, Tim 169
Hope, Bob **frontispiece**, 12, 20, 24, **27**, 33, **132**, 212, 228, **263**, 290
Hope, Dolores 24, 27, **263**
Hopkins, Katharine 180
Hopper, Hedda 40, 206
Horne, Lena **220**
House, Herschel A. 83
Hover, Herman 234
Howard, Joyce 163
Howard, Lt. Cecil John Arthur, Earl of Suffolk 265
Howell, Yvonne 12
Hughes, Carole **109**
Hughes, Howard 26, 44, 113, 290
Hughes, Kathleen 56
Hunt, Marsha **59**
Hunter, Tab **40**, **44**, 56, 57, **210**, **270**
Hurrell, George 71
Hussey, Ruth **166**, 256

Ivano, Paul 28

Jameson, Harry 220
Janis, Dorothy **51**, **62**
January, Lois **219**
Jason, Sybil **225**
Jeffreys, Anne **119**
Jessel, George 93, **281**
Johnson, Helen (*aka* Judith Wood) **155**
Johnson, Van **220**, **234**
Jolson, Al 61
Jones, Buck 191, 262
Jones, Caroline 236
Jones, Shirley 216, 232
Jones, Tom 198
Jordan, Kevin 141
Joy, Leatrice 139
Judge, Arline 296

Kaaren, Suzanne 291
Karloff, Boris 49, 120, **185**
Keach, Stacey, Jr. 295
Kean, Jane **248**
Keaton, Buster 74, **96**
Keel, Howard 194
Keeler, Ruby 17, **61**
Keeley, William **269**
Keighley, William 37
Kelly, Gene 74, **121**, 193, 199
Kennedy, Bobby 290
Kent, Barbara **282**
Kerr, Deborah **88**
King, Charles **78**
King, John **30**, **203**, **243**
Kirk, Lisa **278**
Knapp, Evalyn **277**
Knight, Felix 169
Knight, June **133**
Knowlden, Marilyn **64**
Knowles, Patric **58**
Kohner, Paul 47, 147
Kohner, Susan **47**
Kyser, Kay 161

La Plante, Laura 175, **178**, **262**
La Rocque, Rod 27
La Rue, Jack **129**, 290
Ladd, Alan 291, **292**
Laemmle, Carl 141, **274**
Laemmle, Carl, Jr. **221**
Laemmle, Carla **140/141**, **274**
Lahr, Bert 219
Lake, Veronica 161, 292

Lamarr, Hedy 229, **252/253**, 291
Lamas, Fernando 278
Lamour, Dorothy **212**
Lancaster, Burt 107, **123**
Lanchester, Elsa 183
Lane, Abbe **247**
Lane, Marjorie **215**
Lang, Barbara **149**
Lang, June **126**
Langdon, Harry 116
Laughton, Charles 214
Laurel and Hardy 12, 48, 67, 101, 169, 177, 182, 218
Lautner, John 24, 27
Laven, Arnold 141
Lawford, Peter **88**, 227
Lawrence, Rosina **48**
Layton, Dorothy **277**
Lee, Anna 40
Lee, Bruce 40
Lee, Frances **91**, **209**
Leigh, Vivien 191
Lemmon, Jack 19
Levy, Ben 280
Levy, Jules 141
Lewis, George J. **38**
Liberace 17, 235, 239
Lillie, Beatrice 74, **222**
Lind, Della (Grete Natzler) 48
Lister, Bruce **262**
Lloyd, Harold 12, **122**, 175, 176, 280, 282
Loder, John **252/253**
Logan, Joshua 57
Lombard, Carole 221
London, Babe 176
Loren, Sophia **210**
Lorre, Peter 265
Louis, Jean 29
Love, Bessie **78**, **111**
Lovett, Dorothy **136**
Loy, Myrna 11, **11**, **116**
Lubitch, Ernest 171
Luce, Clare Boothe 10
Lugosi, Bela 4, **101**, 147
Luke, Keye 11
Lund, Lucille **120**
Lupino, Ida **229**
Lupino, Rita **229**
Lyles, A.C. **226**

MacCloy, June **92**
Mack, Marion **96**
MacLaine, Shirley 108
MacLaren, Mary **192**
MacMurray, Fred **108**, **135**
Madison, Mae **108**, **190**, 193-4, **208**, **283**
Majors, Lee 141
Mallory, Boots **277**
Malone, Randal 'Film Star' 70-84, **79**
Mansfield, Jayne 40, 198
Marion, Joan 12, **131**, **267**
Marquis, Rosalind **109**
Marsh, Joan 74, **158**
Martin, Richard **106**
Martin, Tony **113**, **271**
Marx Brothers, The 92, 120, 266
Marx, Groucho **100**
Mason, James 163
Mason, Shirley 185
Matthews, Joyce **203**
Mature, Victor 107
Mayehof, Eddie **248**
Mayer, Louis B. 75, 165, 215, 295
McCarey, Leo 147
McCrea, Joel **159**
McDermott, Hugh **163**

McGann, William 283
McHugh, Jimmy **31**
McPhail, Addie **186**
McQueen, Butterfly **151**
McQueen, Steve 270
Medford, George 147
Menjou, Adolphe 171
Meyer, Paul 122
Milland, Ray 30, 227
Miller, Ann 12, 77, **168**
Miller, Patsy Ruth **19**, **20**, 25-30
Mineo, Sal 47
Minnelli, Vincent **220**
Miranda, Carmen 187, **247**
Mitchum, John 45
Mitchum, Robert 12, **45**, 161
Mix, Tom 176
Monroe, Marilyn 57, 143, 198, 232, 235, 238, 248, 273, 279
Montalban, Ricardo **278**
Montgomery, Robert 49
Moore, Colleen 11
Moore, Constance **144**
Moore, Dennie 10
Moore, Terry **44**
Moorhead, Natalie **126**
Moreno, Antonio 275
Morgan, Frank 291
Mori, Toshia **246**, **277**
Morrison, Joe **44**
Moss, Cruse W. 65
Muir, Esther **100**
Munchkins, The 232
Murnau, F.W. 99
Murphy, A. Stanford 4
Murphy, Audie 47
Murphy, George **134**
Murray, Don 57
Murray, Johnny 234
Murray, Ken 273
Murray, Mae 295
Mussolini, Benito 70, 75

Nagel, Conrad 146
Nash, Noreen 232, **250**
Negri, Pola **171**
Newman, Paul 56, 270
Nicholas Brothers, The (Fayard and Harold) 175, **180**, 190, 191-4
Nigh, Jane **169**
Niven, David 10
Nixon, Richard 209
Nolan, Doris **118**
Norman Taurog 88
Novak, Eva 176
Novak, Jane **176**
Novak, Kim **217**
Novarro, Ramon 51, 70, 73, **74**, 75
Nureyev, Rudolph 286, 290-1, **293**
Nurmi, Maila see: Vampira

Oakie, Jack 92, 120, **260**
Oberon, Merle 194
O'Brien, Edmund **251**
O'Brien, George **94**
O'Brien, Margaret 77
O'Brien, Pat 93
O'Connor, Donald **199**
O'Day, Molly **261**
Odets, Clifford 165
Offield, Evelyn **260**
O'Hara, Maureen **259**
Oland, Warner 146

Page, Anita **62**, 70-84, **71-4**, **76**, **78-82**, 85
Page, Linda 75-84
Palance, Jack **149**
Pall, Gloria ('Voluptua') 77, **235**
Parsons, Louella **31**

Patton, Virginia **65**
Pavlova, Anna 146
Peck, Gregory 163
Peel, Sir Robert 222
Pellegrini, Margaret **142**
Peppard, George 43
Perkins, Anthony 238
Pickford, Mary 26, 51, 101, 225, 260
Pine, Chris 55
Pinsky, Morton 210
Ponti, Carlo 210
Powell, Eleanor 215
Powell, Jane **206**
Powell, William 74, 75, **116**
Power, Tyrone 264
Preminger, Otto 57
Presley, Elvis 56, 57, 198, 232, 235, **239**
Prince, Frank **109**
Pringle, Aileen 11, 74

Quillan, Eddie **90**, **209**
Quillan, John 209
Quillan, Marie 209

Raft, George **170**, 221, 286
Rainer, Luise 12, 165
Ralph, Bellamy **145**
Ralston, Esther **283**
Rambova, Natacha 28
Ramsden, Frances **122**
Rand, Sally 221
Randall, Rebel **160**
Rappe, Virginia 186
Rat Pack, The **93**
Rathbone, Basil **185**
Ray, Johnny 234
Raymond, Gene **156**
Reagan, Nancy 28, **33**
Reagan, Ronald 21, **23**, 28, **33**, 67, 135, 143, 166, 227, 276
Reid, Wallace 275
Reisner, Charles 76
Revier, Dorothy 12, 27
Reynolds, Burt 141
Reynolds, Debbie **199**, **217**
Rhodes, Billie **192**
Roach, Hal 102, 169, 182
Roberts, Beverly 10, 12, **13**, **93**, 205, 269
Rogers, Charles 'Buddy' 20, **26**, **27**, 202
Rogers, Ginger 10, 17-24, **22**, **23**, 27, 30-2, **52**, 77, **183**, 156, **157**, 192, 201, 214, **223**, **277**
Rogers, Jean 11, **117**
Rogers, Lela 183
Rogers, Roy **95**, 286
Rogers, Walter Browne **124**
Rogers, Will 189
Roland, Gilbert 32, **148**, **245**
Rollins, David **99**
Romberg, Sigmord 281
Romero, Cesar **246**, **256**
Rooney, Mickey 129, 168
Roosevelt, President Franklin D. 281
Rose, Billy 203
Roselli, Johnny 126
Ruggles, Charles **18**
Russell, Jane **95**
Russell, Ken 290, 293
Russell, Patricia 202
Russell, Rosalind 183
Ryan, Maurice 111

Saint, Eva Marie 57
Sale, Virginia **179**
San Juan, Olga **251**
Savage, Ann **139**, **152/153**
Sayers, Jo-Ann **49**, 291

Sayers, Loretta **262**
Scott, Lizabeth **57**, 107, 163, **249**
Scott, Randolph **214**
Seeger, Miriam **36**, **276**
Selwyn, Edgar **205**
Selznick, David O. 49, **150**
Sennett, Mack 12, 90, 99
Shannon, Peggy **166**
Shay, Adeline **264**, 289
Shay, Mildred 12, **106**, **162**, **264**, 286-96, **287-9**, **292-4**, **297**
Shearer, Norma 74, 175, 290
Shepherd, Elaine **244**
Sheridan, Ann 106, 291
Shilling, Marion 12, 70, **80**, **281**
Shockley, Marian **277**
Shumway, Lee **20**
Siegel, Lee **250**
Simms Ginny **212**
Sinatra, Frank 20, 24, 32, 33, **41**, **119**, 163, 198, 235, 236, 255, 290
Sirk, Douglas 47, 227
Smith, Alexis **164**
Sondergaard, Gale **125**, 183
Sonnenberg, Gus 'the Goat' 12
Sothern, Ann **258**
Spielberg, Steven 171
Stanley, Clifford 'Red' 182
Stanton, Helene **210**
Stanwyck, Barbara 108, **138**, 141, 205
Steele, Geoffrey **288**, 289, **289**, 290, **297**
Steele-Waller, Georgiana 289
Stephenson, James **166**
Stepin Fetchit' (Lincoln Perry) 176, **189**
Sterling, Jan **148**
Sterling, Robert 119
Stevens, Craig 164
Stevens, Mark **88**
Stevens, Risë **167**
Stevenson, Robert 40
Stevenson, Venetia 40
Stewart, James 11, **137**, **207**, **223**
Stewart, Margie 12, **106**
Stewart, Rod 289
Stone, Sharon 232, 236-7
Stuart, Gloria **112**, **276**, **277**
Sturges, Preston 122
Sullivan, Ed 248
Summerville, Slim **124**
Sutton, Grady 183
Swanson, Gloria 10, 171
Sweet, Blanche 11

Talbot, Lyle 10
Taurog, Norman 113
Taylor, Elizabeth 10, 12, **129**, 228
Taylor, Kent 161
Taylor, Robert 152, 276, **279**
Temple, Shirley 64, **105**, 154, 225
Thalberg, Irving 70, 74, 175, 290
Thaw, John 290
Thiess, Ursula **279**
Thomas, Frankie **103**
Three Stooges, The 175, 218, 266
Tierney, Gene **254**
Tierney, Lawrence 119
Tobin, Genevieve **37**
Todd, Ann **163**
Toler, Sidney 146
Tom Jr., Layne 146
Toomey, Regis **66**, 81, **126**, **162**, 175
Torres, Raquel 221

Torres, Renee **221**
Totter, Audrey **152**, 163
Tovar, Lupita 47, **147**
Towne, Rosella **166**
Tracy, Spencer 93
Travers, Linden **229**
Travis, June **109**
Trevor, Claire **214**
Turner, Lana 11, 17, **135**, **254**, 290

Ulmer, Edgar G. 139

Vale, Virginia **94**, 200
Valentino 28, 73
Valentino, Rudolph 146, 148, 171
Valli, Virginia 31
Vampira (Maila Nurmi) 232-8, **233**, **234**, **235**, **237**, **238**, **239**
Van, Vera **281**
van Doren, Mamie **198**
Vaughn, Alberta **99**
Vélez, Lupe 296
Vera-Ellen **226**
Vernon, Bobby **91**, **209**
Vidor, King 242
Villarías, Carlos 147
Vitagraph girls 12
Voluptua see: Gloria Pall
Von Sternberg, Josef 54
Von Stroheim Erich 102, 274

Wagner, Robert 43
Walken, Christopher 21
Walker, Robert **88**
Waller, Gordon 289
Walsh, Raoul 54
WAMPAS Baby Stars **277**
Warner, Jack 93, 130, 131, 274
Warner, Sam 98
Watts, Twinkle **55**
Wayne, John 67, 99, 108, 141, 191, **259**
Weissmuller, Johnny 183, **188**, 296
Welles, Orson 201, 228
Wellman, William 219
Wells, Jacqueline (aka Julie Bishop; Diane Duval) **67**
West, Adam 246
Whelan, Tim 276
White, Thelma **187**, 189-90, **206**
Whitmore, James **88**
Whitty, Dame May 286
Widmark, Richard 47, 107
Wilde, Cornel **244**
Wilder, Billy 148, 258, 276
Wilder, Honeychile 296
Willat, Irving 26
William Powell **126**
Williams, Esther **42**
Williams, Van **40**
Wilson, Dorothy **277**
Wilson, Lois **146**
Wilson, Marie **27**
Winchell, Walter 17, 248
Wing, Toby **89**
Winters, Shelley **123**
Winwood, Estelle **192**
Withers, Jane **255**
Wong, Anna May 202
Wood, Ed 12, 236
Wood, Judith (aka Helen Johnson) **155**
Wood, Natalie 286
Woods, Donald **29**
Woods, James 232, 235-6, **235**
Worth, Frank 232
Wray, Fay 209, **261**
Wyman, Jane 20, 162, **227**

Yates, Herbert 55
Young, Loretta 19, **29**, 32, 158, 224
Young, Polly Ann **158**
Young, Robert 53, 70, **147**

Zanuck, Darryl F. 107, 128
Ziegfeld, Florenz **224**
Zorina, Vera **132**
Zugsmith, Albert 198
Zukor, Adolph 226
ZZ Top 271

THE PICTURES AND THE PLAYS

2000 Women (1944) 202
42nd Street (1932), 61

A Thousand and One Nights (1945) 244
Abbott and Costello Show, The (TV) 228
Ace in the Hole (1951) **148**
Adventures of Huckleberry Finn, The (1939) 49
Adventures of Jane Arden, The (1938) **166**
Adventures of Robin Hood, The (1938) 58
Advise & Consent (1962) 57
Affairs of Martha, The (1942) 59
African Queen, The (1951) 118
Age of Innocence (1993) 164
Alias Nick Beal (1949) 152
All About Eve (1950) 10
All Quiet on the Western Front (1930) **124**
All That Heaven Allows (1955) 227
Ankles Preferred (1927) 4
Anna Christie (1923) 101
Anthony Adverse (1936) 64, 125
Apartment, The (1960) 108

Babes in Toyland (1934) **169**
Band Wagon, The (1953) 271
Bandit of Sherwood Forest (1946) 244
Batman (1960s TV series) 246, 272
Beat Generation, The (1959) 198
Between Two Worlds (1944) 10
Big Money (1930) **276**
Big Valley, The (TV series) 141
Birth of a Nation (1915) 201
Bitch, The (1979) 272
Bitter Tea of General Yen, The (1932) 246
Black Cat, The (1934) 120
Black Cat, The (1941) 55
Black Pirate, The (1926) 32
Blithe Spirit (1945) 280
Blossoms in the Dust (1941) 59
Blue Danube, The (1932) 262
Bluebeard's Eighth Wife (1923) 67
Border Incident (1949) 278
Border Treasure (1950) 169
Bohemian Girl (1937) 169
Bolero (1934) 221
Bombardier (1943) **106**
Born to Dance (1936) 215
Brazil (1944) 229
Bright Eyes (1934) 154
Bringing Up Baby (1938) 118
Broadway Melody of 1929, The (1929) 62, **78**

Broadway Melody of 1936, The 215
Broken Dreams Blvd (Web series)
Buck Rogers (1939, film series) **144**
Bus Stop (1956) 57
Butterfly (1924) 175

Cabin in the Sky (1943) 220
Call Me Madam (1953) **273**
Camelot (1963, Broadway) 119
Cape Fear (1962) 45
Carnation Kid, The (1929) 91
Carnival (1931) 262
Carnival Day (1936) 169
Caught in the Draft (1941) 160
Chances (1931) 283
Charge of the Light Brigade (1936) 58
Charlie Chan (1930s, film series) 60, 107
Charlie Chan at the Circus (1936) 246
Charlie Chan at the Olympics (1936) **146**
Charlie Chan in Honolulu (1938) 146
Charlie Chan Murder Cruise (1940) 146
Charlie Chan on Broadway (1937) 246
Cheyenne Autumn (1964) 278
Chicken a La King (1928) 91
Christmas Carol, A (1910) 185
Citizen Kane (1941) 201
City Lights (1931) 267
City Slickers (1991) 149
Collegians, The 38
Come Back, Little Sheba (1952) 44
Courage of the West (1936) 219
Covered Wagon, The (1923) 146
Crossfire (1947) 53
Crowd, The (1928) 242

Daddy Long Legs (1955) **121**
Dallas (1980s, TV series) 164
Dark Shadows (1960s, TV series) 257
David Copperfield (1935) 64
Day at the Races, A (1937) **100**
Dead Reckoning (1947) 107
Deadwood (2004-2006, TV series) 226
Detour (1945) 139
Dillinger (1945) 119
Dino (1957) 47
Dive Bomber (1941) 164
Double Indemnity (1944) 108
Down Argentine Way (1940) 192
Dracula (1927, Broadway) 101
Dracula (1931) **140/141**
Drácula (1931, Spanish version) 147
Dress Parade (1927) **111**
Duck Soup (1933) 266
Duel in the Sun (1946) 201
Dumb Girl of Portici, The (1916) **146**
Dynasty (1980s, TV series) 43, 272

Eagle, The (1925) 28
Easiest Way, The (1931) 74
East of Borneo (1931) **147**
Easter Parade (1948) 168
Elmer Gantry (1960) 216

Endless Love (1981) 57
Falcon, The (film series) 60
Falcon Crest (1980s, TV series) 227
Fantasy Island (1978-84, TV series) 278
Fast and Loose (1939) 49
Father Knows Best (1954-60, TV series) 53
Feet First (1930) 282
First Love (1939) **139**
Flash Gordon (1936, film serial) **117**, **144**
Flesh and the Devil (1926) 282
Flipper (1960s, TV series)
Flirtation Walk (1934) 61
Flying Down to Rio (1933) **156**, **157**
Follow the Fleet (1936) 17, 20, 214
Forbidden Paradise (1924) 171
Fort Osage (1950) 169
Fort Worth (1951) 214
Freaks (1932) 70
From Here to Eternity (1953) 41
From Soup to Nuts (1929) **177**
Front Page (1931) 260

Gaucho, The (1927) 60
General, The (1926) **96**
Give My Regards to Broadway (1948) 169
Go Into Your Dance (1935) 61
Godless Girl, The (1929) 98
Gold Diggers of 1933 20, 61
Gone With the Wind (1939) 49, **150**, **151**, 191
Good Earth, The (1937) 146, 165
Goodbye Mr. Chips (1939) 104
Great Gatsby, The (1926) 146
Great Lie, The (1941) 115
Great Stampede, The (1932) **108**
Great Ziegfeld, The (1936) 165
Green Grass of Wyoming (1948) **128**
Green Hornet, The (1960s, TV Series) 40
Guess Who's Coming to Dinner (1967) 118
Gun Crazy (1949) 10
Gypsy (1937) 262

Hail the Conquering Hero (1944) 160
Hatful of Rain, A (1957) 57
Hi Diddle Diddle (1943) **171**
High School Confidential (1958) 198
High Wall (1947) **152**
His Majesty and Co (1935) 202
Hit the Deck (1955) 168, 206
Holiday (1938) **118**
Hollywood Canteen (1944) 65
Hollywood Revue of 1929 84, **277**
Hollywood Show (1945) 206
Home From the Hill (1959) 43
Honeymooners, The (1955-56, TV sitcom) 248
Hot Cha! (1932) **133**
House of Frankenstein (1944) 55
House of Numbers (1957) **149**
How Green Was My Valley (1941) 259
Hunchback of Notre Dame, The (1939) 28, 30, 259
Hurricane, The (1937) 146

I Love Lucy (1950s TV series) 142, 228
I Was A Teenage Frankenstein (1957) 211
I Was A Teenage Werewolf (1957) 211
I'd Rather be Right (Broadway Musical) 17
Imitation of Life (1959) 47
In Old Missouri (1940) **292**
International Squadron (1941) 67
Intolerance (1916) 201
Invisible Man, The (1933) 112
Iron Horse, The (1924) 4
It (1927) 116
It Came from Outer Space (1953) 56
It Happened One Night (1933) **97**
It's a Wonderful Life (1946) 65, 136

Jade Mask, The (1945) 146
Jamaica Inn (1939) 239
Jane Eyre (1943) 228
Janie (1944) 65
Java Head (1934) 202
Jezebel (1938) 130
Johnny Belinda (1948) 227
Judith of Bethulia (1913) 101
Jungle Book, The (1967) 18

Ken Murray Blackouts (1940s, theatrical review show) 273
Kid From Spain, The (1932) **147**
Kid Glove Killer (1942) 59
Kid Millions (1934) 193
King and I, The (1950) 10
King Kong (1933) 209, 261
Kismet (1962, Broadway) 119
Kiss Me Kate (1953) 168
Kiss Me, Stupid (1964) 217
Kitty Foyle (1940) 21, 52, 223
Knack, The (1964) 202

Lady in the Dark (1944) 30
Lady in the Lake, The (1947) 152
Lady is Willing, The (1942) **108**
Lady Vanishes, The (1938) 229
Land of The Pharaohs (1955) 272
Last Wagon, The (1956) 47
Lazybones (1935) 4
Les Misérables (1935) 64
Light in the Piazza (1962) 43
Lion in Winter, The (1968) 118
Lone Operator, The (1911) 101
Lord of the Manor (1933) 131
Loretta Young Show, The 29
Lorna Doone (1922) 4
Lost Weekend, The (1945) 227
Louisiana Purchase (1941) 132
Love Doctor, The (1929) **36**
Loving You (1957) 57

Mad Genius, The (1931) **283**
Mad Love (1935) 265
Madame X (1966) 278
Magnificent Ambersons, The (1942) 201
Magnificent Obsession (1954) 227
Major and the Minor, The 21, 1942
Maltese Falcon, The (1941) 115
Mame (stage musical) 168
Man With Nine Lives, The (1940) 49
Manhattan Melodrama (1934) 191

Marcus Welby, M.D. (1969-76, TV series) 53
Marie Antoinette (1938) 64
Mark of the Vampire (1935) 11, **101**
Marshal from Mesa City (1940) **94**
May Wine (1935, Broadway) 281
Melody Cruise (1934) **155**
Melody Maker, The (1933) 131
Men in White (1937, West End Play) 267
Merry-Go-Round of 1938 (1937) **30, 243**
Merton of the Movies (1924) 185
Mighty Joe Young (1949) 44
Million Dollar Legs (1932) **120**
Miracle of Morgan's Creek, The (1944) 160
Mister Cinderella (1936) 48
Money for Nothing (1932) 229
Monsieur Beaucaire (1924) 146
Monsieur Beaucaire (1946) 228
Moon-Spinners, The (1964) 171
Morning Glory (1933) 118
Mother Knows Best (1928) 4
Movie Crazy (1932) 280
Mr. Moto (1930s, film series) 107
Mrs. Miniver (1942) 104
Munsters, The (1964-66, TV series) 176
My Best Girl (1927) 26
My Favourite Wife (1940) 214
My Sister Eileen (1940, Broadway) 49

National Velvet (1944) 129
New Orleans Uncensored (1954) **210**
Niagara (1953) 273
Night & Day (1946) 164
Night of 100 Stars (TV Special) 21
Night of the Hunter (1955) 45, 201
No Escape (1936) 202
No Highway (1951) 202
No, No Nanette (Broadway musical) 17, 61
No Orchids For Miss Blandish (1948) 229
Northern Pursuit (1943) 67

Old Dark House, The (1932) 112
Old Fashioned Way, The (1934) 154
Oliver Twist (1933) 282
On Golden Pond (1981) 118
Opposite Sex, The (1956) 272
Orphans of the Storm (1921) 201
Our Dancing Daughters (1928) 75
Outlaw, The (1943) **95**

Pack Up Your Troubles (1932) 101
Pagan, The (1929) 51
Pal Joey (1957) 217
Paradise Case, The (1947) 163
Partridge Family, The (1970s, TV series) 216
Perfect Strangers (1945) 163
Perry Mason (TV series) 228
Personal Secretary (1939) 18
Peter Pan (1920) 202
Peter Pan (1924) 260

Philadelphia Story, The (1940) 107, 118, 166, 223, 228
Pick a Star (1937) 48, 169
Plan 9 From Outer Space (1959) 236
Please Believe Me (1950) **88**
Port of Hate (1939) 246
Postman Always Rings Twice, The (1946) 152
Pride and Prejudice (1940) 59, 104
Private Life of Henry VIII, The (1933) 214
Public Enemy, The (1931) **92**, 175

Quiet Man, The (1952) 259

Rains of Ranchipur, The (1955) **135**
Random Harvest (1942) 104
Randy Rides Again (1934) 99
Rawhide (1959-66, TV series) 226
Rebecca (1940) 46
Red-Headed Woman (1932) 70
Reducing (1931) **76**
Reefer Madness (1936) 189
Rifleman, The (TV series) 141
Rio Grande (1950) 259
Road to… (film series) 212
Road to Hong Kong (1962) 272
Road to Victory (1944) **106**
Road to Yesterday, The (1925) 96
Roberta (1935) 214
Rogers, Jean **144**
Roman Scandals (1933) **112**
Rope (1948) 250
Rosalie (1937) 215

Sally (1928) **274**
Salvation Hunters, The (1925) 54
San Francisco (1937) 10
Sand of Iwo Jima (1949) 67
Sandy (1926) 4
Santa Fe (1951) 214
Sayonara (1957) 278
Second Chance (1947) **161**
Secret of the Blue Room (1933) 112
Service De-Luxe (1939) 17, **18**
Set-Up, The (1949) 152
Seven Brides for Seven Brothers (1957) 206
Seven Doors to Death (1944) **160**
Seventh Heaven (1927) 31
Seventh Veil, The (1945) 163
Shadow of a Doubt (1943) 47, 201
Shadow of the Law (1930) **126**
Silk Legs (1927) 4
Sin of Harold Diddlebock, The (1947) **122**
Singin' in the Rain (1952) 121, 199, 271
Singled Out (1990s MTV game show) 77
Skull and Crown (1935) 219
Sleepless Nights (1933) 229
Slippery Feet (1925) 91
So Big! (1931) 283
So This Is Marriage? (1924) 242
Soldiers of the Storm (1933) **80**
Some Like It Hot (1959) 258
Son of the Sheik, The (1926) 28
Song of the Open Road (1944) 206

Souls For Sale (1923) 242
South Pacific (1956) 10
South Sea Love **20**
Spanish Dancer, The (1923) 171
Sporting Venus, The (1925) 101
Stage Door (1937) 21, 168
State Fair (1945) 169
Step Lively (1944) **119**
Stolen Harmony (1935) 219
Stone Heart, The (1915) 185
Stormy Weather (1943) 220
Strangers on a Train (1946) 250
Strangers When We Met (1960) 217
Strong Man, The (1926) 116
Stud, The (1978) 272
Sugarbabes (stage musical) 168
Sugarland Express, The (1974) 171
Sunset Boulevard (1950) 10
Susan and God (1940) 190
Susie's Affairs (1934) 219
Suspicion (1941) 46
Swiss Miss (1938) 48

Tangled Evidence (1934) 131
Tell It to the Marines (1926) 242
Tension (1949) 152
Terror House (1942) 163
Tess of the d'Urbervilles (1924) 101
Thank Your Lucky Stars (1943) 65
That Certain Thing (1928) 185
That Certain Woman (1937) **130**
They Asked For It (1939) 18
They Met in the Dark (1943) 163
Thin Man (1936-47, film series) **116**
Third Man, The (1949) 201
This Day and Age (1933) 154
Titanic (1997) 112
To Hell and Back (1955) 47
Tom Corbett – Space Cadet (1950s, TV series) 103
Too Much Harmony (1933) 154
Topper (1953-55, TV series) 119
Torch Song (1953) **42**
Tower of London (1939) 185
Toy Soldier, The (1941) **167**
Tugboat Annie Sails Again (1940) 227

Unforgiven (1960) 201
Unsuspected, The (1947) 152
Up a Tree (1931) 186

Valentino (1977) 290, **293**
Vanishing Armenian, The (1925) **99**
Vanity Fair (1923) 242
Vanity Fair (1932) 282
Vertigo (1958) 217
Virgin Queen, The (1955) 272
Virginian, The (1929) 260

Way Down East (1920) 201
Way Out West (1937) 48
Wedding, A (1978) 201
Weekend Millionaire (1935) 202
Welcome Danger (1929) 282
Whales of August, The (1987) 201
Where the Boys Are (1960) 43
White Zombie (1932) 4
Whoopee! (1930) 208
Wild Boys of the Road (1933) 219

Willow Tree, The (1920) 185
Wind, The (1928) 11, 201
Wings (1927) 26
Without Witness (1937, West End play) 267
Wizard of Oz, The (1939) 11, 12, 232, **142**, 219
Woman of the World, A (1925) 171
Women, The (1939) 10, 291
Women Love Once (1931) **64**

Yearling, The (1946) 227
You and Me (1938) **170**
You Came Along (1945) **107**
You Can't Have Everything (1937) **113**
You're in the Army Now (1941) 162
You're Telling Me! (1934) **158**

Ziegfeld Follies (1945) 26, 271

SETTING THE SCENE:
STUDIOS, COMPANIES,
STAGES AND PAGES

20th-Century-Fox 107, **128**, **146**, 169, 250

Academy of Motion Picture Arts & Sciences awards (Oscars) 21, 26, 31, 44, 46, 47, 52, 83, 105, 112, 115, 125, 130, 145, 149, 150, 165, 166, 183, 214, 223, 227, 258, 294
Acadmey of Television Arts & Sciences awards (Emmys) 236
Ambassador Hotel 290
American Film Institute 45

B.I.P Studios 229
Beverly Hills Hotel **260**
Biltmore Hotel, The, LA **269**
Broadway 17, 36, 37, 47, 49, 61, 119, 126, 129, 168, 185, 205, 211, 216, 222, 248, 257, 262, 278, 281
Brown Derby, The, Hollywood, **203, 229**

Ciro's nightclub 186, **234, 250, 263**
Columbia Studios 67, 152, 168, 246, 262
Cosmopolitan 161

Denny's 24

Eastman Kodak Company 242
Edison 185
El Capitan Theater, Vine Street, Hollywood 273
Electronic Frontier Foundation 253

Film Fan magazine 62
Film Weekly **26**
Filmograph magazine 64
Fox Studios 133, 205

Golden Globe 43

Hal Roach Studios 67
Harper's Bazaar, Paris 242
Hayes Office 144, 246
Henry Duff Company 28
Hollywood Roosevelt Hotel 77, **79, 281**

Jean Hersholt Humanitarian Academy Award 26
John Robert Powers modelling agency 119

KABC-TV 235

Lasky Film Company 101
Levy-Gardner-Laven 141
LIFE magazine 236

Mack Sennett Studios 266
Metropolitan Opera 167
MGM 43, 49, 53, 59, 62, 76, **78**, 80, 101, **117, 134**, 146, **149**, 165, 166, 167, 168, 174, 198, 205, 206, **242**, 253, 261, **277**, 278, 281
Mocambo nightclub, West Hollywood **244, 247, 251, 252/253, 255, 271**
Modern Screen Magazine **27**, 279
Monogram 119, 169
Monterrey Country Club 25
Motion Picture and Television Country House and Hospital, The 32, 66, 175, **178**, 179, **181**, **186, 189**, 195
Music Box Theater, Hollywood **274**

NBC 123
New York Times, The 122, 160

Paramount Pictures 36, 59, 89, 107, **110**, 154, **164**, 203, 220, 226, 255, 281, 283
Plaza Hotel, New York **264**

Racquet Club **31**
RADA 272
Red Bird restaurant 27
RKO Pictures 46, 94, 119, 136, **155**
Rodeo Room, Beverly Hills **256**

Savoy, The, London **267**
Screen Actors' Guild of America 38, 145, 184
Selznick Studios **201**
Stork Club **222, 248, 250**, 257

Thunderbird Country Club 17, **18**
Trocadero Club, Sunset Boulevard 28, 215, 236, 295
Turner Classic Film Festival 213

Universal Studios **16, 18, 38, 55**, 120, 141, 175, 178, 195, 221, 222, 243, **274**

Vogue 161

Walt Disney 171, 225
Warner Bros. 12, 58, 67, 93, 98, **109**, 130, 131, 161, **166**, 169, 193, 225, 262, 269, 276, 283
West End, London 131, 222, 267

Acknowledgements

Our thanks to Adam Robinson-James for his visionary creative design.

To ACC Publishing: James Smith , Susannah Hecht, Clara Heard and Craig Holden, who turned our tales of Hollywood into a book for all to enjoy.

To our parents, John and Pamela who have given us more than we could ever thank them for.

To our sister, Rowena ('MoMo') for putting up with her two kid brothers.

Also to Ken and Julie Gabb and Elza 'Mrs. S.' Mombers. **And to our extended family**.

To Violet's neighbours at Errol Gardens, who gave us the odd bit of pocket money so we could correspond with Hollywood's old guard; Sylvia Lucas, Gladys George, Bernard and Milly Pauling, Beattie Skilton, Doris Lawrence and Arthur Giles.

To our school teachers and subsequently those at Epsom School of Art & Design, who encouraged our interest – even if they thought it a bit unusual: Liz Shaw, Halina Scharf, Terry Molloy, Patricia Burton, Len Richardson, Natalie Crouch, Jill Jameson, Rob Hillier and Judith Warner.

To the people – friends, colleagues and film stars – who we've had the good fortune to know. You have made our lives so much richer: Coos Adriaanse, Lassie-Lou Ahern-Brent, Barry Ainslie, Kris Alaerts, the late Judith Allen-Rucker, Fenella Allison, Carole Ashby, Christine Baker, the late Barbara Barondess-MacLean, the late Lina Basquette, the late Thomas Beck, Patricia 'Sugar' Bekaert, the late Madge Bellamy, Eileen Berney, George and Josephine Bottino, Samantha Bradshaw, Paola Brandi, Barbara Broccoli, the late Hillary Brooke-Klune, Kevin Brownlow, Tracy Bull, Joe Butler, Andrew and Victoria Byrom, the late Hilda Campbell-Russell, Bill Cappello, Frances Card, Mary Carlisle-Blakeley, the late Shirley Chambers, the late Ruth Clifford-Cornelius, Jacqueline Clodong, Alexandra Coleman, Michael Collins, Douglas Conklyn, the late Kate Courtney, Adrian and Lesley Coyle, Kirsty Craik, Peggy Cummins-Dunnett, John Curran, Lisa De Hert, Steven de Moor, the late Billie Dove-Kenaston, Lynn 'Dottie' Downey, the late Ann Dunne, Joe Dunne, Antonia Ede, Seth Ellison, the late June Epstein, Michele Essayan, the late Muriel Evans, Dominick Fairbanks, the late Douglas Fairbanks Jr., Jessica Fellowes, David and Jane Finch, David Fisher, Richard Foley, Joan Fontaine, Lynsey Fox, Maurus and Ingrid Fraser, Stephen Fry, Arthur Gardner, Steven Gardner, the late Anita Garvin-Stanley, Allan Glaser, Bram Goorden, Noelle Goris, Con Gornell, the late Bruce Guerin, Lucille Guerin, the late Rosemary Hall, Shirley Haner, Leslie Hardcastle, Stuart Harris, Matt and T Hilsdon, the late Rose Hobart-Bosworth, the late Joy Hodges-Schiess, Andrew Holmes, the late Bob Hope and Dolores De Fina-Hope, Tab Hunter, John Huntley, the late Dorothy Janis-King, Anne Jeffreys, Dylan Jones, Jane Kean, Lene Kemps, Simone Kitchens, Amy Klitsner, Kiyoko Koguchi, Pancho Kohner, Jarko Koskela, Maggie Koumi, Carla Laemmle, Richard Lamparski, Alun Lettsome-Jones, Shaun Lee Lewis, Laurence Longree, Rita Lupino, the late A.C. Lyles, Nicola McAllister (Pert), Chris and Martin McAngus, Andrew McKee, the late Addie McPhail-Sheldon, the late Mae Madison, Mara Madison, Sandra Maes, Claire Malcolm, Randal Malone, Corinne Manches, the late Joan Marion-de Rouet, the late Patsy Ruth Miller-Deans, Evelyne Mortelmans, Penny Mountbatten, Greet Moyson, the late Anna Naughton, the late Fayard Nicholas, Barry Norman, the late Maila Nurmi ('Vampira'), Margaret O'Brien, Dianne Ohman, Roberta Older, Jackie Osborne, Moya O'Shea, Alan O'Sullivan, the late Anita Page-House, the late Gloria Pall, Aksel Parmaksiz, Vijay and Anita Patel, Sue Peart, Eric Peeters, Robert Pert, William Prince, Maz Raein, Luise Rainer, the late Barbara Raley, Jackie Ranawake, Gemma Rees, Frank Reighter, the late Dorothy Revier, Brynn Robinson-James, Julie Robson, Guy Roop, Peter Rooney, the late Patricia Russell-Exner, John and Maureen Ryall, Antonia Ryan, Bob Satterfield, Lizabeth Scott, Arthur and Stephanie Seacombe, Ann Segers, Els Seymoens, Miranda Seymour, Jane Shaw, the late Mildred Shay-Steele, Charlie Shearn, Therese Sherman, James Sherwood, Aoife Smith, Norman Soloman, the late F. Maurice Speed, the late Risë Stevens, the late Margie Stewart-Johnson, Kathy Stirling, Jesse Swash, Kenneth and Patricia Sweeney, Barry Thompson, Jane Thompson, Hilton Timms, the late Ann Todd, Layne Tom Jr., Veronica Toomey, Lupita Tovar-Kohner, Rosella Towne-Kronman, Liên-Anh Tran, Simon Trewin, Sarah Tucker, Peter Turner, Rita Tushingham, Tugba Unkan, Adele Urquhart, the late Virginia Vale, Mamie Van Doren, late Vera Van-Ward, Sarah Vaughn, the late Gene Vazzara, Judith Watt, Lord and Lady Frederick Windsor and Sarah Wise.

We should also like to take this opportunity to thank:

Past and present staff on the obituaries desks of *The Daily Telegraph*, *The Independent*, *The Times* and *The Guardian*, who published our work – our life stories of Hollywood's most forgotten.

Our gratitude goes to The Academy of Motion Pictures Arts & Sciences; BAFTA; Ben Glazier Designs; BFI front desk – Stephen Street; British Broadcasting Corporation; The staff of the British Library; staff at *The Chicago Times*; Citadel Press publishers; Clarkson N. Potter Inc. publishers; Condé Nast Publishing; Levi Strauss & Co./Dockers®; Li & Fung/Trinity/SRB; staff at *The Los Angeles Times*; McFarland & Company publishers; Mission Public Relations; staff at *The New York Times*; staff at *The Observer*; Orbis publishing; staff at *The Scotsman*; *The Surrey Comet*; and staff at *USA Today*.

The following film journals and periodicals: *Classic Images*; *Empire*; and *Variety*.

Thanks to the editors and contributors on the former film fan magazines and periodicals that fed our enthusiasm for the era: *Film Fashionland*, *Films & Filming*, *Films in Review*; *Hollywood Studio Magazine*, *Photoplay*; and *Screenland*.

Picture Credits

The majority of the photographs are from the archives of those films stars who signed and mailed them to us; these often bear the names of motion picture studios, whom we thank here. Every effort has been made to secure permission to reproduce the images contained within this book, and we are grateful to the many individuals and institutions that have assisted with this task. Any errors or emissions are entirely unintentional and the details should be addressed to the publisher.

Film photo libraries and photographers: The Estate of Max Munn Autry; Bettman Corbis; Markus Brandes; Culver Service (New York); Ronald Grant Archive; Historic Images; Hulton Getty; The George Hurrell Estate; D'arcy Moore; Jay Parrino; The Estate of Maurice Seymour; and The Frank Worth Estate.

Stills libraries of the following film studios: Amalgamated Films; Balboa Film Studios; B.I.P; Christie Film Company; Columbia; Eagle-Lion; Educational; First National; Fox; Gaumont-British; Hal Roach Studios; Invincible Pictures; Macot Pictures; Metro-Goldwyn-Mayer; Monogram; Paramount; Pathé; P.R.C. Pictures Inc.; R.K.O. Radio Pictures; 20th-Century-Fox; United Artists; Universal; Vitaphone; and Warner Brothers.

BFI Stills Posters & Designs:
Palm Springs: pp. 18, 29, 38. I used to be in Pictures: pp. 81, 82. Hollywood on Set: pp. 91, 92, 102, 111, 116, 133, 147, 154, 165, 166. I'm Still Big, It's the Rooms That Got Small: pp. 174, 178, 180. Hollywood on the Town: pp. 201, 218, 224, 228. Hollywood After Dark: pp. 246, 261, 266, 275, 280, 283

Hulton Getty: Vampira – A Hollywood Horror Story: pp. 235, 239.

Charles Shearn: Cocks & Cocktails: page 288.

Front cover: Dorothy Revier, photographed on the set of *The Black Camel* (1931), Fox Film Corporation.
Back cover: Marion Shilling with Austin Mutti-Mewse, Redondo Beach, California, 1994.
(photo: © 2014 Austin and Howard Mutti-Mewse)
Endpapers: © 2014 Austin and Howard Mutti-Mewse

The images on pages 5, 7, 15, 35, 87, 197, 285 © of Howard and Austin-Mutti-Mewse, 2014.
p. 5: card from Lillian Gish. The first reply sent to the twins in 1984.
p. 35: Mildred Shay's address book from the 1940s.
p. 69: Stack of studio publicity shots of Alberta Vaughn from the '20s.
p. 87: Max Factor – the make-up of choice for Hollywood's make-up artists during the 'Golden Era'.
p. 173: Rose Hobart's own salt and pepper cellars, which she brought to the table every meal time in the Motion Picture and Television Country House and Hospital.
p. 197: One of many hotel room keys belonging to Mildred Shay.
p. 231: Letter to Austin and Howard from Maila Nurmi ('Vampira') with a suitably seductive letter heading.
p. 241: A 1940s menu from the Stork Club, one of most popular nightclubs often frequented by movie stars when in New York.
p. 285: Mildred Shay's costume and hair test shot for George Cukor's *The Women* (1939).

© Austin Mutti-Mewse and Howard Mutti-Mewse 2014
World copyright reserved

ISBN 978 1 85149 753 9

The right of Austin Mutti-Mewse and Howard Mutti-Mewse to be identified as authors of this work has been asserted by them in accordance with the Copyright, Designs and Patents Act 1988

British Library Cataloguing-in-Publication Data
A catalogue record for this book is available from the British Library

Typeset in GillSans Light & GillSans (body text and headings) and Recorda Script by Måns Grebäck (title and chapter headings).

Printed in China for ACC Editions, an imprint of the Antique Collectors' Club Ltd., Woodbridge, Suffolk

Top letter (left, handwritten):
...tin andu are *dear*! Dear,ightful friends indeed. I... ...imagine my pleasure in receiving ...e lovely surprise package. The book on Tudor Britain is ...harming. How clever you were to remember that one of my favorite pastimes is the study of English history. This beautiful little ...ume will be among my cher... ...reminders of two ...

Top right (typed):

VIII - 22 - 199[3]

Dear Howard and Austin Mewse -

Thank you very much for y[our]

letter - and good luck to you

K. H͟s͟p͟-

Middle letter (handwritten):
Delicious choc... You must Have s... major werknes... my Gluttony By st... Dinners!) But I forgiv... ...ith thanks.

Card (right, handwritten):
Joy Hodges
Hi - Thanks for the pictures
I have lost weight so new pho...
of myself will look better with a
nice thin person standing by —
Lots to you both!
J

Lower right (handwritten):
what you are doing soo...
and I wish you great succe...

Peggy C...

Address (lower left, printed/handwritten):
Marguerite Chapman
11558 *Riverside Dr.*, Apt. 304
North Hollywood, Ca. 91602 U.S.A